W9-CID-882

Featuring the largest reveal of country music icon Dolly Parton's private costume archive,

this gorgeously photographed book shares the story—in Dolly's own words, as well as those of her closest collaborators— of her lifelong passion for fashion, including how she developed the distinct Dolly style that has defied convention and endeared her to fans around the world.

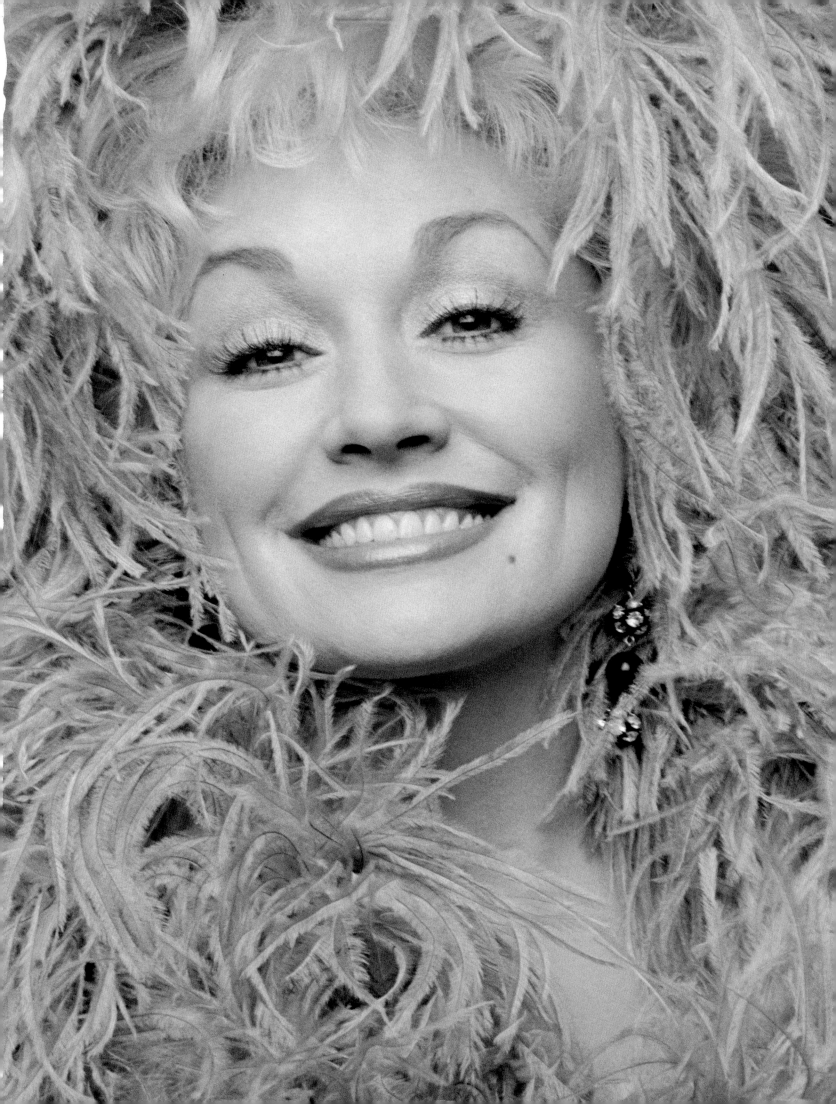

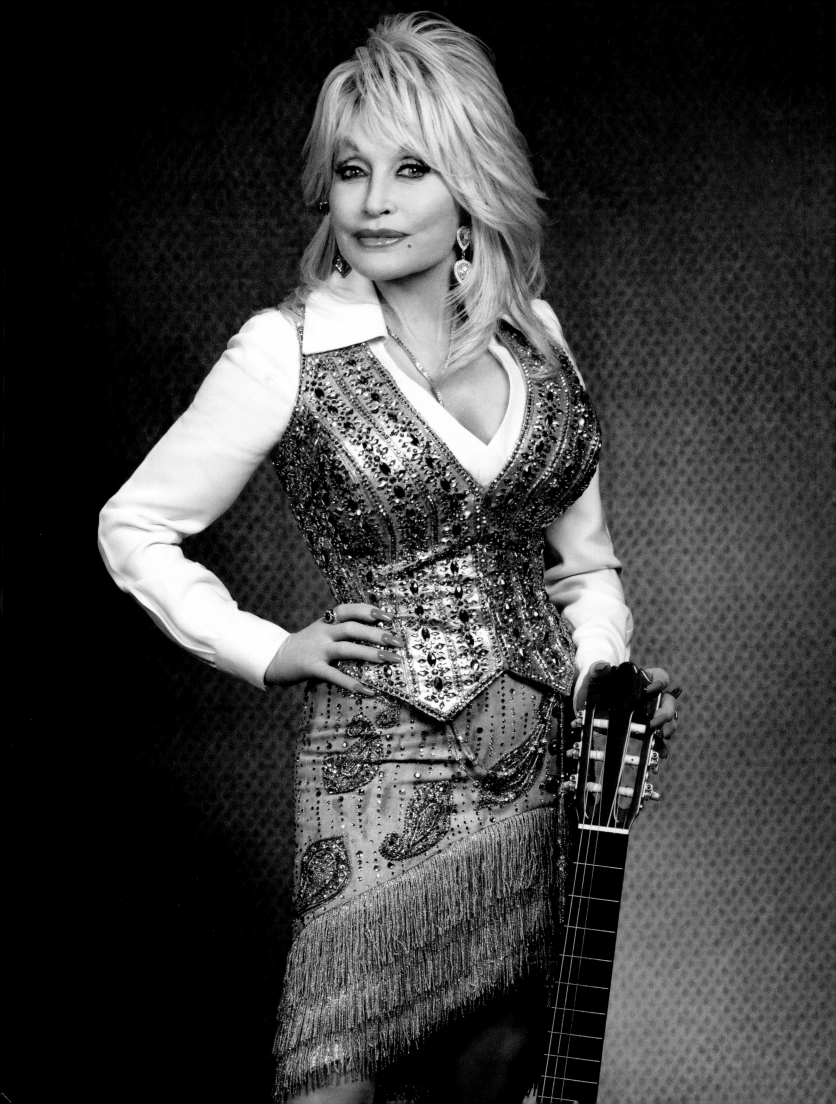

DOLLY PARTON

BEHIND THE SEAMS

MY LIFE IN RHINESTONES

BY DOLLY PARTON

WITH HOLLY GEORGE-WARREN
CURATED BY REBECCA SEAVER

TEN SPEED PRESS
California | New York

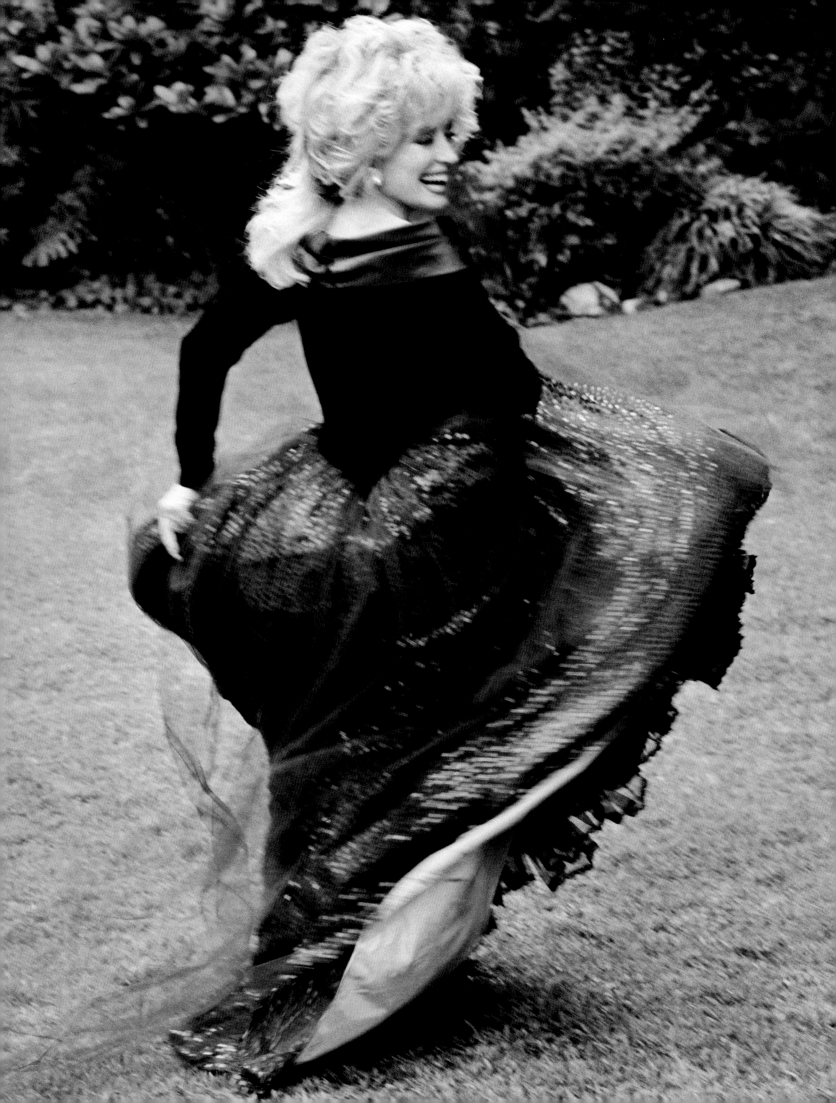

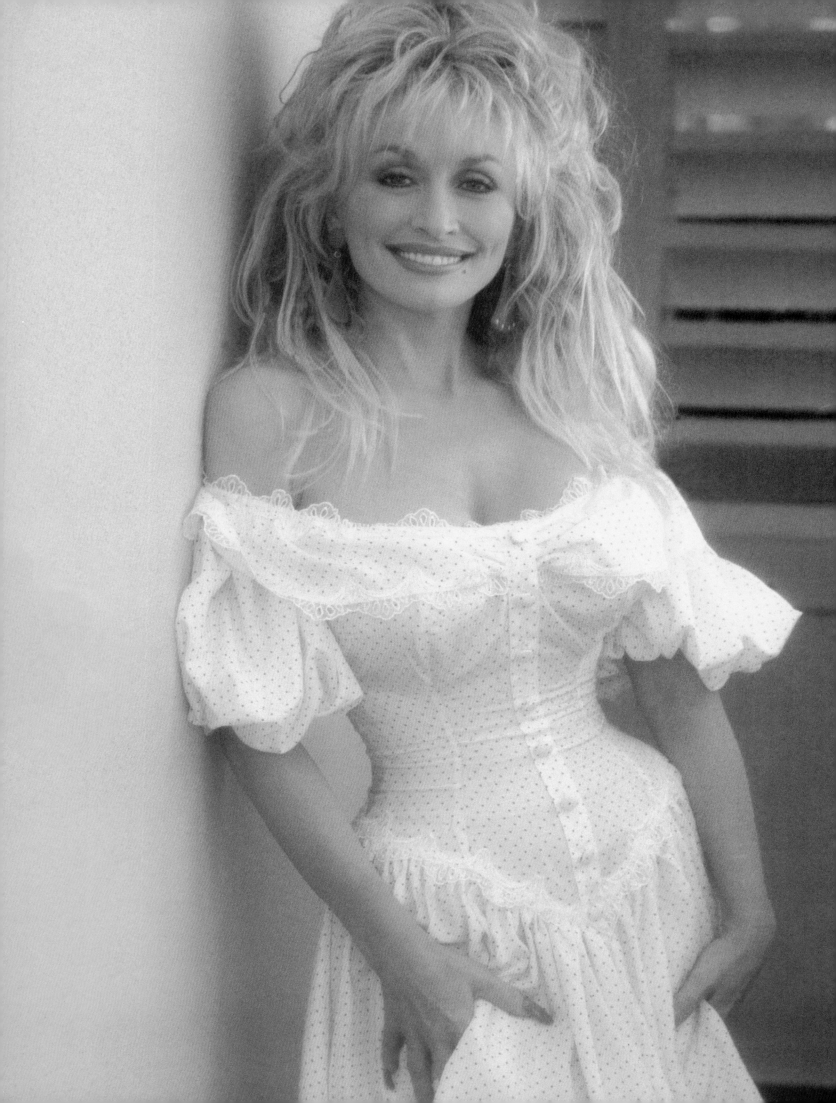

Contents

Introduction 1

1
The Seasons of My Youth
5

2
Isn't a Star Supposed to Shine?
31

3
Iron Butterfly
65

4
And Here I Go . . .
83

5
A Diamond in a Rhinestone World
115

6
Daisy Mae in Hollywood
155

7
The Unsinkable Dolly Parton
191

8
Country Girl Glam
223

9
Head Over High Heels
267

10
Better Get to Livin'
293

Acknowledgments 324

Photography Credits 325

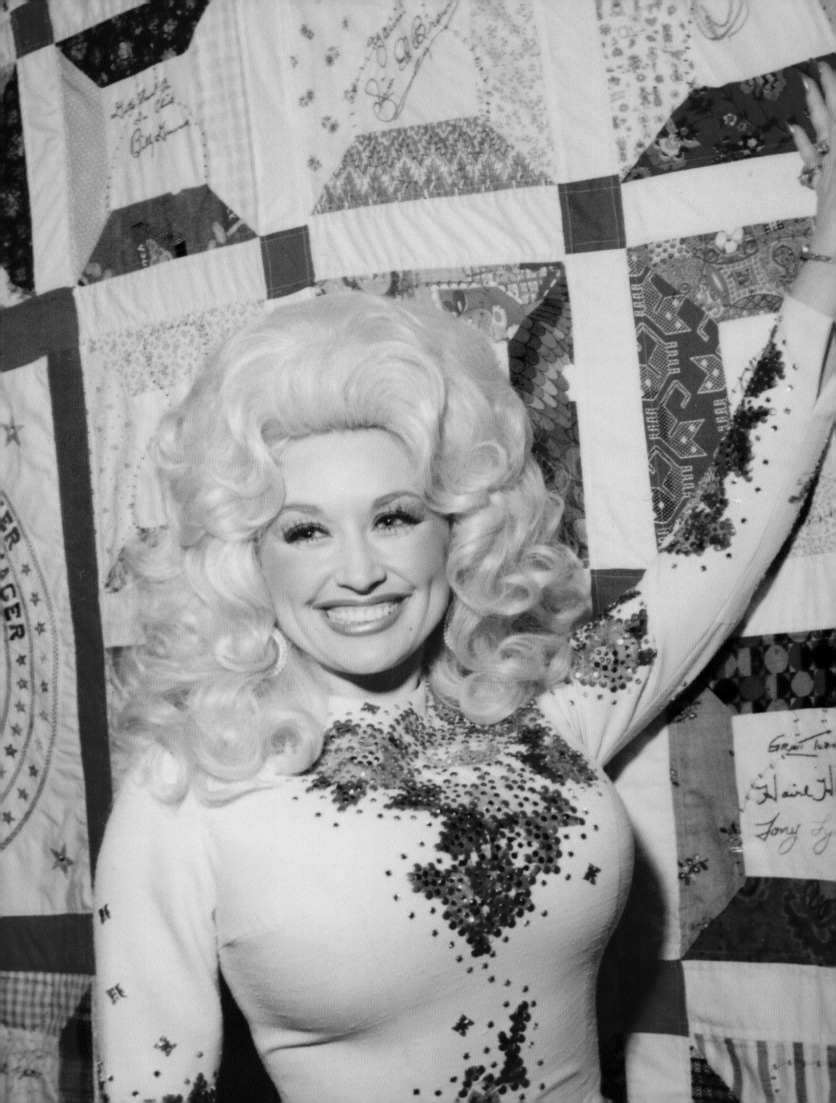

Introduction

Clothes are like songs. Just as hearing certain music brings back particular memories, so it is with certain outfits. I'm so fortunate that, from the beginning of my career, I've had close friends and relatives who have taken good care of the clothing that is important to me. From personal items like the little bolero vest I wore while performing as a child and my simple wedding dress to such gorgeous costumes as the red dress that turned me into Miss Mona in *The Best Little Whorehouse in Texas* to everything I've ever worn onstage, each of these garments signifies something important—a place in my life, a moment in my career, a time when I felt like *me*. I treasure them all.

Behind the Seams: My Life in Rhinestones tells the stories behind some of my favorite outfits, both on and off the stage. It also paints a picture of the evolution of my own personal style that I first developed growing up in the backwoods of East Tennessee. I always loved makeup. I wanted to be pretty. Back then, any woman who wore makeup in the mountains was considered trashy. But I didn't care. When I started buying my own makeup, I also started dressing according to how I felt, which meant wearing tight, low-cut outfits that my mama made. I remember feeling powerful enough to go up against Daddy or Grandpa to say, "Now, that's not that tight. It ain't cut that low. It ain't that much." And they'd say, "Yes, it is!" But I'd be willing to get my ass whupped for it. I would sacrifice for how I wanted to look.

The same thing happened when I moved to Nashville in 1964 to become a country star. Just like I had to persist to get my songs heard and ignite my recording career, I had to resist a lot of "advice" telling me to tone down my look or choose a different type of wardrobe. In these pages, you'll learn I never listened to any of that. From early on, I loved the big hair and makeup, the long nails, the high heels, the flashy clothes, and—as soon as I could afford them—the rhinestones! But believe it or not, I had to fight for that look!

In this book you'll see how, as a young artist, my self-confidence was enhanced by developing my own Dolly style and then sticking to it. I didn't care about trends. Instead, I worked hard to look the way I pictured myself. Although my style has evolved as the years have gone by, I've stuck to the motto "To thine own self be true" over the past six decades—and still do. Much as the fictional characters that populate my songs uncover essential truths about me and the people I've known, my clothes and makeup also reveal the real me. Maybe they're both "made up," but they reflect my innermost self, my own personal truth.

I've had lots of help telling the story you're about to read. You'll hear from some of my designers, tailors, hairdressers, makeup artists, and photographers, and from my longtime creative director, Steve Summers, and his team, all of whom have been essential in transforming my ideas into reality. Early on, my personal assistant and friend, Judy Ogle, began assembling my clothing archive. She did a great job of saving and looking after all my things. Without her, so many of the pictures, so many of the clothes wouldn't be here. Before she retired, she archived everything she could—that was her mission and her calling. My niece Rebecca Seaver, who learned from Judy, has been an integral part of my career for years and has curated the special collection you're about to see, selecting these pieces from among thousands of garments that she and her crew care for. Nobody in this world is better suited to working in my archive. She is perfect because she has been there from the very, very beginning, and she also loves clothes. She grew up with me. Everything I did she was part of, and she knows every dress I ever wore— how it looked, how it felt, how it smelled. No one else could have put together the ideas for this book better than Rebecca. She has selected items spanning six-plus decades—from complete outfits to accessories, shoes, and wigs—to fill these pages.

I hope that as you gaze upon my life in clothing, it will inspire you to develop, and celebrate, your own sense of style. I value my freedom to look like and be my own true self more than anything else, and I hope this book will also give you the confidence to look like and be the person you want to be. Whoever you are, be *that*! And enjoy your journey behind the seams.

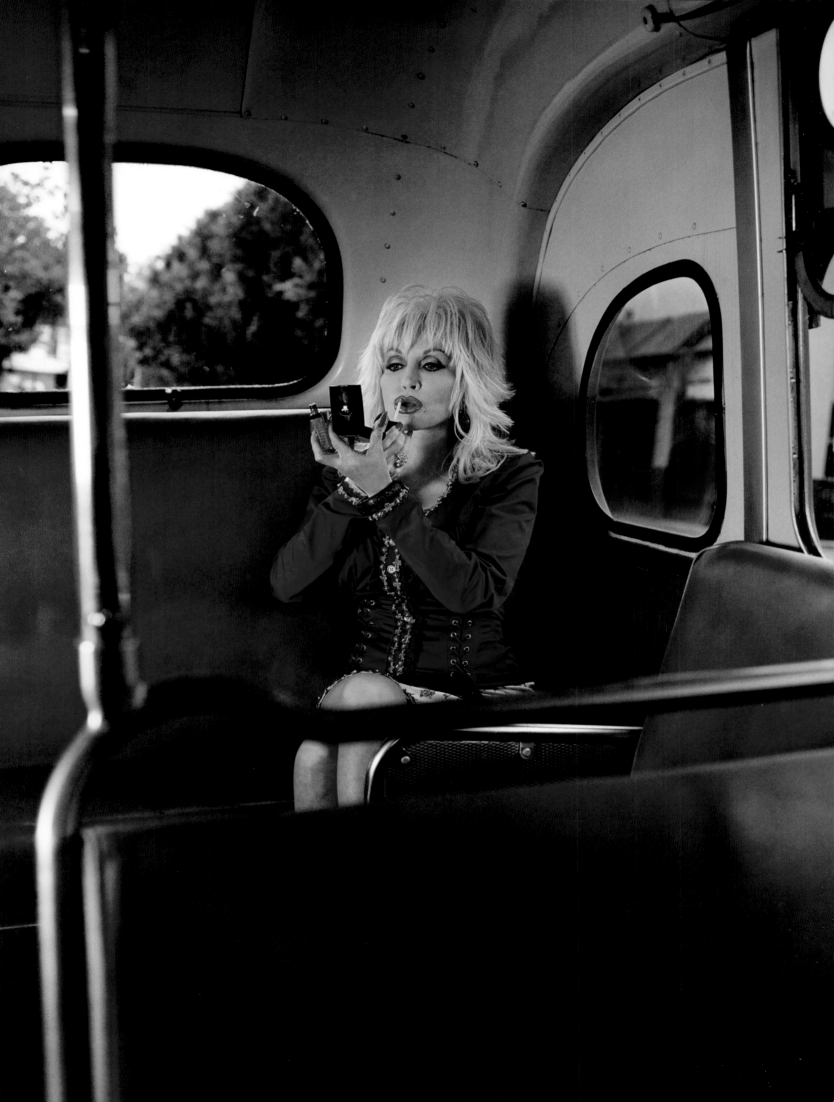

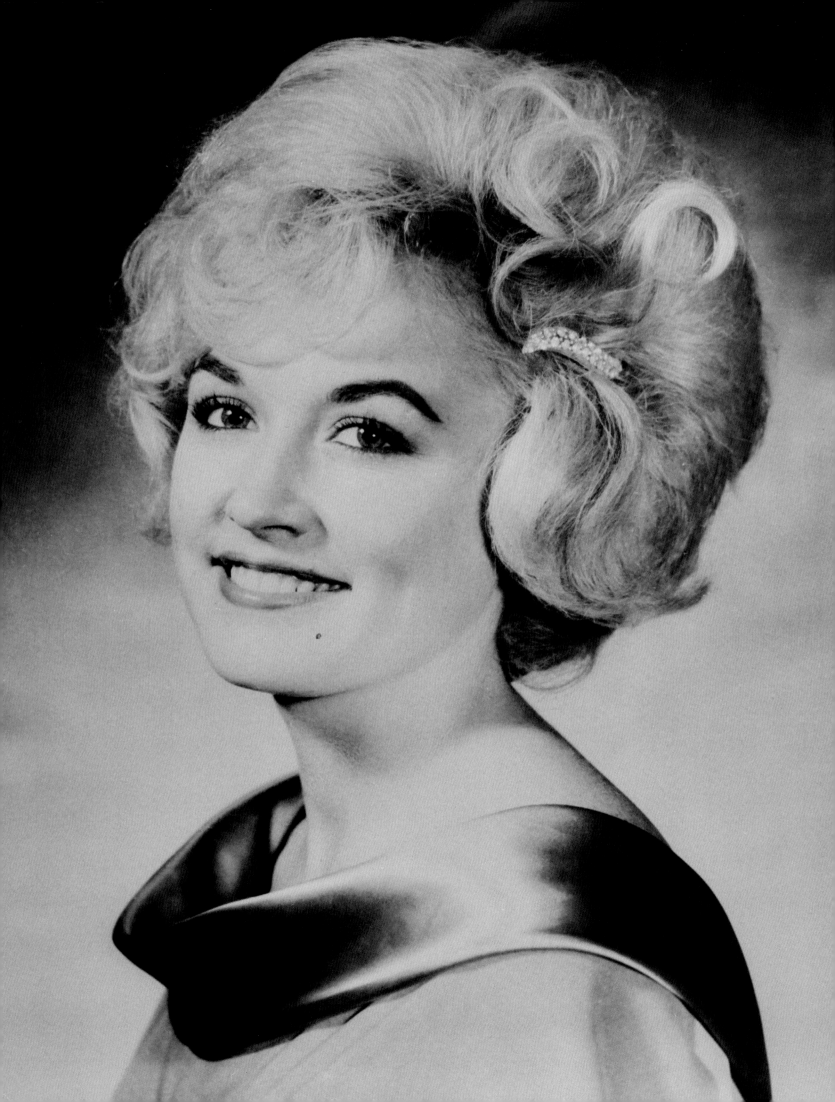

1

The Seasons of My Youth

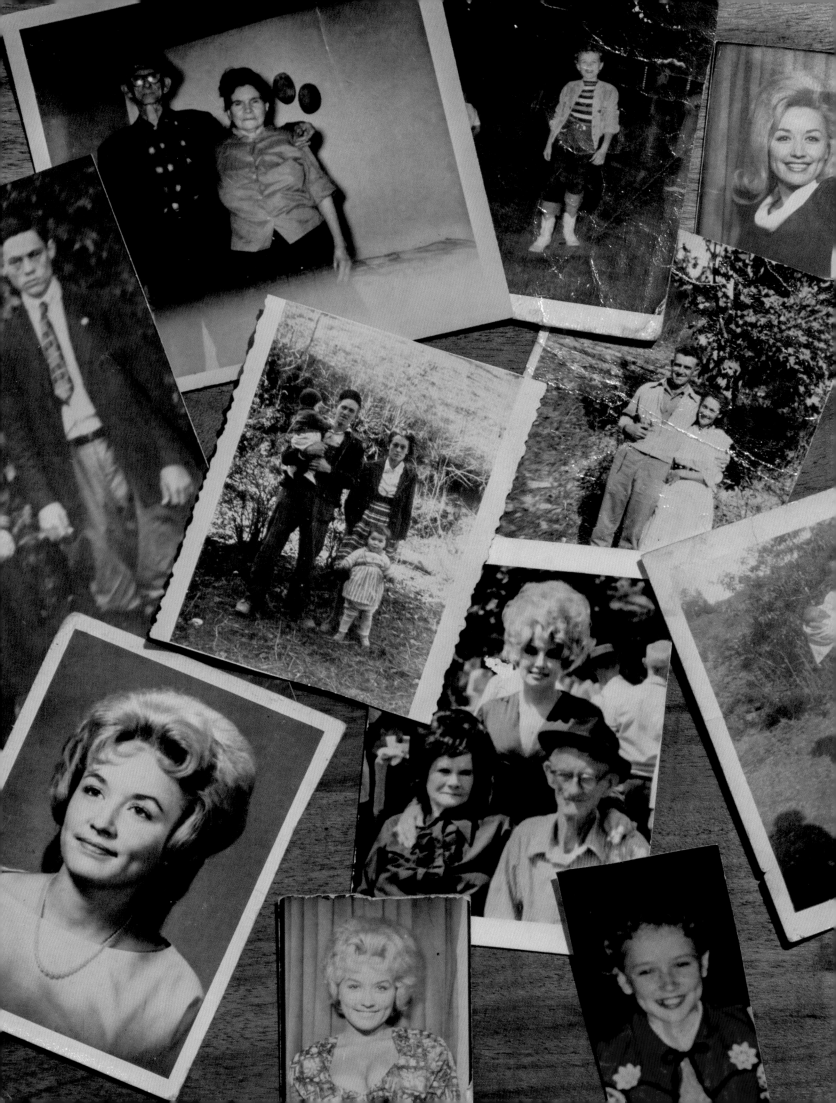

"I just wanted to be different. I wanted to be seen."

Dolly

The fourth child of Avie Lee and Robert Lee Parton, Dolly Parton grew up in Sevier County, in the rural Great Smoky Mountains of East Tennessee, surrounded by a loving family. Her father was a sharecropper and her mother had twelve kids by the age of thirty-five. "If there's one positive thing about being poor," Dolly says, "it's that it makes a person more creative." From a young age, Dolly's creativity was abundant. Along with her parents, Dolly's aunts and uncles nurtured her musical talent, helping her as she developed as a singer, songwriter, and musician. Beginning in childhood, Dolly cultivated her own unique style.

—*Holly George-Warren*

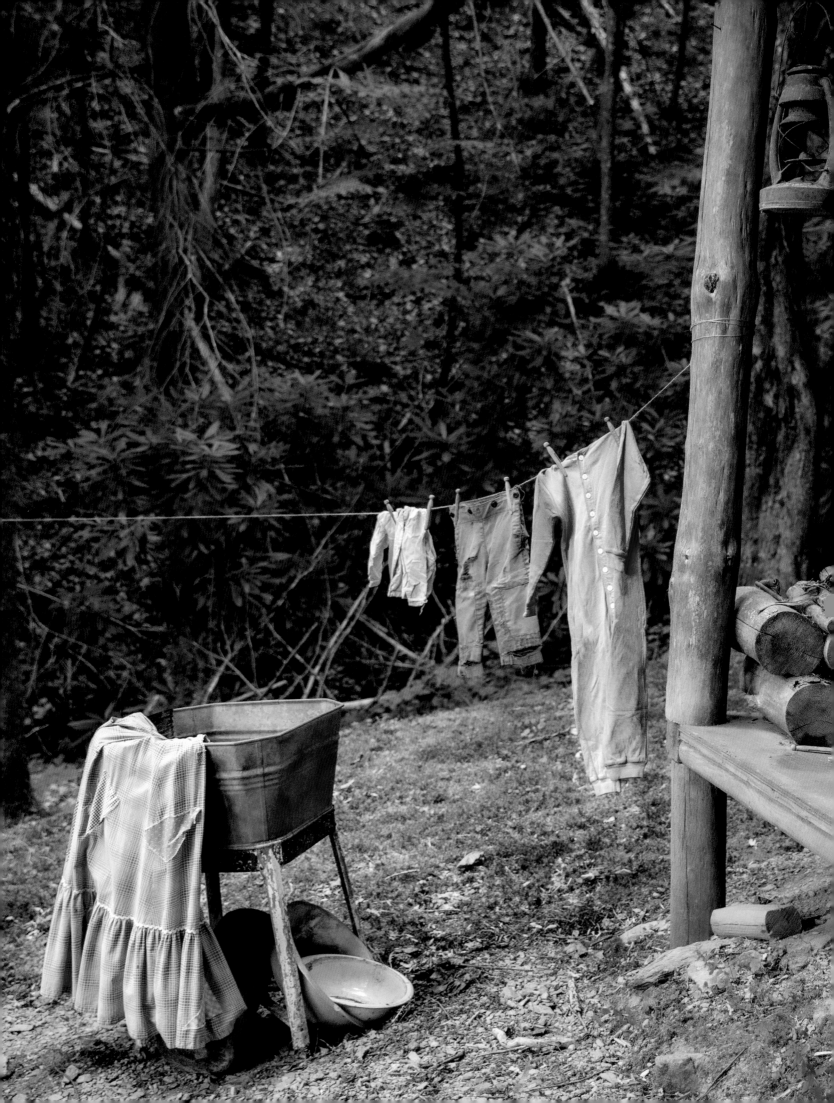

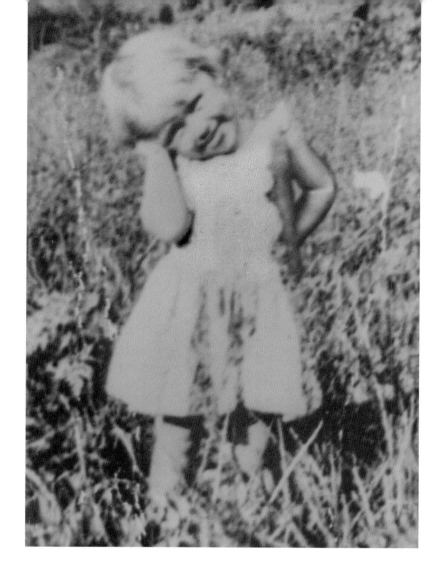

Above: Me striking a pose the first time I crossed paths
with a camera, circa 1949. *Opposite:* I still have my
ol' Tennessee mountain home in Sevier County.

"Look pretty!" That's what my aunt Dorothy Jo told me when I was three years old, right before she took a picture of me wearing a little white dress she'd bought for me. I was standing in a field near my Tennessee mountain home as she took aim with her Brownie Hawkeye camera. "Pretty? How do I look pretty?" I asked her. And she said, "Well, just *pose.*" So I did—and that's my first *pretty* picture.

We were poor people and lived way back in the Smoky Mountains. I didn't have many nice things that weren't hand-me-downs, but I tried to make them look special. Even as a child, I was fascinated with clothes. I wanted to have more than what I had and wanted to wear more than what I should. Even though I didn't know it at the time, I just wanted to be different. I wanted to be seen.

The Seasons of My Youth

When I was really young, my older sister Willadeene and I wore clothes that Mama made from flour sacks and the sacks that held feed we bought for the farm animals. Some of the sacks were decorated with flowers. Mama was making what we called "sack dresses" long before that was a style, and we were always happy when we got a new dress with a pretty print on it. We loved it! To make the dress special, Mama would sew rickrack or a little lace trim on it. Rickrack was a big deal back then. You could buy yards and yards and yards of it at the dime store, so Mama trimmed our flour-sack dresses and made them as pretty as she could.

Because the sack dresses were made from thick, coarse material, they weren't very comfortable against our skin. But there's a saying, "Beauty knows no pain." I didn't really think about it then because usually I'd wear a petticoat underneath the dress, and Mama would also make something for us to wear under that. I remember how excited I was when I got my first half-slip with elastic around the waist so I didn't have to mess with petticoat straps anymore. You could just pull that half-slip up and go for it!

It's fun to think back to all the fashion trends I've seen in my life and how things have changed. Design innovations come along when suddenly somebody thinks, "Well, why don't we make a slip that you can just pull up so you don't have to wear the whole petticoat?"

As a little girl, I liked playing dress-up, even when we didn't have great things to dress up in. I'd mix and match different things that I'd find—like Mama's skirt and Aunt Estelle's blouse or whatever. I was always trying to make myself look good. I wanted to be Cinderella. Even back when I was just a toddler, our neighbor, who I called Aunt Martha, used to bounce me on her knee and sing me a tune with words about "Little Dolly Parton" having a pretty red dress—I think that idea stuck in my head!

We had the woods, too, where you could forage natural beauty products. If a girl has dreams and creativity, she can come up with all kinds of ways to look, and feel, pretty when she doesn't have the real thing. I used to squash up honeysuckle blossoms to make perfume. And *pokeberries*! Pokeberries were major because you could mash them up and make a stain that—boy!—takes forever to come off. I would paint my lips with that. You have to water down the pokeberry stain if you're going to use it as rouge on your face, though, because it's naturally a dark purple. All kinds of vegetables and wild plants and fruits, like blackberries, could also be used for color. With pokeberries, you could even paint your toenails and fingernails. That "nail polish" would stay on for a long time.

Behind the Seams

Mama's sewing kit was full of treasures—to make
clothes for all her young'uns.

I also used household goods to make homemade cosmetics. I'd strike one of
Mama's long wooden kitchen matches, put a little spit on the end of it, and use
that to color in my eyebrows and my beauty mark. And my mama always kept
bright-colored Merthiolate or Mercurochrome to put on our cuts. Since I didn't
have lipstick, I tried putting it on my lips. Merthiolate was more orangey and it
burnt like hell, especially when my lips were chapped. Mercurochrome was redder
and didn't sting as much. Both of them stayed on your lips *forever*. But Daddy did
not like us wearing makeup. He'd try to wash it off my lips, and I'd say, "No, it's
my real color. It's my natural color." He'd say, "'My natural color,' *my ass*! You get
in there and get that off of you." Later on, I'd use Mama's flour as face powder. As
I described in my 1994 memoir, *Dolly: My Life and Other Unfinished Business*, she'd
tease me for that, saying, "What are you going to do when you get all hot and

The Seasons of My Youth

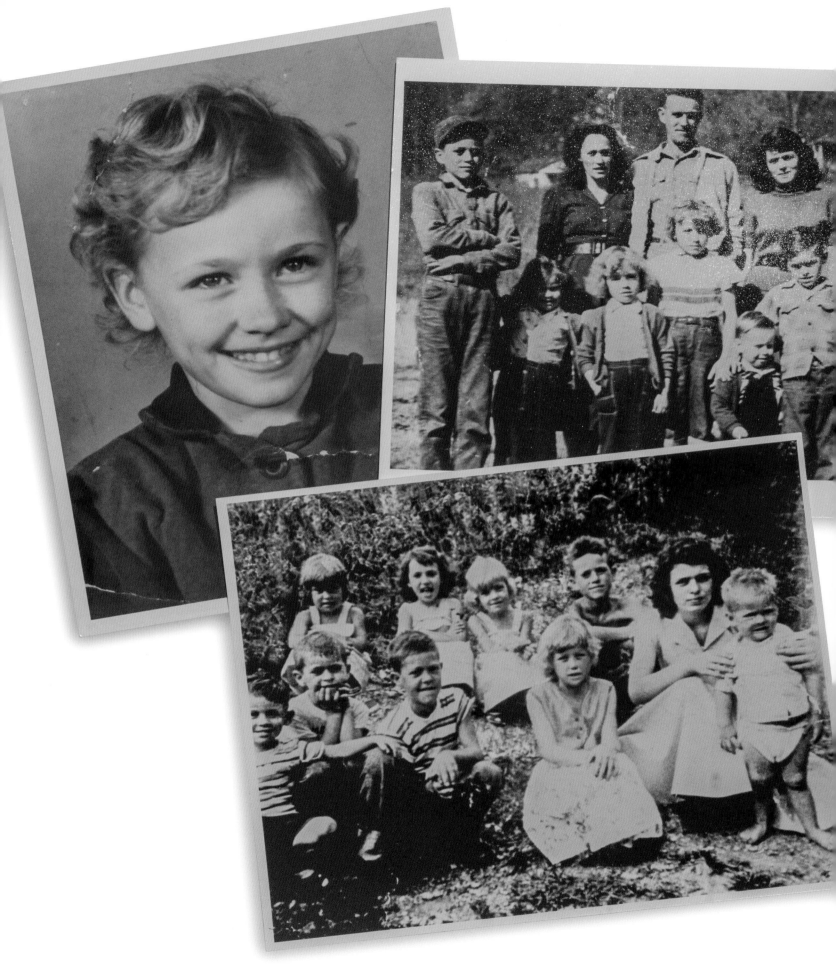

Clockwise from top left: Me in my Coat of Many Colors; some of us Partons, circa mid-1950s *(front row, from l to r:* David, Cassie, Stella, me, Randy, Bobby, and Denver; *back row, from l to r:* Mama, Daddy, and Willadeene); visiting with cousins, circa mid-1950s *(front row, from l to r:* Cousin Dale, Bobby, Denver, me, Willadeene, and Randy; *back row, from l to r:* Cassie, cousin Donna Faye, Stella, and David)

sweaty? Make biscuits?" But anyway, kids make do. If you've got a fascination for clothes and makeup and hair, you'll find ways to make them the way you want them.

And I always liked playing with hair. I never had beautiful hair. Mine was not curly like my dad's. It was straight, like Mama's, and baby fine. I loved curly hair and wished mine was. Some of my sisters had beautiful hair. Mama would get me a perm once or twice a year, which was not necessarily great for my hair. But you go through such things till you find out what's good for you and what's not.

To look better or different, I was always putting stuff in my hair—flowers and twigs and any kind of thing I could root up. We'd find chicken feathers and bird feathers in the woods, and I'd put them in my hair, or I'd make things out of the feathers. I'd attach them to a string and have a necklace. We used lots of other stuff from the wild too. We had oak and buckeye trees by our house, and we'd take those acorns and buckeyes and string them to make necklaces. Mama always had big needles because she did a lot of sewing, making quilts and curtains that needed big needles. I'd take Mama's big needles and heavy thread and string up all kinds of berries and things we'd find in the woods to make jewelry.

"If a girl has dreams and creativity, she can come up with all kinds of ways to look pretty when she doesn't have the real thing."

—Dolly, 2022

We certainly didn't have any money to buy stuff. We'd play "pretend"—or what we called *p'like*, or "play like." My brothers and sisters and I would p'like we were characters in Bible stories. Denver, Bobby, David, Cassie, Stella, and I would pretend we were wearing "Jesus sandals" that had straps going all the way up our legs. I used pokeberry stain to paint the sandal straps on my little brothers' legs. We used to put on those sandals to walk around like we were disciples in the Holy Land. After all, there were enough of us to make a group of disciples.

My aunt Estelle never had children, and she and my uncle Dot brought things up to us from their home in Knoxville. They'd bring catalogs and newspapers that we'd look through to see the ads. I was obsessed with the Sears & Roebuck catalog. Oh man, I would dream on those things. I wanted everything in the catalog and I thought, "Someday, I'm going to have it."

The Seasons of My Youth

My Homemade Foraged Cosmetics Kit

Flour

In Mama's kitchen, I found some real good face powder.

Pokeberries

Mashed pokeberries straight from the vine were my "go-to" for rouge.

Feathers

The birds in the woods near our home helped me decorate my hair and gave me some of my first jewelry.

Matches

I used the burnt tips of Mama's kitchen matches to line my eyes and eyebrows and make a beauty spot.

Mercurochrome

Mama's medicine cabinet hid one of my favorite tricks for making my lips bright red. Talk about long-lasting beauty!

We'd use pictures from catalogs to make paper dolls because we didn't have toys except for those that Daddy whittled and the dolls that Mama made. She turned a corncob into a doll with a dress made of corn shucks, which I named Tiny Tasseltop, and I wrote my first song about her, "Little Tiny Tasseltop." I cut out pictures of people in catalogs and switched their clothes around by cutting the head off of one figure and then putting a different cutout set of clothes on it—just like store-bought paper dolls.

Sometimes, folks traveled to our little country schoolhouse way back in the hills to bring us boxes of donated rags and clothes and scraps. Charitable people gave us a chance to have something nice and different to wear. That was like Christmas or payday for us. All the women around the mountains would dig through the boxes, and I couldn't wait to get into them. The boxes were like treasure chests. I wanted everything I saw. Bright colors—especially red—caught my eye as a child, and I'm still fascinated with color. I'd see something colorful and drag it out, whatever it was. I was drawn to fancier fabrics, like velvet, relating them to kings and queens and all royalty. And I loved the intricacy and beauty of lace.

One of my favorite finds in the treasure boxes was a pair of red high heels. When I saw those shoes, I grabbed them out and hoarded them. I wouldn't let anybody else have them. They were saying, "No, those are for grown girls. You're just a kid." I said, "No, they'll fit me. I know they'll fit me." Oh, I longed for those shoes. I loved high heels even before I knew I was gonna be short! They took them away from me, of course, and wouldn't let me have them because they were for an adult. I grieved over those shoes for a long time and eventually wrote a song called "Red Shoes" loosely based on that story. I still love red shoes!

The most beautiful thing that Mama made me from scraps was my Coat of Many Colors, which inspired one of my best-known songs. It is not only my signature song but also my own favorite among the thousands of songs I've written. When I was little, I'd watch Mama make patchwork quilts from a variety of different fabric scraps. But when she sewed clothes for us, she usually made them out of cloth that matched. Maybe because she knew how much I loved bright colors, she came up with the idea of making me a winter jacket using lots of different colors and fabrics. I watched her as she spent days carefully sewing it. As I recalled in *Dolly: My Life and Other Unfinished Business*, "As soon as it started to look anything like a coat, I would beg her to let me put it on, and I would strut in front of the fire like some kind of patchwork peacock." My song lyrics tell the story of how much I loved it and what happened when I wore it to school. My schoolmates mercilessly made fun of my coat, ridiculing me and even pushing me into a coat closet

Behind the Seams

As a kid, my hand-me-down shoes never lived up to
those in the Sears & Roebuck catalog.

and locking the door—all because I was different! When I went home and cried
about it to Mama, she explained how my coat was made with love and that there
was a unique beauty to it that money couldn't buy. In the end, I loved that coat
even more than before. It came to signify many life lessons: how it's okay to be
different, how it's wrong to make fun of people or bully others, how the love of
family sustains us through tough times. Funny how such important ideas can be
conveyed through clothing!

Because Mama had to make ends meet to clothe all of us, my beautiful coat was
later remade into something for somebody else to wear. So I guess there was even
a recycling message there! Back then, of course, we had no idea that little coat
should be saved for posterity. The cover of my 1971 album, *Coat of Many Colors*, has
an artist's illustration of me as a girl wearing the coat. I asked Mama to create a
little replica so I could once again have a Coat of Many Colors. Her second one
had more patchwork and colors than the original. Then years later, Mama remade
one for my museum at Dollywood in Pigeon Forge. Although Mama had taken the
original one apart to reuse the fabric, an image of that little coat remains intact
in my mind. I'll always keep that.

The Seasons of My Youth

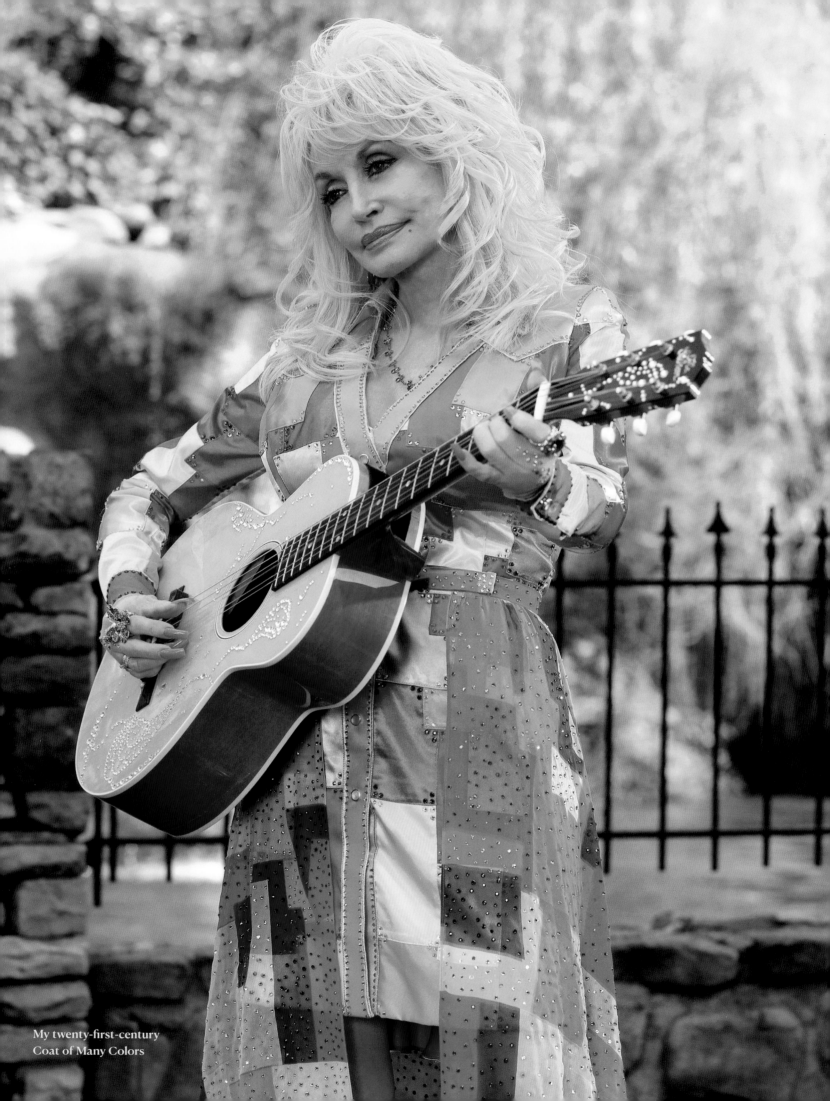

My twenty-first-century
Coat of Many Colors

The Coat of Many Colors
Through the Years

Inspired by my song, several Coat of Many Colors garments, in addition to the replicas Mama stitched, have been created for me over the decades. It all started one day when one of my first designers, Lucy Adams, had this idea. She decided she was going to make me a beautiful coat out of the scraps from all the stage clothes she had created for me through the years. Early on, another designer, Ruth Kemp, also made me something out of scraps from things she had sewn. And fans make me stuff all the time. Lord, I am lucky to have so many wonderful Coats of Many Colors!

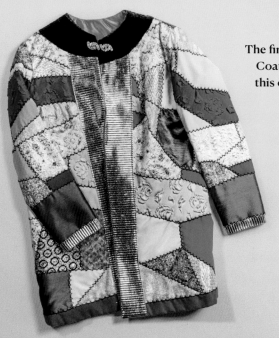

The first of many re-created Coats of Many Colors— this one by Lucy Adams, circa 1972.

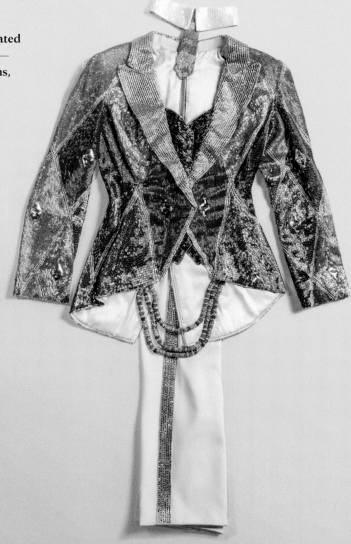

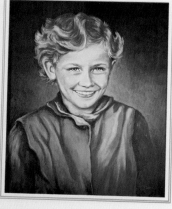

This is the record that started it all!

Designer Robért Behar and my creative director Steve Summers dreamed up this version when I performed at the Academy of Country Music Awards with Katy Perry in 2016. I'd just won the Tex Ritter Award for my movie *Dolly Parton's Coat of Many Colors*.

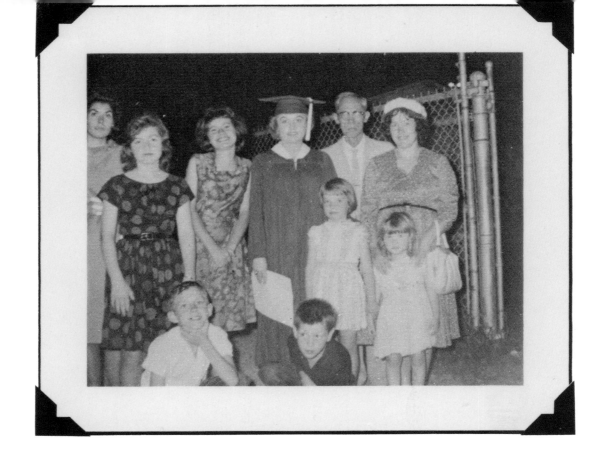

My high school graduation day, in 1964, surrounded
by friends and family, including Cassie to my right and
Grandpa Jake to my left.

By the time I was ten, my uncle Bill was taking me around to sing on a local country music station. I started performing on *The Cas Walker Farm and Home Hour* and practically grew up on Cas Walker's radio program and then his TV show, where I worked until I was eighteen. Mama made my outfits to wear on his program, and I tried to fancy them up as best I could. The first time I remember feeling really pretty was when I wore my first professional outfit, a little blue-and-white-checked dress. My uncle Lester—a truck driver with no wife or kids—gave Mama the money to buy the cloth. That was the first time I wore "show clothes" made just for me, and it made me feel special.

I also borrowed clothes from Aunt Estelle to wear on Cas Walker's show. When her skirts were too big for me, I'd fold them down at the waist and rig them up to fit. I remember one time I borrowed a beautiful cashmere sweater from a friend, and I begged her to let me wear it on the show. Before giving it back, I rinsed it out and put it behind the woodstove to dry. But it got scorched and was ruined. One of the sickest feelings I've ever had in my life was when I had to tell her that I'd ruined her sweater. I told her, "I'll buy you a new sweater. Do you want this one back?" And she said, "No, I don't want that one. It's burnt up." And I said, "Well,

Behind the Seams

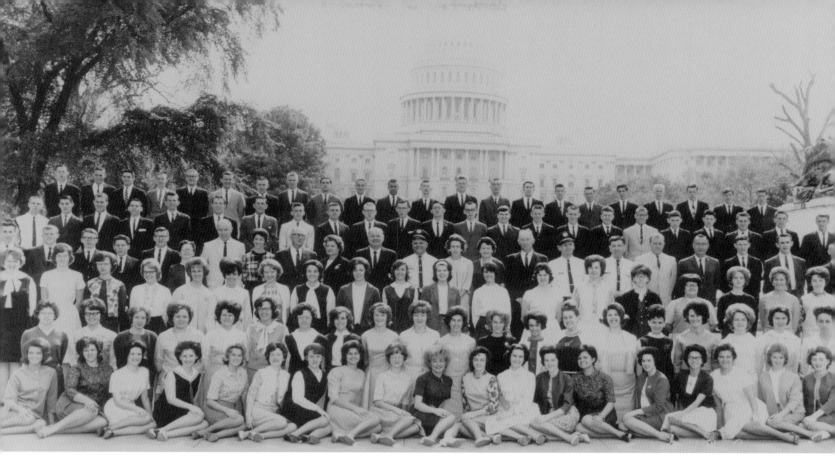

My senior trip to Washington, DC. That's me front and
center in the first row, wearing a dark dress, and my best
friend, Judy Ogle, is second from the right in the front row.

I'll keep it." And I remember paying her off a little bit at a time with my Cas Walker
earnings until I'd paid off the cost of that sweater.

When I was a teenager, I'd beg Mama to make me low-cut clothes that fit real
tight. I really wanted to look sexy in high school. I'd get my hands on anything
that looked cheap and gaudy. I loved that—it was my style, my taste. But Daddy
didn't want his girls looking what he considered trashy or tacky. He was afraid
something was going to happen to us. Mama would do it anyway because she
understood me. She'd say, "Now, don't tell your daddy I put some push-ups in
that dress." While I couldn't afford to buy a push-up bra, I wanted *them* pushed
up a little. I like to tell the story about how I used to steal the shoulder pads out
of my grandma's coats—or I'd *borrow* them, let's put it that way. And I'd put them
in my bra because they made good little push-ups. And as I got older, if I wanted
something tighter or if I wanted something pushed up a little, Mama trusted
me. She knew that was just my personality, my nature. She knew I wasn't trashy.
I was only trying to look showy. I wanted to be a showgirl. I knew I'd get the boys'
attention, but I was able to do that regardless of what I wore.

The Seasons of My Youth

I joined the high school band, but since guitar playing wasn't allowed, I marched to the beat of my own drum.

SEVIER COUNTY HIGH SCHOOL

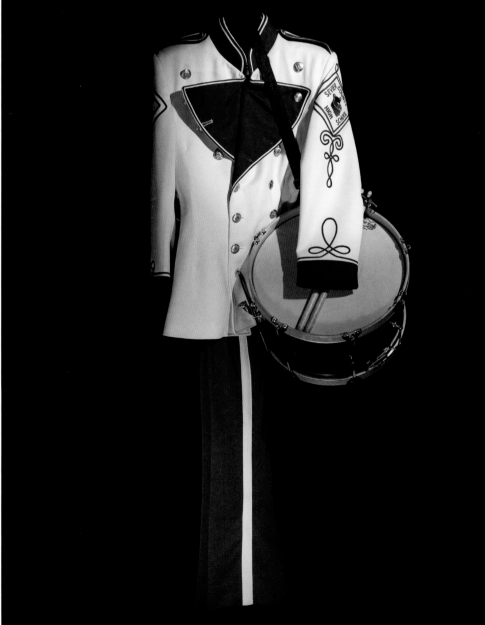

I've told the story many times that I patterned my look after the "town tramp," a woman who walked the streets of Sevierville with her tight skirts and her high-heeled shoes and her red nails and her red lipstick and her peroxided hair. I thought she was beautiful. But everybody said, "She's trash!" I laughed and said, "Well, if that's trash, that's what I want to be when I grow up!" She introduced me to how I wanted to look. Whenever Mama and Daddy let me ride in the back of the truck on their trips into town, I'd get to see her. I'd also go to the drugstore and look at photos of movie stars in magazines and think, "That's the way I want to look." And the Frederick's of Hollywood catalog! All that sexy lingerie! I thought that was the greatest thing ever. It spoke to me.

In high school, I got in trouble for the way I looked—especially with my grandpa, who was a preacher. Of course, Daddy didn't like me dressing like that. He didn't like the idea of me wearing short skirts and tight sweaters. I'd try to change into something else before he got home from work. In high school, because of the way I looked, I got a reputation, with some parents thinking I was a bad influence on their daughters. Well, those girls were the ones sleeping around—not me. I just *looked* like a party doll. I looked cheap and that was the way I liked it. That was how I felt like *me*! The boys liked it, and I liked that because I loved the boys, but some of the girls were jealous. I didn't care what people thought, and I still don't.

"I don't care what other people do as long as I'm left alone to do things my way."

—Dolly, 2022

Around this time, I wanted to lighten my hair. I was born blond, but my hair had turned a dirty-dishwater color. My dad's beautiful sisters Irmatrude, Nordale, and Christine peroxided their hair, but they let it grow out to the point that their roots were longer than their legs. With my money from *The Cas Walker Show*, I bought some peroxide to make my hair look like the town tramp's. My big sister Willadeene colored my hair the first time. I went over to her house and took my peroxide with me. She had an old well outside because she didn't have in-house water. I remember us carefully reading the directions on the hair-color box. They said, "Do not get in eyes; to do so may cause blindness." When Willadeene was pouring dippers of water over my head to rinse the stuff out of my hair, it started getting in my eyes and scared me to death. I cried out, "You can't get it in my eyes! To do so may cause blindness!" I was just quoting what I'd seen on the box. When I realized that I wasn't going blind, I was off and running!

The Seasons of My Youth

My Inspirations
Mae West

Ever since I was a young girl, looking up to that "town tramp," I've related to Mae West more than any other star because we're both little and we're both outrageous and we both like our high-heeled shoes. I've even heard that when she was older and in a wheelchair, she still wore her high heels. I'm sure I'll do the same thing. She was a tiny little thing—even shorter than me. She loved the platinum hair. I totally relate to her in every respect, not just the way she looked. She was a very smart businesswoman. A lot of people don't realize that she owned half of Hollywood, and she had her own production company. She did all that. She made good decisions and stood her ground. It's amazing how advanced she was as a woman in business back at that time.

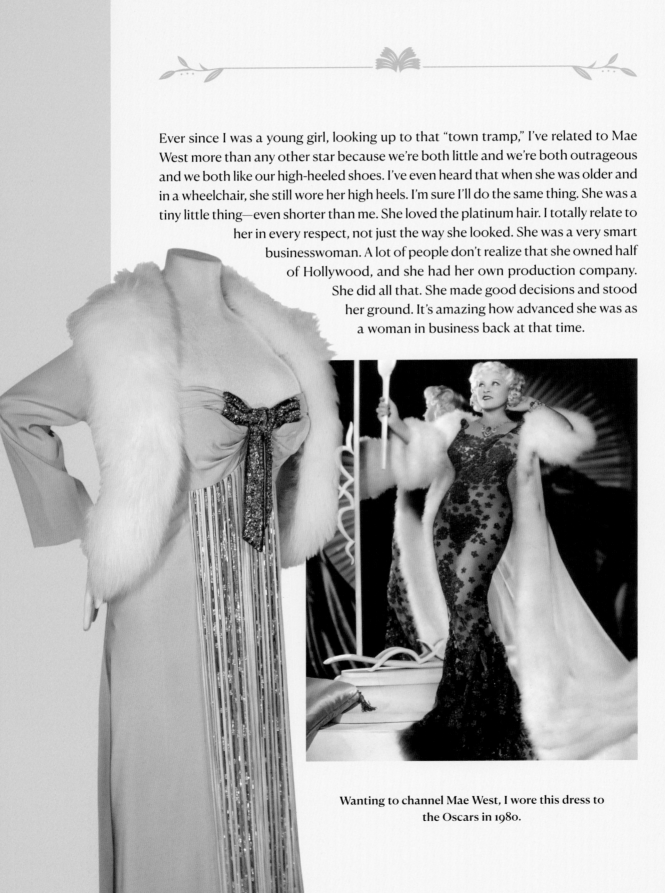

Wanting to channel Mae West, I wore this dress to
the Oscars in 1980.

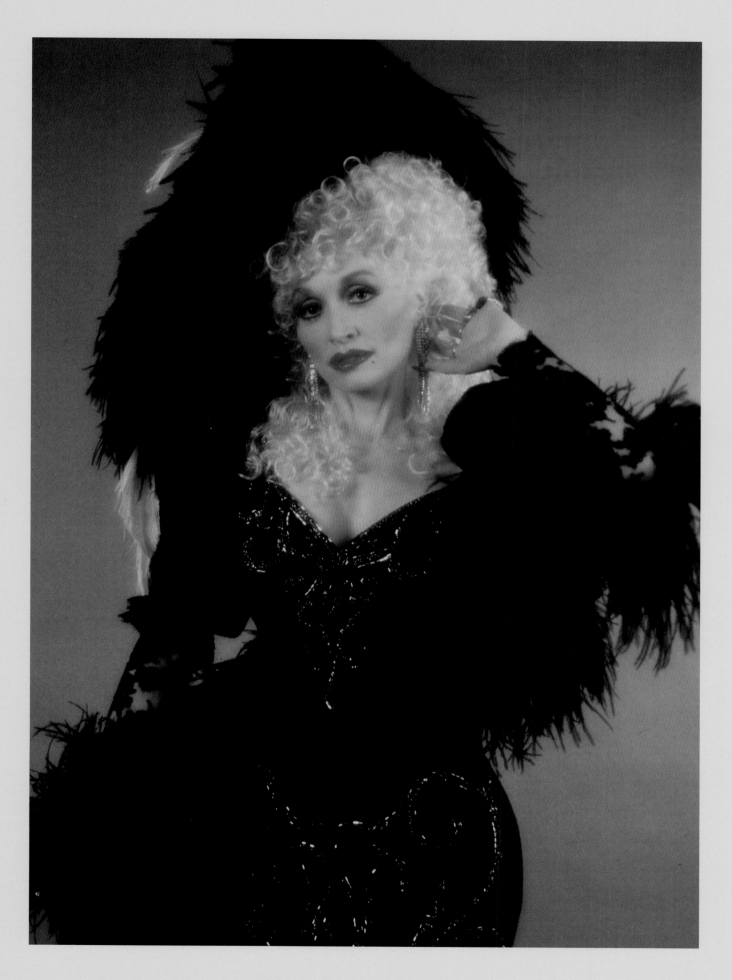

I actually got to play Mae on my TV show, *Dolly!*, in 1988,
wearing this outfit designed by Tony Chase.

After I started making a bit of money singing, I spent it on hair and makeup. There was a little area in the Sevierville drugstore where you could buy Maybelline makeup and perfumes. I'd also buy Evening in Paris and Heaven Sent perfumes. But Maybelline was the star of the show. You could always trust it. I still wear Maybelline.

And oh my goodness, pantyhose were like the microwave oven. When we started getting pantyhose, I thought it was one of the greatest inventions that's ever been. I still wear pantyhose. They're like a little body girdle. They make your legs prettier and shapelier. They mash in some of that loose stuff you don't want to show; you just feel more self-contained. You don't even have to wear panties with pantyhose. I guess that's why they called them *panty*hose.

Before pantyhose came along, I wore a garter belt and nylon stockings because I'm so fair skinned. I didn't like my little white legs running around. You really had to treat nylons with care. I remember the first nylons I ever got. Mama said, "Now, you're going to have to be real careful with those because you're going to pick 'em. They're going to run, and they don't look good with runs. You're going to look like trash." But as you can imagine, the "looking like trash" part didn't bother me too bad.

I wore fishnets as soon as they came out. To this day, I love wearing them, and not always on my legs—sometimes on my arms! Back then, I'd worry about ripping a hole in my fishnet hose. That was a big, big deal. We used to cry about having to wear torn things. Years later, ripped fishnets and nylons actually became a trend! And we used to cry when we got holes in our jeans. We didn't know ripped jeans were going to be fashionable one day too.

In my teens, I lived for a while in Knoxville with my aunt Estelle, who took me around to different department stores and helped me pick stuff out. While staying with her, I'd catch the bus to appear on Cas Walker's TV show. The bus came by her house at the top of the hill, and I'd ride it downtown, always carrying my guitar. After I finished the show, I usually had to wait on the sidewalk for the bus. I don't know what gave me the idea, but one day, just to pass the time, I opened up my guitar case while I was waiting and started playing and singing. Somebody came along and dropped money into my guitar case, and then it happened again and again. I got the idea to wear a more raggedy outfit for playing on the street. I started taking a little shabby shirt in my guitar case and changing clothes in the bathroom after the show. I'd put on that shirt, go out to the street, pull out my guitar, and start singing. I made a little money—not a lot, but enough to buy some hamburgers from the Jiffy Burger place. Years later, my baby brother, Floyd, and

My first-ever store-bought formal dress, a gift
from my uncle Lester for homecoming. Wearing it,
I felt like a Hollywood movie star.

I wrote a song called "Nickels and Dimes" based on my time staying with Aunt Estelle and busking on the street.

Aunt Estelle will always be special to me because she took me shopping for my first fancy dress, a formal gown paid for by my uncle Lester. That was the first time I got to really dress up. I remember Daddy feeling so proud of me. He thought I looked like an angel because the dress was kind of fluffy and a baby pale pink. I really did feel pretty in that. I felt like a real grown-up. I was eighteen years old. That was a special night and a special dress.

In May 1964, the day after I graduated from high school, I packed all my clothes in my matching luggage: four paper bags from the Piggly Wiggly. I boarded a Greyhound bus to Nashville, where my life—and my style—would soon change.

The Seasons of My Youth

27

Using her original sewing machine, Mama made a replica of my Coat of Many Colors, which I'll always be grateful for.

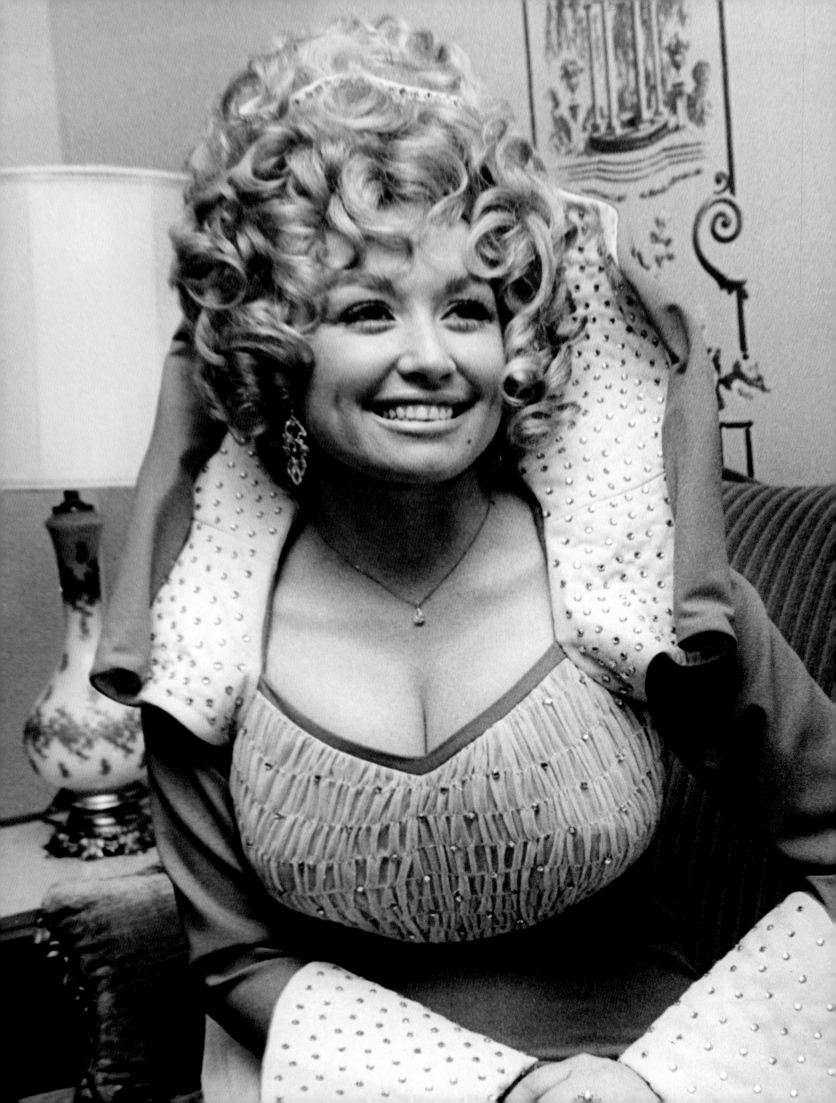

2

Isn't a Star Supposed to Shine?

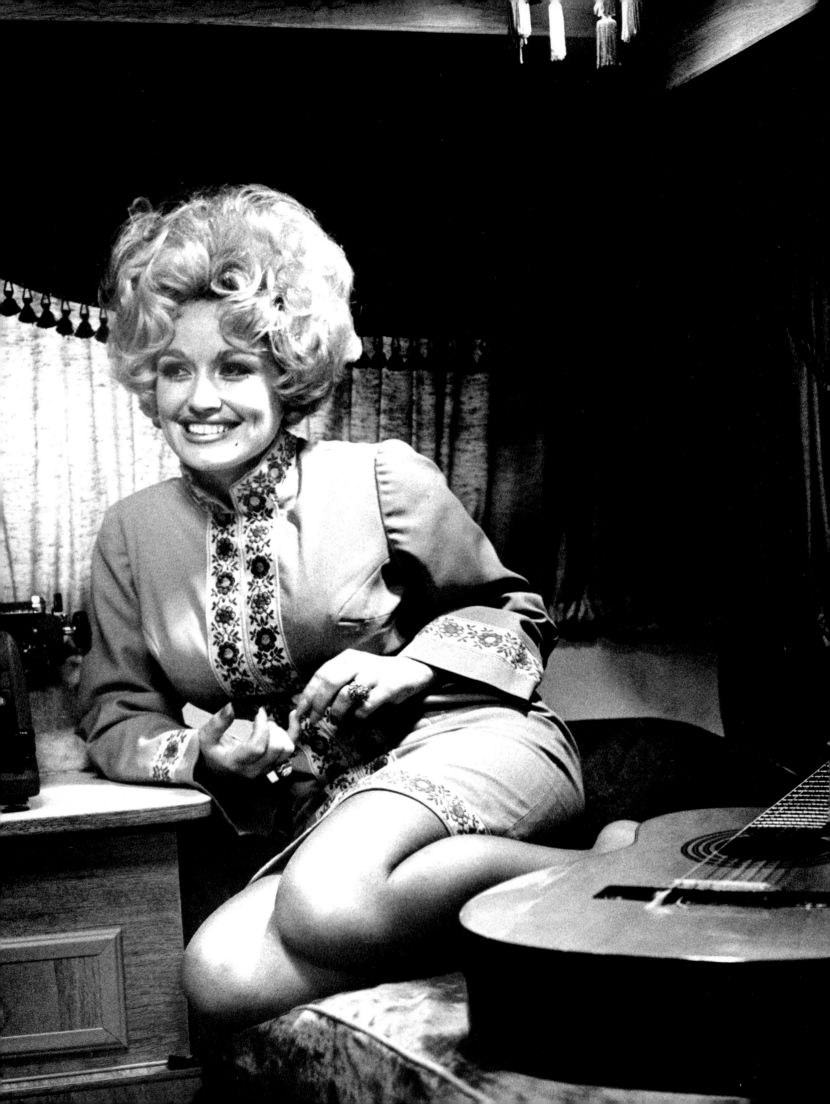

"I want to wow the audience. I want to really dazzle them if I can."

Dolly

Dolly's personal and professional life changed within a short time after relocating to Nashville. She almost immediately met Carl Dean, a Nashville native who became her boyfriend and then her husband. She got a recording and publishing deal with Monument Records, and after two years of cutting pop tunes at the label's behest, she finally began singing the traditional country music she loved. As she started getting airplay, she came to the attention of country star Porter Wagoner, whose popular TV show was syndicated in one hundred markets. He hired her as the "girl singer" on his show and for live performances, as well as on duet recordings for RCA Records. Dolly's prolific songwriting began to pay off, on both her own RCA albums and the duet albums she cut with Wagoner. In addition to writing hit songs, her effervescent presence, unique style, and mountain soprano led to her becoming one of the most popular artists in Nashville. She was on her way to stardom, and soon she'd be dressing like the star she always envisioned she'd be.

—Holly George-Warren

When I moved to Nashville, I already had some ideas about what I wanted to look like onstage—and off. Country stars had to have big hair and some sparkles, and you had to have a Cadillac. I had the big hair but not yet the Cadillac—or enough sparkles. I related to the clothes that were worn then. The girls on the Grand Ole Opry, like Jean Shepard, dressed up.

Early on, even before I moved to Nashville, I had two musical mentors who taught me a lot: country-western performers Pearl and Carl Butler. They lived in Knoxville, and I used to work with them on Cas Walker's TV show. Sometimes on Saturday nights, we'd sing together at a place up in Sevierville called the Pines Theater. Pearl had no children, and she took me under her wing. She'd give me small things or buy something for me to wear onstage—including a little bolero vest. I was so proud of that little bolero. Pearl and Carl Butler moved to Nashville, and they started doing pretty good with some hits like "If Teardrops Were Pennies."

One night, I got to see them perform with a group from California called the Maddox Brothers and Rose. That's where I got some of my showmanship. What I loved about Rose Maddox and her band of brothers was that they were the first people I'd ever seen who dressed in such colorful, sparkly Western clothes. They all wore matching outfits embroidered with cactus and flowers and all kinds of things. I loved those fancy clothes. I never wore that kind of Western stuff, but I did like the shine.

From the Maddox Brothers and Rose, I also learned how to put a show together with little skits and exchanging jokes with your band and the dynamics of how to pace a show. They were fantastic with that. I learned a lot from them. I remember thinking, "What a show!" You do routines, you fool with the crowd, you make them laugh. As one of the old-time stars used to say, "Make them laugh, make them cry, scare the hell out of them, and go home."

My uncle Lester, who was so proud of my singing, continued to buy things for me or give me money to buy clothes to wear on some of the shows I was on. Years later, when I could afford to pay for my clothes, I still always thought of Mama and Uncle Lester and all the people who helped me.

I remember that feeling of first standing onstage in show clothes. When I was around twelve or thirteen, visiting Nashville with Uncle Bill, I got to sing on the Opry on a Friday night. I wore a little blue-checked satin dress with a lace collar that my uncle Lester had gotten me. I got three encores that night.

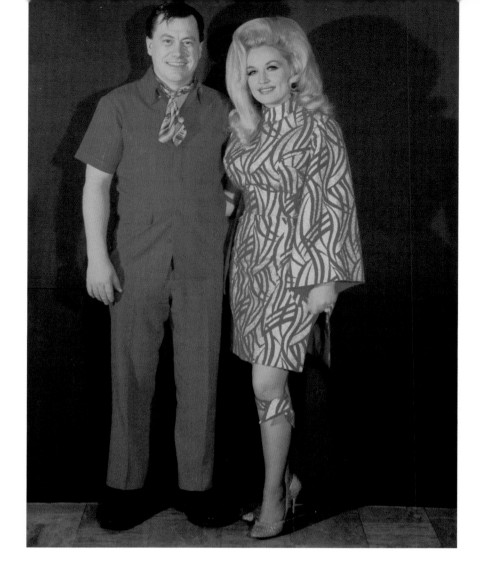

Here I am with my uncle Bill, who helped me get my start in
the music business. I was really trying to stand out in this
red-and-gold number in those early Porter days. The knee
scarf never really caught on, but I still think it's cute!

By the time I was fifteen, Uncle Bill and I were making the rounds in Nashville
trying to get me a record deal. I never wore just "whatever." I'd wear my very best-
fitting clothes, in what I thought were my best colors, red (of course!) and blue.
When I was fifteen, I made a 45 rpm record for Mercury Records. I returned home
to finish school, and at my graduation, I was asked, "What are you going to do?"
I said, "Be a star." Everyone laughed, but I knew what I wanted, and I moved back
to Nashville for good.

On one of my first days living in Nashville, in May 1964, I was at the Wishy Washy
doing my laundry. I was standing outside when a guy who turned out to be Carl
Dean drove by, saw me, and came back around to talk. I will never forget what I

Isn't a Star Supposed to Shine?

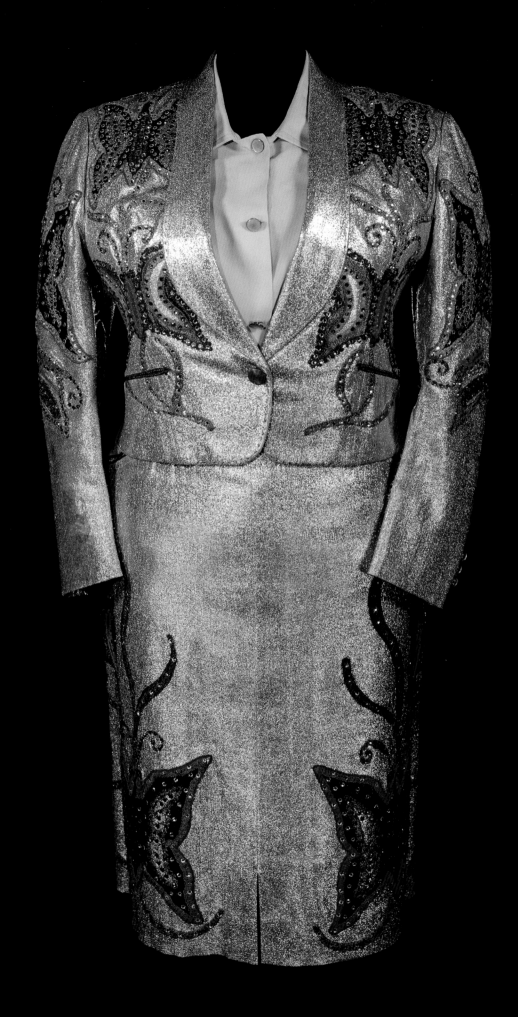

My mentor, Pearl Butler, gave me one of her beautiful custom-made
costumes, decorated with my future emblem, butterflies.

was wearing. It was a red sleeveless midriff top with ruffles—a rib-tickler—and you could see my belly. I had on tight hip-hugger bell-bottoms, and you could see from here to there. I had a real small waist—that's why I thought I could wear that sexy outfit. It was the thing to wear! And evidently, Carl thought so too! He saw me walking around out there, drinking a Coke, and he just turned right around and came back, and we started talking. And fifty-seven years later, we're *still* talking. I had that blond hair, and he said I was the girl of his dreams—the kind of girl he had always wanted. He liked the movie stars, and I looked like one of those girls to him. And he *still* thinks I'm that pretty—but he's half blind.

Fast-forward to 1965: I finally signed my first recording and writing contract with Monument Records. The label's president, Fred Foster, thought that I was prettier than I really am. He even thought I could be a movie star. But he and his people wanted to change my style into a 1960s pop look. They wanted to flatten my hair. They wanted me to look more chic and wear more streamlined clothes. He had his assistant take me around, and they set me up with a good hairstylist and a wardrobe person. But I hated everything about it! I felt naked. I might as well have been naked, because they took away my own look. It was just like trying to wear your mama's clothes when you're little: they weren't my clothes—that look wasn't me.

Then they did a bunch of photos, and I hated those pictures—again because it was not me. It was like, "Where am I? I don't like this hair. I don't like these clothes." I told Fred Foster, "Look, this is just not me. I have to dress like me." I kept saying, "I just don't feel comfortable looking another way. I can't do what I'm supposed to do as a performer if I don't feel comfortable within my own skin. I'll make it eventually if I'm good enough. I think I've got the talent if somebody hangs with me long enough." I knew I had some other things going too. I had a nice personality, and I had a good sense of humor. I could talk to people, and I loved to write and sing. I took my music more serious than anything!

I'm not a natural beauty. But I have my own idea of what beauty is. I try to make the most of whatever I've got. I take my negatives and try to make them into positives, and I always feel better being more flamboyant.

When I started wearing that big hair and my flamboyant clothes and my boobs sticking up, a lot of people said, "Dolly, you need to dress down. Nobody's ever going to take you serious as a songwriter or a singer if you look like that, because you look more like a hooker than you do a singer." I said, "Well, tough. This is who I am. They'll get used to it!"

Isn't a Star Supposed to Shine?

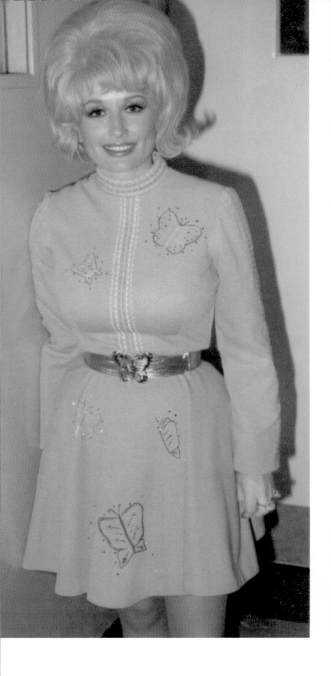

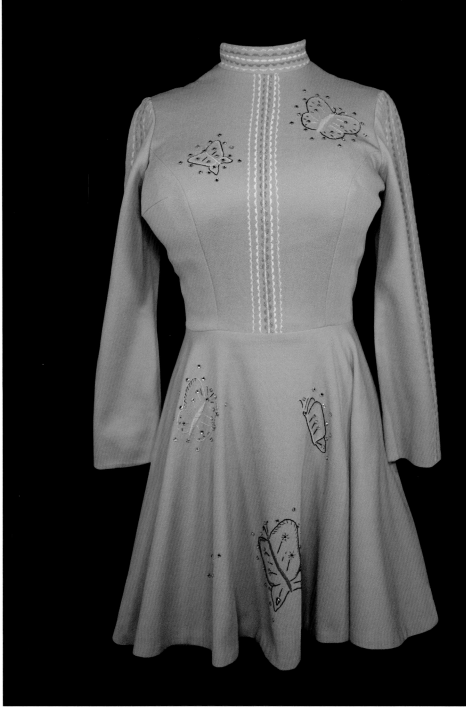

Beginning in 1968, I got my own custom outfits, decorated with butterflies and other things. I wore this dress designed by Lucy Adams on the cover of *Love and Music*, my 1973 album with Porter Wagoner.

I remember having a lot of arguments about my look. I said, "Well, if you don't want me, somebody will, because I've got good songs and I know how to sing them. I've got great ideas and I'm a creative person. I think I've got something more to sell than just the way I look."

Fred Foster was just trying to help me, and at that time, a lot of people thought that I would've made it sooner and more easily if I had looked different. Maybe I looked cheap, but I knew I *wasn't* cheap. It's just like my song "Dumb Blonde," my first hit record in 1967: "Just because I'm blonde / Don't think I'm dumb / 'Cause this dumb blonde ain't nobody's fool." I knew who I was, and I knew that eventually if I had any talent at all, it would show in spite of all that.

By 1967, I'd had some hit records—not really big records, but "Dumb Blonde" and "Something Fishy" and *Hello, I'm Dolly*, my first album on Monument. Porter Wagoner had heard me on the radio and seen me on television on *The Bobby Lord Show*. And Porter's girl singer, Norma Jean, was leaving, and he wanted a new partner. And that was me!

At first, I had to fit into that mold. In fact, during our initial meeting about his show, we had a funny misunderstanding about the kind of wardrobe I'd have to wear to fit in. Porter dressed up in those sparkling cowboy suits covered in wagon wheels—and so did his band, the Wagonmasters. They were called Nudie suits, named after Nudie's Rodeo Tailors, the shop in North Hollywood owned by Nudie Cohn that made ornate custom suits for lots of country stars. I had to wear lady-like dresses because, Porter said, he had a family type of show. He then asked me if I knew "many hymns." Well, my mind was still on the kind of outfits he wanted me to wear, so I asked him, "Minnie Hemms? No, I don't think I know her. Does she sew here in town?" It didn't take long before I realized he was talking about church hymns—because the show included a gospel song each week!

Originally, I never wanted to be part of a group. I wanted to have my own group. I wanted to have my own band, and I came to Nashville thinking, "I'm going to be my own star." I still thank God every day for my uncle Bill, who took such an interest in me at the very beginning. I owe him a great deal for even getting me to *The Porter Wagoner Show*, or at least being responsible for taking me back and forth to Nashville enough to get me introduced, and for the first time I was ever on the Opry. Uncle Bill just did so many things for me. I even wrote a song for him titled "I Wouldn't Be Here, If You Hadn't Been There."

Isn't a Star Supposed to Shine?

The trim on this Lucy Adams dress reminds me of the rickrack Mama put on my clothes. I sang my hit "Mule Skinner Blues" wearing this dress on Porter's show, circa 1970. *Bottom Left:* Me and Lucy, Christmas 1970.

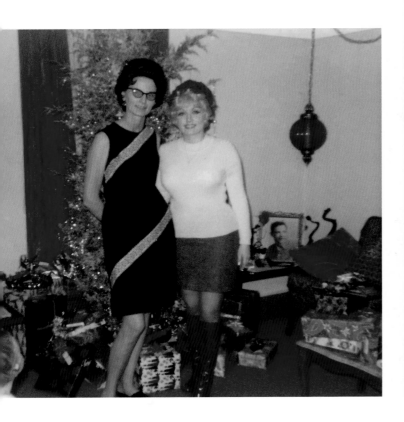

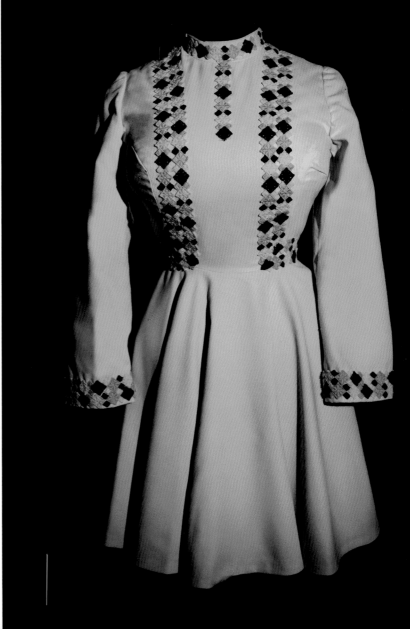

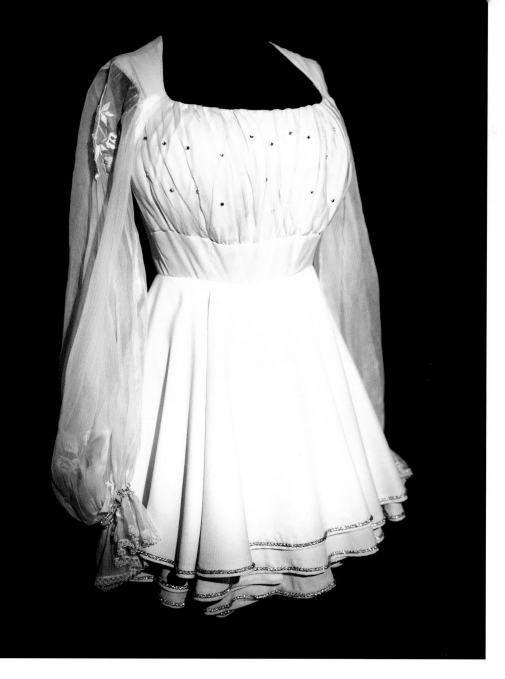

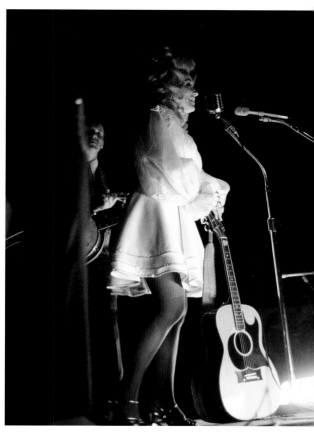

I love the chiffon sleeves and, of course, the rhinestones on this Lucy Adams dress that I wore onstage at the Grand Ole Opry, circa 1969.

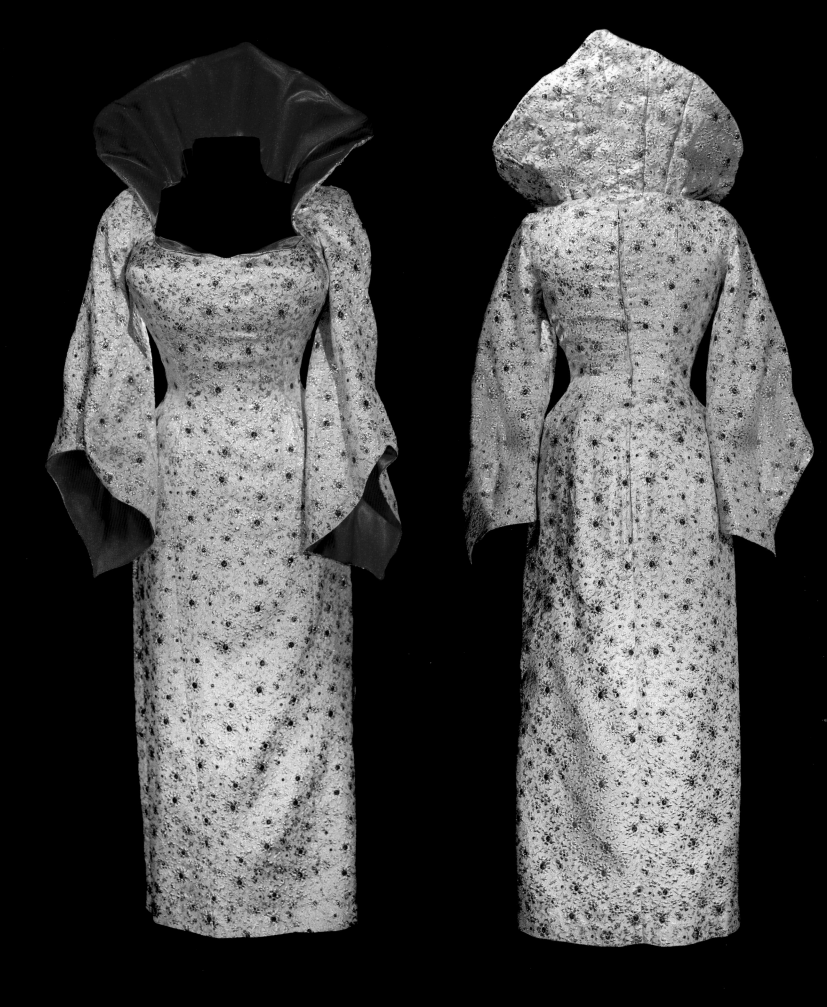

Lucy Adams treated me like royalty with these queenly gowns I wore at
events during CMA Week in 1969. Later on, Lucy used a swatch of fabric
from this dress to make me a new Coat of Many Colors.

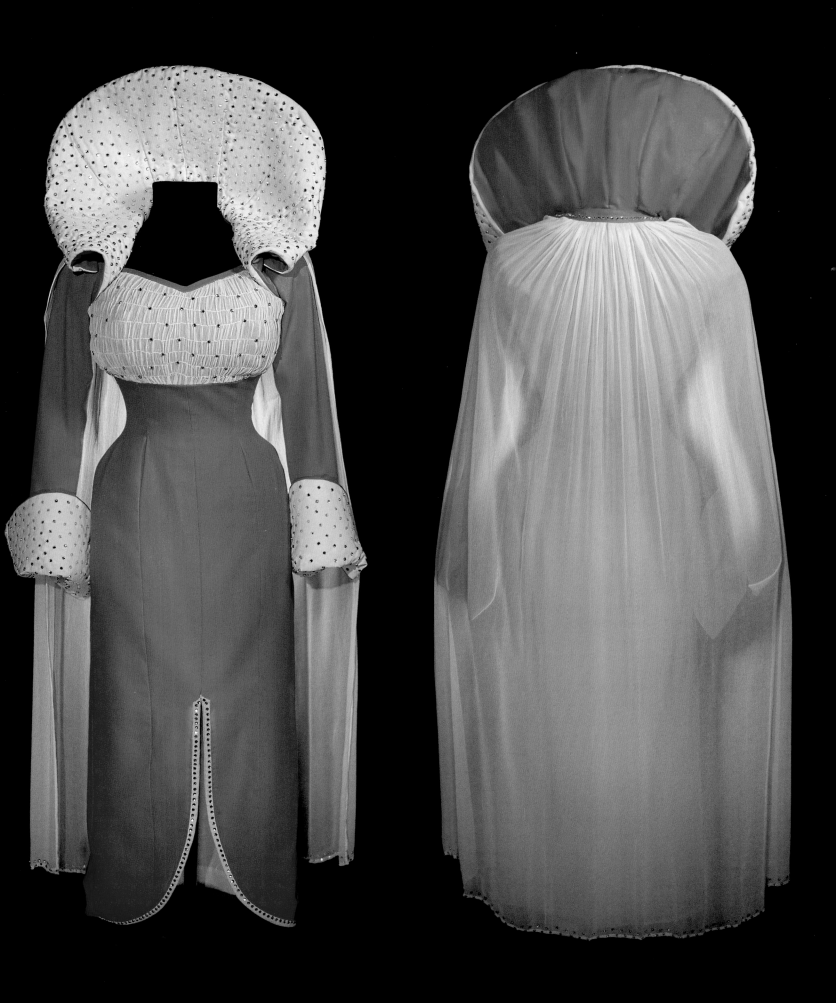

You can see me in this gown on the back cover of my 1970 album,
Porter Wayne and Dolly Rebecca.

Being on Porter's TV show the first time—September 5, 1967—was great. I wore a sleeveless fuchsia dress with a high neckline. It was a conservative kind of show. Not that those Nudie suits of Porter's were conservative! I wore colors that matched the fancy Western costumes Porter and the Wagonmasters wore. But I didn't wear low-plunge outfits at the time, and I dressed a little more traditionally because of it being a family-oriented show. I went along with Porter's rules, which I respected. I'm sure he didn't want me to outshine him in any way—it was *his* show.

When I appeared with Porter, I tried to look a little more like what the people in Nashville were wearing. Though Porter always wore those big ol' sparkly suits, I never wore anything similar. Porter had wanted me to have some things made by Nudie, but they were very expensive, and I was too cheap to buy them. Also, the Western look was just not my taste. Back then, people referred to country music as Country & Western. And those Nudie suits had desert scenes and were more cowboy-like. I just didn't think that was the right style for me. My music was more *country*, and I was a country-mountain girl. Although I didn't want the Nudie suits, I wanted my clothes to shine and sparkle.

A lot of people say, "Oh, I bet you learned a whole lot from Porter." Well, you always learn from anybody that's good. I did learn from anybody and everybody. I'm like a sponge. I just gather stuff without even knowing it. And you just try to put to use whatever suits your personality, however you can apply it. Porter and his group shined so much, I thought, "Well, I got to start adding a little more shine—pizzazz—through my clothes." I always loved rhinestones.

The first time that I had clothes tailor-made for me on a regular basis was after I started working with Porter. My husband, Carl, had a friend whose wife, Ruth Kemp, told me, "I can make you some show clothes." She was a seamstress, and she'd made things for different people. She made me a lot of things. Lucy Adams, another lady who would start making my clothes, used to sit in the audience of *The Porter Wagoner Show* because she loved country music. She lived near the WSM Studio, where we filmed the show. One night after the show, she said, "Here's my card. I sew and I would love to make some things for you." That's how I met the two of them. They made so many of my clothes during the Porter Wagoner days. Both Ruth and Lucy were seamstresses who were like, "I love to sew. Now I've got a star I can sew for!" It became a real fun thing for us. They both got a big kick out of seeing their clothes on TV—that meant a lot to them. It meant a lot to me, too, and we all became good friends.

Runaway Feelin'

Memorial Day, May 30, 1966, was a very special day. Carl and I got married in Ringgold, Georgia. Originally, we had planned to have a big wedding in Nashville thrown by Carl's mother, Mama Dean. She had one daughter, Sandra, and she had wanted to have a big wedding for her. But Sandra and her husband eloped, so Mama Dean didn't get to do the big wedding. When it came time for us to get married, she was so excited because she was finally going to do the big wedding. But I was with Monument Records, and they didn't want me to get married. They were spending a lot of money prepping me for stardom and said, "Could you at least wait for one year before getting married?" But Carl and I had already planned to get married, so the next weekend we went to Ringgold because we didn't want our marriage listed in the Nashville newspaper. Mama Dean was so disappointed that she lost out on another big wedding, but she took me to Castner Knott in Nashville and bought me a little white dress. My mama made me the veil that went with it. I loved that little dress, and I loved that whole day.

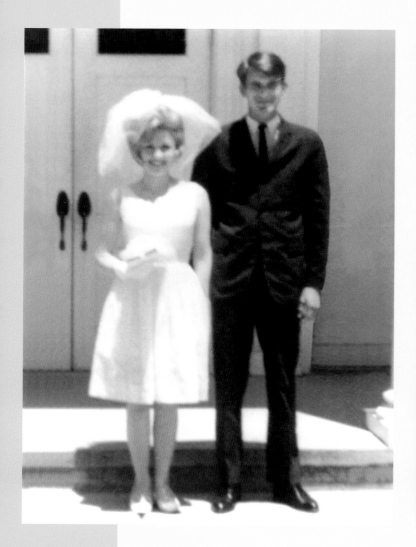

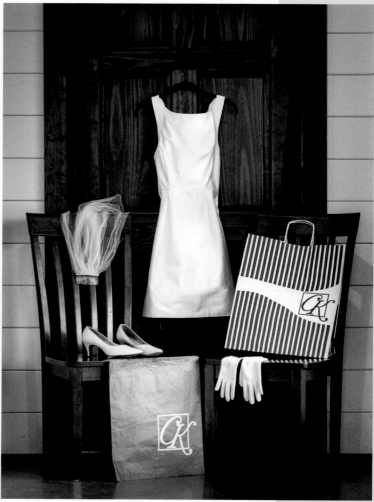

I loved the big bell sleeves on this Lucy Adams dress. Lucy came
up with so many creative ways to embellish clothes, even without
using rhinestones.

I had a hand in a lot of those outfits made by Ruth and Lucy in the early days.
It was fun cooking things up together. Sometimes I would go shopping with
Lucy to find fabrics. That was before I got so famous I couldn't go out without
everybody slowing down my shopping. Lucy and Ruth knew the colors I liked—
different shades of pink and red. My husband, Carl, loved me in the color he
called "pinch"—a peachy pink. Lucy and Ruth would pick out fabrics and ask,
"Do you like this? Do you like that?" We would choose some fabrics with cute
prints. They made me lots of little A-line dresses with all kinds of eye-catching
trim—modern versions of the rickrack that Mama used to decorate the dresses
she sewed for me. I'd sometimes have Ruth and Lucy sew two or three variations
of a particular dress style in different colors or shades.

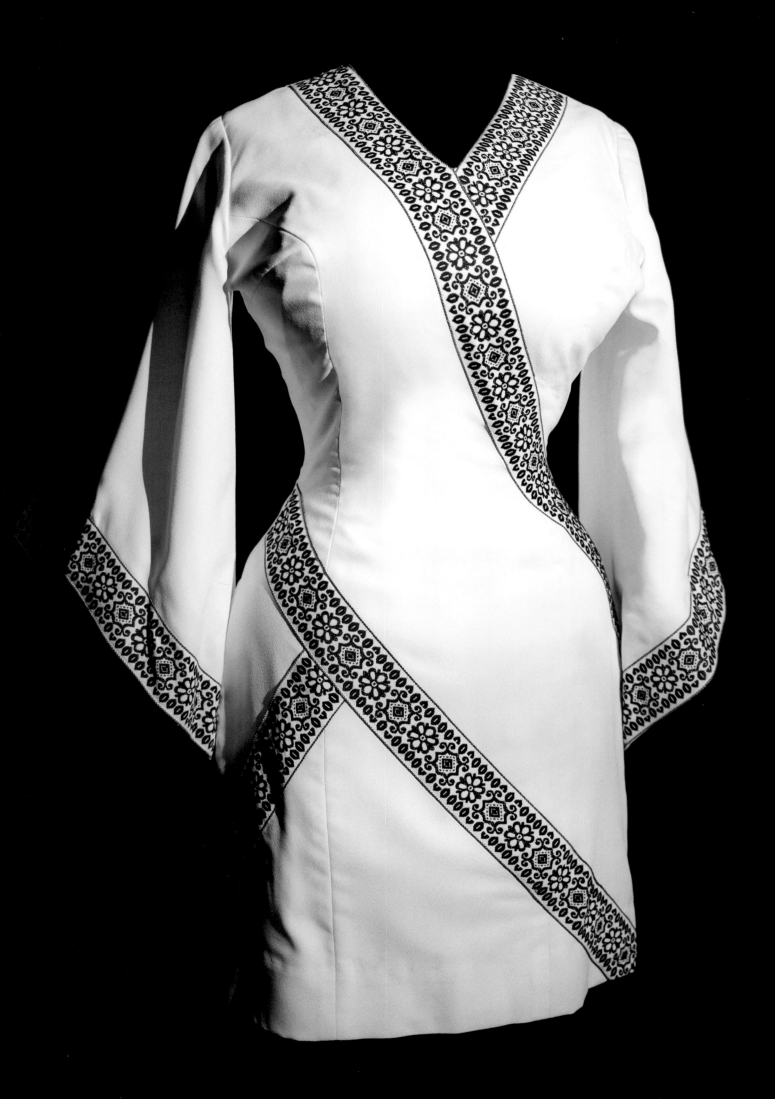

Lucy and Ruth also made me little headscarves that matched the outfits. Because I had all that big hair, I thought I could make my hair look a little more casual by pulling it in just a little bit with the scarf. Since the scarf matched the outfit, it looked good.

I've always loved gingham. I've had blue and red mainly, but I had a little yellow gingham dress too. I just love that print because it reminds me of how I wanted to look when I was young—if I could have had all those pretty fabrics as a girl. Today, they remind me of being a sweet country girl, and I like that.

Gradually, as time went by, Lucy started making me more flamboyant clothes. She'd never sewn for anybody who was as flamboyant as I wanted to be. I'd say, "Can you put this on that? Can you put some roses around this?" She liked being more extravagant than most people were at the time.

I loved Ruth and Lucy very much. We had a lot of wonderful years together. They both worked out of their homes and did all the sewing themselves. Later on, after Lucy started adding a lot of sequins and rhinestones to my clothes, her daughter and a couple of people helped with that. I kept them pretty busy, especially after I started wanting all those rhinestones.

When I joined Porter's show, I moved from Monument to RCA Records for my recordings, beginning with "Just Because I'm a Woman." I also started making duet albums with Porter for RCA. A similar thing happened at RCA as had happened at Monument regarding my look and how I dressed.

It came from the head of RCA, Chet Atkins, who became one of my dearest friends. He happened to be born and raised in East Tennessee. He felt like he was my brother or my father. He wanted to give me advice. He pulled me over to the side and said, "Dolly, you've got a lot of talent. I think you could have a really bright future, but to be taken seriously, you have got to change the way you look—that big hair and all those gaudy clothes and all that."

It hurt my feelings and kind of embarrassed me when he said that, but, of course, I didn't change my look. If anything, it got "worse." Then several years later, after I became a pretty big star, Chet came over to me one day and said, "Ain't you glad that you listened to me back then?" I joked back, "Yeah, I sure am." He then said to me, "You know what you're doing. I'm not going to give you any more advice."

Behind the Seams

Cover Girl

My first cover story in "Showcase," the Sunday supplement of *The Tennessean*, ran on September 27, 1970, and was titled "Miss Dolly Parton: Blonde Bombshell of Great Smokies," with the subtitle, "Miss Dolly Parton is more to *The Porter Wagoner Show* than just a country music Marilyn Monroe." This is how the article's author, Jack Hurst, described me in the office of my publishing company:

"On the wall behind the desk, her picture—a large and engaging color photograph framed in gold—beamed down. . . . Her hair hung in perfect golden ringlets beside her face, and she was smiling in the wacky way she does when people tell her she is beautiful, grinning as if it is maybe the most hugely funny lie she has heard all week. . . . [She] walked into her office in a glittering black jumpsuit dotted with regularly spaced, diamond-shaped white patterns the size of once-folded dollar bills. The blond hair hung long today, not done up high in ringlets. . . . She kicked off the gold shoes and pulled her feet into the chair with her, holding her knees in both arms."

This article helped to put me on the map, and two years later we got Jack Hurst to write liner notes for *Burning the Midnight Oil*.

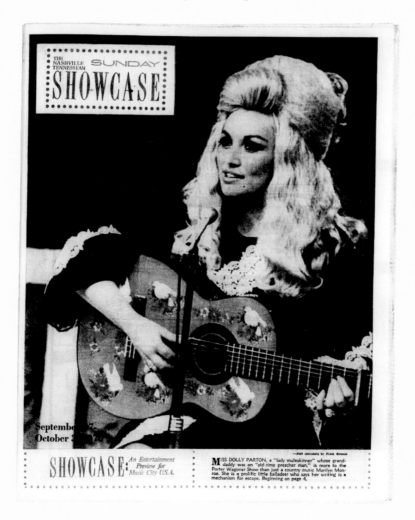

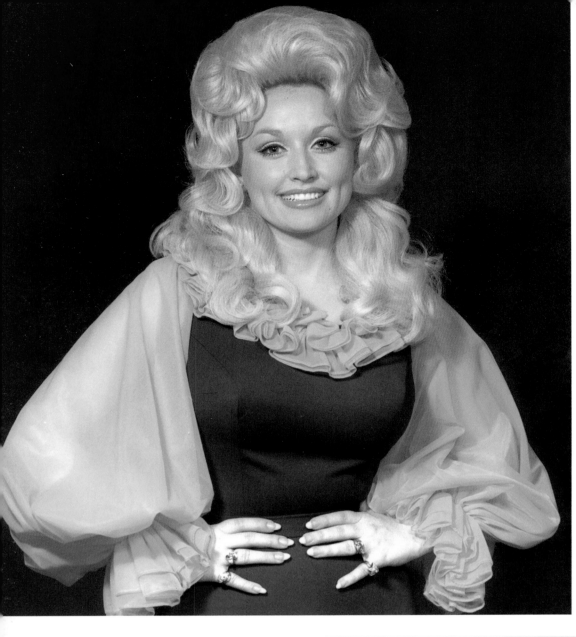

My best friend and assistant, Judy Ogle, helping me prep for a photo shoot. I'm wearing what would become my onstage staple—a stretchy jumpsuit accented with chiffon.

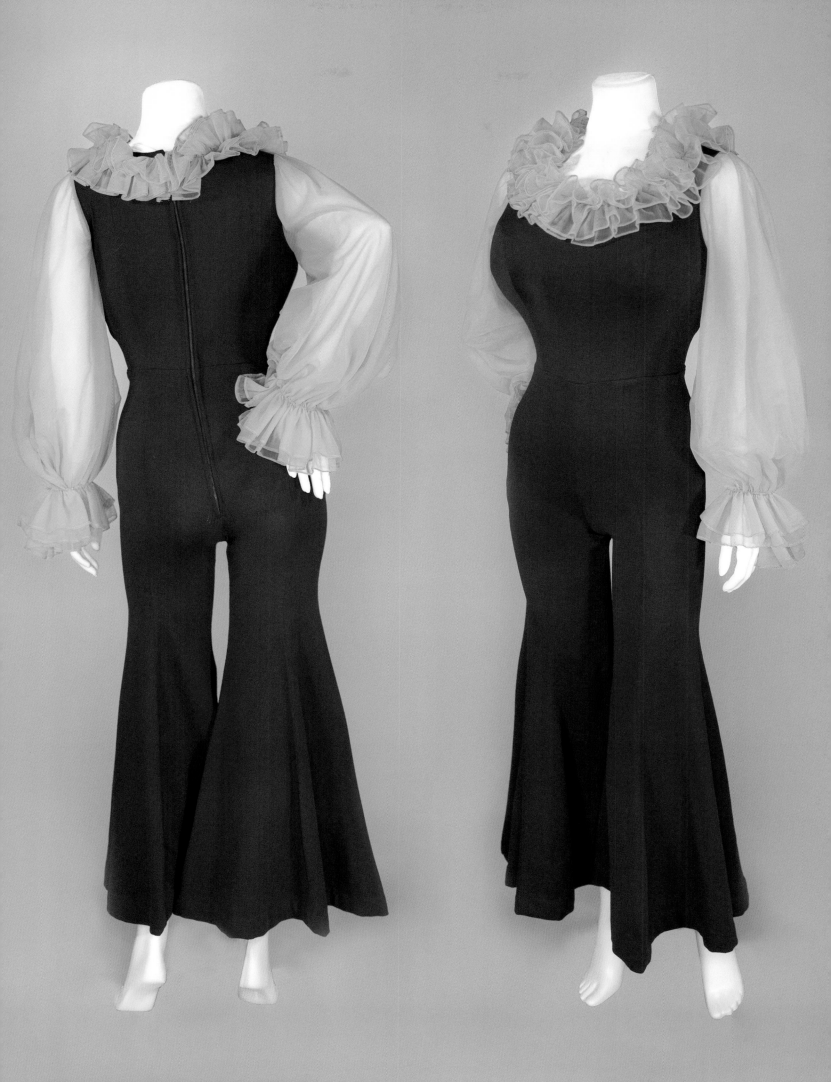

Colleen Owens

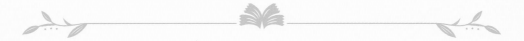

Colleen Owens was my very first hairstylist. When we met in high school, she was a big Elvis fan, just like me. She also loved fixin' hair, and she helped me come up with some dos for my appearances on Cas Walker's show. After she married my uncle Louis Owens and attended beauty school, she became my hairdresser in Nashville. Then she transitioned to styling my wigs. Colleen created all kinds of looks, and my big hair complemented Porter's pompadour. It became my trademark. As my clothes got wilder, so did Colleen's hairstyles. By the time I was touring, I had more than two hundred wigs. She made a chart of them and kept a lot of my wigs at her place. She'd style 'em and they'd be ready to go when I got off the road. People would ask me how long it took to do my hair, and I'd tell them, "I don't know. I'm never there." Colleen sure did—she spent hours creating those elaborate styles. Her ideas would live on as an influence on my future stylists. Colleen passed away in 2017 at age seventy-six.

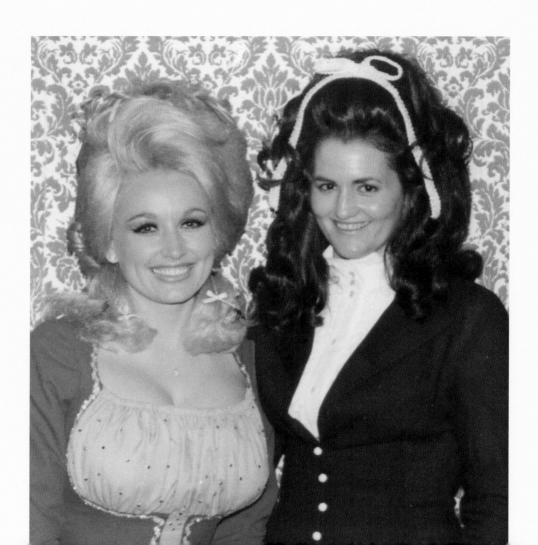

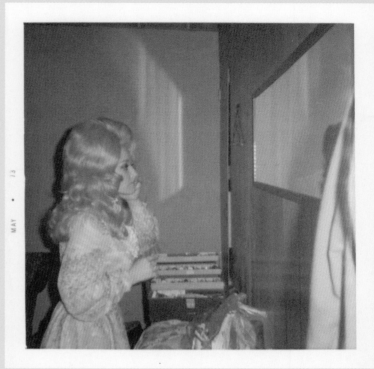

Colleen created so many amazing styles, mostly using synthetic
wigs, which I preferred back then because they held the curl longer
than those made from real hair. Even when Colleen wasn't on the
road with me, I could take her creative hairdos along for the ride.
Opposite: Colleen and me, 1971.

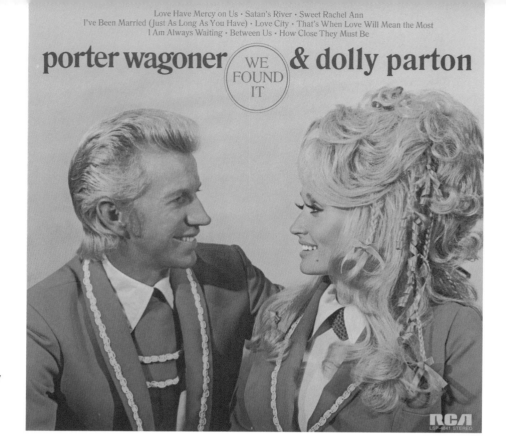

Love Have Mercy on Us · Satan's River · Sweet Rachel Ann
I've Been Married (Just As Long As You Have) · Love City · That's When Love Will Mean the Most
I Am Always Waiting · Between Us · How Close They Must Be

porter wagoner

WE FOUND IT

& dolly parton

RCA
LSP-4841 STEREO

Lucy Adams made these "his 'n' her" outfits for me and Porter—and a few other versions too. My niece and archivist, Rebecca Seaver, calls the variation-on-a-theme outfits "sisters." You know what they say, when you find something you like, buy it in every hue!

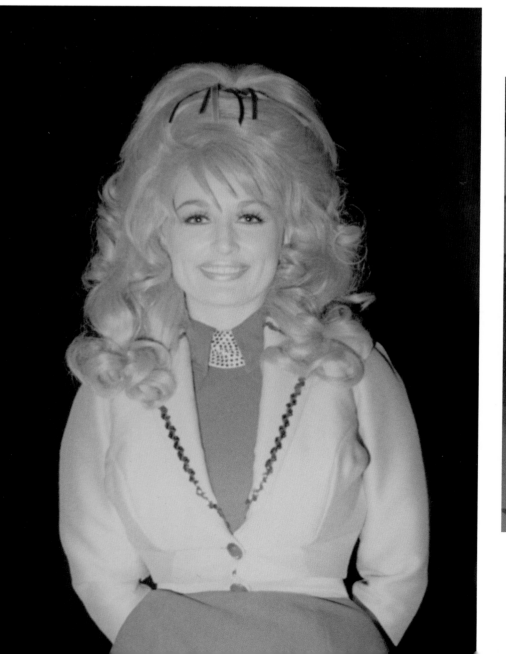

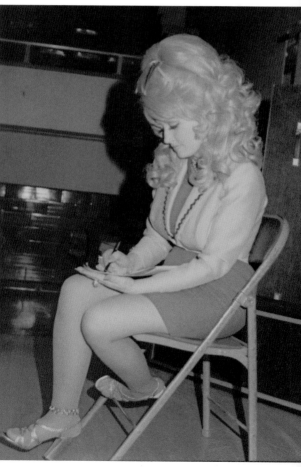

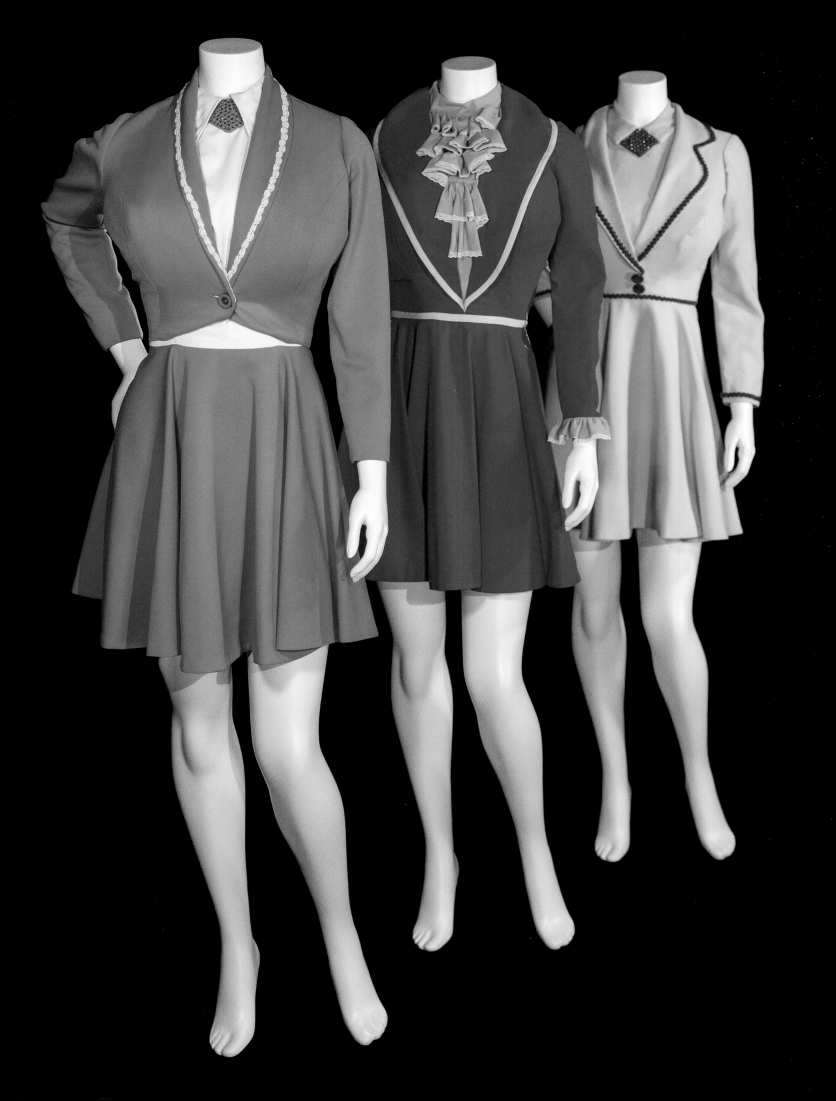

I liked looking the way I looked—no matter where I was—and I still do. I'm always "Dollied up." Once, I went to a party at Porter's house at Center Hill Lake. Everybody was dressed casual, but I showed up all decked out in my high heels and this fancy dress and that big ol' hair.

Working with Porter, I was controlled as much as I was ever going to be controlled. I always felt like a liberated person, but when you work within a group, like with Porter's show, you have to go along with the group effort. Porter and I fought all the time, though, because I was so independent in my thinking. I had said that I would stay for only five years, but I wound up staying seven.

> *"Porter and Dolly deserve . . . credit . . . as the most successful man-woman singing duo that there has ever been. They had that combination of voices, that authenticity, and they were eye-catching. . . . They just had everything going for them."*
>
> —Minnie Pearl (as told to journalist Alanna Nash)

When I left home in 1964, I was teasing my own hair. I teased it up big and fixed it all the way through high school and early trips that I would make back and forth to Nashville. I could tease that hair like nobody's business. Once I got my hands on what was called a rattail comb, I learned I could raise my hair up even higher with the tail on that comb. You lift it up, then spray it to keep it in place. I used a great hair spray—Aqua Net—for years. It was the stiffest one you could get at the time.

When I look back at pictures of myself in the 1960s, I laugh out loud. I wonder, "Oh my Lord, what was I thinking? Was my hair bigger than me?" I mean, that hair was wearing me! I get such a kick out of it. But at the time, I thought I looked good, and that's what lots of girls were wearing. In those days, my hairstylist, Colleen Owens, wasn't necessarily thinking about *me* as much as just doing great hairstyles with all kinds of intricate stuff. And I really liked her hairdos. Back then, I started wearing hairpieces before later switching to wigs.

I wore a cute little short wig once when visiting Carl while he was in boot camp at Fort Stewart, Georgia, before we were married. He's so tall that when he bent down and gave me a big hug, the wig started to fall off. I guess I hadn't pinned it. And when I raised my head back, he put his hand on the back of my head and

The Red Dress

The cover of *Burning the Midnight Oil* has two photos: one of Porter and the other of me, taken in the den of my home on Antioch Pike in Nashville, the first house that Carl and I bought. We lived there for years. And in that very den was where I wrote "I Will Always Love You," "Jolene," "Love Is Like a Butterfly," and "The Seeker." I wrote so many songs sitting on a corner of the couch in that den. I loved that bright red dress I'm wearing on the album cover. It always reminds me of that room, which was so special to me, and of the song Aunt Martha sang to me on her lap: "Tip-toe/tip-toe ain't she fine/ Tip-toe, tip-toe little Dolly Parton/She's got a red dress just like mine."

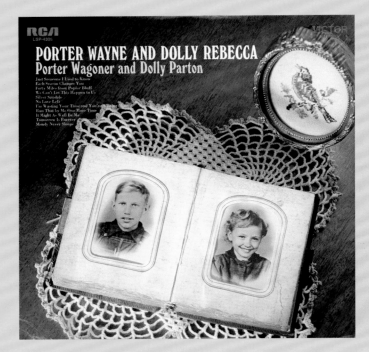

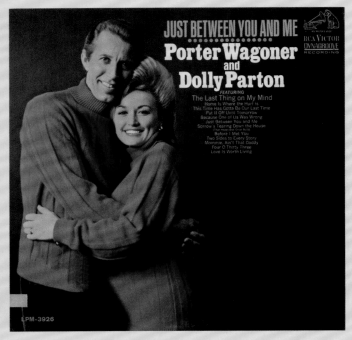

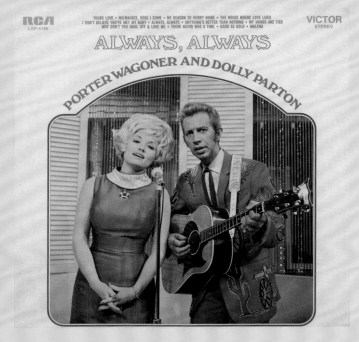

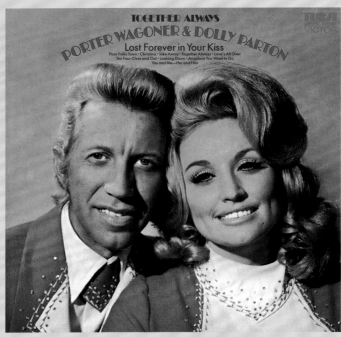

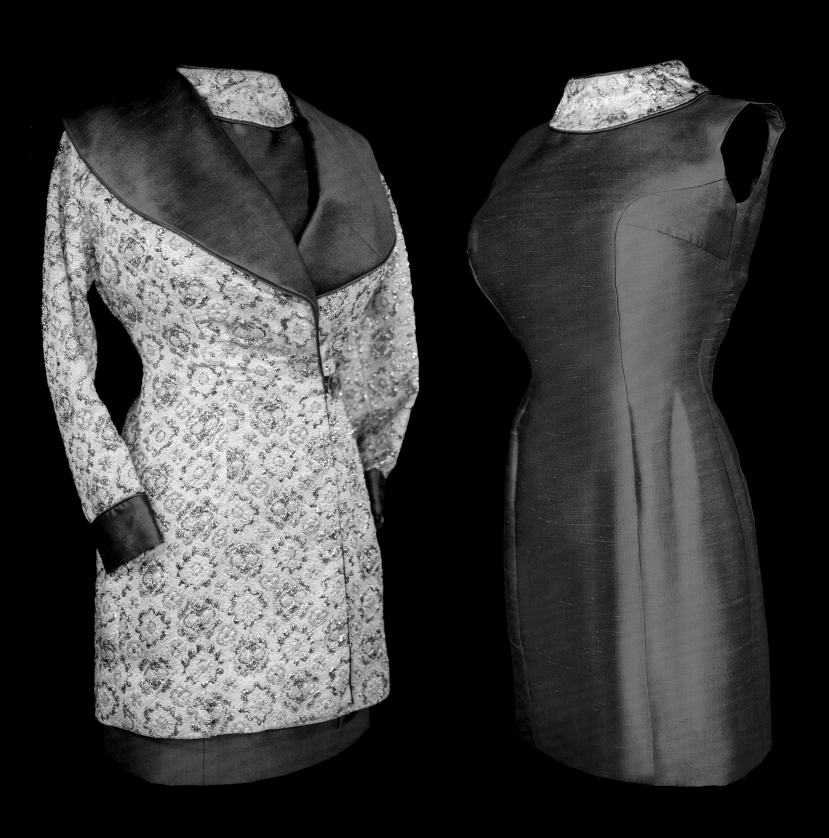

Lucy Adams designed this gorgeous brocade-and-silk ensemble
for my induction as a member of the Grand Ole Opry in 1969.
The dress also appeared on the cover of *Always, Always*. I will
always wear things I love more than once!

I wore this rhinestoned chiffon gown when I won
my first CMA Award in 1968.

just held it in place there. He didn't care. At the time, I was embarrassed, but I
later laughed about it.

When I started to work a lot with *The Porter Wagoner Show*, I needed more hair.
That's when I took up wearing wigs, because we couldn't continue with all that
bleaching, perming, sitting under a hair dryer, and teasing—it was just too damag-
ing to my own hair. Plus, I didn't have the time for all that. I was doing too many
things—performing, touring, recording—and I found out early on that wigs are
just so, so handy. Colleen was great at styling the wigs for my shows too.

When you dress up for a performance, it makes the audience feel good. You come
to a show, *you want a show*! You want something up there that's going to catch your
eye. You want to be wowed! And I want to wow the audience. They come to see
me look a certain way. I want to really dazzle them if I can.

When you're under the lights, you want to feel important. Isn't a star supposed to
shine? That's what stars do. They shine. And it makes me feel like I've got more
to give, makes me want to try to live up to my shiny clothes. It's like, okay, you got
on this outfit. You're going to have to rise to the occasion. You have to put on that
personality and add a little more sparkle to everything you do.

Behind the Seams

Hell's Belles

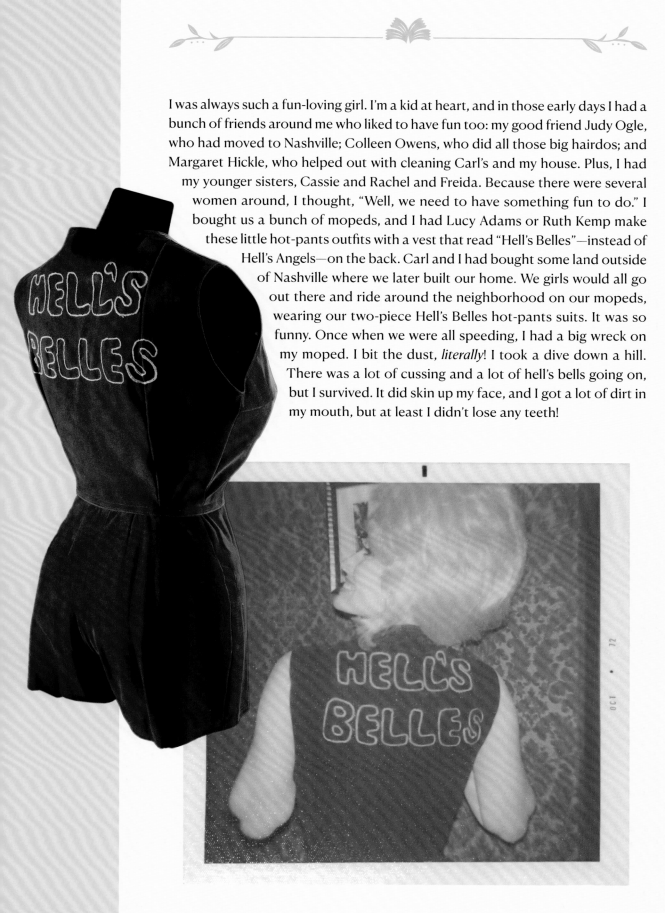

I was always such a fun-loving girl. I'm a kid at heart, and in those early days I had a bunch of friends around me who liked to have fun too: my good friend Judy Ogle, who had moved to Nashville; Colleen Owens, who did all those big hairdos; and Margaret Hickle, who helped out with cleaning Carl's and my house. Plus, I had my younger sisters, Cassie and Rachel and Freida. Because there were several women around, I thought, "Well, we need to have something fun to do." I bought us a bunch of mopeds, and I had Lucy Adams or Ruth Kemp make these little hot-pants outfits with a vest that read "Hell's Belles"—instead of Hell's Angels—on the back. Carl and I had bought some land outside of Nashville where we later built our home. We girls would all go out there and ride around the neighborhood on our mopeds, wearing our two-piece Hell's Belles hot-pants suits. It was so funny. Once when we were all speeding, I had a big wreck on my moped. I bit the dust, *literally*! I took a dive down a hill. There was a lot of cussing and a lot of hell's bells going on, but I survived. It did skin up my face, and I got a lot of dirt in my mouth, but at least I didn't lose any teeth!

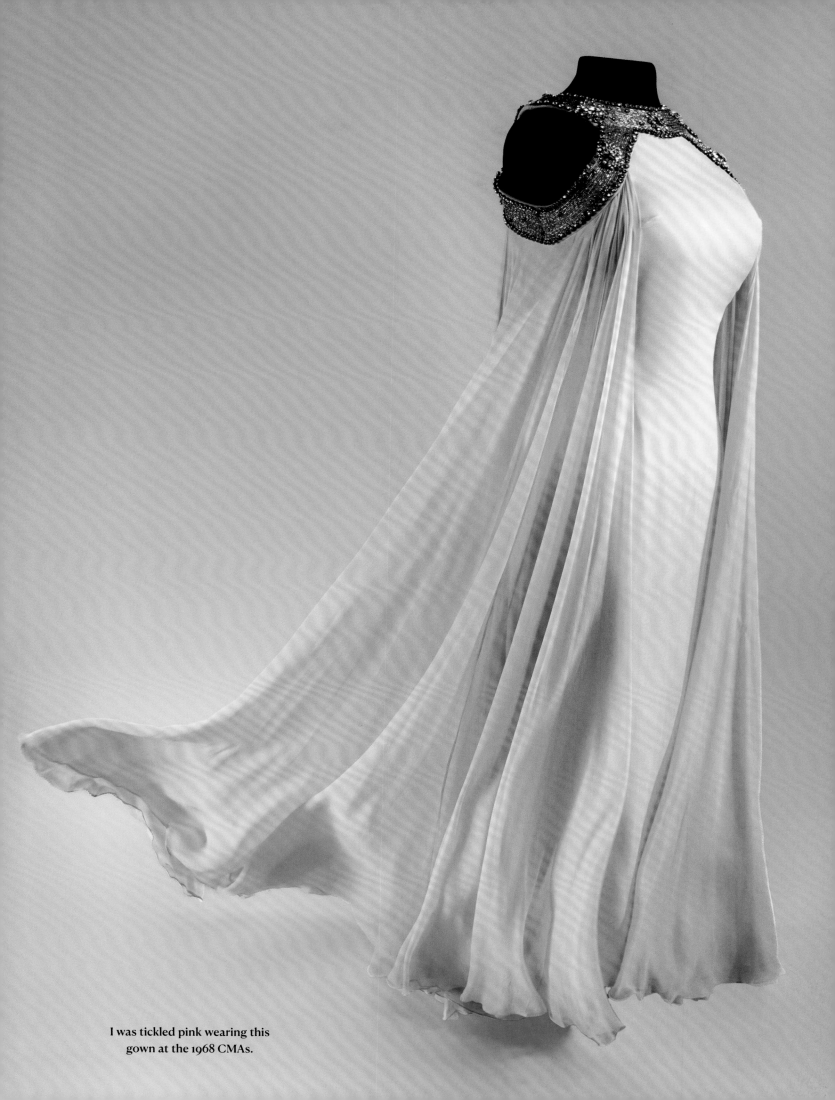

I was tickled pink wearing this
gown at the 1968 CMAs.

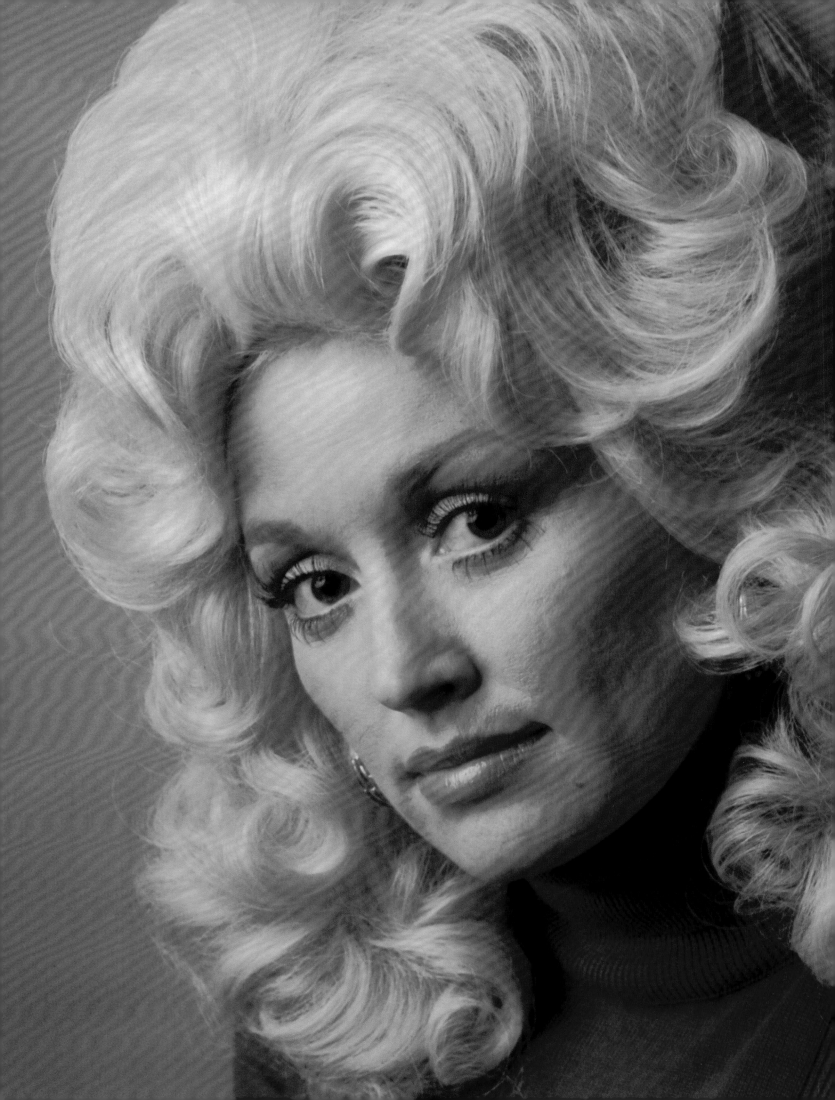

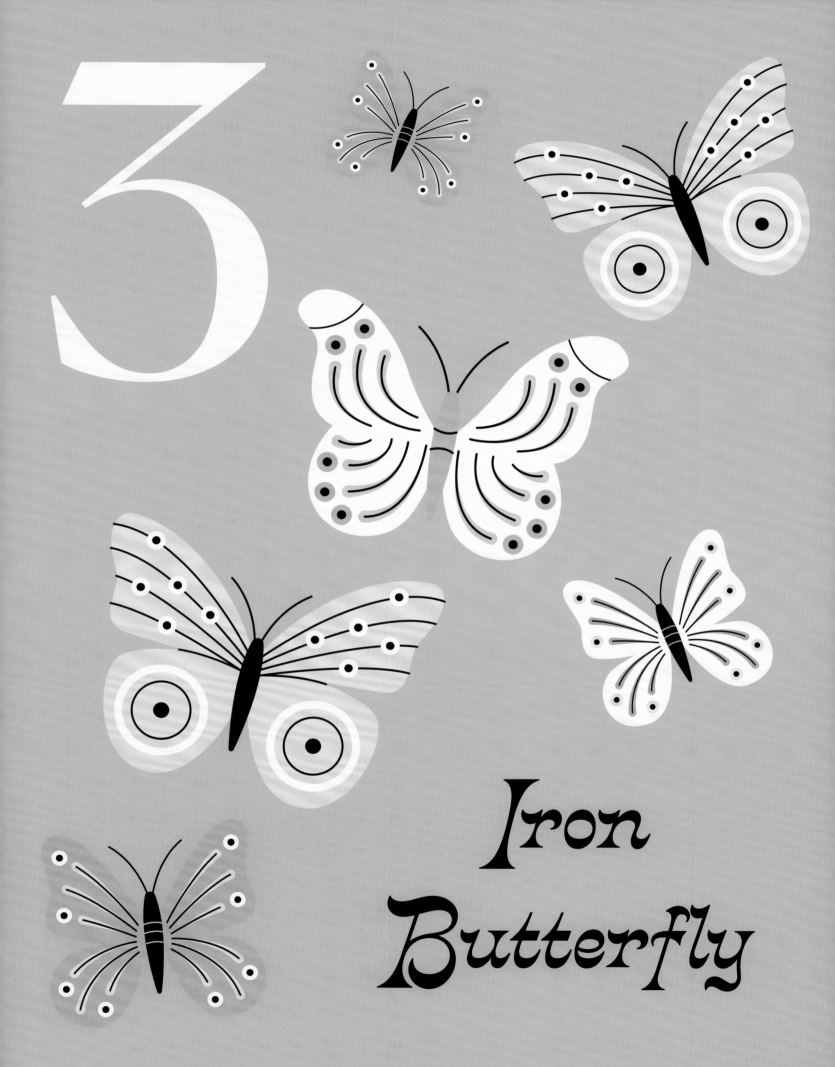

3

Iron Butterfly

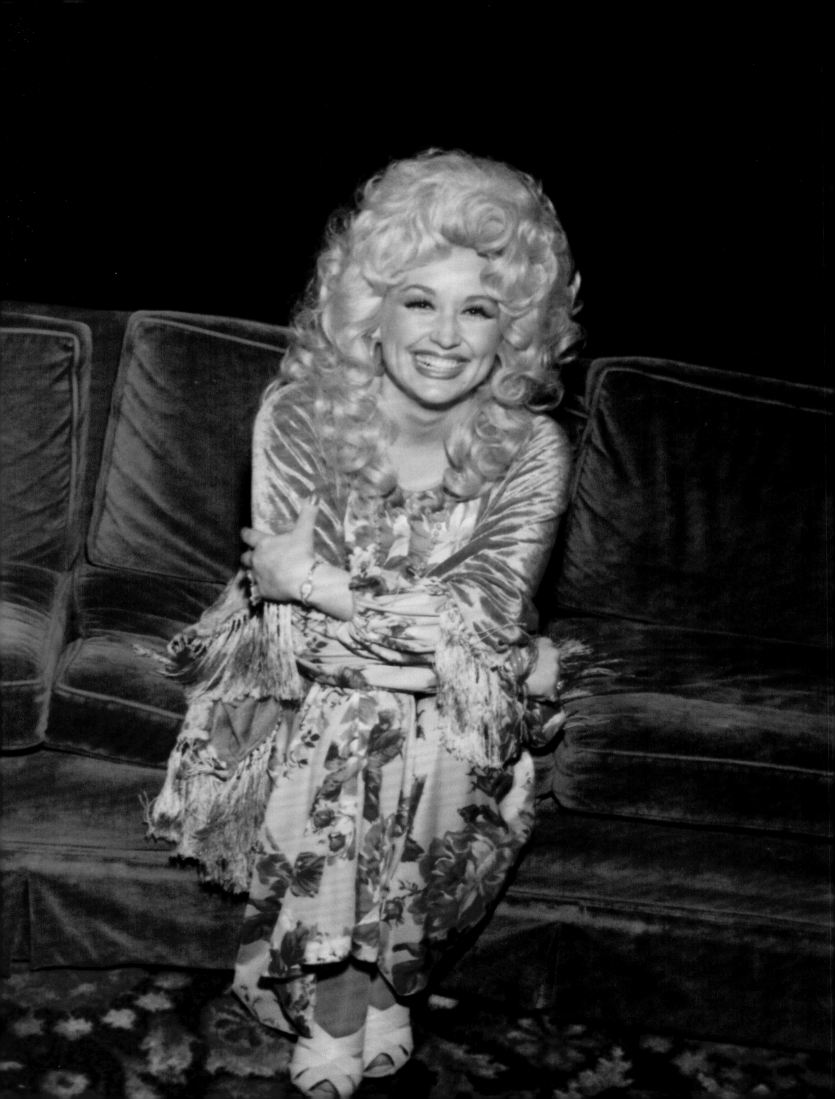

"I feel like I'm a butterfly when I'm in all my colors."

Dolly

In the early 1970s, Dolly's star as a solo artist was rising. In 1971 alone, she released three albums, scored her first number one solo smash on the country chart with "Joshua," and earned three Grammy nominations for three different songs. It was time to present her unique look and style to the world. She had hinted at what was coming with her first album of the '70s, *The Fairest of Them All*. Unlike previous covers, which featured more conservative outfits, this one showed Dolly in a queenly gown looking at herself in the mirror like a fairy-tale character transformed for a night at the ball. She was striding toward independence and solo stardom—just three years away—and her bolder wardrobe choices projected her increasing confidence. Soon, there would be glamour galore, with Dolly calling the shots and choosing clothes that were as beautiful as ever but that also represented her as someone "fierce and wild."

—*Holly George-Warren*

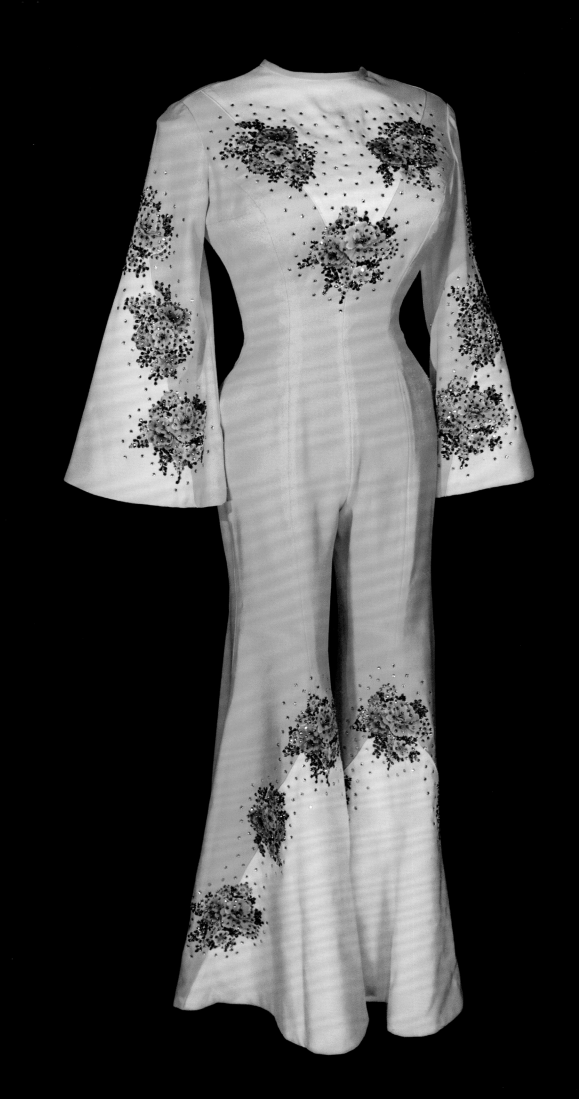

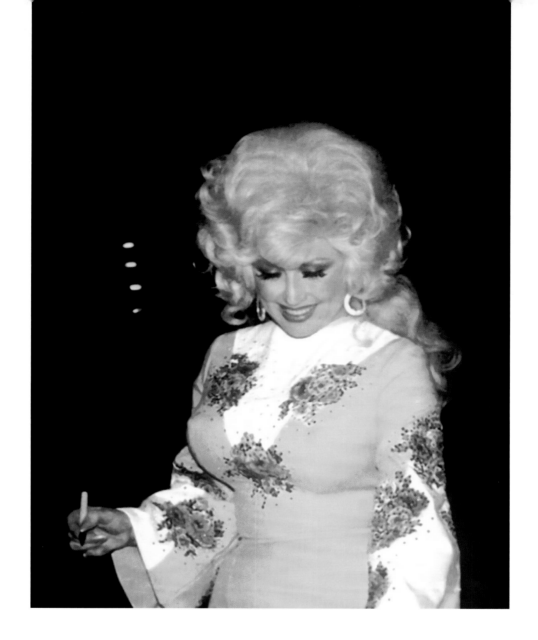

Lucy Adams made my signature jumpsuits, decorated with appliquéd flowers and other imagery, and lots of rhinestones. Over the years, in photos of me wearing them, they've been mistakenly labeled as Nudie suits—but let's give Lucy her flowers. They're my "Lucy suits"!

It makes me laugh when people call me a fashion *icon*. I always say I'm more like an *eyesore*, because it never, ever crossed my mind to be fashionable—and I never was fashionable. As long as I'm comfortable in what I'm wearing and I think it looks good on me, then that's my fashion. That's my style.

Beginning in the 1970s, I just let my imagination run wild. I gained more freedom to choose the looks I wanted to wear, and Lucy Adams continued to help me, making my outfits brighter and more sensational with everything from colorful buttons arranged in decorative patterns and gold braid accents to flashy sequins

Iron Butterfly

and sparkling rhinestones. Some of the clothes were so intricately rhinestoned—and even hand-painted—that it took Lucy days to make them.

We often used polyester for my outfits because the fabric was durable and so easy to take care of. I also liked chiffon, and Lucy would make flowing chiffon overlays or capelets that I'd wear over tight-fitting jumpsuits and pantsuits. She also made little dresses that looked like a solid-color blouse paired with a bright-print flared miniskirt. But as a one-piece, this kind of dress was much quicker to slip into than putting on two individual pieces.

A new popular style in the '70s were formfitting jumpsuits and pantsuits with big bell-bottom pant legs—in fact, this is one of my favorite styles of all time. I have them in a rainbow of colors. You can see one of my favorite jumpsuits on the back of the *Jolene* album cover.

I don't remember exactly how the jumpsuit came to be. A lot of the rock-and-roll stars seemed to be wearing them. They were kind of like Nudie suits in that you could put a lot of rhinestones and embroidery on them. Since I had a real small waist and was short, I thought the jumpsuit style showed off my body better. And with a jumpsuit, you don't have to wear a belt. Plus, practically speaking, wearing jumpsuits onstage prevented folks in the front row from getting the kind of "peep show" that wearing a miniskirt could sometimes accidentally offer! Those jump-suits really became my go-to look in that decade—and my big ol' bell-bottoms were ringing louder than most.

"She used to change clothes so fast that I couldn't rub the scrub board fast enough to keep up with her. Now, the last time I was at Dolly's home, I counted over a thousand pairs of shoes she had. I wouldn't even go to the closet to count her clothes. I told her she could retire right now and spend the rest of her life trying on her shoes and clothes."

—Avie Lee Parton to the *Knoxville News-Sentinel*

Along with my clothes getting more flamboyant, my hair kept getting bigger and bigger, which was easy to do with all my wigs. Colleen created the most elaborate styles. They were like pieces of art. She really got into it, and the hairdos became more and more amazing.

Behind the Seams

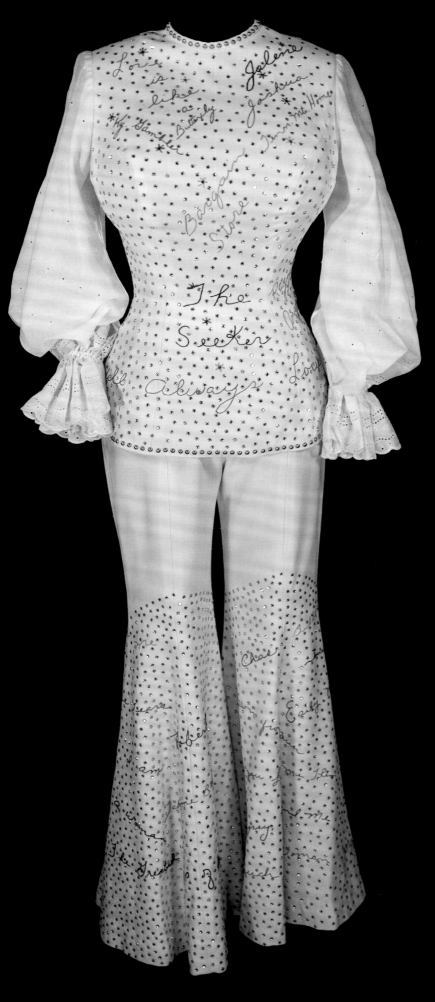

This "Lucy suit" is extra special because it has the names of
my early hits hand-embroidered on it, surrounded by rhinestones.

Hair You Come Again

My big blond hair has attracted attention since the '60s. I've been so lucky to have such amazing hairstylists create an array of eye-catching looks for me. Beginning with Colleen Owens, then David Blair in LA and Cheryl Riddle in Nashville, they all helped me be *me*. Thanks to my multitude of wigs, I can change my look in a flash! As the old saying goes, "Variety is the spice of life," and that's certainly been the case with my one-of-a-kind hairstyles.

Mid-1960s

Even though my hair was big by some standards, it was modest for me.

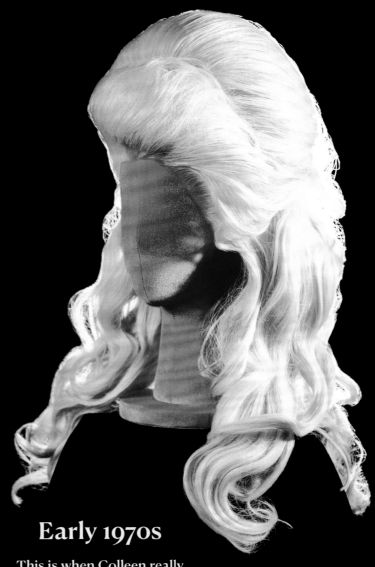

Early 1970s

This is when Colleen really challenged herself to see how much hair I could handle.

Colleen Owens wig designs re-created by Sarah Necia of Necia Hairstyling

1970s

I didn't care if my little ribbons and bows looked gaudy. To me, they looked sweet and cute!

1980s

Hollywood hair! When people used to ask me how many wigs I owned, I said, "Three hundred sixty-five—one for each day of the year!"

Late 1970s

This is my crossover pop star look!

1980

Here's my Doralee do from *9 to 5*.

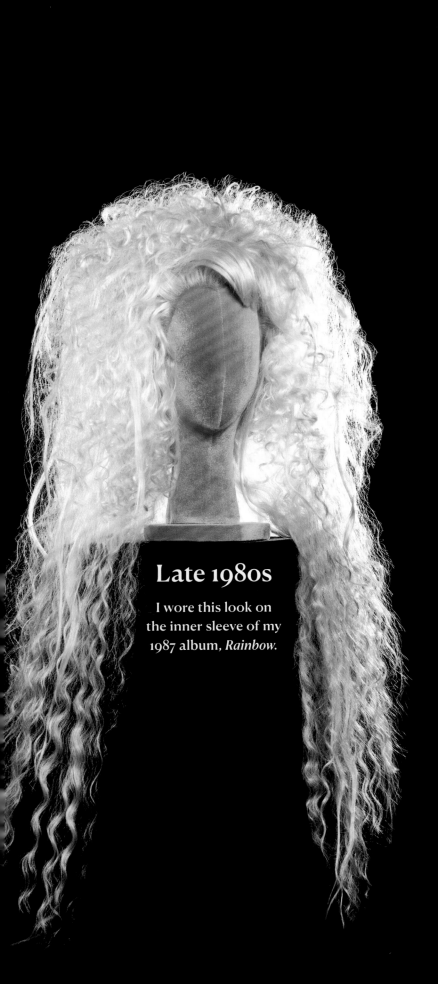

Late 1980s

I wore this look on the inner sleeve of my 1987 album, *Rainbow*.

1984

Big hair for a big movie: I wore this wig to play a country gal in the city named Jake in *Rhinestone*.

David Blair wig designs re-created by Sara Andrews of Wig Takeout

Late 1980s

Hollywood hair stylist David Blair
created my amazing dos for my
TV show, *Dolly!*, which ran from
1987 to 1988.

1990s

I wore this style on the cover of my
album *Something Special.*

1990s

My dress-for-success look as
a businesswoman.

Sometimes I was lost under all that hair. Carl said that I was so small that from a distance I looked like a Q-tip. He'd just see this white head of hair on this little stick of a person. But I just loved it. As I've said before, you had to have big hair and a Cadillac in order to be a star. And now, in the 1970s, I had both!

But that *hair*—it was all about that hair. Still is.

When I consider the Bible scripture that says that every hair on your head is numbered, I laugh, thinking, "Well, every hair on my shelf is numbered too!" It's hard for God to keep up with me and my wigs. Even when I was doing my own hair early on, before I had Colleen, I enjoyed teasing it and fixing it. I was a good little hairdresser. I used to fix Mama's and my sisters' hair for special occasions, and they liked it. If I hadn't been a star, I'd have been a beautician!

Just like my big hair became my trademark, the butterfly image became my symbol. When I was growing up, butterflies made a big impression on me. They were so colorful and gentle, and you didn't have to worry about a butterfly stinging or biting you. They just went about their business, casual-like and not bothering anybody, coloring up the world in a beautiful way. I was drawn to them, and that's why the butterfly became my emblem early in my career. I've written many songs that have butterflies in them, including "Love Is Like a Butterfly," one of my bigger country hits.

Some people have called me an "iron butterfly." I'm not offended by that, because I am a strong person. I'm tenderhearted. I'm a softie in my emotions, but I'm strong in my will. I'm strong in my beliefs, and I'm strong in what I need to get done. And you know, I like to think I'm colorful like a butterfly. Maybe that's why I go for shiny, flashy, and colorful clothes, because I feel like a butterfly when I'm in all my colors. I can't get enough color, because it fits my personality.

Over the years, I've needed that iron will, especially back in April 1974 when I played my last concert with Porter, after which we held a press conference and announced I would be leaving his show.

When Porter and I worked together, maybe I shouldn't have tried to outshine him. That caused some of the problems we had. I was beginning to get my own big following, and that became a touchy spot. One of many reasons I needed to get on out and be on my own was because we argued a lot—not about our clothes so much but just about me wanting to branch out. And would I ever branch out!

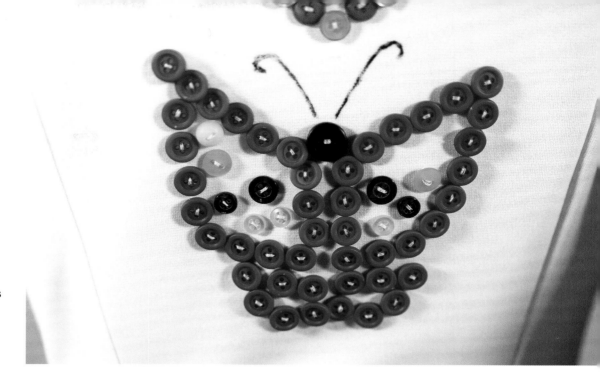

Buttons and butterflies!
Two of my favorite things
are on this Lucy Adams
suit, which I wore on
an episode of my first
television series in 1976.

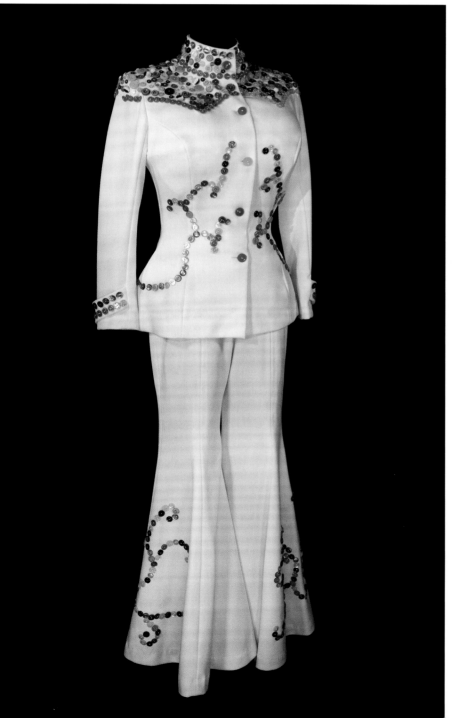

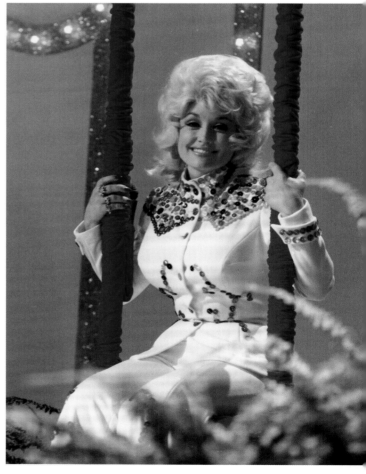

Behind the Outfit
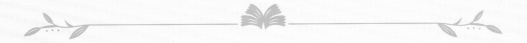

1975 CMA Awards

In 1975, I was so happy to win Female Vocalist of the Year for the first time at the Country Music Association Awards ceremony. I'd always wanted to win that award one day and had worked just as hard—regardless of trying to get nominated for an award. I figured the CMA folks knew what they were doing, and maybe I'd get a chance to win. But if I had just been working for an award, I would have quit long ago. When I did finally win, it was wonderful! I'm just a mountain gal and very proud to be a country artist.

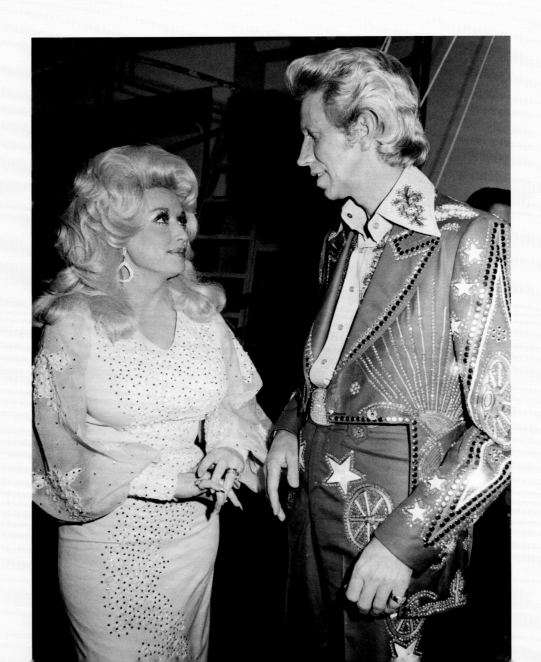

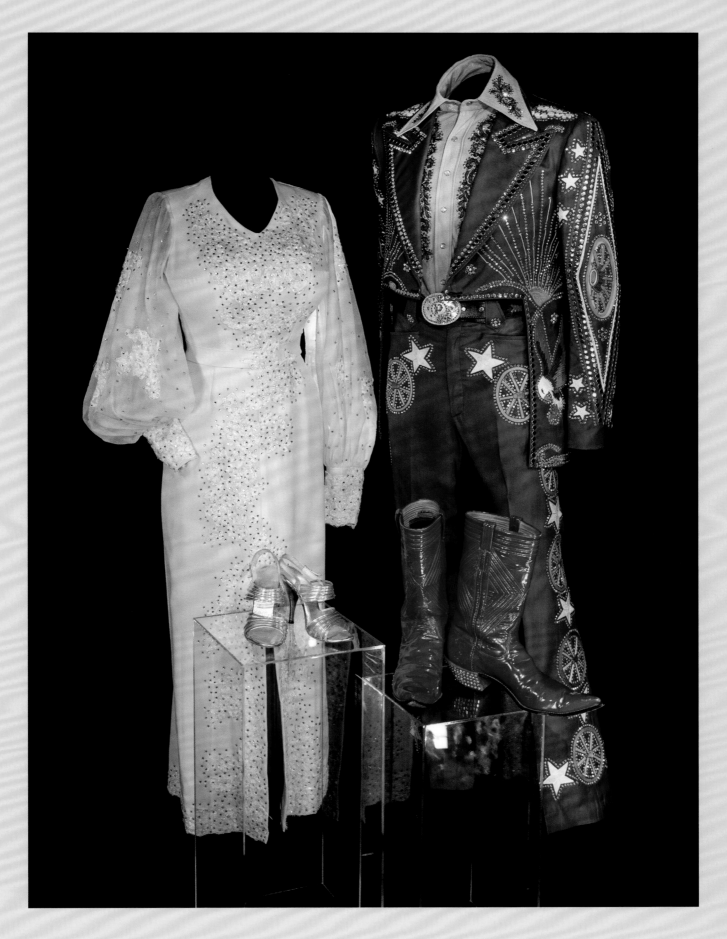

In 1970 and 1971, Porter and I won Vocal Duo of the Year at
the CMAs. At our last CMAs together, in 1975, Porter wore one of
his flashiest Nudie suits, and I wore a rhinestoned pink gown
with lace trim designed by Lucy Adams.

I felt just like a little baby doll in this sweet red dress, which I wore when Captain Kangaroo was a guest on my TV show in 1976.

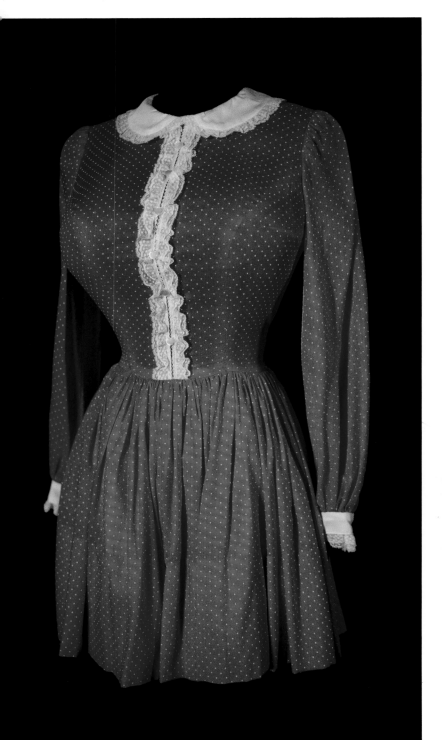

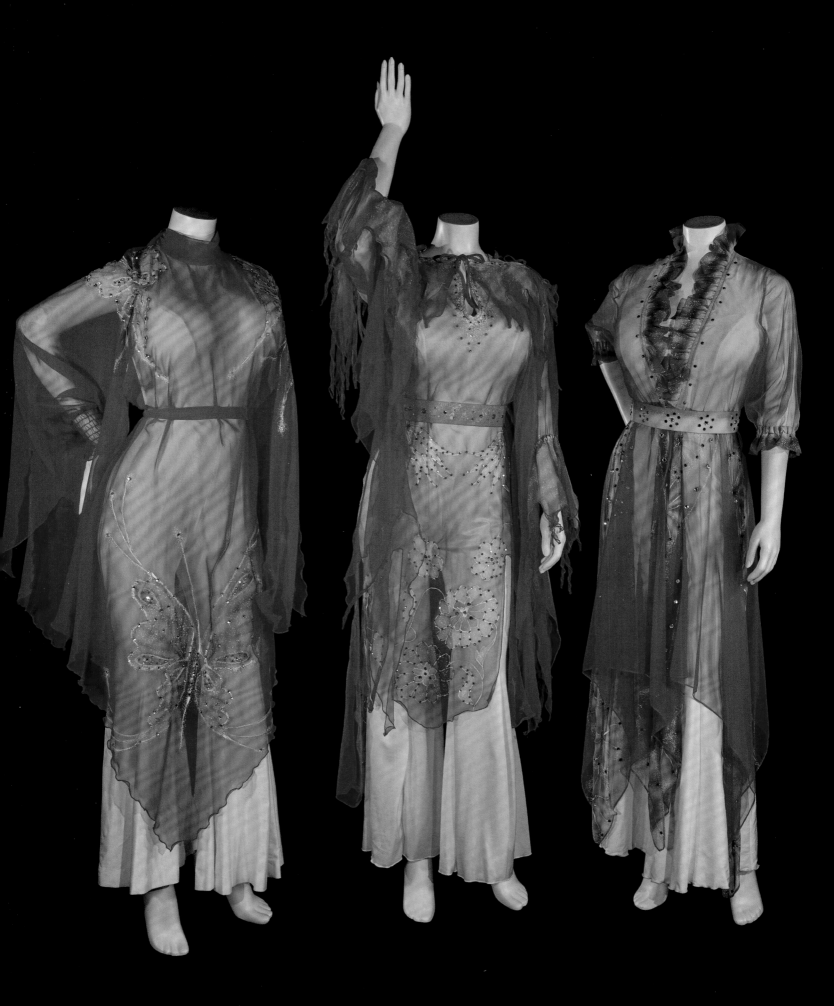

More sisters! I loved wearing these chiffon overlays
onstage. They're beautifully airbrushed and sprinkled
with rhinestones, and they billow around onstage.

4

And Here I Go . . .

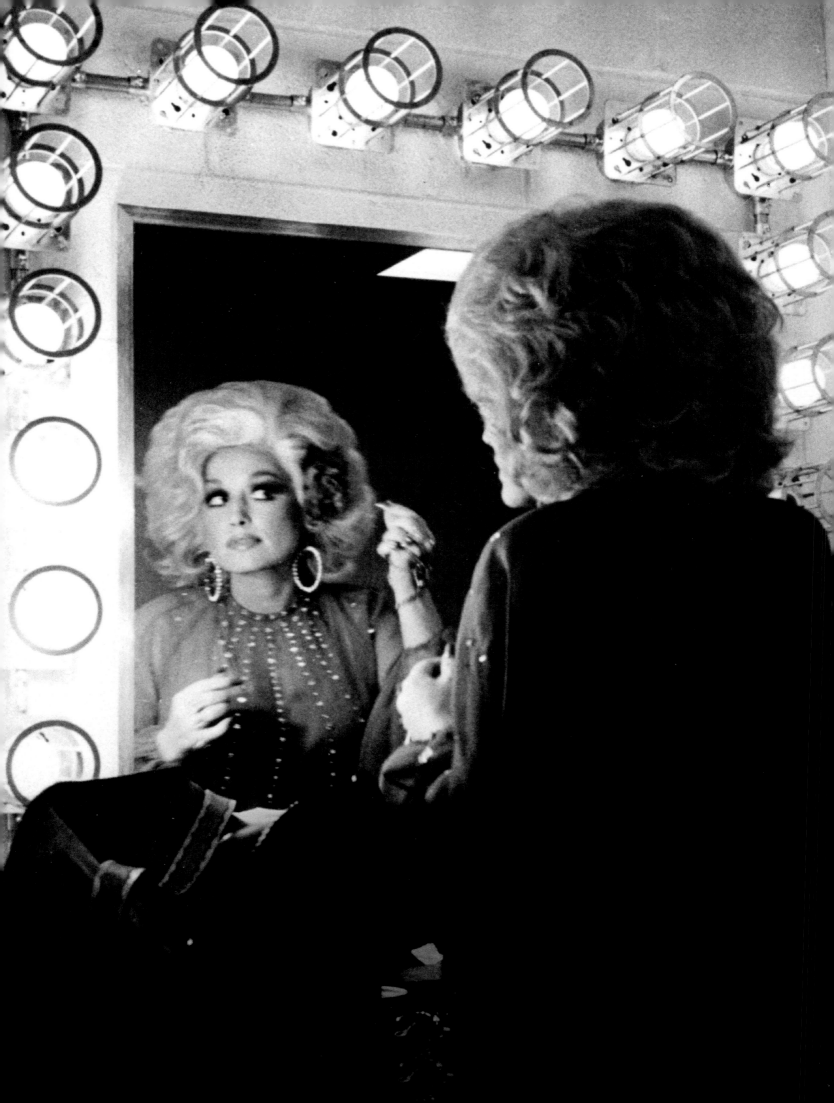

"I felt like God wanted me to be more, and to do more, and to get out and do my own thing."

Dolly

In 1977, Dolly was the subject of an extensive *Rolling Stone* magazine article photographed by Annie Leibovitz and featuring a then-unknown, scantily clad Arnold Schwarzenegger. The writer of the piece, Chet Flippo, described Dolly as "an angelic, creamy-skinned, honey-wigged, golden-throated, flashing-eyed, jewel-encrusted, lush-bodied, feisty enchantress of a songwriter and singer." Her place in the national spotlight was at hand—and she was ready, sparkling clothes, big hair, and all.

During this era, her wardrobe got sexier, and the new, liberated Dolly showed more skin, occasionally wearing gowns with plunging necklines. She crossed over in a big way with the massive *Here You Come Again*, which sold one million copies. She was reaching a broader audience, and with guest appearances on network television shows hosted by Cher, Carol Burnett, and Barbara Walters, her singular style was beamed into millions of homes around the country. Dolly became a household name.

—*Holly George-Warren*

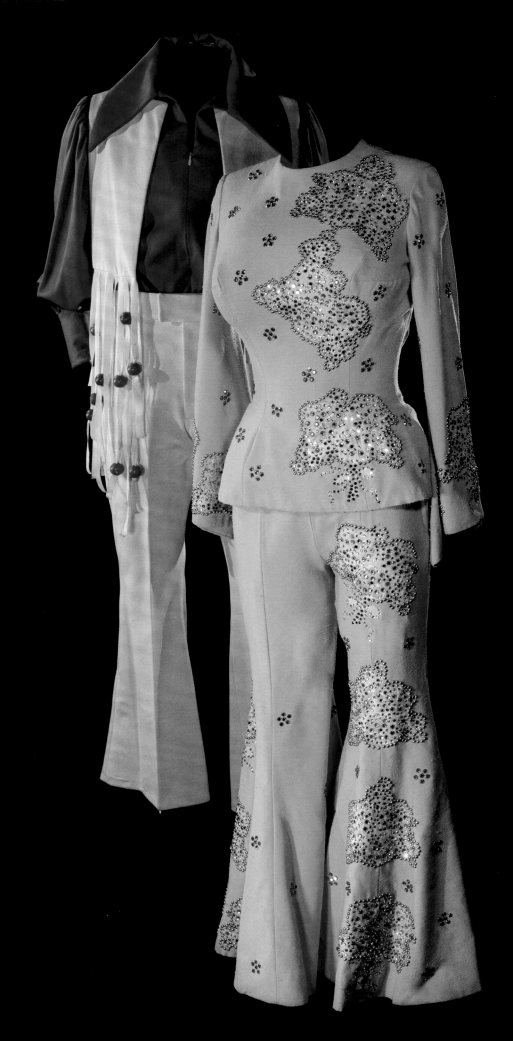

Our look for the Traveling Family Band, 1975.

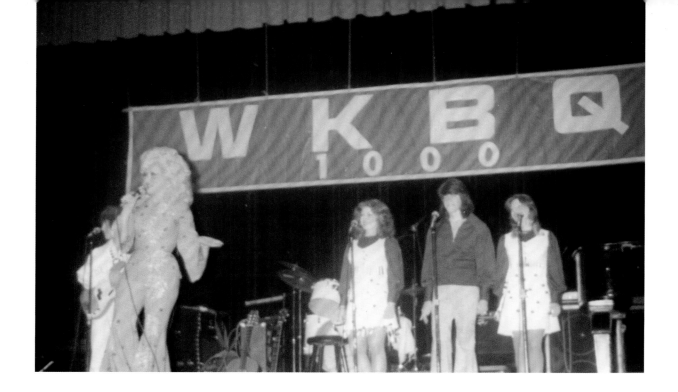

Here we are onstage in Covington, Tennessee (*from l to r:*
Randy [obscured], me, Rachel, Floyd, and Freida).

*W*hen I left Porter, I felt liberated in every way. I never was one to be told what to do for too long because I never could do what anybody else told me to do if it went against who I am. I couldn't just stay there forever being somebody's girl singer. I felt like God wanted me to be more, and to do more, and to get out and do my own thing in how I thought, how I worked, the songs I wrote—and what I wore. I just felt free.

I always wanted to be everything. I dreamed that if I was successful, I could do more things. I wanted to travel the world, make money, even make movies when the time was right. But I didn't want to do that till I was ready, because I was serious about my music. I believe that you need to stick with one thing long enough to make it happen. Your career is like a tree. You've got to have good roots—a solid foundation—to grow a good one. Then you get lots of limbs and you can have lots of leaves on that tree once you branch out. I knew that if I made it with my singing and with my writing, which was my first love and still is, I could really branch out, so to speak.

In 1974, when I moved on from Porter, I put my own band together and hit the road. Called the Traveling Family Band, it included my uncles, my cousins, my sisters Rachel and Freida, and my brothers Floyd and Randy. I got matching outfits for the band in a variety of colors. A favorite was turquoise and white with fringe—a country style with a hint of Western.

And Here I Go . . .

Most of my costumes—jumpsuits and pantsuits—were made from stretchy polyester, easy to "wash and wear." That was important, because we didn't stop. We were doing one-nighters and weren't in a town long enough to go to the dry cleaner. I wore things that looked great onstage that I could wash out by hand. Barbara Walters interviewed me on my bus for her TV show, and I proudly told her about that. After all, it's better to wash those clothes out a little bit than keep wearing them and stink everybody out of the bus until you get to the cleaners!

I couldn't wash everything—like all the chiffon things. But I'd wash and rinse my jumpsuits, then lay them out and let them dry. I had to be careful washing the ones with rhinestones, but I learned how to do it without pulling out the stones. I also knew how to replace the stones, and I traveled with my own rhinestone repair kit. When you're new at something, or when you're out there on your own, you've got to learn. And putting rhinestones on things gave me something to do while I traveled on the bus. It's kind of relaxing in a way.

"I'm just an extremist, and so I like to dress the part. If I have extreme parts of my body, then I might as well have extreme hairdos, or have extreme clothes to match the boobs and the hairdo. And my personality is really extreme!"

—Dolly, 1977

In 1976, when I did my very first variety show, *Dolly!*, in Nashville, Lucy Adams designed my costumes. I'd open the show drifting down to the stage in a red velvet swing. I had great people as guests, like KC and the Sunshine Band, who'd just had their first hit, "That's the Way (I Like It)." KC was just a boy. The band wore colorful outfits with embroidery and rhinestones. I'd wear some of the same kinds of things that I'd wear on the road: pantsuits with chiffon tops and jumpsuits in all kinds of colors, with big, big bells and kick pleats. Mama had made me a pair of pants with a kick pleat when I was a teenager, and my new pants were sort of inspired by those. For some numbers, I'd wear a beautiful chiffon gown. Later, I'd have chiffon capes made in different shades of peach, pink, and red, some sprinkled with rhinestones. The chiffon was great for hiding those extra pounds I tended to put on when I was on the road. My jumpsuits were really easy to work in. I could sit down to play an instrument without having to worry about popping a zipper. And I just loved that smooth, sleek look the jumpsuit provided.

Behind the Seams

Designer
Lucy Adams

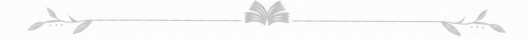

Lucy Adams (as told to journalist Alanna Nash): "My things weren't wild to start with, but we gradually built up more and more to where she'd say, 'I'd like them crusted.' Just crusted with rhinestones. Then we came up with the big wide-bottomed legs on her pants. She'd wear long dresses for conventions and special occasions, and she'd wear some short dresses too. But she found the pantsuits more practical for the stage, for modesty's sake. From then on, just about all of her stage things were pantsuits or jumpsuits, and I just kept getting them wider and wider at the bottom. Sometimes I'd make her things and think they fit real nice, but she'd say they were too big—for me to take them up more. If she could reach down and pick [something] up, it was too loose. If she'd left it up to me, I wouldn't have done that. It looked like it would be uncomfortable. But I'd just push her in and zip her up. That's the way Dolly wanted it. I made a lot of the jumpsuits out of swimwear material, and it's stretchy. She likes red and pink, but I would say she likes to wear white above anything else. Sometimes I'd put a design of rhinestones on 'em. I got me a rhinestone machine. Those rhinestones got as expensive as diamonds. There were times I'd order $300 worth a week."

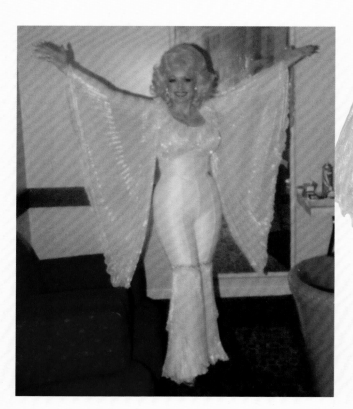

This is one of my first pure-white outfits with angel wing sleeves, circa 1978. I absolutely love this look—designed by Lucy Adams!

My Rainbow of Bells

Back in the 1970s, it was "have jumpsuit, will travel" for me. In a rainbow of colors, these jumpsuits and pantsuits had it all (especially those bell-bottom pant legs I loved). They looked great and were so practical, and I've been wearin' them ever since. I suppose most people who've followed my career for decades associate me with jumpsuits. In the '70s, I wore them for most of my high-profile appearances: on my TV show, posing for *Rolling Stone* magazine, visiting with my buddy Johnny Carson, on my record covers, and on stages here and abroad. I guess you could say I never left home without one (or five)!

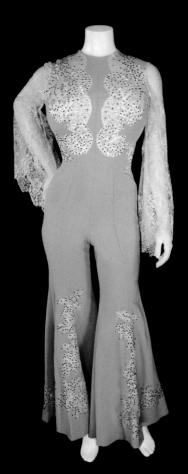

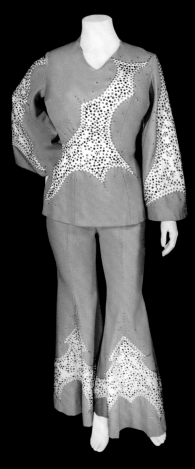

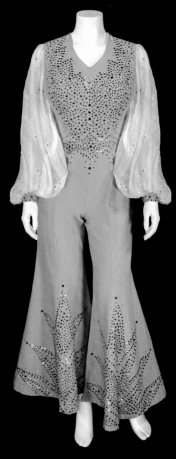

On my TV show, I sang "Joy to the World" in this jumpsuit.

I performed "The Seeker" wearing this on the TV show *That Good Ole Nashville Music*.

I wore this jumpsuit on my last guest appearance on *Hee-Haw*.

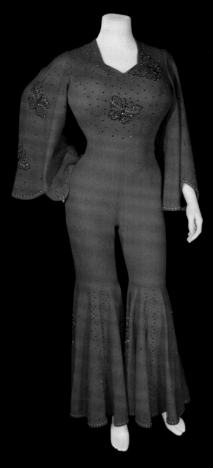

A favorite of mine made an
appearance on the cover of my LP
Love Is Like a Butterfly.

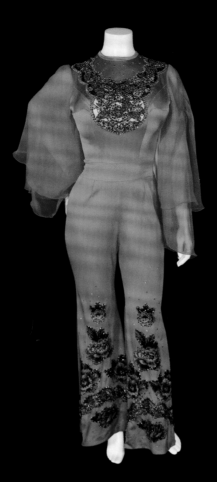

This outfit really knocked
the socks off Johnny Carson when
I wore it on his TV show.

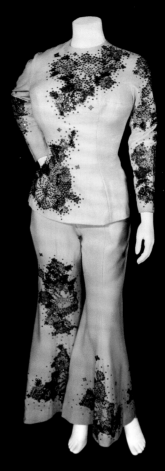

I performed in this with my brother
Randy and the singer Anne Murray on
"Drift Away," on an episode of my show.

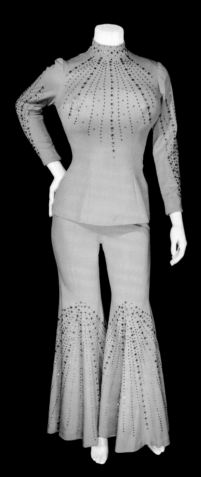

I wore this gorgeous pantsuit at the UK
Country Music Festival in London in 1976.

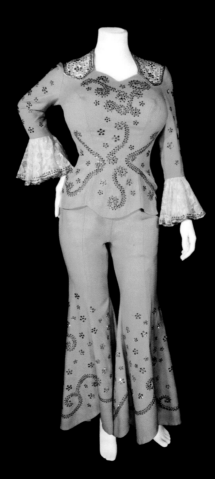

I sang "Rhinestone Cowgirl" wearing
this sparkly suit on my TV show.

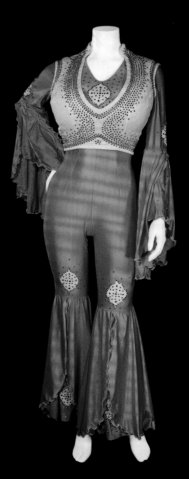

Annie Leibovitz photographed me in
this outfit for *Rolling Stone* in 1977, with
Arnold Schwarzenegger as my prop.

Designer

Bob Mackie

Bob Mackie began as a fashion illustrator working for top movie costumers Edith Head and Jean Louis. In 1962, he drew the illustration of the Jean Louis–designed rhinestone-covered, flesh-colored marquisette gown worn by Marilyn Monroe when she sang "Happy Birthday" to John F. Kennedy at Madison Square Garden. Mackie loved the showgirl look, which inspired some of his own striking designs. On TV, he started as the costumer to Judy Garland and Lucille Ball. He made Cher's outrageous outfits for *The Sonny and Cher Show* and continued to work with her once she left Sonny for a solo career and TV show. Mackie also worked as costume designer for Carol Burnett's television series. When Dolly costarred on a special with Burnett, he designed an exquisite black gown with a butterfly motif embellished on the bodice, complemented with butterfly-wing sleeves. The dress became one of Dolly's all-time favorites.

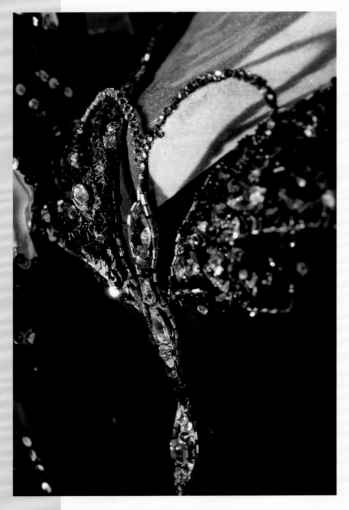

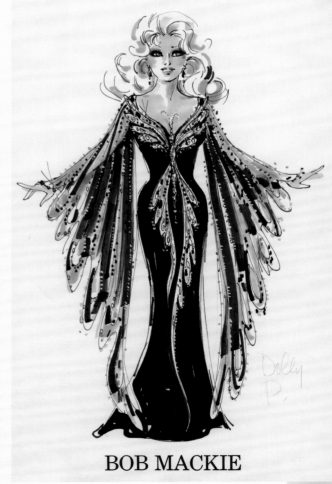

BOB MACKIE

At this time, I started appearing as a guest on other people's variety shows. I worked with so many great people through the years. In 1978, I was on *Cher...* *Special*, where I worked for the first time with Bob Mackie. That was really fun, and on top of it, I got to wear a Bob Mackie! He was the hottest thing going.

I worked with Bob Mackie again in 1979 for a TV special with another of his long-time clients, the wonderful Carol Burnett. In my opinion, she's at the top of all the TV variety show stars. On *Dolly and Carol in Nashville*, we appeared onstage at the brand-new Grand Ole Opry House, out at Opryland. We wore gorgeous Bob Mackie gowns, except for a down-homey number where we were pickin' banjo and guitar in blue jeans and plaid shirts. My favorite Bob Mackie gown was black (not a color I often wore back then). I wore it during a solo number that I performed onstage at the old Ryman Auditorium, which the Opry had stopped using. There's something powerful about the Ryman—you always get the feeling there that you're standing on sacred ground. Growing up, I'd always wanted to be on the Grand Ole Opry and be a member of it. And being able to bring people from California to be part of the old and new Opry House was really nice—I loved sharing that history with other people.

These years were so busy, mainly because in 1977, I got a new manager based in LA, a New Yorker named Sandy Gallin, whose expertise in reaching into main-stream popular culture took me from country star to superstar. I used to say, "He's got the taste, and I've got the talent." Sandy and his team were hitting on all cylinders and my career was booming. They got me on the cover of nearly every magazine in the country. I was home for only eight days in four months. By then, I'd put together a new band called Gypsy Fever. No longer did we wear matching outfits. *Cosmopolitan* magazine described them like this:

> *The Gypsy Fever Band—seven male musicians and one "girl" singer— are, themselves, human indications of the new, changed Dolly. . . . Not for them the cowboy hats and studded belts that mark most Nashville ensembles. The young men wear fresh sport shirts and plain slacks, while the girl looks pretty in a sundress. They could pass for college kids on summer vacation, instead of a country-western band.*

Sandy also introduced me to some fascinating people, including Andy Warhol. Andy and I would hang out together at Studio 54, which was great. Steve Rubell, who owned the club, also became a dear little friend of mine. We really liked each other. He was a close friend of Sandy's, who remained my manager for twenty-five

And Here I Go . . .

Cher

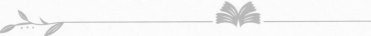

I'm a Cher fan and have always loved watching her on TV. It was the most spectacular thing on earth to see her dressing like she did. I knew I couldn't look like that because she has a whole different body structure. But she inspired me to wear costumes designed by Bob Mackie, who did all the amazing clothes for her. When I got to be on her show in 1978 and wear those Bob Mackie costumes, I just loved it. Once you are in a show like that, you long to have that yourself. So that's where I first got the taste for it. Then after I started getting bigger and bigger, doing the movies and getting real popular, I thought, "Well, why not just go for those extravagant clothes?" At least for great occasions! After that, I never minded paying big money for my stage clothes.

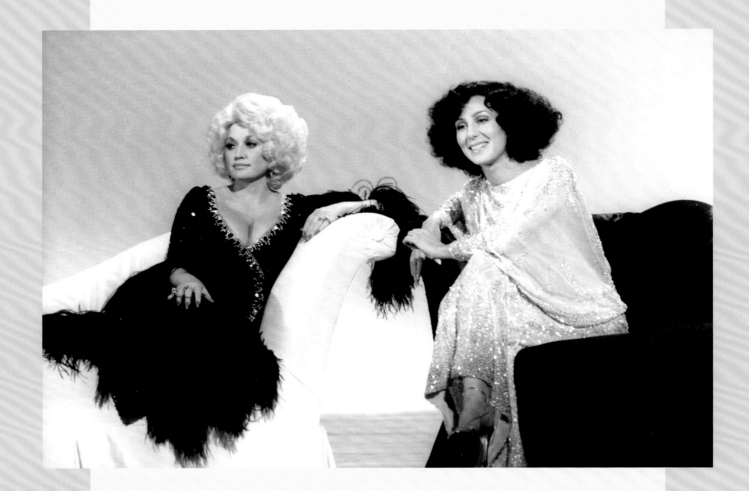

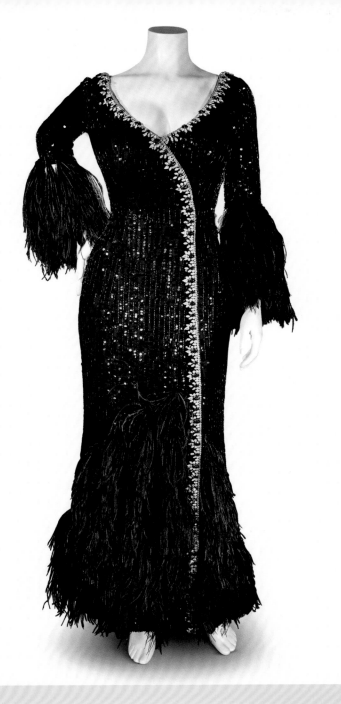

Once I put on this gorgeous Bob Mackie gown, I really understood what it felt like to shine from head to toe. I wore it on the Cher special, and I even got nominated for an Emmy for my appearance.

I wore black chiffon, but most everybody else got duded
up in cowboy clothes at the country-western-themed
birthday party Steve Rubell threw for me at Studio 54.

years. (Sandy passed away in 2017, and I still miss him.) During that time, I met a whole new circle of friends through Sandy. That's how I got to know Calvin Klein and Diane von Fürstenberg. We hung out together. I got acquainted with all these famous people, and they just loved me and my polyester. They didn't care. We'd go to Studio 54, and they would be up dancing, doing whatever. Andy and I would mostly just sit on the couch and watch all these crazy people out there doing their thing. We really got to know each other, just sitting on that couch.

Sandy commissioned Andy to do a portrait of me. Sandy always thought I was prettier than I was, and he loved Andy's picture of Marilyn Monroe. I remember sitting for the photos for Andy and all that. But when Andy finished the portrait, Sandy didn't like it; he thought I was supposed to look like Marilyn Monroe. Well, I looked like Monroe—but more like *Bill* Monroe, the Father of Bluegrass. So Sandy didn't want the portrait and he gave it back to Andy, even though he had commissioned it. And then it became worth millions. Sandy lived long enough to kick his own ass about that!

Behind the Seams

Big Dreams and Faded Jeans

I think denim's always going to be associated with country music. I introduced the high heels and denim look when I did that *Rolling Stone* photo shoot with Arnold Schwarzenegger in 1977. I had on my denim pants kind of rolled up, and I had on high heels, and I wore that combo again for the cover of *Here You Come Again*. Years later, people were wearing their high heels and denim.

I loved things from the 1950s, and to me, the denim pedal pushers and the little tied-at-the-waist shirts were great. I liked wearing the checkered shirts, and I just loved those scarves 'round the hair. That's country. It's kind of dressing like you're home and keeping your childhood near you.

I was always proud to be country, to be a country girl. I'm very proud to be a born-and-raised Tennessean.

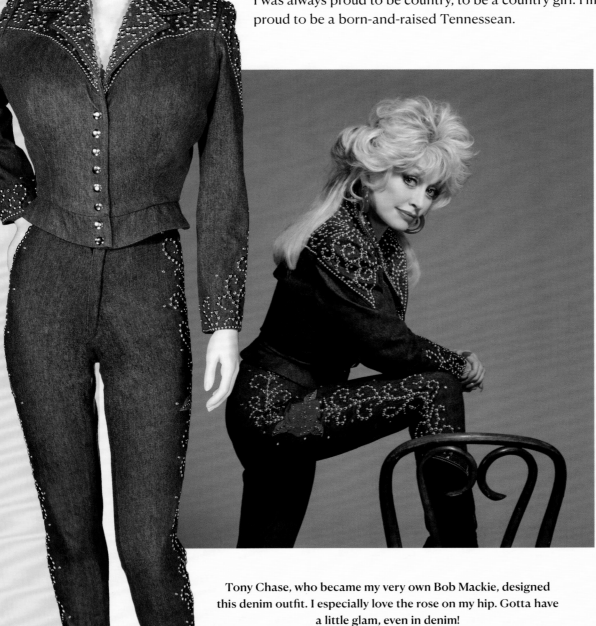

Tony Chase, who became my very own Bob Mackie, designed this denim outfit. I especially love the rose on my hip. Gotta have a little glam, even in denim!

Hanging out at Studio 54, I would sometimes see outfits I liked, and I would incorporate certain pieces into something I'd wear. Or if I liked the way a certain skirt flips out here, I'd think, "Ooh, I need a little skirt that does that." But most of the Studio 54 crowd were way too high fashion for me. They knew how to dress and were dressed to the nines. It was fun looking at them. That was quite the show.

Studio 54 was just full of energy. Everybody was having a good time. Andy and I didn't do too many drugs or drink too much alcohol, so we'd just sit and watch the people party. I met Halston there, and he liked to drink. He was at Studio 54 all the time. He had nice designs, but they were just not my style, though I liked him as person.

Around that time, people tried to talk me into wearing certain things. I usually said, "This is not me." But I'll tell you what I did like, and what I wore even before I got to know Diane von Fürstenberg—that wraparound dress she designed. It's just a great little dress. Those dresses are so convenient, and they're very feminine—and very sexy. They make your butt look good. All that stuff that some of us girls like to conceal is camouflaged by the way the skirt falls. I probably wore one of those at Studio 54. To this day, I love that dress, and that style is still popular. If you're a designer, that's the kind of fashion piece you want to design—something that'll live that long.

One year, Studio 54 threw a big birthday party for me. Steve filled the place with hay bales. They did a whole country scene with cows and a beautiful white horse too. And people loved it. Everybody dressed in country-western outfits, but I was wearing sparkly black chiffon that night. I had a lot of gay fans then, and they came to my party in their little country-western getups, and we were just having a big ol' time.

In those days, I was also getting a lot more creative with my makeup. But with such a busy schedule I needed a helping hand when possible. My first professional makeup artist, Jo Coulter, was in Nashville. She showed me the difference between making up my face for television cameras and just "Dollying" myself up for appearances and concerts.

Going to LA in the 1970s also gave me the opportunity to meet and work with Hollywood makeup artist Bobbe Joy. That was one of the great pleasures of my life. She did my makeup when I posed for the cover of *Playboy* forty-three years ago. I wasn't comfortable doing that cover, but they just wouldn't hush until I did a cover for *Playboy*. I'm glad I did, because it turned out really good.

Behind the Seams

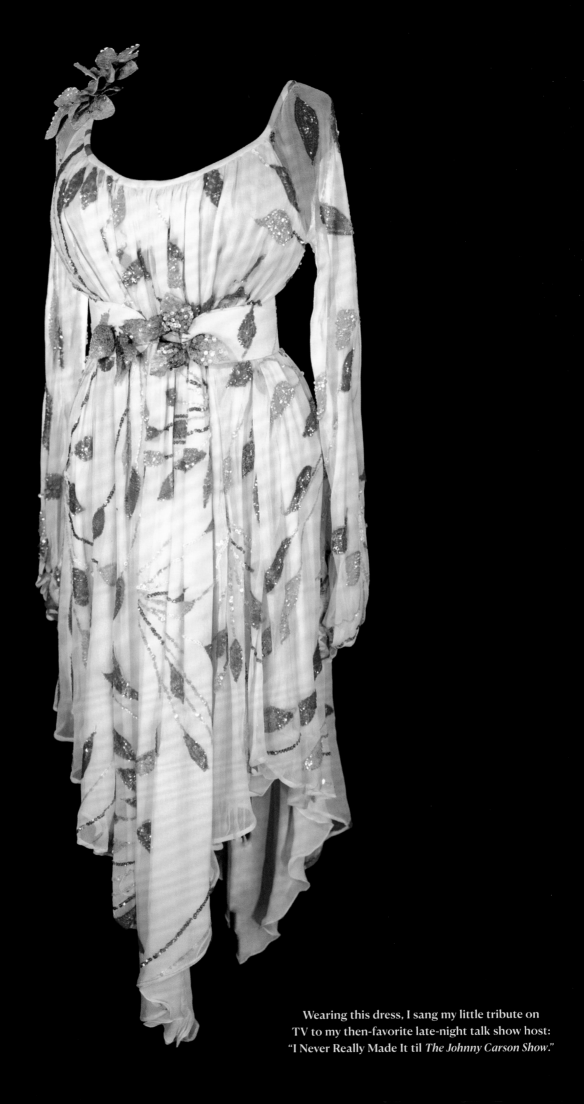

Wearing this dress, I sang my little tribute on
TV to my then-favorite late-night talk show host:
"I Never Really Made It til *The Johnny Carson Show*."

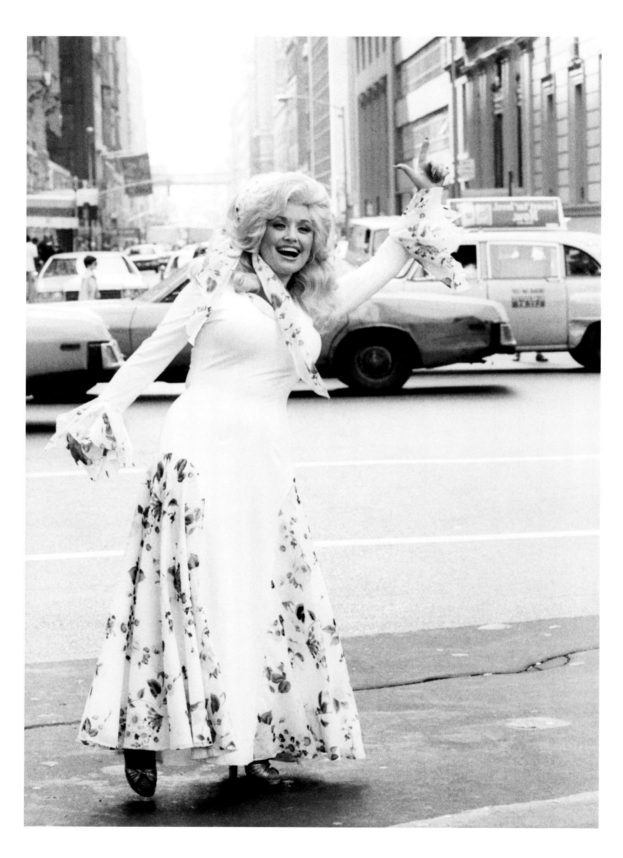

I wore this dress on the back cover of my 1977 album *New Harvest . . .
First Gathering*—a very special record for me. Photographer David Gahr
got me to hail a taxi wearing it in New York City in 1976.

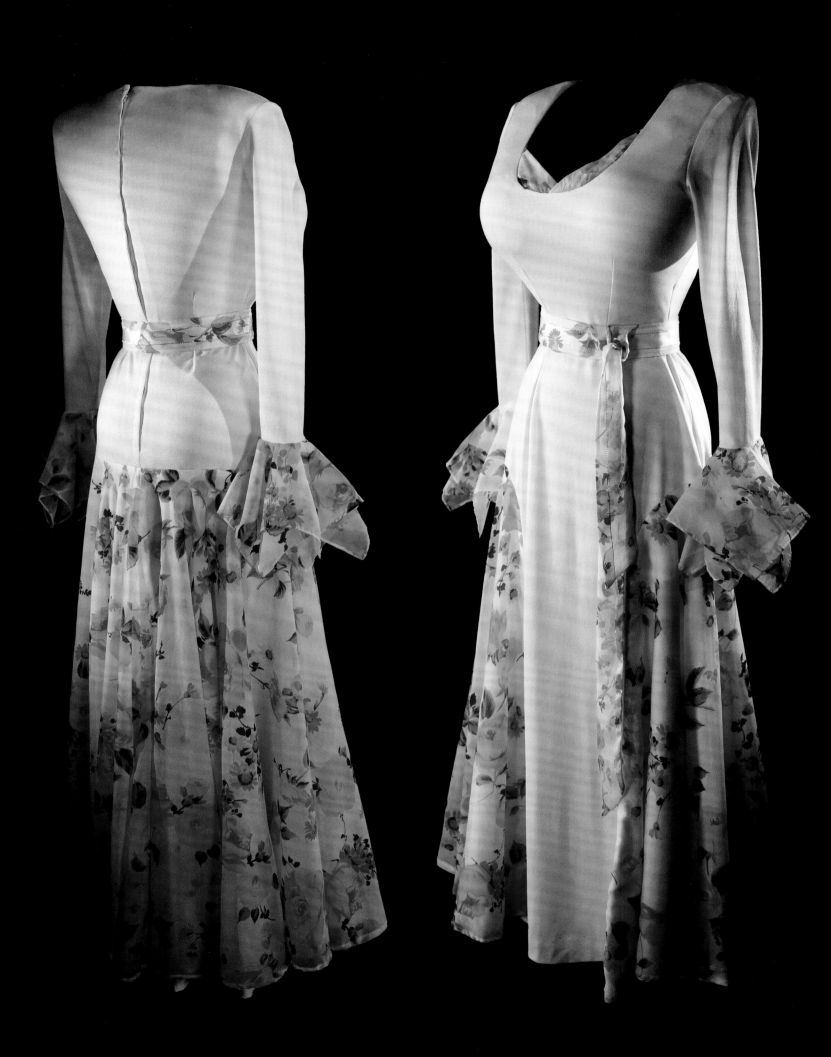

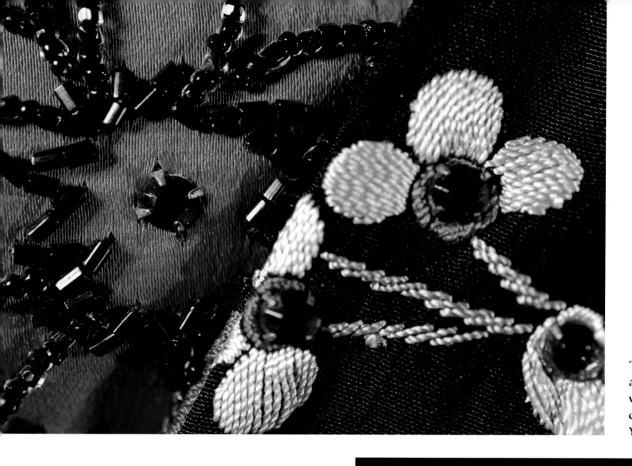

This is the outfit I wore at the 1977 CMA Awards when I sang my huge crossover smash, "Here You Come Again."

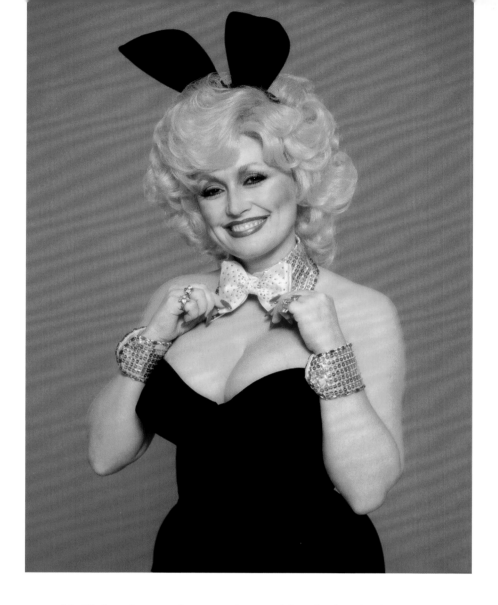

My *Playboy* photo session was quite scandalous back in the day! I recently re-created this look—originally designed by Patricia Taylor, who also happens to be Keanu Reeves's mom—as a little surprise for Carl.

We did a great interview for the issue. I was never willing to do a *Playboy* spread—if you pardon the expression. My intention was to take a good picture for the cover and do a good article, which I did. Because, of course, everybody reads *Playboy* for the articles.

Looking back at the 1970s, I realize how much fun I had wearing lots of adventurous new styles. I loved expressing myself through my evolving wardrobe. Down the road, I'd sometimes return to those '70s styles. As they say, what goes around comes around. . . .

And Here I Go . . .

Makeup Artists
Jo Coulter and Bobbe Joy

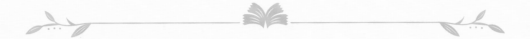

Jo Coulter (as told to journalist Alanna Nash): "I was Dolly's makeup artist on the TV shows, both Porter's and [later] hers. . . . She can do her own makeup, and does a lot of the time. She knows it because she worked to learn it, since anybody who's going to be in the spotlight needs to know something about makeup. . . . She doesn't necessarily always outline her lips because her mouth is very full and sensuous. She doesn't need to do anything to make it look larger. We do put lip gloss on because it catches the lights and makes the mouth prettier. But mostly it's just base, eye shadow, and false eyelashes. They help to open up the eye and make it look larger, because cameras and heavy lights tend to diminish eyes. She likes to change her eye shadow, to use a lot of different colors. She did a rainbow eye once that I love—all different pastel shades painted over her eye. She loves to create . . . and she simply adores playing with makeup."

Bobbe Joy: "In late 1976 or early 1977, I got a call from photographer Dick Zimmerman who wanted to know if I would like to do Dolly Parton's makeup for the cover of *Los Angeles* magazine. I said, 'I love Dolly. Of course!' I get there and she comes walking in with hair done, makeup done, ready to go! I say, 'Hi, my name is Bobbe Joy. I'm the makeup artist here. I see you already have your makeup on, but if there's anything I can do to help you, I'd be happy to do so.' And she looked me up and down. She says, 'Well, what would you do?' I say, 'I'd just clean you up a little bit.' She walked away for a little while, then she came back and said, 'I'll let you do it.' I sat her down. No mirror. I wouldn't let her see what I was doing. I started wiping off and cleaning up and fixing and whatever, and we started having a nice chat. Just before I was done, I said to her, 'Look, if you don't like it, let me know, and I'll fix whatever it is. But I think you're gonna be happy with what I did.'

"She goes, 'Oh my gosh, this is great! By the way, I want one of *those* boxes.' And I said, 'I can get you a makeup box.' She says, 'I want it with everything in it. Call me when you get it all together, and I want you to teach me how to do my makeup too.' I called her, and I went over with the makeup box, thinking I'm gonna teach her how to do her makeup. And she opens the door, and she's got her hair done, her makeup done, *everything*! I said, 'How do you expect me to teach you how to do your makeup if you have your makeup on already?' So she took off her makeup and came back out, and we started doing it, and she was like a kid in a candy store! She was so excited. I taught her how to do her makeup, and I said to her, 'I'm going to make you a bunch of paint-by-numbers-style face charts to follow. I will make it very easy.' She recently told me that she still has them."

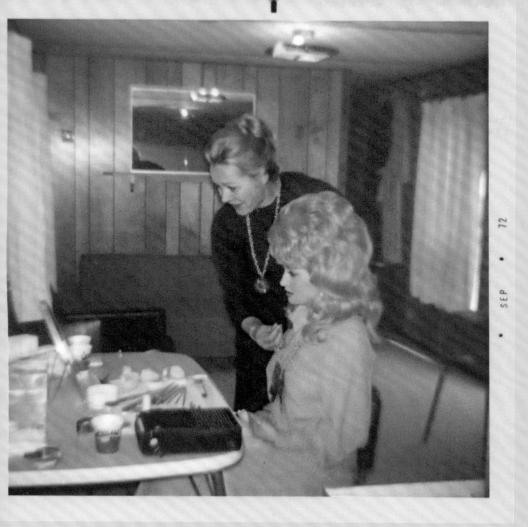

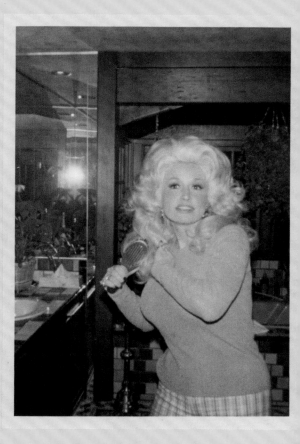

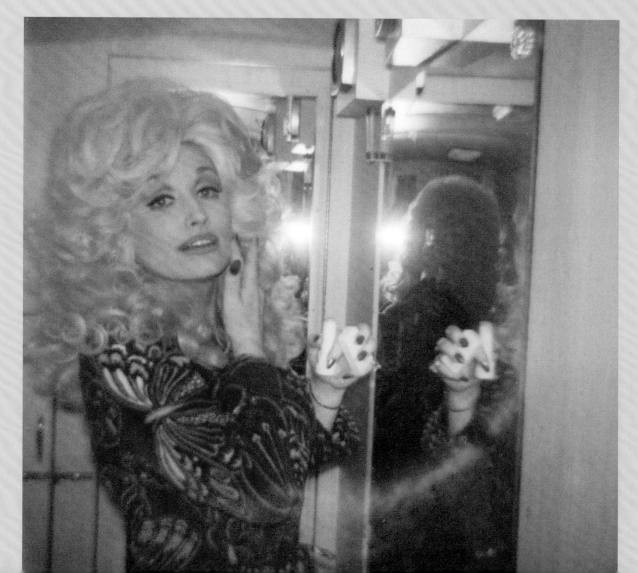

Me and Jo Coulter, who did my makeup for Porter's and my TV shows, 1972. Back then, I always did my own makeup on the road.

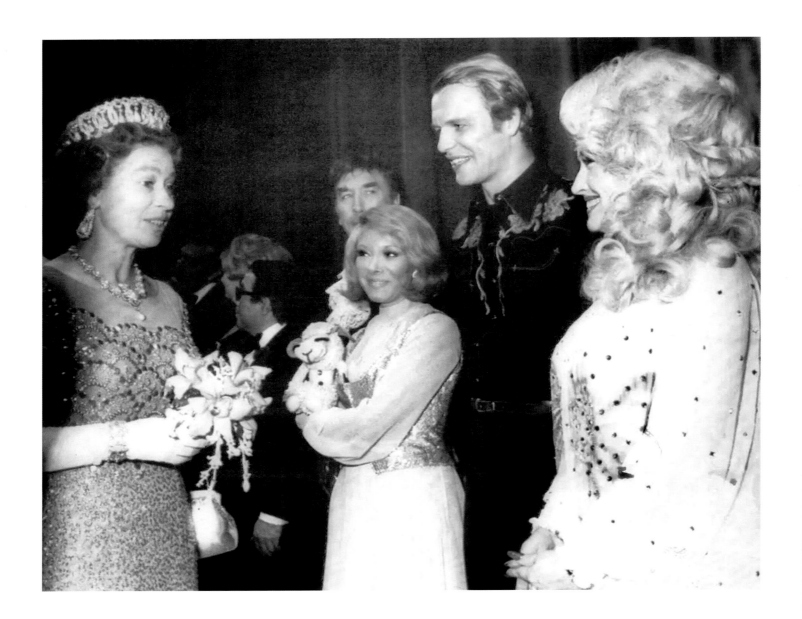

I'll never forget meeting Queen Elizabeth II in 1977, especially since I didn't know it was going to happen! Because it was so last-minute, I hadn't packed anything special, so I just wore one of my stage outfits made by Lucy Adams. Here I am with Shari Lewis and Lambchop, as well as David Soul.

Behind the Seams

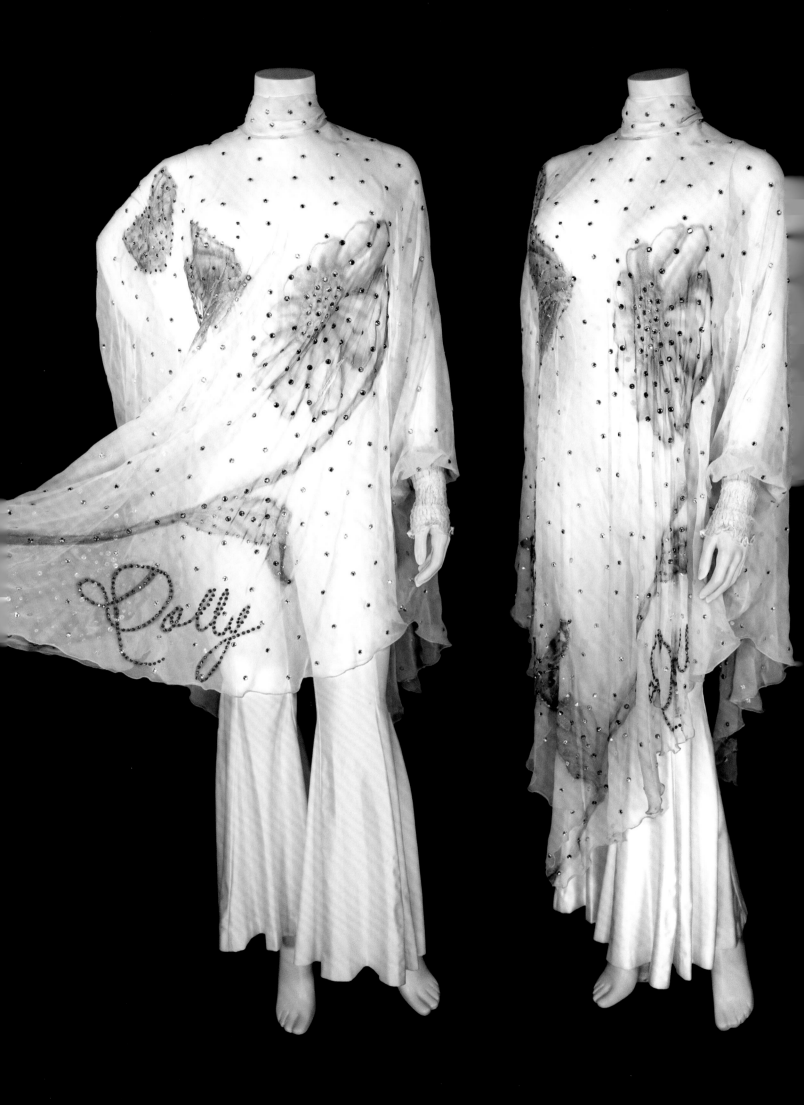

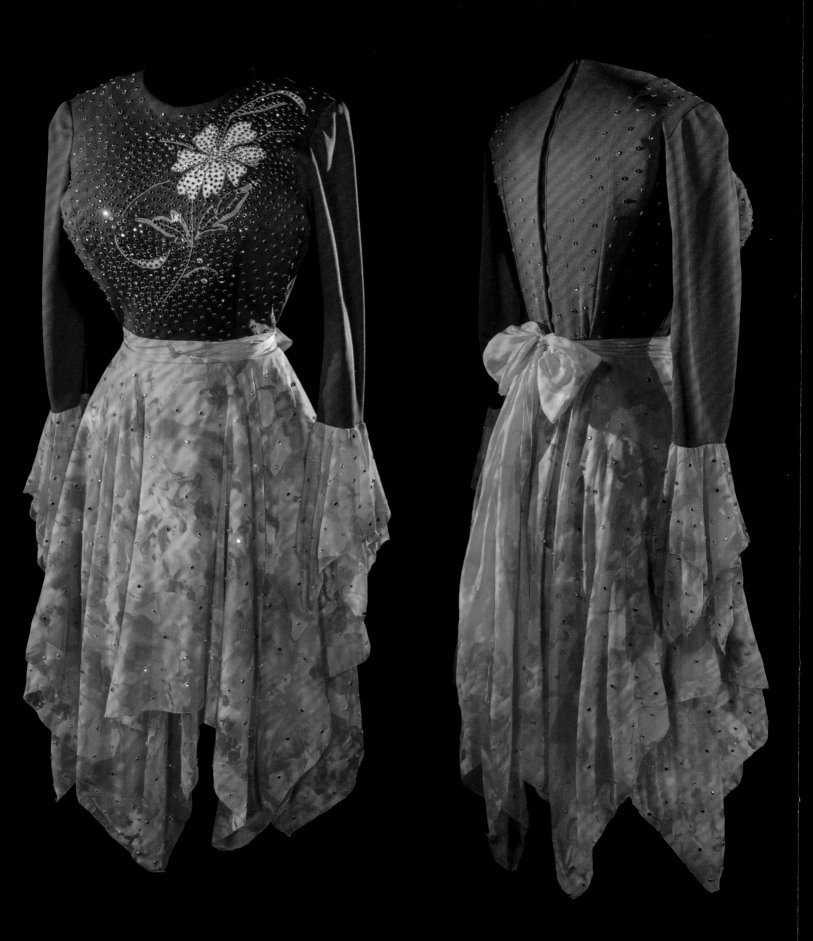

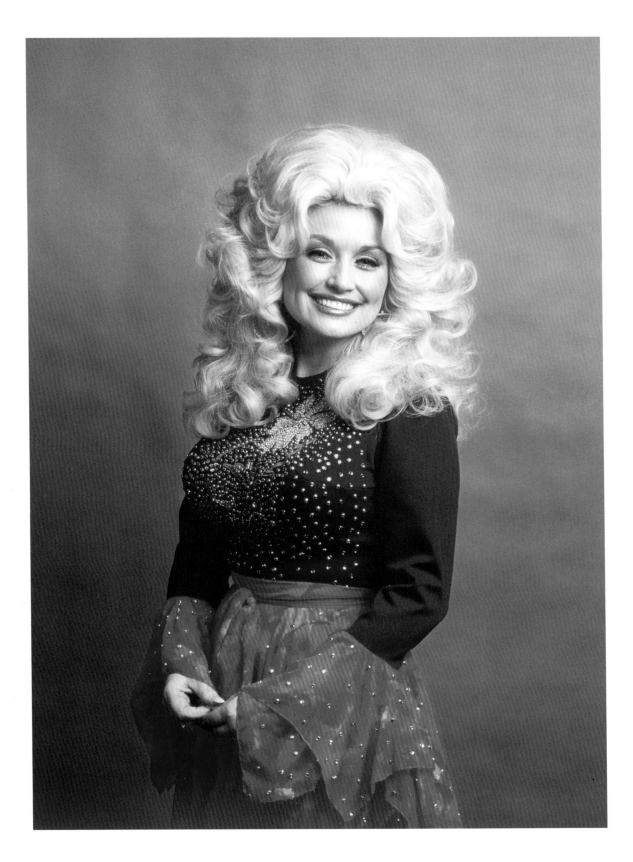

This is the Lucy Adams dress I wore on my first *People* magazine cover in 1977. The cover line read: "Hello, Dolly Parton. It's Not Goodbye Nashville, But Watch Out Hollywood."

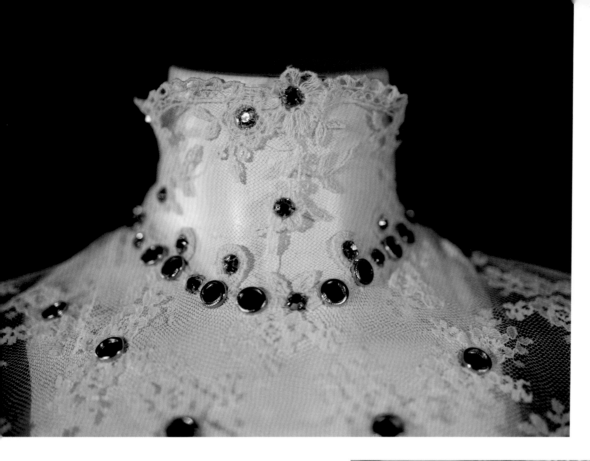

This lace and fringe poncho was another Lucy Adams creation that I wore over my bell-bottom jumpsuits, dressing them up in new ways. Here I'm on tour in 1978.

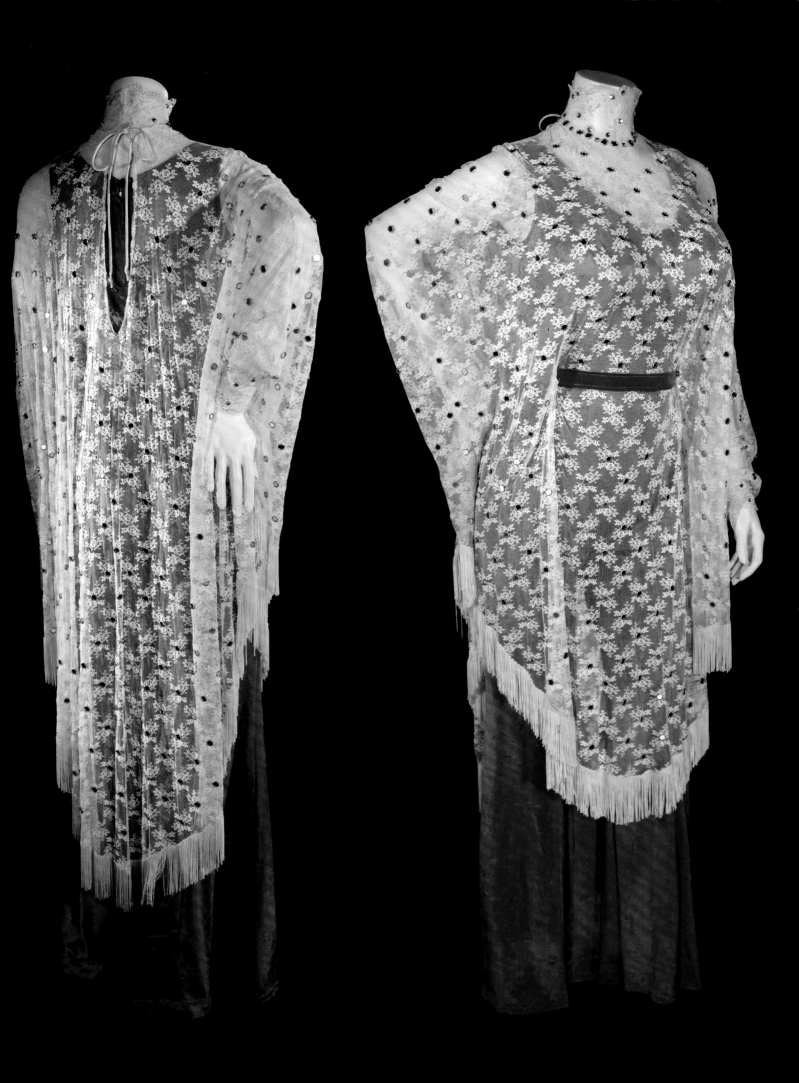

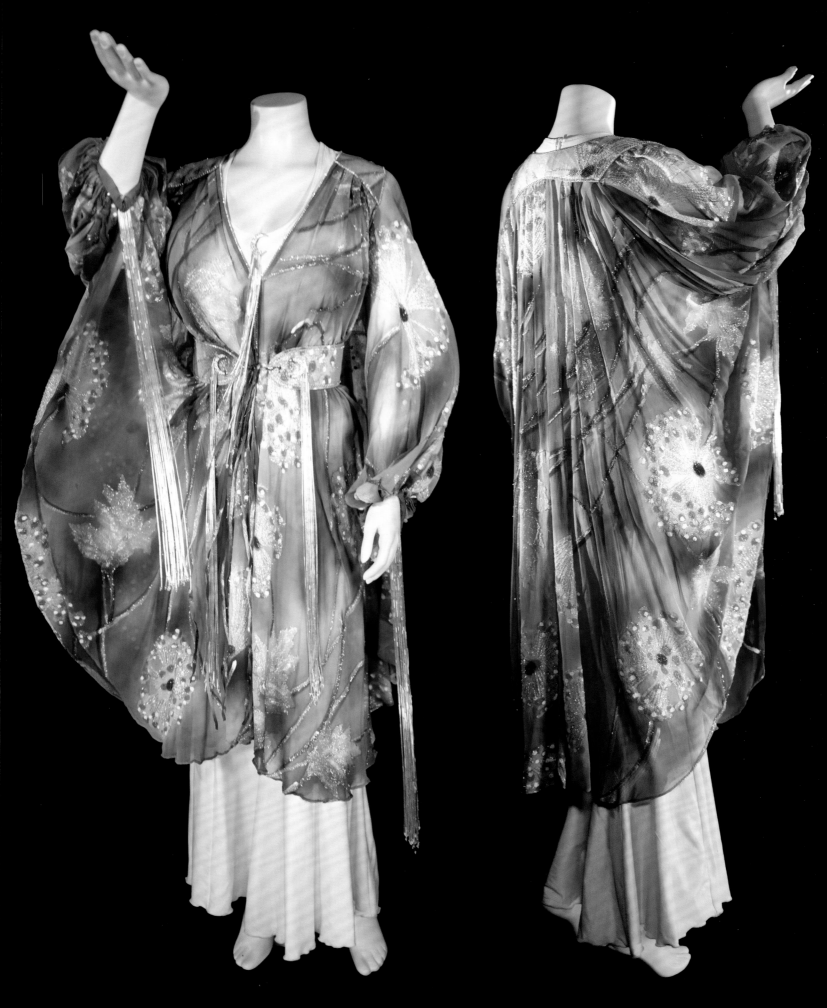

I made a video for my song "Star of the Show" wearing
this outfit—I think it was the real star of the show!

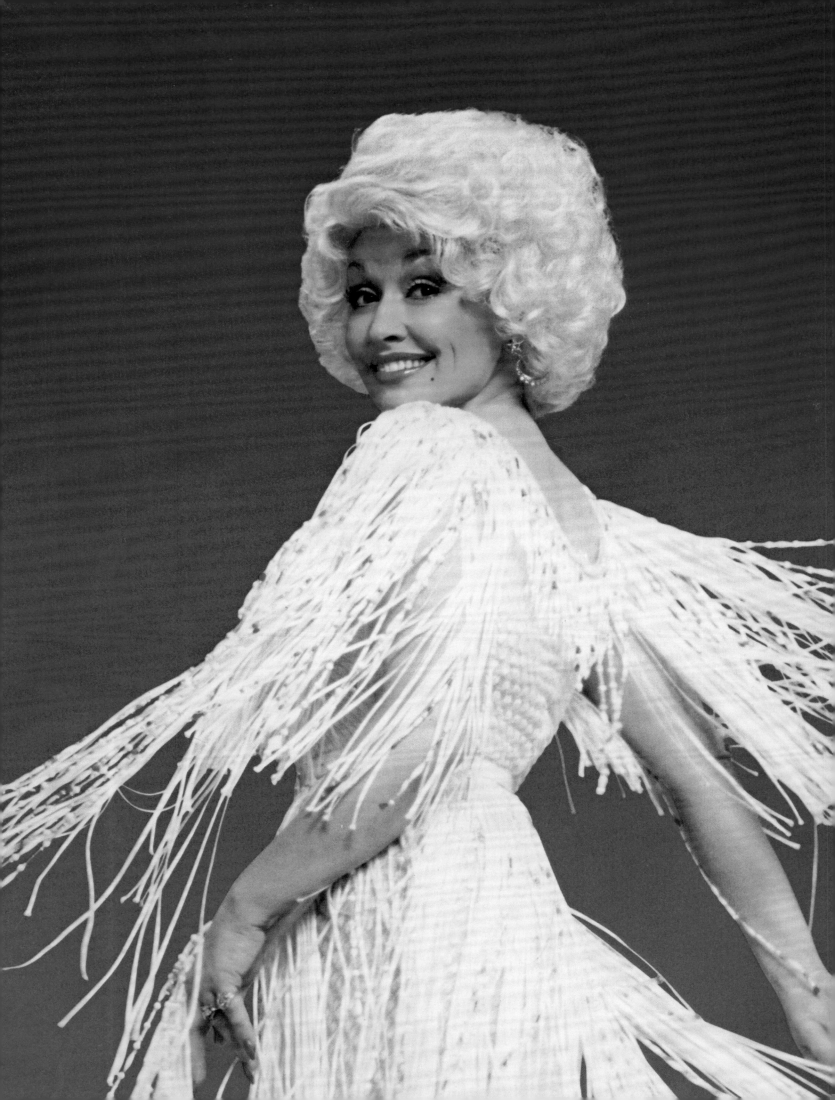

5

A Diamond in a
Rhinestone World

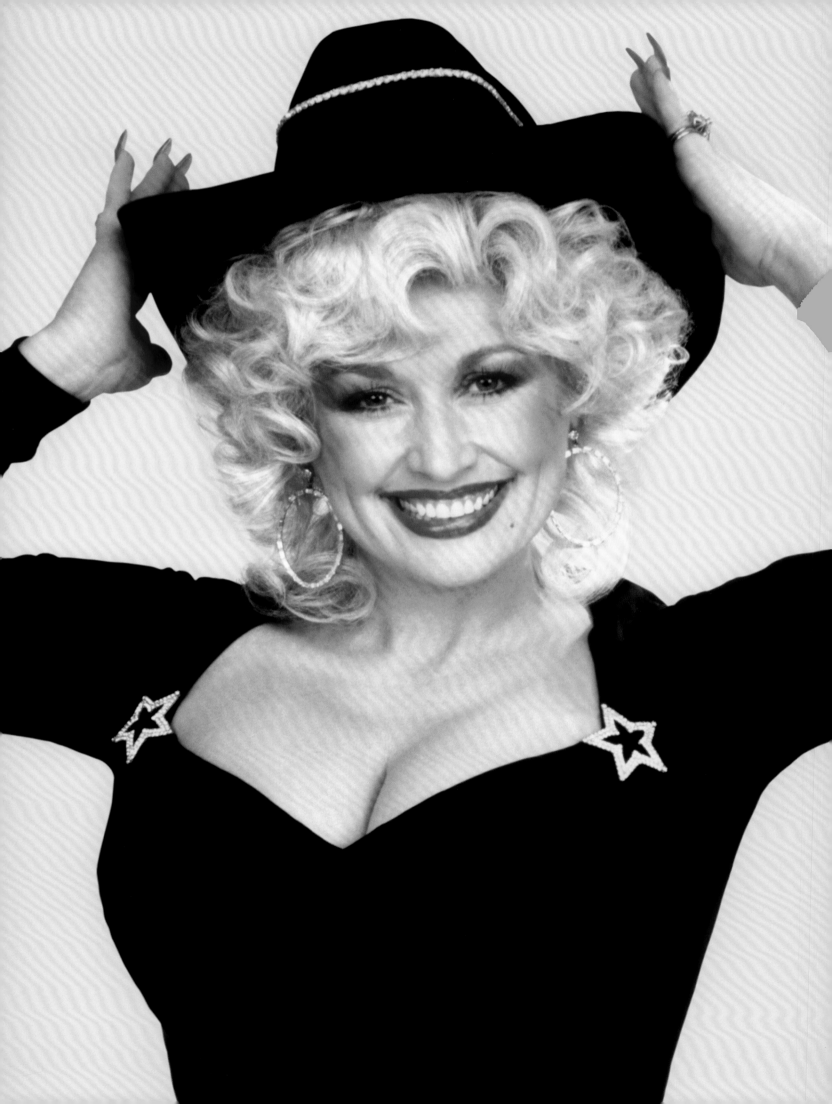

"I got dreams so big they'd scare some people."

Dolly

Dolly launched into the movies in the 1980s, beginning with *9 to 5*—the second-highest grossing film of 1980—costarring Jane Fonda and Lily Tomlin. On the set, while waiting in her trailer and tapping out a rhythm with her red acrylic nails, she came up with its title song; "9 to 5" soared to the top of the pop, country, and adult contemporary charts. It was nominated for an Oscar, and of four Grammy nominations, it won two. And she recorded a Grammy-winning album with Linda Ronstadt and Emmylou Harris called *Trio*, its cover portrait featuring the three in cowgirl garb designed by Nudie Cohn's former head tailor, Manuel (Cuevas). Dolly followed *9 to 5* in 1982 with *The Best Little Whorehouse in Texas*, costarring Burt Reynolds, and *Rhinestone*, with Sylvester Stallone, in 1984. Two years later, in 1986, Dolly opened her own theme park, Dollywood, in the Great Smoky Mountains, where she would often appear—in a variety of costumes. Dolly has always enjoyed playing dress-up, and becoming a movie star and running a theme park gave her ample opportunities to do just that.

—Holly George-Warren

There is never anything as great as a first time—like your first love—and one of those firsts for me was when I made *9 to 5*. It's not that you can't love again, but that first one will always be outstanding in your heart and mind.

The script came from Jane Fonda, who later said she thought of me for the part when my song "Two Doors Down" came on her car radio one day. My manager, Sandy Gallin, and I had previously received movie scripts to consider, but this one really resonated with me. Jane and Lily Tomlin were already set to play the parts of Judy Bernly, a first-time secretary, and Violet Newstead, who really ran the office. Jane wanted me to play Doralee Rhodes, a sexy, feisty country gal who has to fight off the boss, Franklin Hart Jr., played by Dabney Coleman.

I was very nervous about taking on an acting role. I didn't consider myself an actress—and I still don't! But Sandy reassured me that I only had to be myself. He told me, "This part is exactly like you." I'm so happy I took Sandy's advice. The role was perfect for my debut in the movies. Lily, Jane, and I had great chemistry, and our director, Colin Higgins, made the experience so enjoyable.

I had no idea how movies worked until I did *9 to 5*. They choose your clothes, your hair, and your makeup. They hire the costume designer, hairstylist, and makeup artist. That was a bit scary for me, and something I really had to get used to. I don't like to be "surprised" when it comes to what I wear and how I look. I have certain things I like to play up and others I like to play down. I'm little, and my boobs are too big. I like to play up my waistline and the best part of my legs. Since I've been making movies for decades now, I've learned to work with the costume designer and sometimes say something like, "I will not be comfortable in that. If you show me the designs, I'll show you what I will and won't wear." But great designers will work with you because they're not going to put you in clothes you don't feel good in.

I hit the jackpot with *9 to 5*. The costume designer, Ann Roth, was famous in theater and movies. In my first movie role, though, I was uneasy because I had to tone down my look to play a secretary. But talking with Ann made me feel more comfortable. She was also little, so she understood how to design for small women, which was not the case with other designers I worked with later on. I told Ann, "I don't want this to show." She said, "Trust me, I know what I'm doing. I know the parts you don't want to show. I know what you want to look like." She listened

Behind the Seams

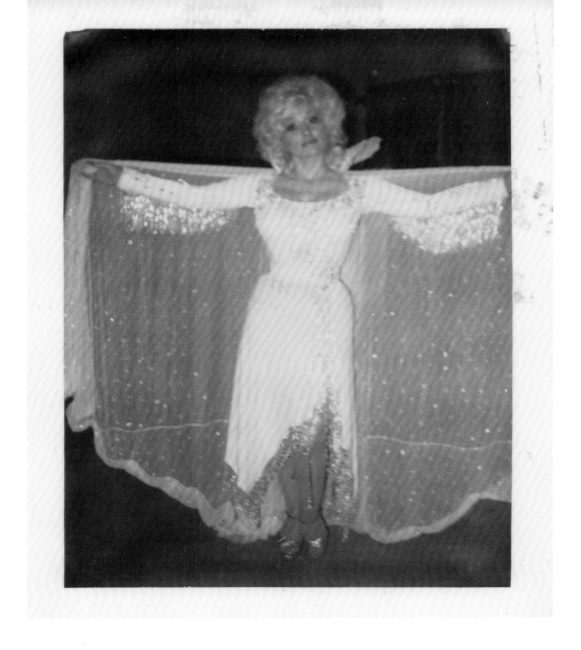

Wearing a costume by Western Costume Co. at my
first-and-only residency in Las Vegas, in 1981.

to me, but I also had to listen to her when she said, "You can't look like that and
play this role. You're playing a character. I'm designing for the character, but I will
make you as comfortable as I can in what you're wearing." That's what my favorite
designers do: they make you believe that they know what they're doing, and then
they actually show you that they do! Some of my favorite Doralee outfits were
the light blue coat and her cowgirl outfit. I wound up loving Ann's designs, and
we became good friends.

A Diamond in a Rhinestone World

While I never wanted to dress like a cowgirl onstage, this costume made by the Western Costume Co. was the perfect way to rope my grabby boss in *9 to 5*.

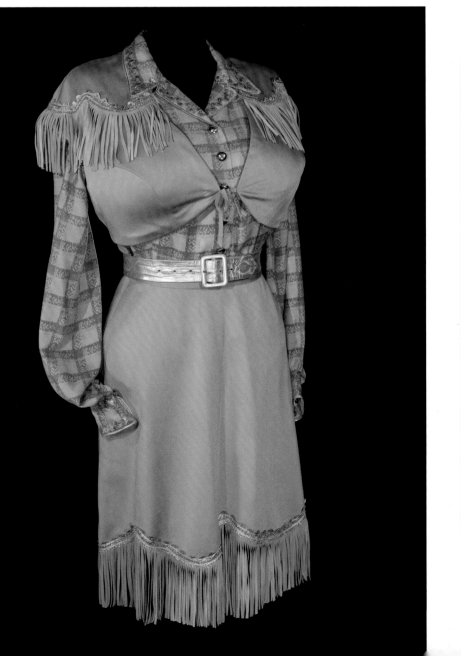

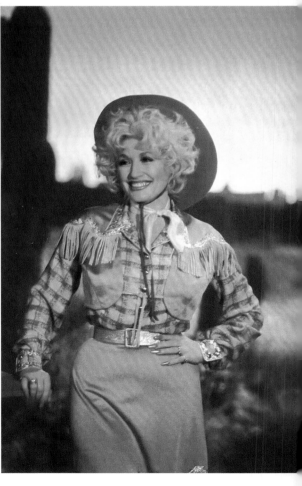

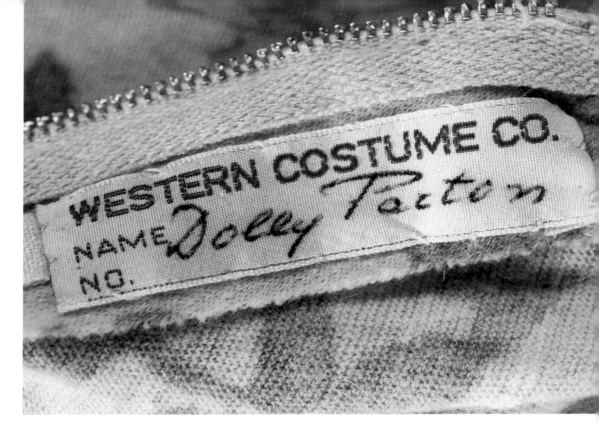

Playing Doralee in *9 to 5* was a great entrée into the movies! I loved the memories of playing her so much that I had to make sure they stayed with me forever!

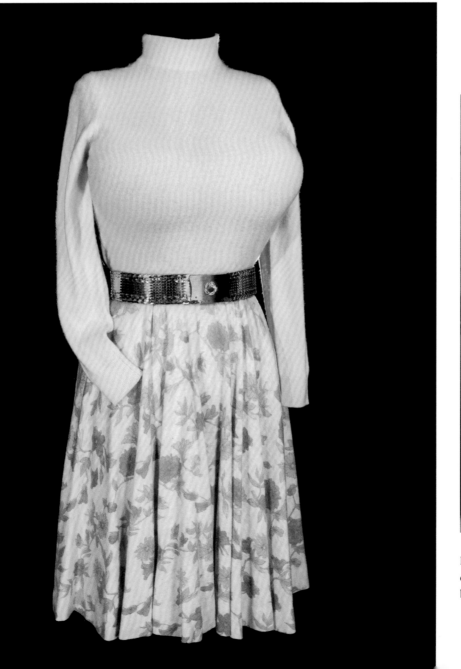

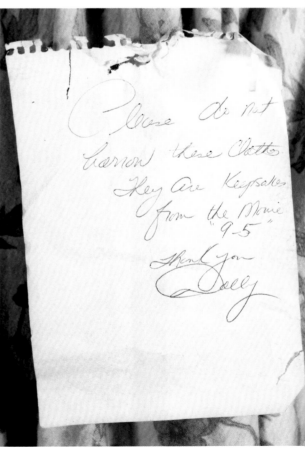

Please do not borrow these clothes. They are keepsakes from the Movie "9-5"

Thank you

Dolly

If I didn't put a note on my clothes, my sisters would borrow everything!

Costume Designer
Ann Roth

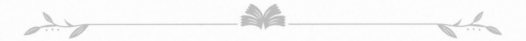

Born in 1931, Ann Roth graduated from Carnegie Mellon, then began working in costume design on Broadway in 1957. She has since designed costumes for hundreds of theater productions and films. She has been nominated five times for an Academy Award for Best Costume Design, winning twice, for *The English Patient* in 1996 and *Ma Rainey's Black Bottom* in 2020, at age eighty-eight. Ann recalls her collaboration with Dolly:

"I'm not a fashion person. I do costumes for the character that is written. I came from a world where when a movie star would say, 'Oh, I never wear yellow,' I'd say, 'Who gives a damn what you wear? We're not talking about *you*. We're talking about the character Genevieve,' or whatever her name is. 'Cause that's the key to what I do. This isn't about her—this is about the character she's playing. I loved doing *9 to 5* and working with Dolly. The point is that Dolly *got it* after she read three pages of the script. There was no intellectual discussion about the preparation of the Doralee character—she just got it.

"The cliché of the American $5.70-an-hour secretary in a city was the white blouse and the skirt, the little sweater or jacket, and the purse. This was 1980, so we didn't get the full flavor of the later '80s—the shoulder pads and the big hair. For Dolly, anyway, I wouldn't use shoulder pads on top of boobs and a tiny waist—that would've been freaky. She was to look like the secretary in the next room. And somehow we achieved that without losing Dolly.

"I assume that the actors don't want to present *themselves*. They want to create a character—and Dolly was game for it. The way to do it is to make it real. The minute you put a pair of four-year-old shoes that are worn down at the heels on somebody, it's real. That helps the actor enormously. She's standing in the fitting room and looking in the mirror and she sees herself [in costume]. Dolly sees herself; Lily sees herself. And then you try this and try that, like shorten the skirt, and suddenly there's somebody in the mirror that you've never seen before. They don't see themselves in the mirror, and they are free to become someone else. *9 to 5* was like that.

"Dolly has what I would call a figure that cannot be ignored—a bustline and a perfectly fabulous tiny waist and good legs. We had Dolly's seventeen wigs in the camper, and that was a great pleasure. She and I became friends. I remember one afternoon she asked me to come to the recording studio on Hollywood Boulevard to sing backup on her song '9 to 5.' It was a gang of us, and that was a sort of life-changing experience. It was a divine time because it meant that Dolly knew how she wanted the song to sound. I mean, God knows, no one would choose me to sing anything. But that's what she wanted. She wanted it to sound like women who went to work and who sang that way."

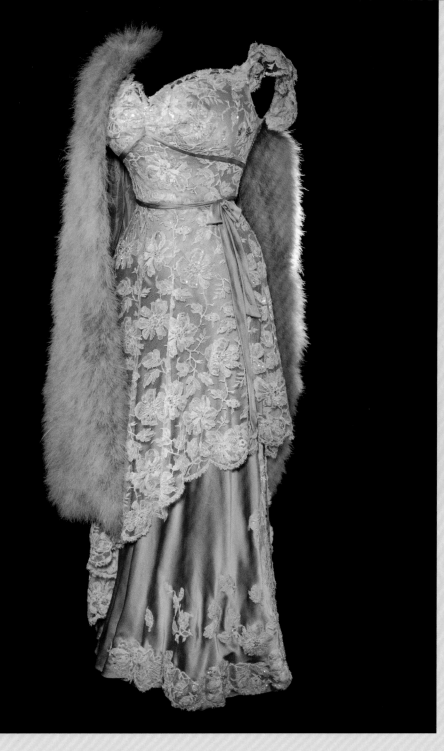

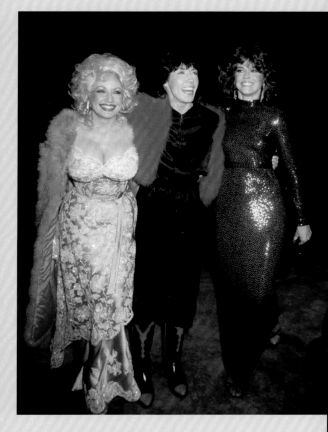

Ann Roth designed the dresses Lily Tomlin, Jane Fonda, and I wore for the *9 to 5* New York premiere. She clearly knew our personalities!

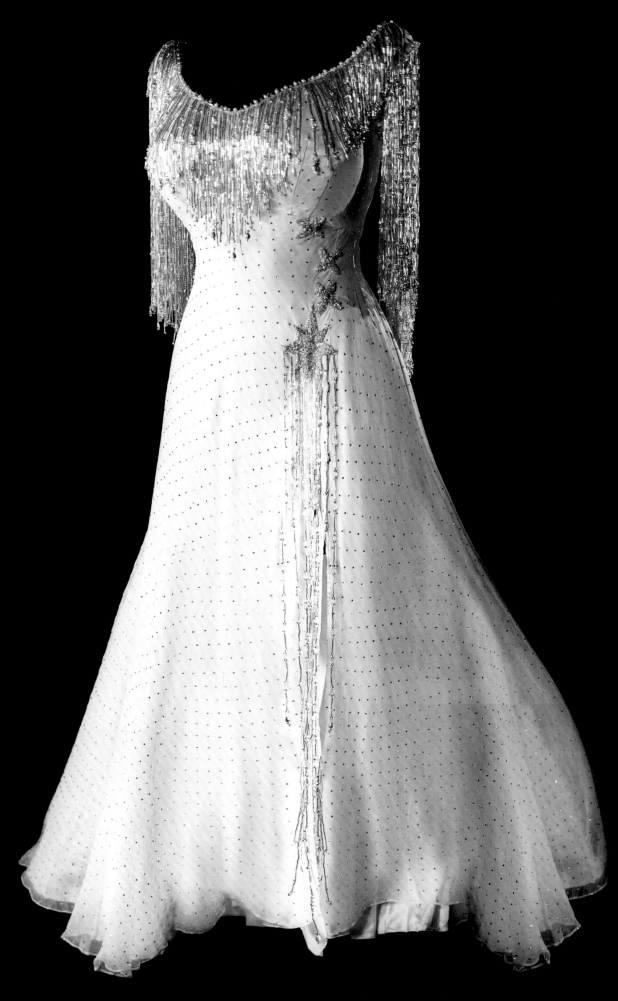

I wanted to look like a movie star from the Golden Age of Hollywood,
and I think I did at the Los Angeles premiere of *9 to 5*.

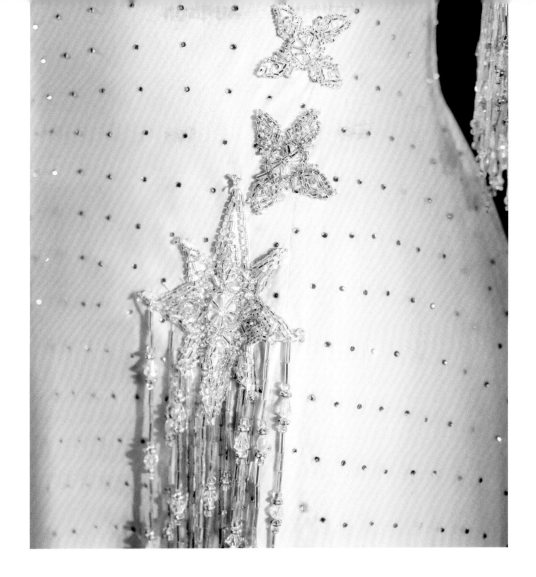

Now that I was a star on the silver screen, I even got
to wear silver stars on my dress!

My song "9 to 5" was nominated for an Oscar, and my outfit for the ceremony was made by Western Costume Co., overseen by Tzetzi Ganev, who started helping me with some of my fanciest dresses. As head of Western Costume Co., Tzetzi worked with Ann Roth on her designs and oversaw all the seamstresses. She made sure the measurements were correct and that my clothes fit right. That was the first time I worked with a team of people doing my costumes. After *9 to 5*, I'd go to Tzetzi for things even when I wasn't working on a movie. I knew that her whole department was great. I would come up with ideas on my own and then they would execute them.

My new love of Hollywood soon led to a move to California, and when I arrived in LA in the '80s, I started sleeping with my makeup on, partly because of the earthquakes. I thought, "I'm not heading out on the street without makeup in case there are cameras out there! I'm going to be ready to go."

A Diamond in a Rhinestone World

Even today, I get up very early in the morning and the first thing I do is to take care of my face. It doesn't matter *when* you clean your face as long as you clean it once a day. After I wake up, I do all the little rituals, and then I start over again and go out every day and look good all day long. This is also true back at home in Tennessee. I don't want to go to bed looking like a hag with Carl!

During my LA years, Bobbe Joy was the first professional who did my makeup in a way that I didn't have to change too much afterward. I'm always going to play with makeup myself, but she had a great look. And when I was going to the Academy Awards or something else special, I'd go down to her shop and let her do my makeup in the afternoon because I knew it was going to look more glamorous than what I do. Basically, I wear the same makeup in the day or the night. But sometimes you need to have a little more elegance or be a little more tasteful. Bobbe Joy did that, and I hired her for a lot of photo shoots and different events.

Bobbe knew the way I felt about my makeup, just like the designers did about the clothes. It's the same as trying to wear something that's not you; you might wear it, but you don't like it. I prefer to like it!

When you're making a movie, you have a makeup artist on set because your face on a movie screen is so big that every little thing shows. You can't wear as much makeup as I do unless you're playing a hooker or someone like Miss Mona in *The Best Little Whorehouse in Texas*. But seriously, after my makeup is done, I go to the trailer and touch it up a little so I don't feel like I don't know who I am. And I always arrive on set all made up with my hair in place *before* I go in to have my makeup and hair done.

While making movies over the years, I got to work with different hairdressers. I was always picky about my hair. Although a director has a definite look for the character, I have a definite idea about who I am, and I just can't wear flat hair or weird hair, unless I'm playing a character. But almost every movie I've ever done, I've pretty much played my own personality, so I really feel like those characters need to look like me.

Take *The Best Little Whorehouse in Texas*, the next movie I made, in 1982. I went from doing *9 to 5* to *Best Little Whorehouse*—from one extreme to another. I was far more comfortable in the *Whorehouse* wardrobe and makeup because my character, Miss Mona, the madam of a brothel called the Chicken Ranch, was much more my style. In other words, I made a better whore than I did a secretary. The costumes looked like they'd been designed for Mae West back in the day. I loved

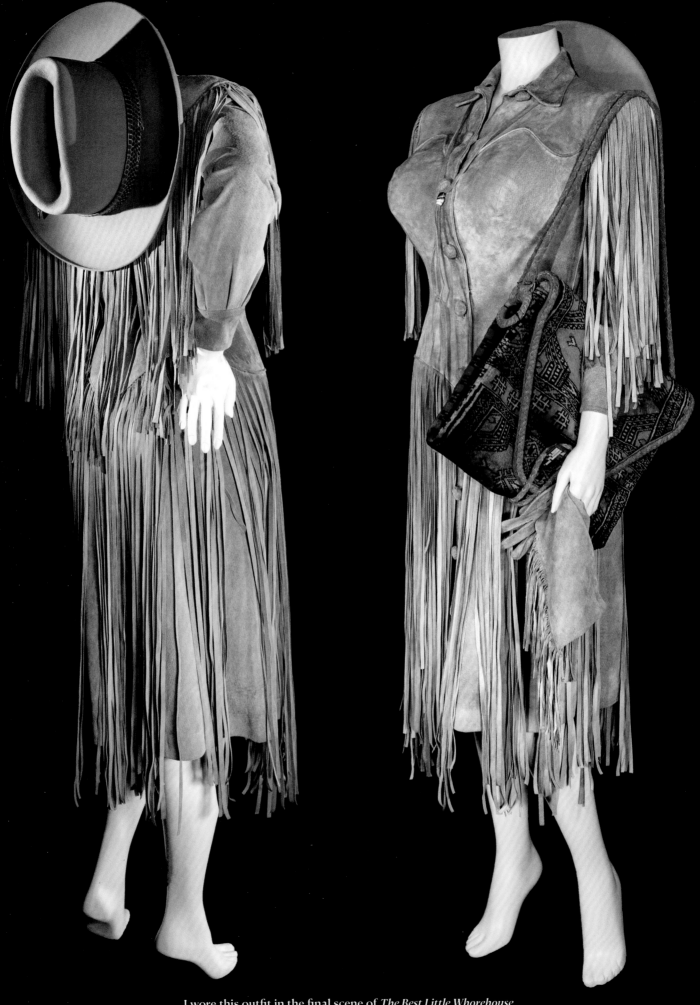

I wore this outfit in the final scene of *The Best Little Whorehouse in Texas*—aka my "Chicken Ranch movie"—when I sang "I Will Always Love You" to Burt Reynolds, who played my sheriff beau.

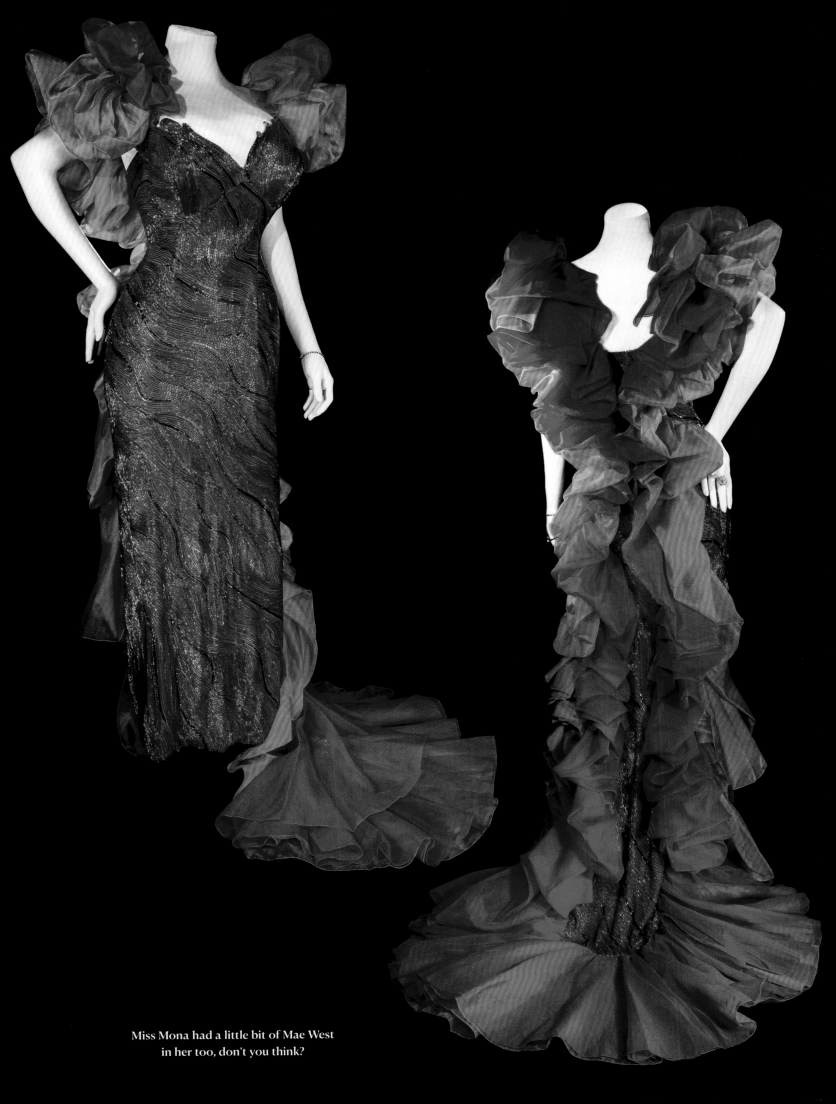

Miss Mona had a little bit of Mae West
in her too, don't you think?

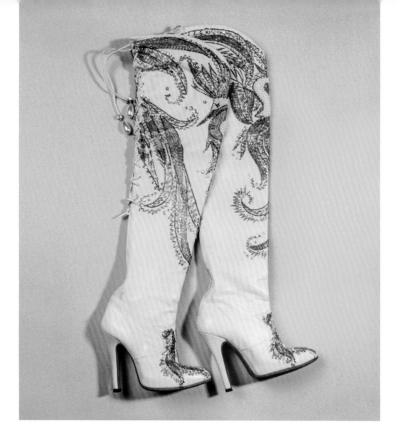
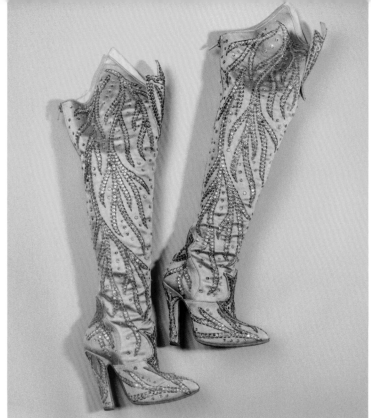

Tony Chase changed my life when he brought in
Pasquale Di Fabrizio to make my shoes. And as you
can see, some of my boots have my highest heels!

them, although I was a bit nervous about showing so much skin, especially in the scene where I wore a skimpy black-satin corset.

Of course, Miss Mona had to have beautiful shoes. I got to work with a custom shoemaker, Pasquale Di Fabrizio, who catered to the TV and movie studios in LA. Custom shoes are very expensive but are covered by the movie wardrobe budget. That's when I learned how great your feet can feel wearing high heels custom made just for you. He measured my foot and made shoes with a really high heel to fit those outfits. Di Fabrizio was the grand shoemaker at that time for all the movie stars. In the '90s, another guy, Grisha Nazarian, who used to work with Di Fabrizio, went out on his own and opened Grisha's Custom Shoes in Burbank. He started building my shoes and made me many beautiful pairs over the years.

Playing roles in movies prepared me for the most transformative period of my career: the late 1980s. I'd take on new challenges, both professionally and personally. I was consciously trying to branch out, but I also made sure I'd continue doing things my way. As my personal style changed—more glitz than ever!—I held tight to my inner Dolly, which I was determined would shine as bright as all those rhinestones enveloping me from head to toe.

Behind the Seams

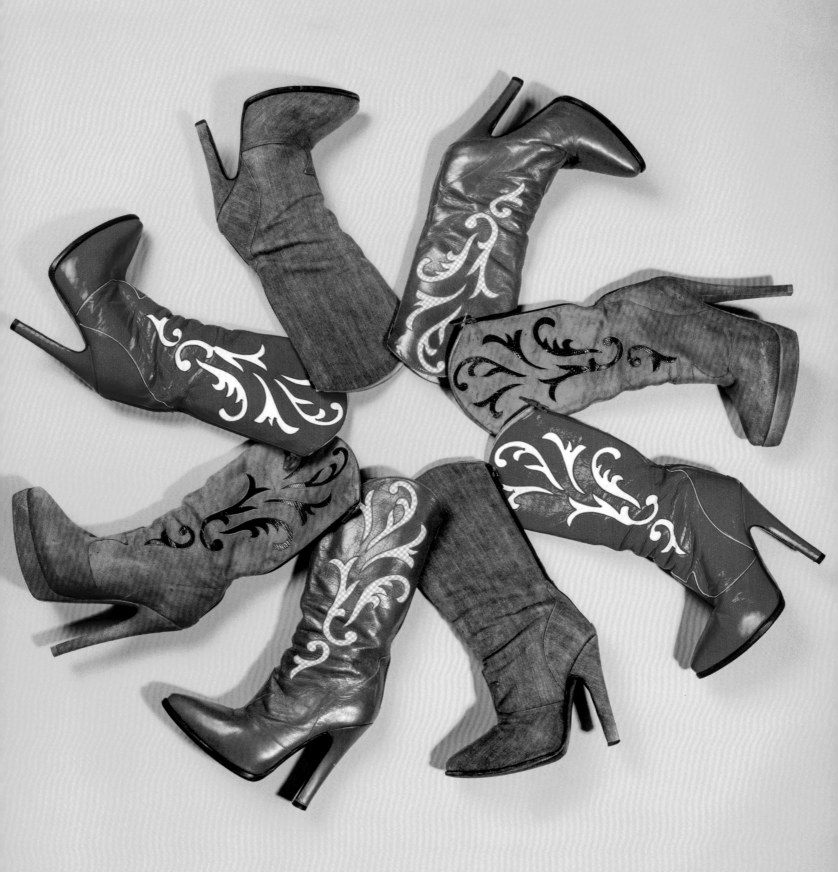

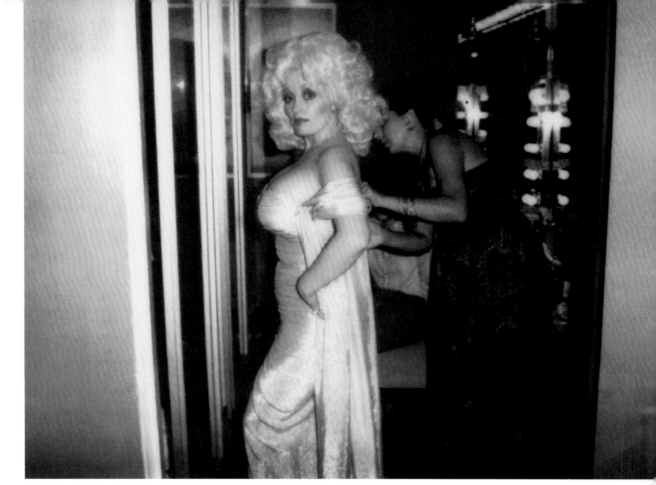

I wore this gold-and-silver lamé gown in my "Chicken Ranch movie," along with these Di Fabrizio gold-and-Lucite mules. Believe it or not, they're comfortable!

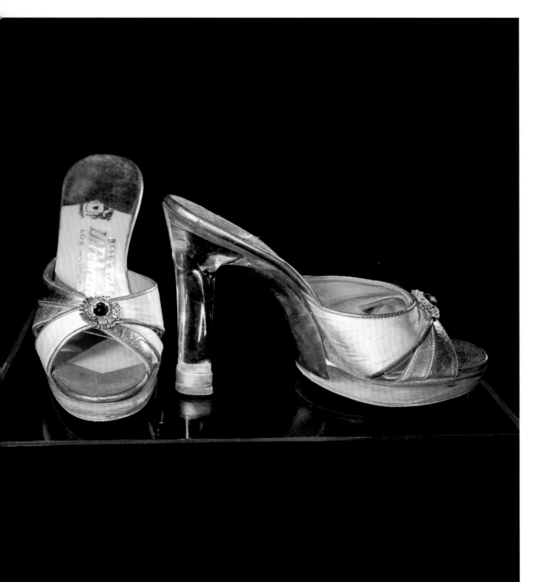

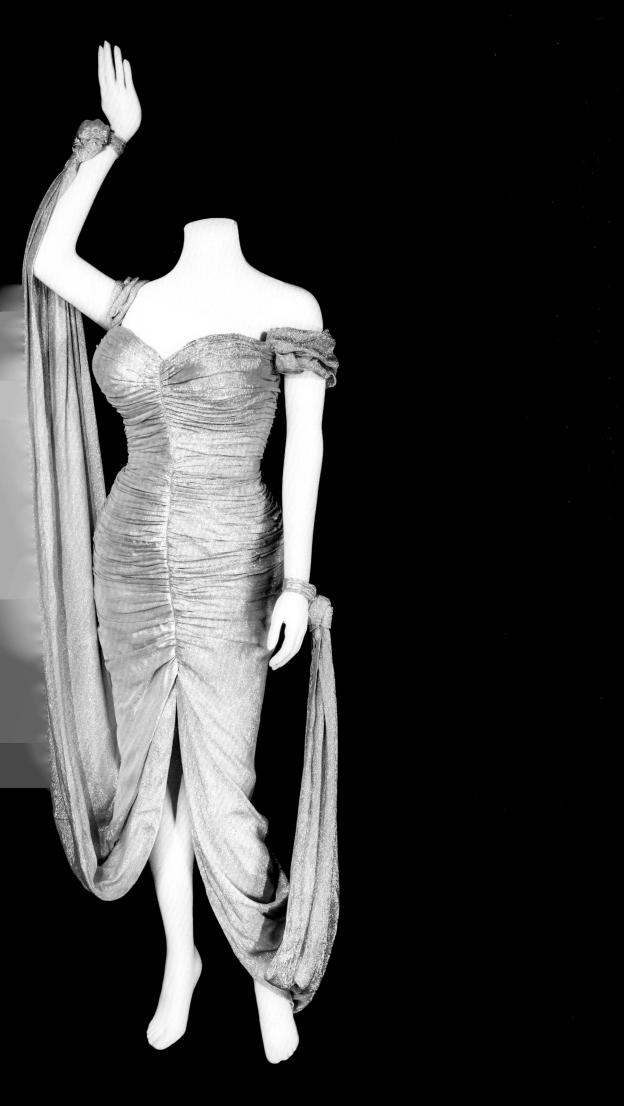

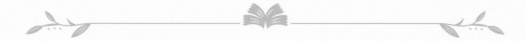

1983 Live in London

I love my English audiences, and performing at the Dominion Theatre in London in 1983 made me feel like showbiz royalty. Maybe it was my spectacular gold dress with all those sparkles, but my inner Elvis came out. I told the crowd how, as a young girl, I used to imitate him—and I showed 'em I could still do my Elvis impression, with my version of "All Shook Up." That and my hits like "Baby, I'm Burnin'" really brought down the house at a concert I'll never forget.

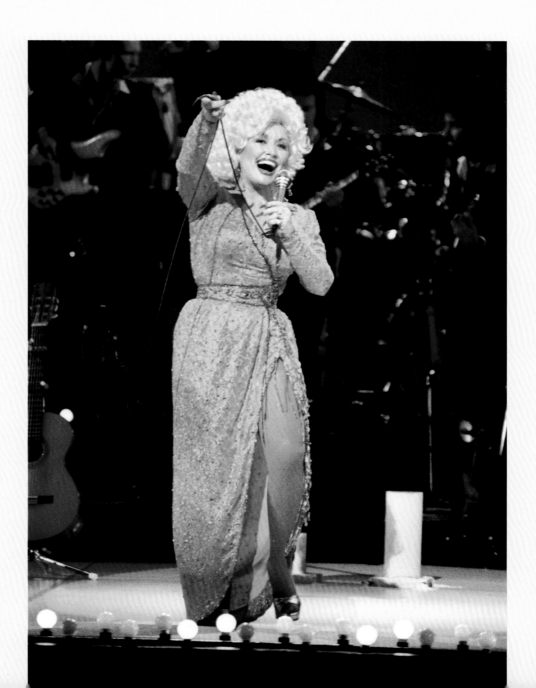

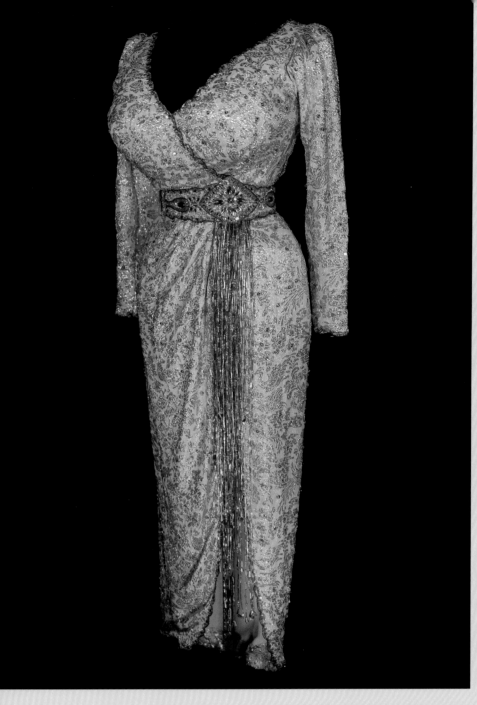

This bejeweled outfit was created by Western Costume Co., under the supervision of Tzetzi Ganev. My sister Cassie was my traveling makeup artist at the time, and she had to make sure my skin glowed as much as my dress.

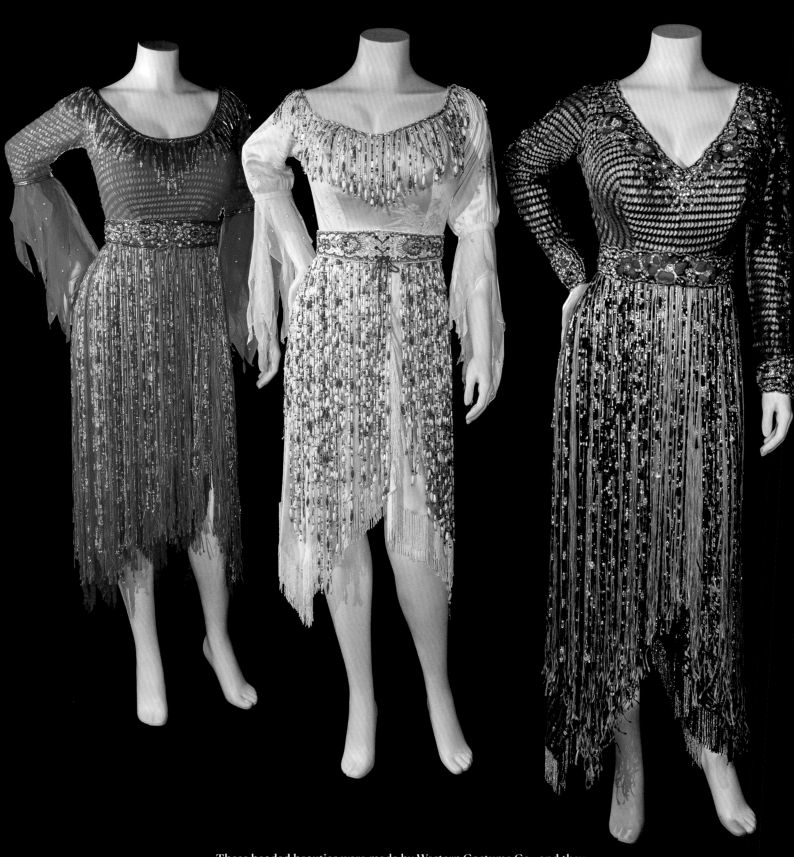

These beaded beauties were made by Western Costume Co., and they
accompanied me when I toured the globe in the '80s. I wore the white one at
my filmed "Live in London" concert; the red one at the Opryland premiere of
the "Chicken Ranch movie" and on tour with Kenny Rogers in 1987; and the
black one at a gala event at the Waldorf-Astoria in New York in 1984.

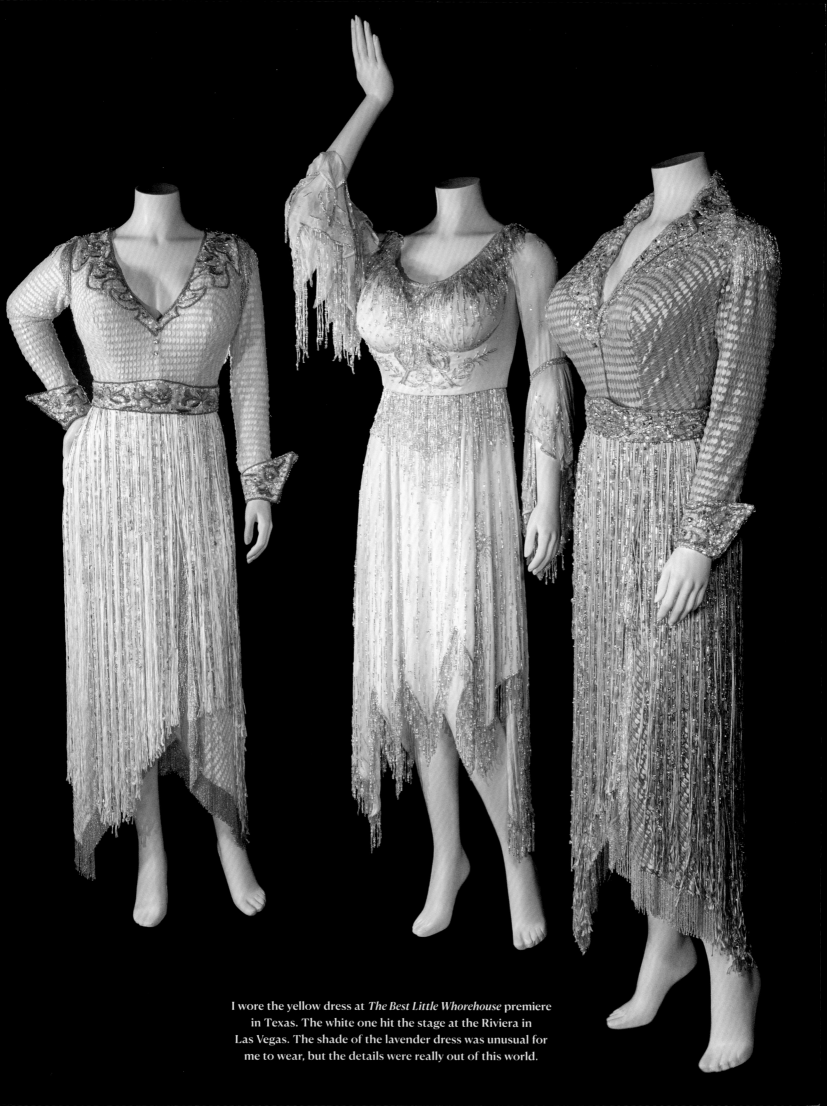

I wore the yellow dress at *The Best Little Whorehouse* premiere
in Texas. The white one hit the stage at the Riviera in
Las Vegas. The shade of the lavender dress was unusual for
me to wear, but the details were really out of this world.

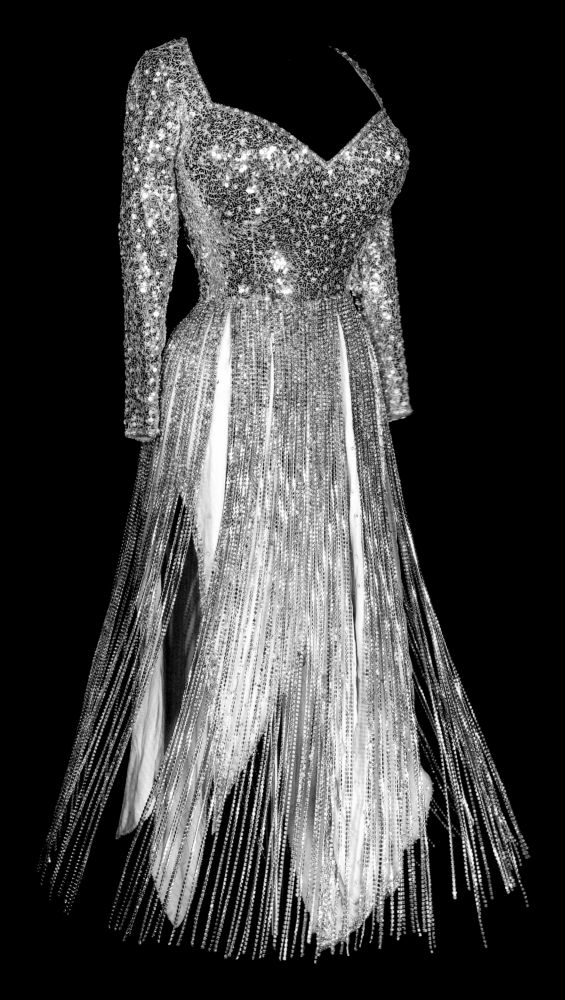

Costume designer Theadora Van Runkle did my costumes for *Best Little Whorehouse* and *Rhinestone*. This is what I wore as Jake in my last scene with Sylvester Stallone in *Rhinestone*. It's a role I was clearly born to play!

I wore this at the *Rhinestone* premiere in New York City on June 20, 1984. I showed a little leg and raised a few eyebrows!

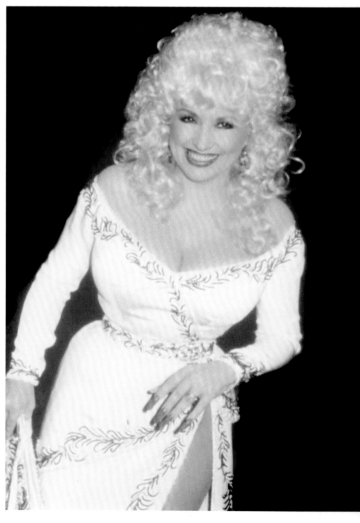

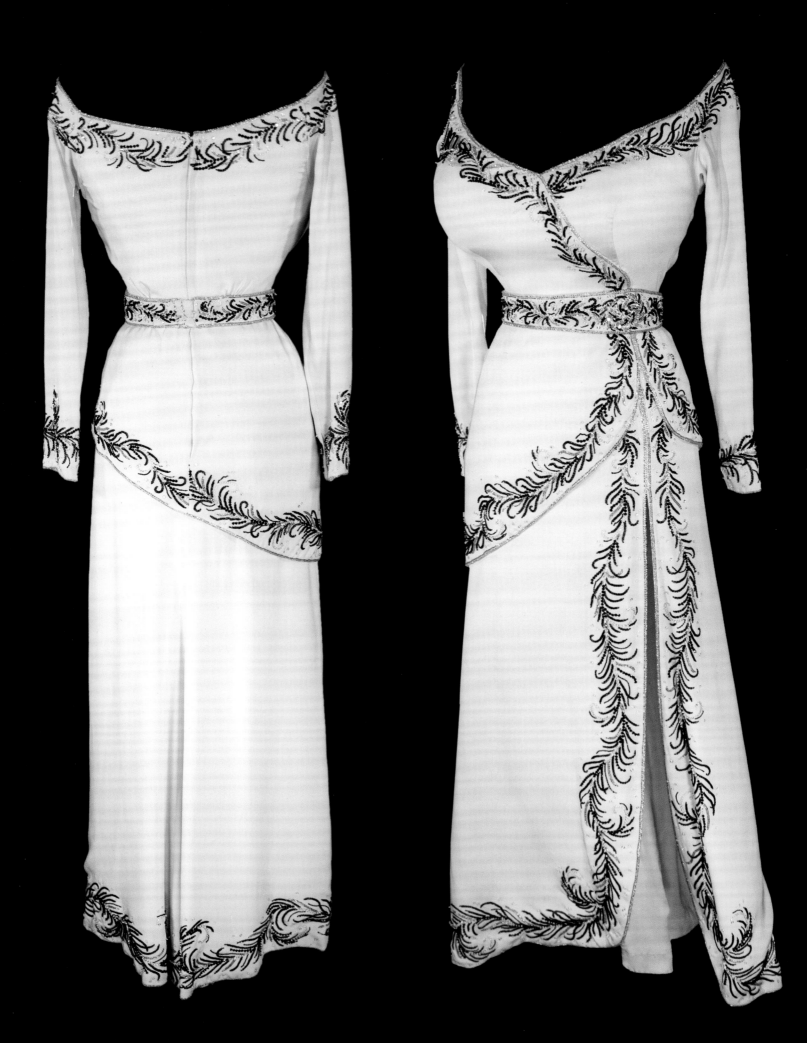

I Will Always Love . . .
Shoes

Ever since I was a little girl, rummaging through those "treasure boxes" of donated goods, I've loved high heels. Wearing them gives me confidence, like getting a height boost. Beginning in the late 1960s, I started ordering boots and shoes from the Frederick's of Hollywood catalog. I also bought shoes at a place called the Wild Pair. I would go anywhere that sold shoes and try to find pairs high enough for me.

Now almost all of my shoes are custom. It's essential I have the right shoe because I wear heels all the time. Buying custom shoes is like a personal investment that makes sure the shoe properly fits my arch and my toes. Some of my shoes have a bit of canvas on the sides to give my feet a little room to move. People ask me, "How do you walk in those high-heel shoes?" I say, "Very *carefully* and very *often*." I would wear them even if they were killing me, but fortunately, thanks to my shoemaker, I can wear high heels and they don't have to kill me.

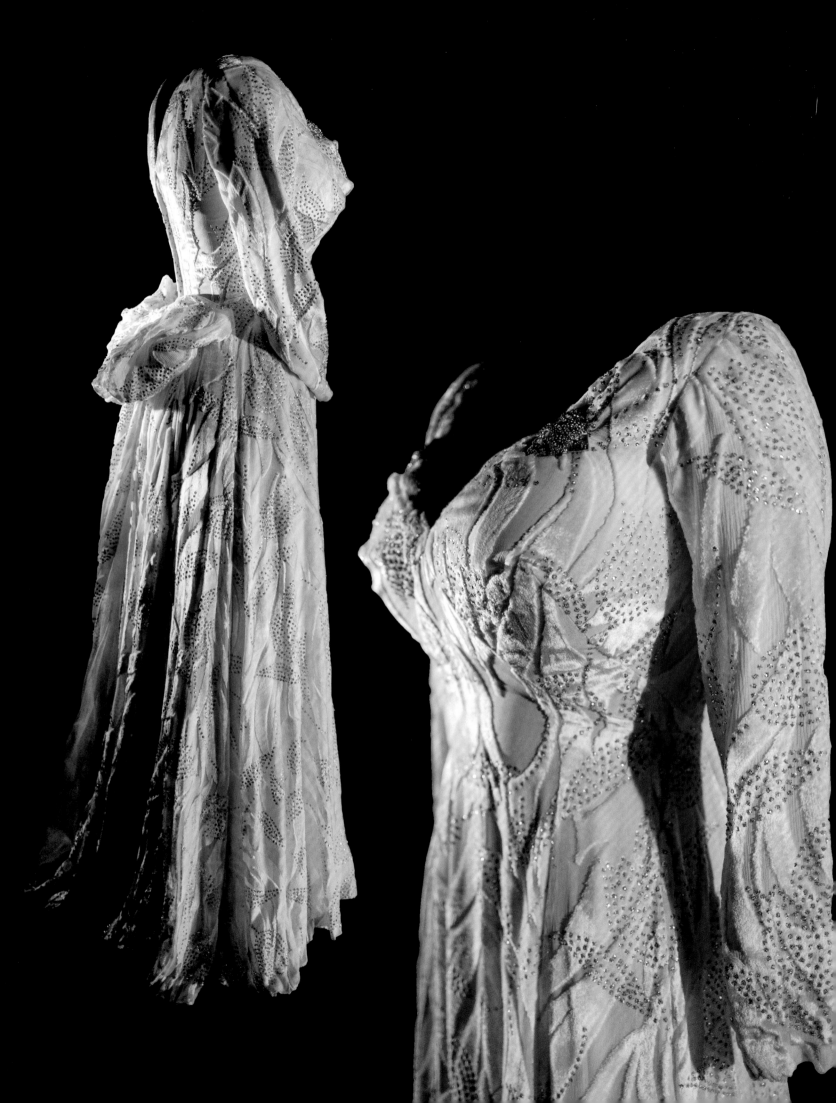

Sadly, you can't actually see this gorgeous Western Costume Co.
dress I'm wearing in the cover shot of my album *Real Love*. But on
the left you can see all those intricate details up close.

My Keeper of the Flame
Judy Ogle

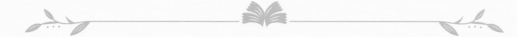

Judy Ogle and I became best friends in third grade. We grew up taking every class together. Even back when we were kids, she was always there for me. We were in the school band together. She excelled in sports, while I had my head in the clouds and wanted to spend my spare time in the school's music room, where there was a piano. She'd watch me pick out a tune on the piano, and when I started coming up with a song, she'd write down the words for me. After high school, Judy went into the service. When she got out in 1968, she moved to Nashville. We've just been inseparable our whole lives as best friends—and that was her job as well. I didn't pay for the friendship, but I paid her as someone who worked with me. She was my personal assistant. At one time, she was my secretary when I started my first office. When I opened my publishing company, she'd send off the copyrights. Often, she'd put pen to paper and write down the words to the songs I was writing—just like back home. She also helped me when I had my TV show in Nashville.

As my career advanced, she'd say, "Well, we got to save everything." So she literally did! Early on, she wanted me to have a museum. She did a great job, and without her, so many of the pictures, so many of the clothes would have gone missing. She kept logbooks, matching photos of me in magazines and onstage to Polaroids of the clothes, noting the dates of when and where I wore them. That was her mission—and that was her calling. I was out doing the stuff, and she was the keeper of the keys. And she saved the scripts, the notes, the photographs, the clothes, the shoes. *Everything.* While I was out doing whatever, I knew that one day I would have this wonderful collection, all thanks to Judy. I'm so glad that before she retired, she showed my niece Rebecca everything she knew about the archive.

What would Judy do?

My clothing archive wouldn't exist—or be organized so well!—without Judy's diligence and hard work.

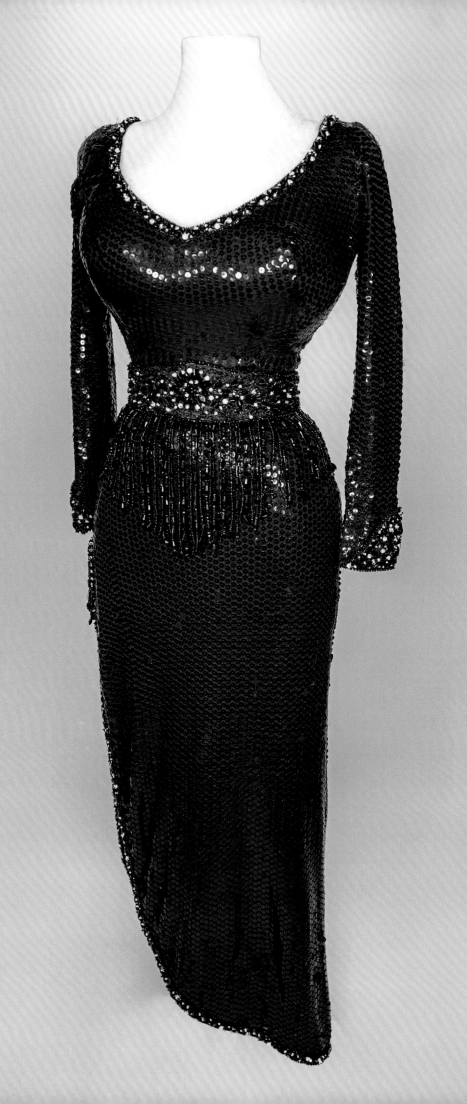

Tzetzi and Western Costume Co. made this glamorous dress, which I wore to the Academy Awards when *9 to 5* was nominated in 1981. She always paid attention to details in my fittings, making sure everything was just right.

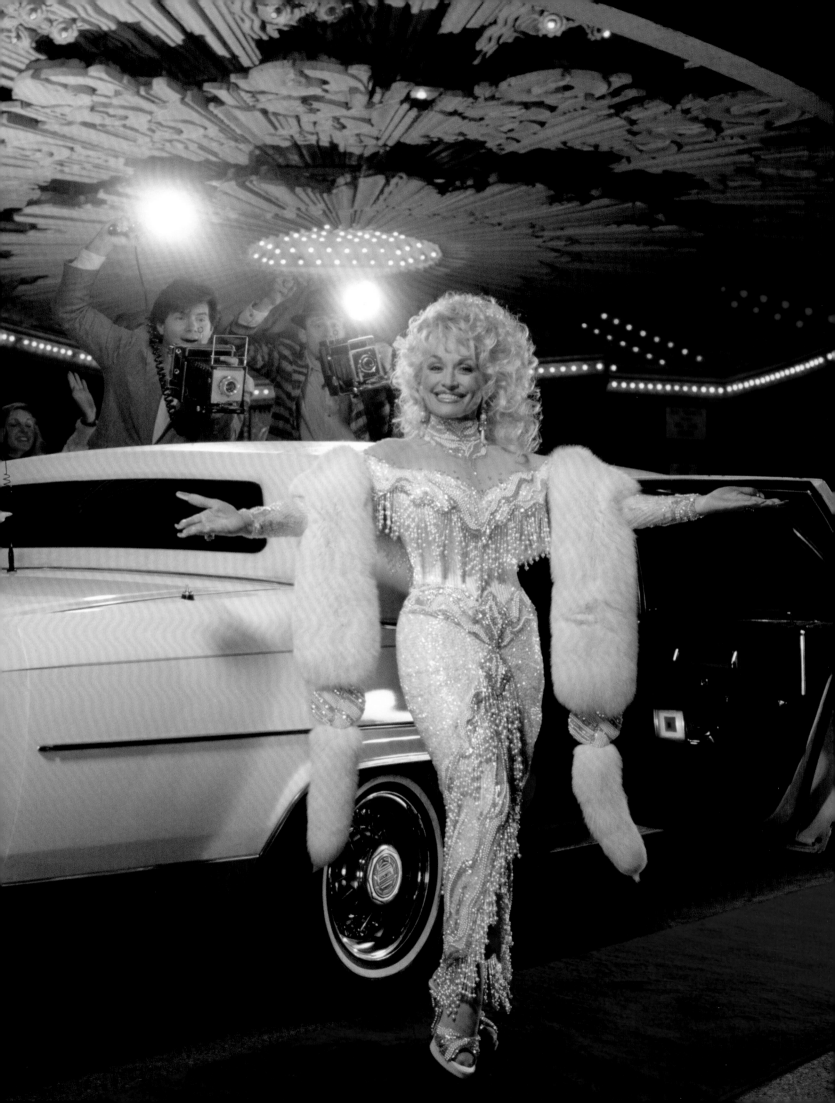

6

Daisy Mae in Hollywood

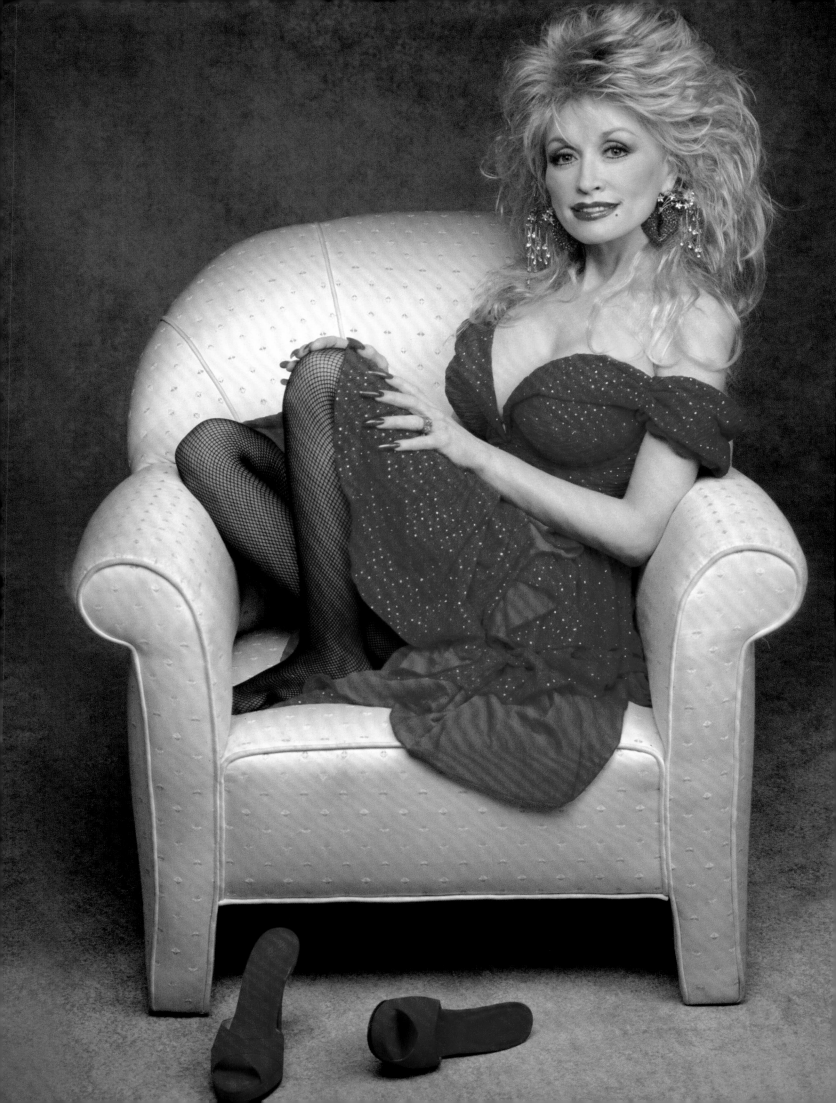

"When I turned forty, it was like a switch clicked on. . . . I'd always known what I wanted, but now I knew what to do to get it."

Dolly

By the end of the 1980s, Dolly had become one of the country's top celebrities. She began the decade making her mark in Hollywood and went on to host her own network television program during an era in which variety shows like hers had vanished. She continued to grow a global audience through such massive hits as "Islands in the Stream," a duet with Kenny Rogers, who appeared on Dolly's TV shows. As the muse to designer Tony Chase, Dolly dazzled in her most glamorous gowns yet, in a kaleidoscope of fabrics with exquisite embellishments. Her hit song "White Limozeen," cowritten with her dear friend Mac Davis, summed up her life in the 1980s: "Now she's a-living her dreams like a movie queen / Diamond rings and all things good / From the breadlines to the headlines / She's the toast of Hollywood."

—Holly George-Warren

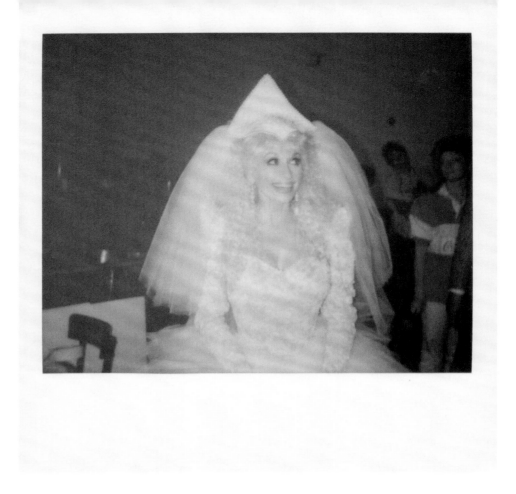

Hulk Hogan tried his moves on me—and eventually
made me his bride—when we did our "Headlock on My
Heart" video for the premiere of my TV show in 1987.

*T*he 1980s were great times for me. I was truly becoming a household name. I had moved into the pop field, and I wanted my look to evolve beyond country too. I never *left* country music, nor my home, nor Tennessee, nor Nashville. As I've said over the years, "I'm not leaving country. I'm taking it with me wherever I go." But I did want to try to do better, be bigger, do more—even though I didn't know that much about fashion or how to connect with new designers. I had to feel my way through that. After getting with my new management, things started to click in that direction.

In September 1987, my ABC-TV variety show, *Dolly!*, premiered. It ran for twenty-two episodes until May 1988. It was lots of fun, and I had so many wonderful guests, including Merle Haggard, Patti LaBelle, Pee-wee Herman, Miss Piggy, Loretta Lynn, Tammy Wynette, Little Richard, Tom Petty, and Kenny Rogers, and that made it especially enjoyable.

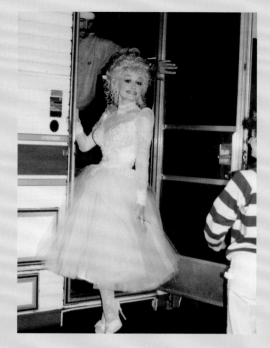

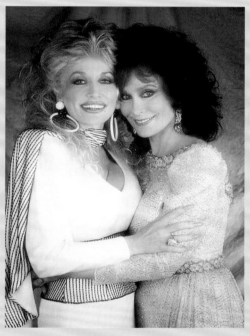

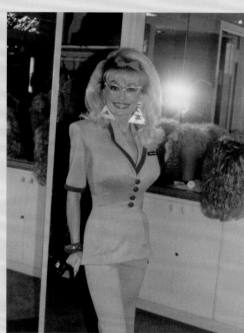

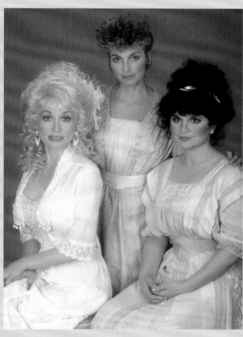

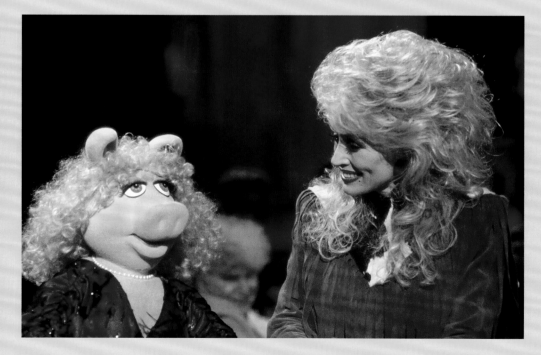

Top row, left to right: A fitting with my new designers Tony Chase (costumes) and David Blair (hair), 1987; me and my dear friend and singin' partner Kenny Rogers, 1988; Tony (behind me) and Judy (in stripes) standing by on location in New York. *Middle row, left to right:* With Loretta Lynn, from the last episode of my show, 1988; Tony and David dressed me up for a skit as Neva Jean, a grocery store cashier; Trio with my harmonizing girlfriends Emmylou Harris and Linda Ronstadt, 1987. *Bottom row:* Me and Miss Piggy having some fun together, 1988.

Best of all, I began working with the amazing designer Tony Chase. On my show, I wore beautiful, intricately hand-beaded gowns that he'd designed. My wardrobe was top of the line.

Tony had a big budget for the show, so he made the most of it. He had a wonderful seamstress named Rose Sanchez, who was so good at making patterns and doing my fittings. He had a good crew, primarily a place called Silvia's Costumes in Hollywood, which did all the beading on the gowns by hand. What fantastic work! I could spend hours just looking at the detail on those dresses. I would think, "Golly, how do people even do that? How would you have the patience? And how many hours did it take?"

Tony was very tall, and he was always trying to put me in something that *he'd* like to wear: opulent beaded gowns. They were so heavy that I'd have to say, "Tony, I'm this little bitty person!" He had to really think on me—because he loved designing for tall, glamorous women. And at that time, I wasn't either. And I still ain't tall.

Tony really let his imagination run wild for every episode of my show. He was inspired by Bob Mackie, and he talked a lot about his work. Tony had been the costume designer for *The Patti LaBelle Show*, and when Patti was a guest on my show, he designed gorgeous complementary gowns for the two of us. A fun thing about having a variety show was that, because I did so many skits and sang so many songs on each show, I could look several different ways within one single episode. Talk about playing dress-up!

On the first episode of my show, Hulk Hogan was a guest. For the occasion, I wrote a song called "Headlock on My Heart," and we made a video with me playing Hulk Hogan's bride. We got married in the ring, and I wore the cutest little wedding dress designed by Tony. The video was a big hit with the TV audience.

Tony made so many incredible outfits for my show. In a November 1987 episode, my guest, Miss Piggy, and I dressed alike. She sang "Someone to Watch Over Me," and I loved it. That was one of my favorites. When I did the "My Hawaii" episode in February 1988, on location, he designed a slew of tailor-made tropical clothes. Those were just great times and wonderful outfits. The headpieces, the clothes, the shoes—it was fantastic. I have so many incredible pieces in my collection from those days.

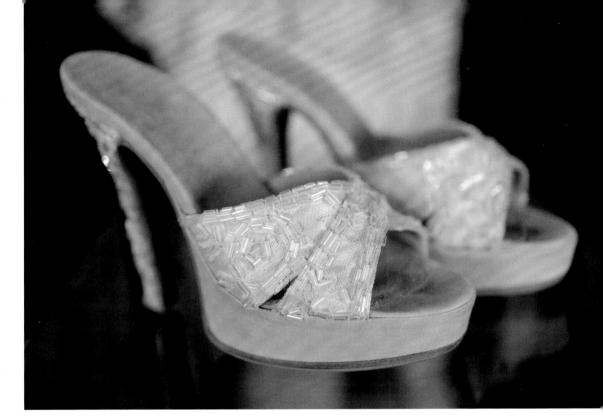

When Miss Piggy tried on her miniature version of this beaded lace gown by Tony Chase, we both squealed with delight.

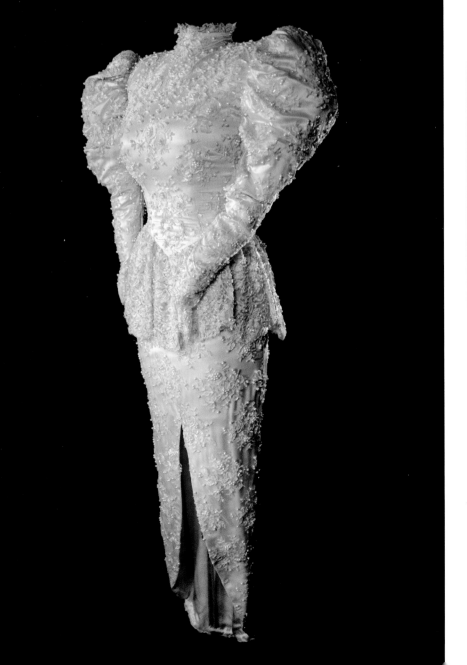

Designer
Tony Chase

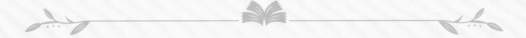

Renowned Hollywood costume designer Tony Chase hailed from New York, where he began sketching at age four. Barely in his teens, he redesigned an old fur coat his grandfather gave him into a fashionable garment to wear himself. Tony moved to Los Angeles at twenty to pursue an acting career, but after getting a small role in the television miniseries *Moses the Lawgiver* (starring Burt Lancaster), he returned to New York. There, he pursued fashion design and launched his first couture line in 1982. He once said of his goal as a designer, "I design for women with a past—women who've had children, who've known pain, women with big hips and big thighs, who are too tall or too short. Real women."

By 1985, he was the costume designer for Patti LaBelle's television variety show. LaBelle once said of him, "Tony designs for women of substance with lots of curves. I do have a lot of curves, thank God, and he knows how to accent them. Instead of making clothes for models, he makes them for women." His other clients included Victoria Principal, Morgan Fairchild, Elizabeth Taylor, Jennifer Holliday, and Bette Midler. Tony told a *People* magazine reporter, "I got attention from women who wanted to get attention. I knew how to turn heads, and that's what celebrities want."

Dolly and Tony began their lengthy relationship in 1986 when he became the costume designer of *Dolly!* as well as the designer of her personal wardrobe. She wore his glamorous gowns to attend numerous awards ceremonies, including the Academy Awards in 1990, and other special occasions. He also designed the costumes for Dolly's TV movie, *Wild Texas Wind*. His book, *Fashion Therapy: A Revolutionary Program for Looking Your Best by Loving and Accepting Yourself*, was published in 1991.

Tony passed away due to complications from AIDS on October 9, 1994.

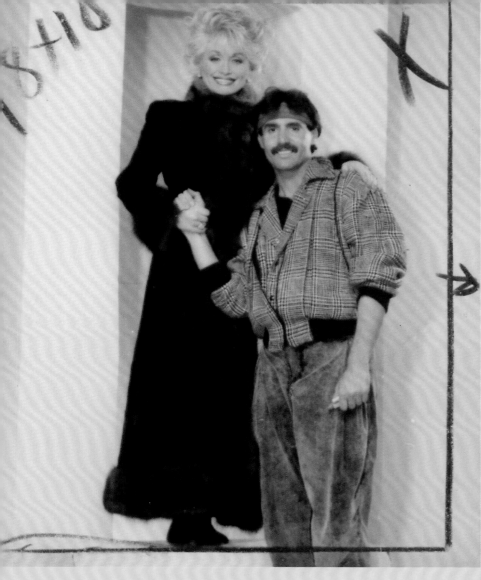

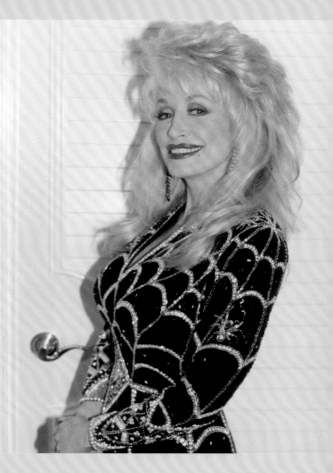

From Dollywood to Hollywood, the talented Tony Chase made me feel like a superstar.

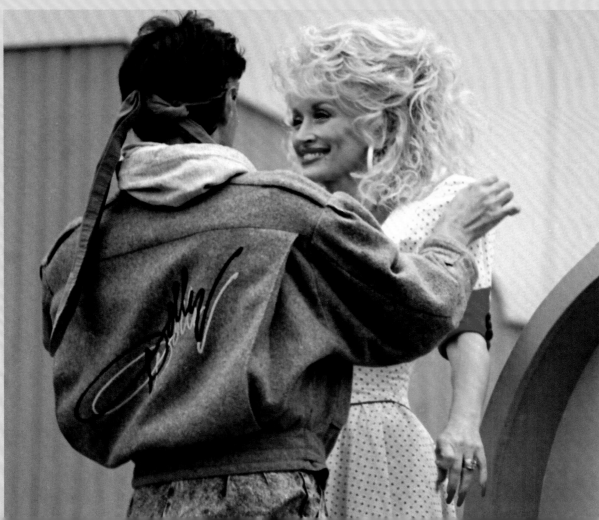

Back Through the Years
Tony Chase Gallery

When I hit the "big time" in Hollywood in the '80s, Tony Chase was right there by my side. Inspired by the glamour of the Golden Age of cinema, he dressed me in gorgeous gowns and dresses that stars from the past could have worn. I'd have to say that some of his clothing really are works of art. Hours and hours went into doing the beadwork by hand. I always felt special in those clothes, whether wearing them on my television show, at awards shows, on tour, or to some other special event. Tony really knew how to make me shine.

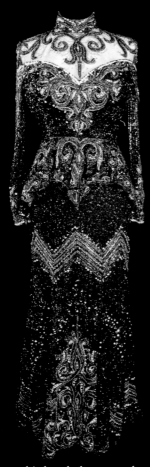

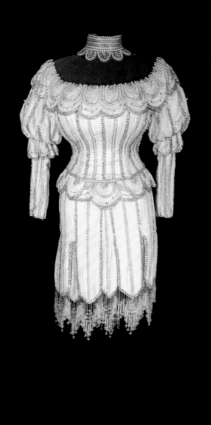

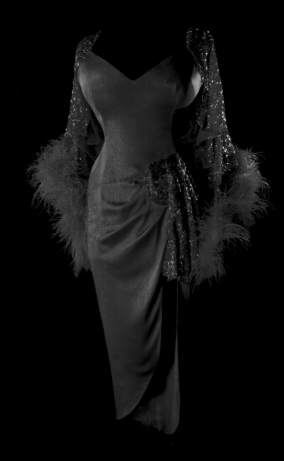

I wore this beaded gown to host the 1988 CMA Awards.

I sang "He's Alive" in this dress at the 1990 Dove Awards, honoring gospel music.

On location in New Orleans, I wore this while singing "House of the Rising Sun" on my TV show in 1988.

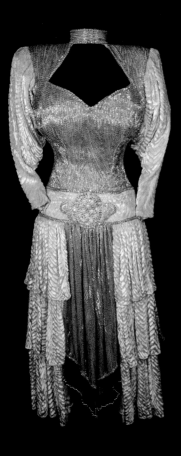

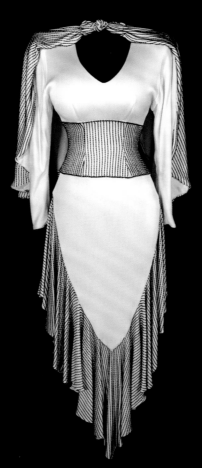

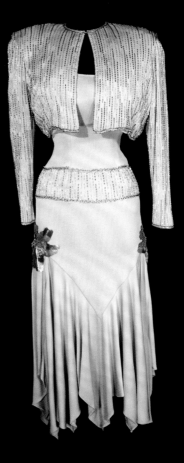

My old partner Porter Wagoner joined me at the Ryman for an episode of my TV show. My dresses sure had changed since the days of his television series.

I wore this while singing "I Shall Not Be Moved" on the final episode of *Dolly!*, 1988.

I sang with the one and only Little Richard on my show while wearing this beauty.

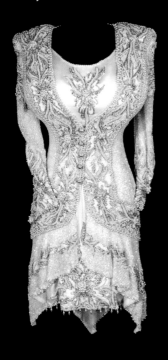

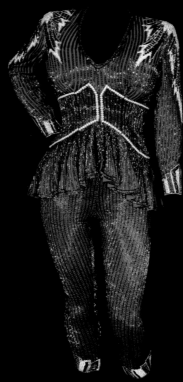

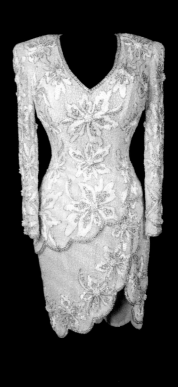

Tammy and Loretta joined me on "Silver Threads and Golden Needles" at the 1993 CMAs, where I wore the perfect dress for that song.

This was a favorite outfit to wear while touring with Kenny Rogers in 1988.

I was proud to be asked to present Whitney Houston with her Grammy for "I Will Always Love You" in 1994, and I wore this for the occasion.

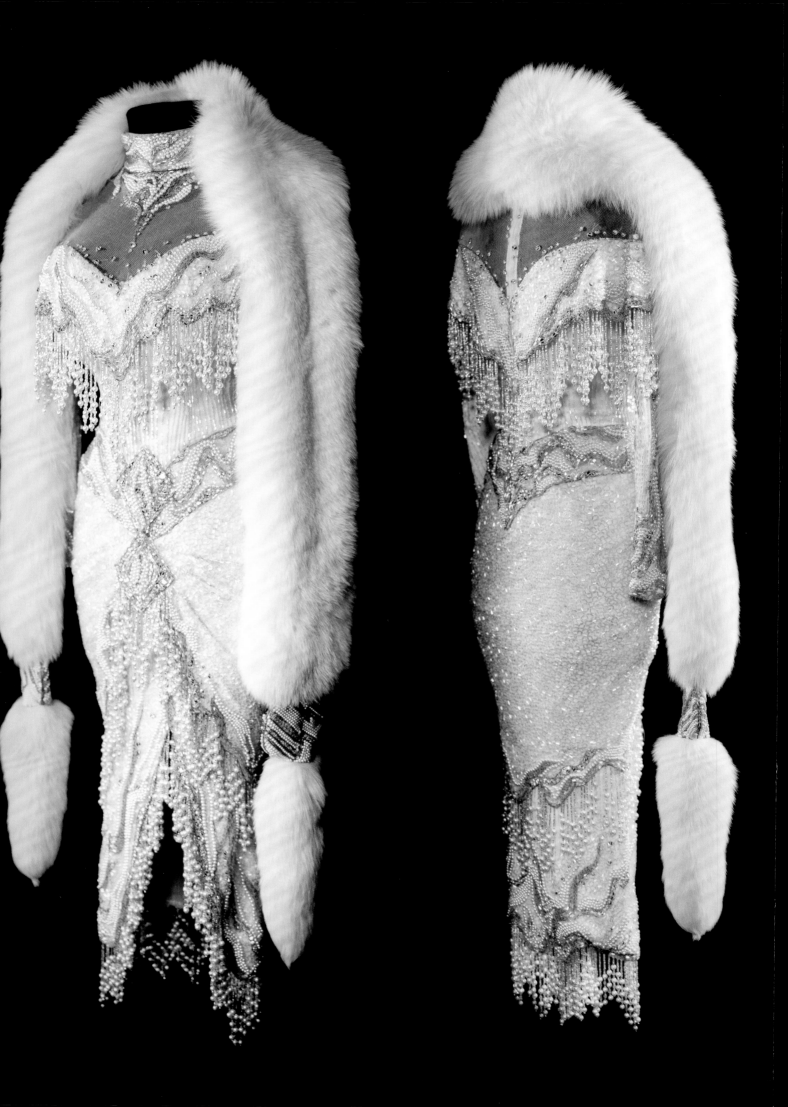

I wore this on the cover of
White Limozeen, my hello-
to-Hollywood album, as
I stood in front of a real
white limousine.

My costumes make me feel special onstage, but performing in them isn't always easy. Some are super heavy with lots of beading and beaded fringe, weighing as much as twenty pounds. People have asked me, "How do you keep your balance in something like that, wearing heels, singing, playing multiple instruments, and doing duets? How do you even stand up straight in those heavy costumes?" And I say, "Why do you think I'm so short? I've been beat down to the ground with them!" But seriously, when you put them on, they actually don't feel that heavy once your whole body is holding up the dress. That weight is distributed all over, so the dress feels lighter on the body than in your hands. I've had people pick up a gown, or try to hang one up, and say, "Oh my God, how in the world are you even wearing that?" But Lord, we do anything to look good! Once I get to performing, I don't think about the weight unless something about the dress gets in my way. But I do think I was taller till I started working with Tony! All those beads just kept wearing me down.

To be honest, I only wear the heavy gowns onstage when I'm simply singing. When I'm running around or playing an instrument, like guitar, fiddle, or dulcimer, it's very important that I'm comfortable. Sometimes your designers don't think about that. They're just thinking about their design and how you're going to look in it. They don't take into consideration that you have to put all these instrument straps over your head and then play. You can't have a bunch of beads in your way. They're going to get hung up somewhere, which does happen at times. For example, I'll have to jerk my arm up so I can get my hands over my guitar neck, and then beads fly all over the floor. I'll get distracted, thinking, "I've got to be careful where I walk." Because if you break a strand of beads, you can't walk around on that stage. You're going to fall. I've had to stop the show and have someone bring a broom and dustpan onstage. When I've had my crew come out and sweep up the beads, I just make it part of the show.

I try to work out the kinks before I go onstage, but I can't always control what happens out there. Sometimes I don't have time to try on a new dress and practice performing in it before the night of a show. Other times, a dress has worked in the past, but then one night, you start jumping around onstage, picking a banjo or playing your fiddle, and something gets hung up. It doesn't take but one thing. I have to consider what *not* to wear as a performer who's playing different instruments. I've had so many mishaps! I've had to stop and tell an audience, "My hair's hung up in my rhinestones!" Learning the hard way, I've had to tell my designer, "Let's not put rhinestones hanging back there."

Behind the Seams

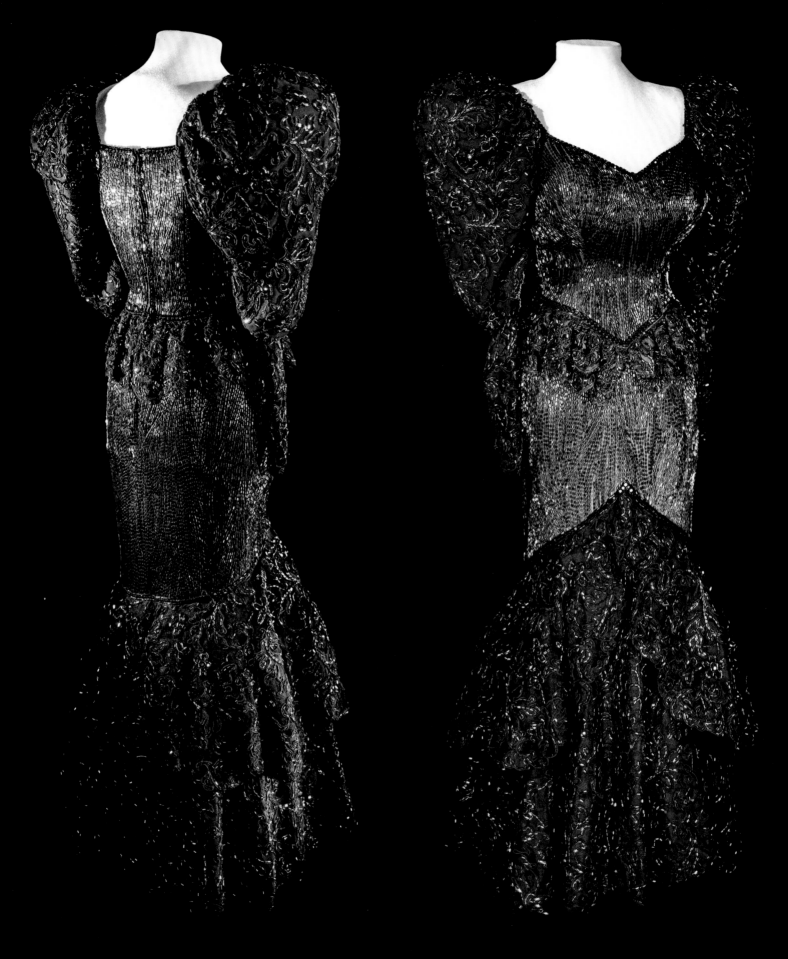

Tony designed this nine-and-a-half-pound gown to be worn
off the shoulder, but that wasn't for me. So, at the last minute,
we just used a little electrical tape to move it up to the right
place before I wore it onstage on my TV show.

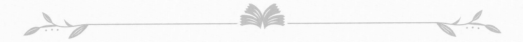

Behind the Outfit

Oprah on the Dolly Show

Oprah Winfrey appeared on my TV show's premiere, which aired on September 27, 1987. That episode set a new record for the highest-rated series premiere up to that time—not bad for a pair of gals with roots in Tennessee. Oprah and I sang "This Little Light of Mine"—a song for dreamers like us! We both came from backgrounds where our first doll was a corncob and our early dresses were made from sacks. We've come a long way . . .

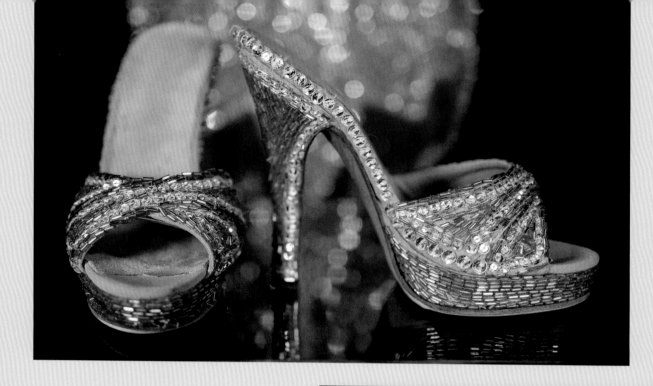

I asked Tony to alter a lot of my gowns to be shorter for my performances. This is one of 'em. I wore these rhinestoned, beaded shoes with both versions of this gorgeous dress.

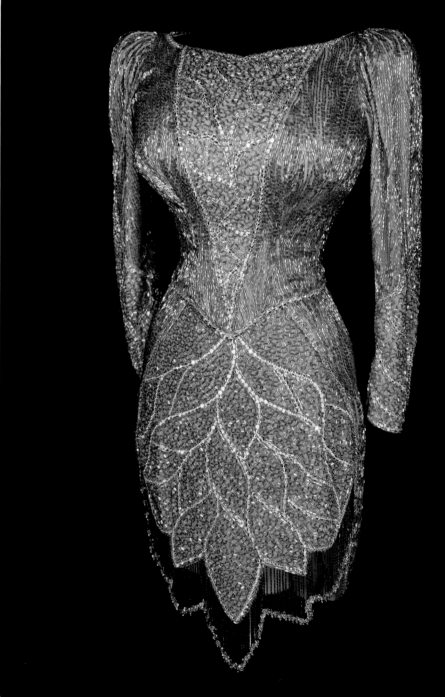

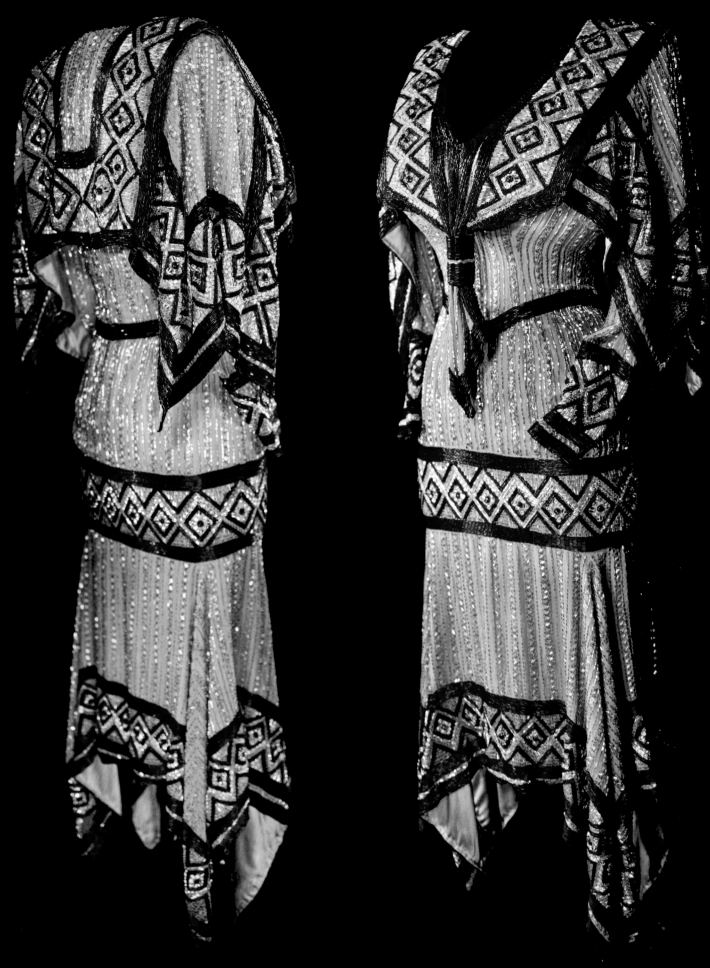

I wore this bejeweled 1920s-inspired sailor dress on my TV series to sing
"Star of the Show." . . . Speaking of "star of the show," the dress weighs
about the same as a big ol' sack of potatoes—twelve and a half pounds!
It's one of the heaviest dresses in my collection.

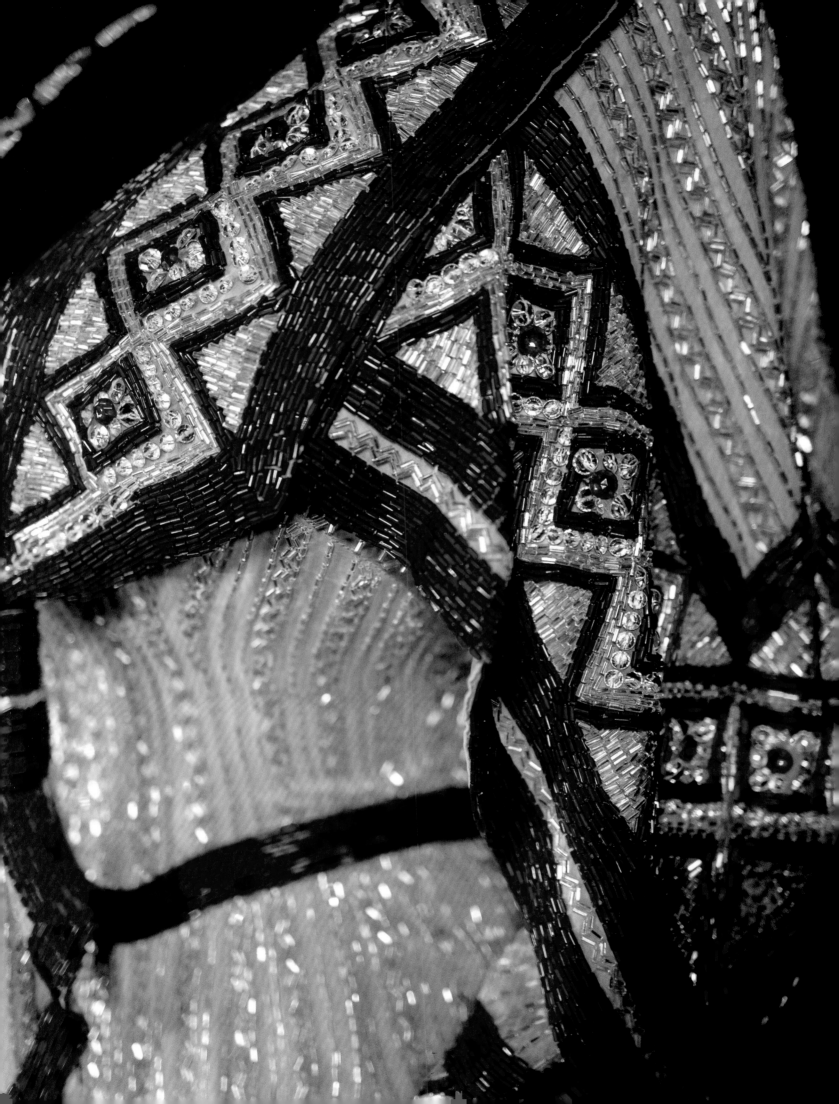

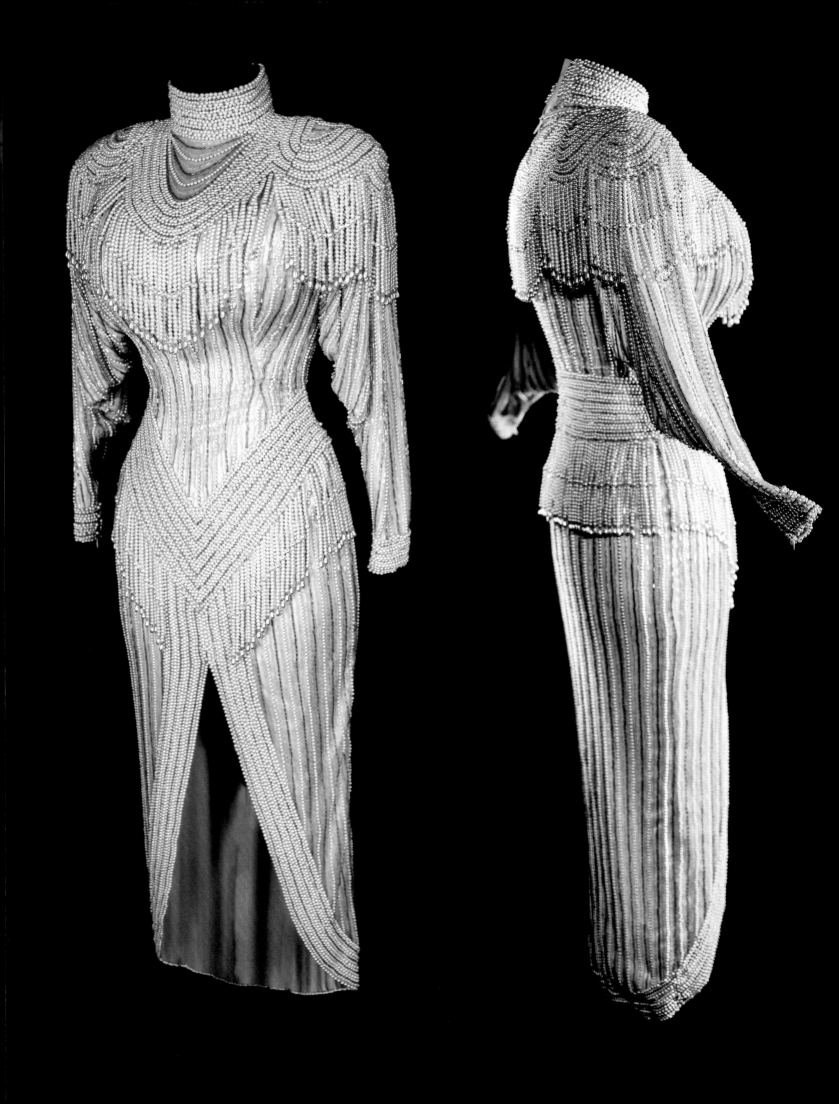

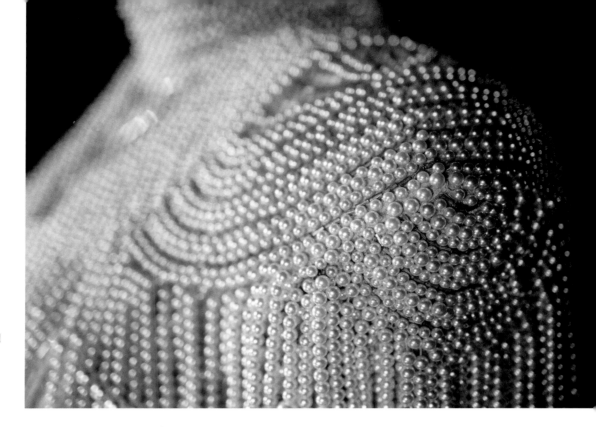

Covered in thousands of pearls and beads, this is the kind of dress I dreamed of as a little girl. Even though it's heavy, it's still one of my all-time favorites. I managed to lift my arm to play banjo while wearing it—it was good for toning those arm muscles!

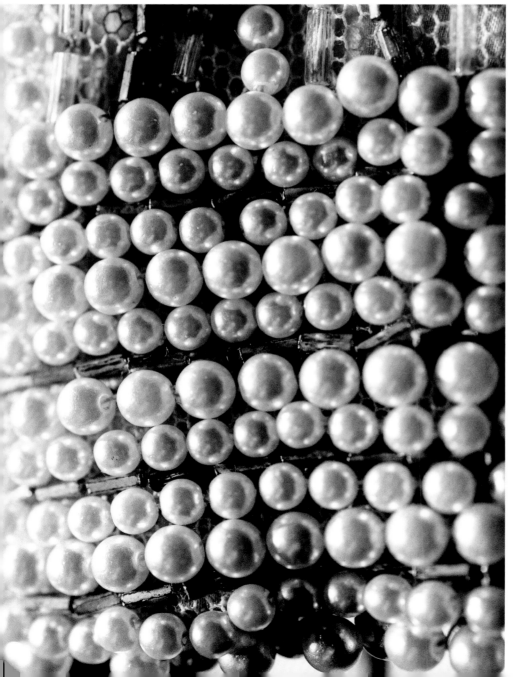

The Cowgirl with the Big Hair

When Linda, Emmy, and I were planning the photo shoot in our new outfits made by Manuel for the *Trio* album cover, Emmy and Linda were saying, "Oh, cowgirls didn't have that big hair," and I said, "Well, *this* cowgirl does." Linda was always so precise in how she looked with her makeup and her hairstyles and her little bangs. She wanted to look just exactly right for those photos. Of course, Emmy always looks exactly right. And then there was me . . . *ha!* My hair was bigger than the outfit. I look at it now and laugh, and when I'm autographing the sleeve of the *Trio* record, I'll sign it, "With love from the cowgirl with the big hair."

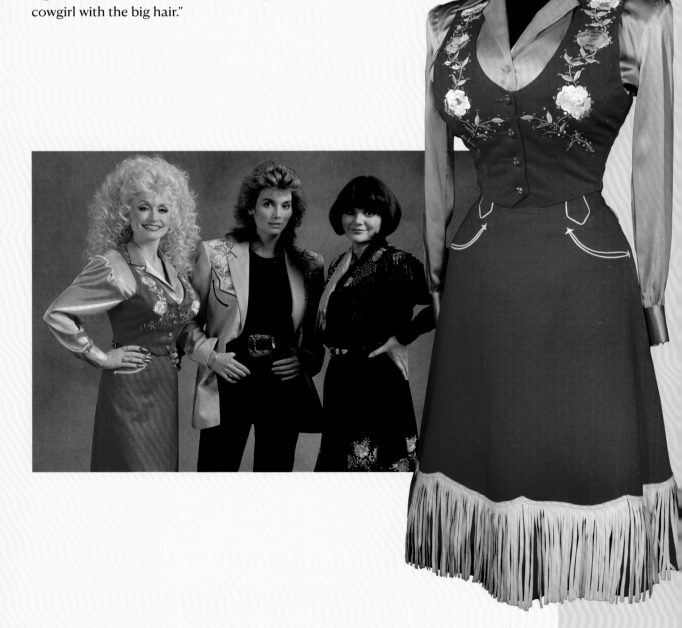

Since I have rhinestones on *everything*, I've had to make some other adjustments. If I've got rhinestones on my guitar strap, I am extra careful putting that strap on. To prevent it from yanking out an earring, we usually tape my earrings on. By putting tape on the back of my earlobe to hold the earring, it doesn't come off so easily. I've got to take everything into consideration. You don't want to flip your wig right there in front of an audience! But if that ever happened, I'd make a show out of that too!

I love the feeling of going back onstage after the intermission wearing a different outfit. It's like saying, *"I'm back!"*—and you always hope you haven't lost the crowd while you were gone. When you return, you want to wow them again with a new look. I was never one of those artists who changed clothes a lot throughout the show, like Cher and Patti LaBelle. It would wear me out and scare me to death that I wouldn't get my outfit on in time. I'm too anxious to please my audience. I usually do one costume change for the set after the intermission. Sometimes I'll do a little add-on, like a cape or a sleeveless cape over an outfit that I've already got on. Other times, for the encore, I'll put on a sheer skirt with stones on it—just a little add-on while the crowd is applauding.

Dressing for my concerts is a very different feeling from wearing my every-day clothes. That's why I only feel good about spending a lot of money on stage clothes—because I'm cheap, like Daddy was. He would always watch every dollar that went out, and I'm not the kind of person who wants to spend much money on casual clothes. But when it comes to my stage wear, I'll go all out because it makes me feel like I'm *on*, that I'm an entertainer, a singer. For me, it's a completely different feeling dressing up for the stage than dressing up for anything else. I don't mind spending the money for that, even $15,000 for a Tony Chase gown in the 1980s. I'll always be a country girl at heart, yet I know that sometimes stars need a little more sparkle to shine bright.

I call those my "Daisy Mae in Hollywood" years because the 1980s gave me more chances to get "Dollied up" on television and in movies. On April 15, 1989, I hosted *Saturday Night Live* on NBC. Tony Chase made all the clothes for my appearance. It was one of the hardest things I've ever done as an entertainer, but the clothes were magnificent. Since NBC's logo is a peacock, Tony designed a drop-dead gorgeous blue dress embroidered with his version of that fabulous bird, along with matching boots. During my opening monologue, I showed off my dress and told the audience it was perfect for shakin' my tail feather. I was also the musical guest, plus I did so many skits. I about killed myself because Tony insisted that I wear a different outfit for each thing I was doing. And the show is *live*. You have to be on

Daisy Mae in Hollywood

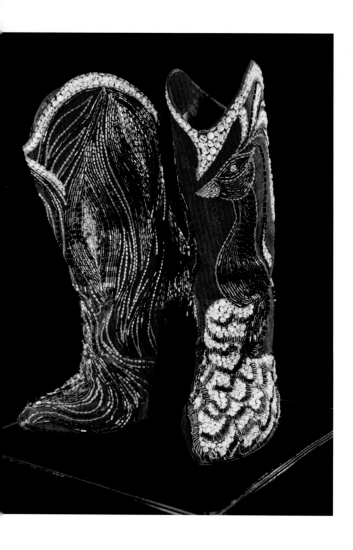

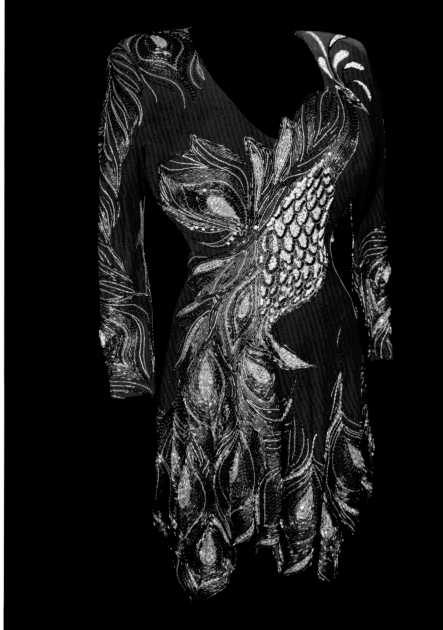

My peacock outfit
was a big hit when
I was guest host
on *Saturday Night
Live*, and afterward
I had Tony turn it
into a dress that I
could wear on tour.

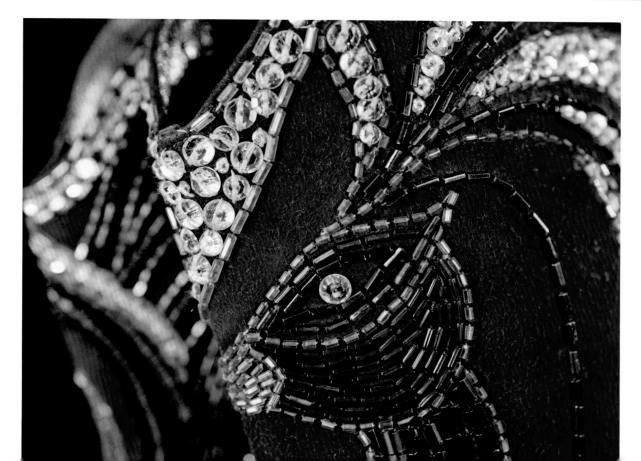

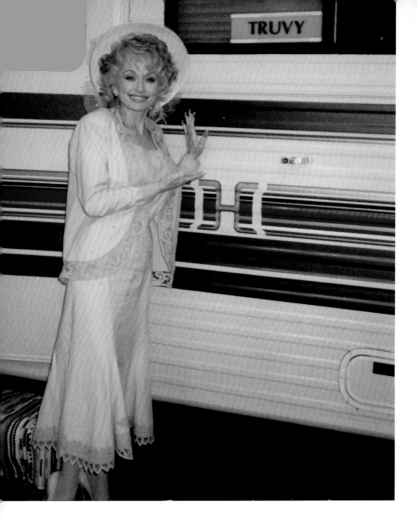
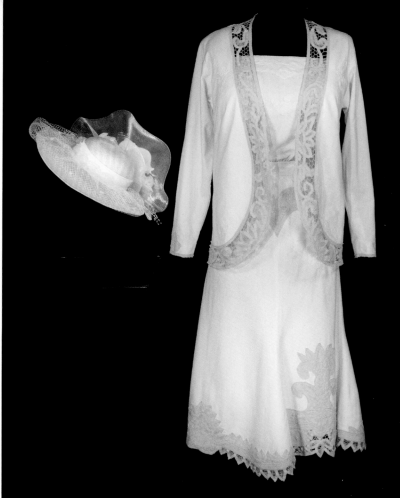

Here I am as Truvy in *Steel Magnolias*, all dressed
up for Shelby's (Julia Roberts) wedding.

your game. I was a nervous wreck, and we barely got the clothes on. He'd be lacing up a boot or putting on something right as the producers were saying, *"Move, move, move. Three, two, one."* Then I'd have to act like nothing was happening, even though I was so stressed. You don't realize how hard it is with that many costume changes when you're trying to keep things rolling. When you've got lots of outfits to change into, that's where the wigs really come in handy.

I ended the 1980s appearing in another movie that holds sweet memories for me. *Steel Magnolias* premiered on November 5, 1989. As in *9 to 5*, I was surrounded by some amazing women in the cast, including Julia Roberts, Shirley MacLaine, Sally Field, Olympia Dukakis, and Daryl Hannah. (I also had another handsome man playing my love interest—this time, Sam Shepard.) I could really relate to my character, Truvy Jones, a small-town beautician. I've always said, if I hadn't made it as an entertainer, I would have been a beautician or a missionary. *Steel Magnolias* was written by a Southern boy, Bobby Harling, and inspired by his sister and the

Daisy Mae in Hollywood

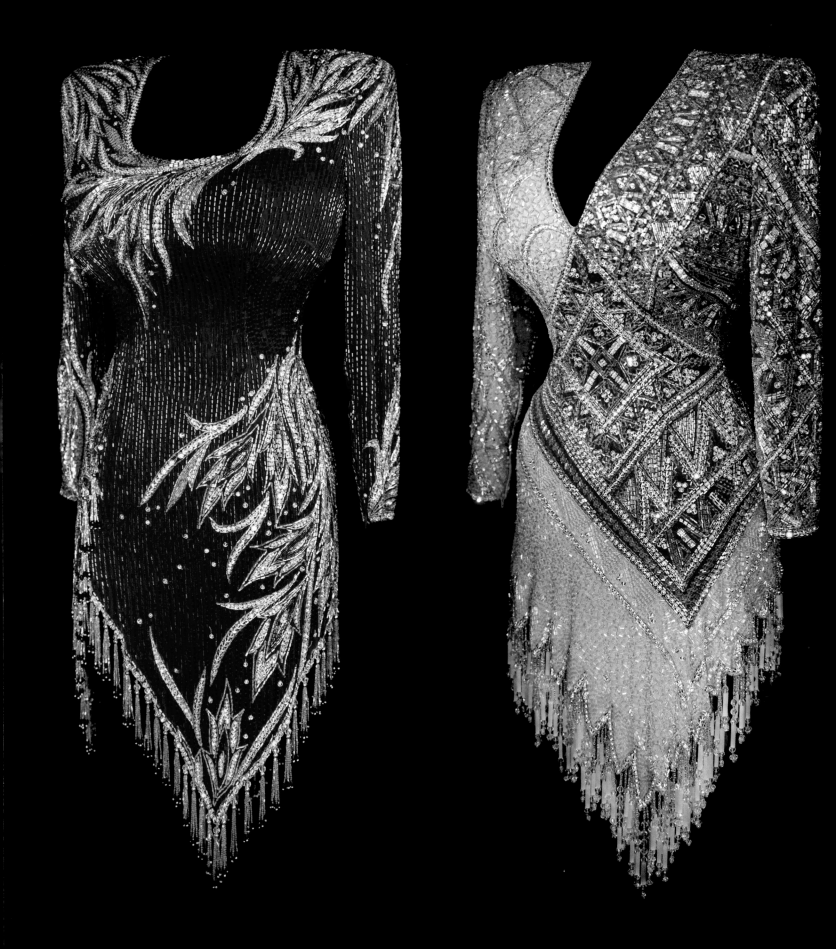

Tony Chase was so creative with all the embellishments on my gowns. I love looking at the intricate beadwork in his sketches, which I still have. I wore this blue dress on tour in the '90s, and the lavender and purple one for the premiere of *Steel Magnolias* in Louisiana in 1989.

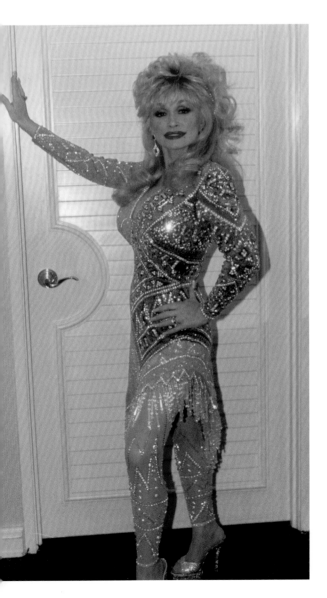

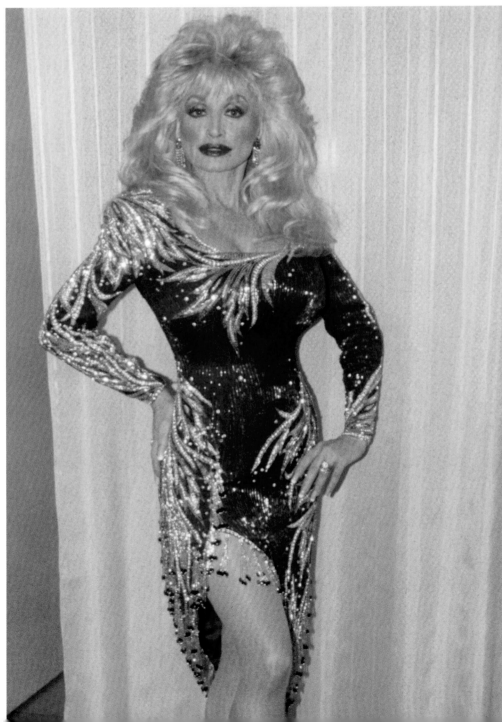

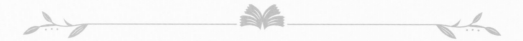

My Favorite Looks
1989 CMA Awards

Tony Chase made one of my favorite dresses that I ever wore. I just felt so spiritual and pretty in that dress. I debuted it at the Country Music Association Awards show in 1989 when I performed "He's Alive," which appeared on my next album, *White Limozeen*. Of course, I still have that gorgeous white beaded dress. It has pearls scattered all over it. You can see how Bob Mackie inspired Tony with the sleeve design. When I raise my arms in that dress, it looks like angel wings underneath. "He's Alive" is one of my favorite spiritual songs, and it's very popular at Easter. At the CMAs that night, I just felt transported while singing it. It was such an emotional experience. The audience response was astounding—and made me feel as though I was putting out some good into the world. So ever since, I've associated that dress with the uplifting feeling I had singing "He's Alive."

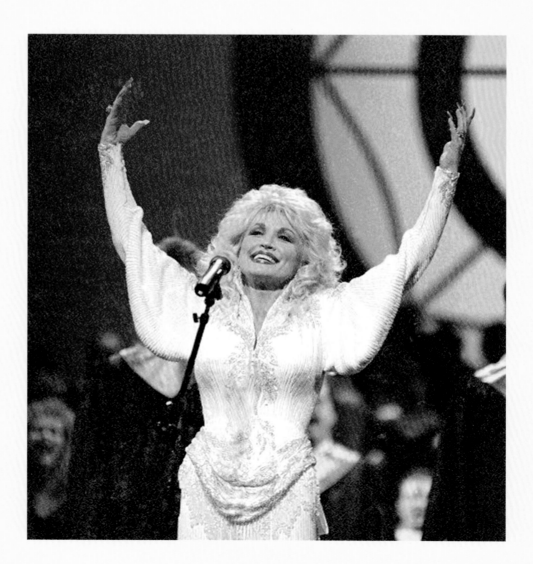

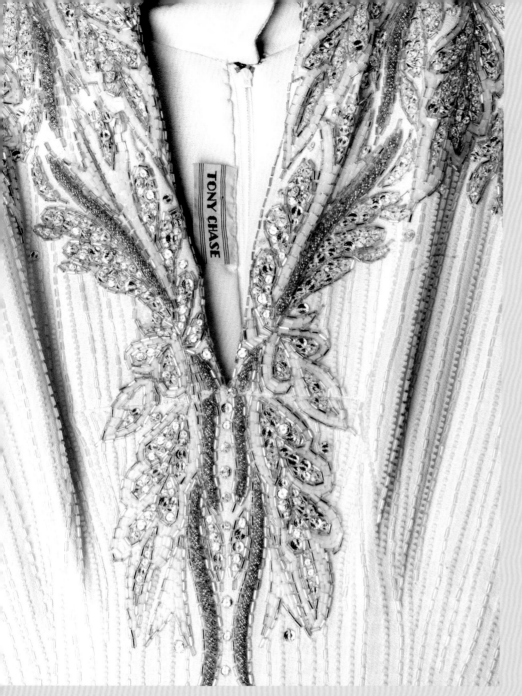

What could be more
heavenly than a dress
with wings?

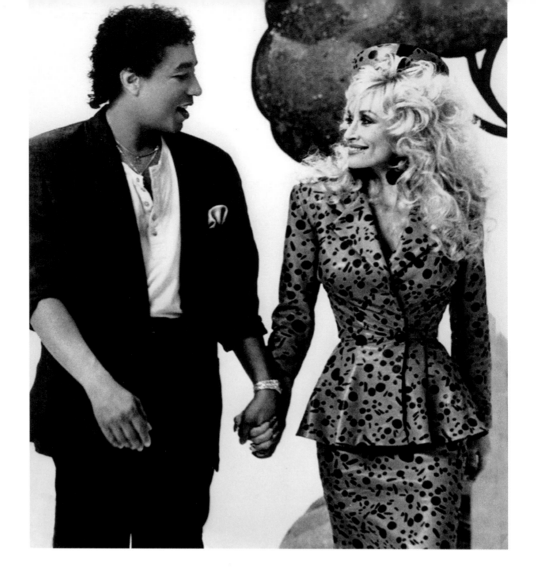

town where they grew up, Natchitoches, Louisiana. The director, Herbert Ross, did a good job of capturing the South. I liked a lot of my wardrobe, especially some colorful sweaters, which were awfully hot to wear in Louisiana! And I liked the gaudy details, like the holiday decorations and the smocks that I wore in my beauty shop. Some of my lines from the movie have made it onto T-shirts and posters, like "There is no such thing as a natural beauty" and "I ain't perfect but at least I ain't fake."

As Truvy, I had a couple of real zingers about hair: "I can usually spot a bottle job from twenty paces," and "I don't trust anybody that does their own hair. I don't think it's normal." I knew what I was talking about! David Blair, who did my hair for *Steel Magnolias,* had done my hair for my TV show in 1987 and '88. We worked really well together. He was very flamboyant, gay, and wild. David wore his hair long, and he had a style all his own. He was little, like me. I always imagined he was styling my hair the way *he* wanted to look if he had been a drag queen, which he wasn't. He had an exact idea of what he wanted me to look like. He did a lot of really crazy hairdos that I loved, including one that made me look like a poodle!

Behind the Seams

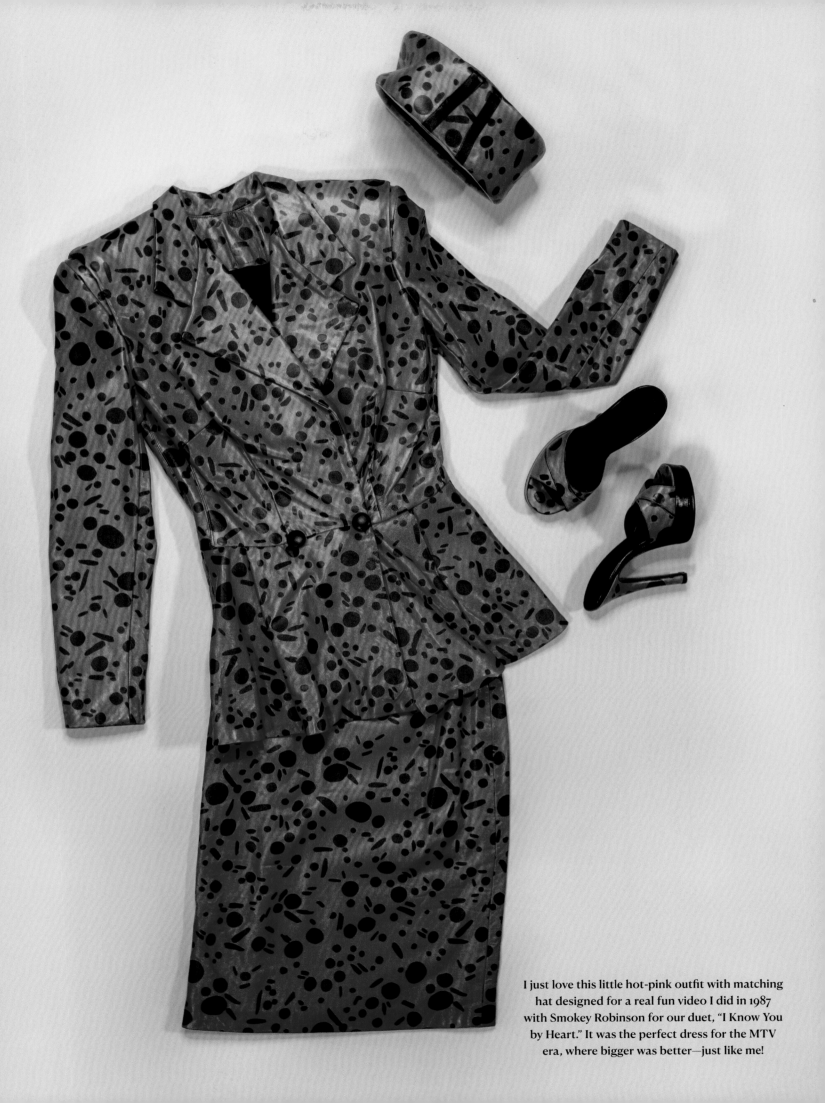

I just love this little hot-pink outfit with matching hat designed for a real fun video I did in 1987 with Smokey Robinson for our duet, "I Know You by Heart." It was the perfect dress for the MTV era, where bigger was better—just like me!

Hairstylist
David Blair

I found a gem in David Blair, who started doing my hair in LA in the early '80s. He stayed with me for a long time. One of my favorite early projects we did was my TV movie, *A Smoky Mountain Christmas*. A Southerner, he hailed from Rayne, Louisiana, and used to watch me on *The Porter Wagoner Show*. He told me he loved my piled-up dos and even thought at the time, *I want to get my hands on her hair!* Well, he certainly did—thousands of 'em! He styled my dos on my television show in 1987 and '88, and he worked his magic when I starred in *Wild Texas Wind* and *Steel Magnolias*. You can see his work on record covers like *White Limozeen*, *Eagle When She Flies*, *Slow Dancing with the Moon*, and *Treasures*. And that's what David was to me—a real treasure.

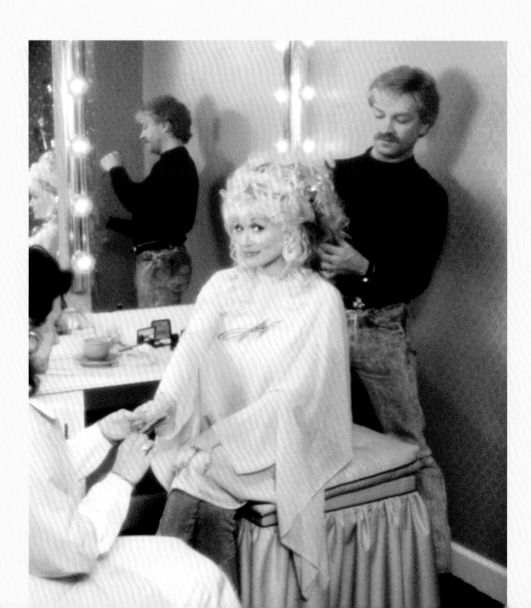

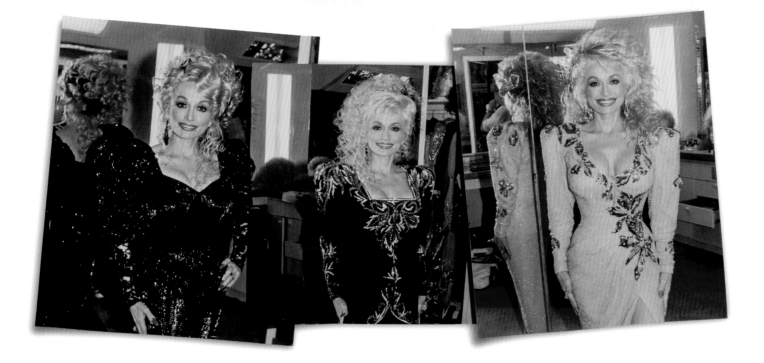

David Blair did things to my hair that ranged from campy to rock and roll to high glam. David wasn't afraid to go wild with my looks back in the '80s, and I happily went along for the ride.

During the 1980s, my weight fluctuated a lot. I remember my very first photo shoot with Annie Leibovitz for *Rolling Stone* when I was a bit curvier. Thankfully, when Arnold Schwarzenegger picked me up for one picture, it was like he was picking up a baby! He was so big and had just been named Mr. Universe. Then, a few years later, Burt Reynolds had to pick me up—as Miss Mona—for a scene in *The Best Little Whorehouse in Texas*. I could see in his face that I was too much for him, and sure enough, he got a hernia!

In the mid-1980s, I decided to take control of my weight once and for all. Sylvester Stallone, my costar in *Rhinestone*, gave me lots of advice about eating healthfully and exercising. I changed my attitude about portion control, and that really worked for me.

When Annie Leibovitz photographed me in 1991 for the cover of *Vanity Fair*, I was wearing a slinky Marilyn Monroe–style halter dress designed by Tony Chase. By that time, I felt great. Photographed in Fort Hood, Texas, I was surrounded by courageous Gulf War soldiers still dressed in their fatigues. The article, written by Kevin Sessums, started with "Why was Dolly Parton the hottest pinup of Desert Storm? Because she's every down-home virtue wrapped up in a sizzling blond bombshell. And she's a country music angel . . . who commands her own $100 million empire. Dolly Parton *is* an American Dream!"

Not a bad way to start a new decade!

Daisy Mae in Hollywood

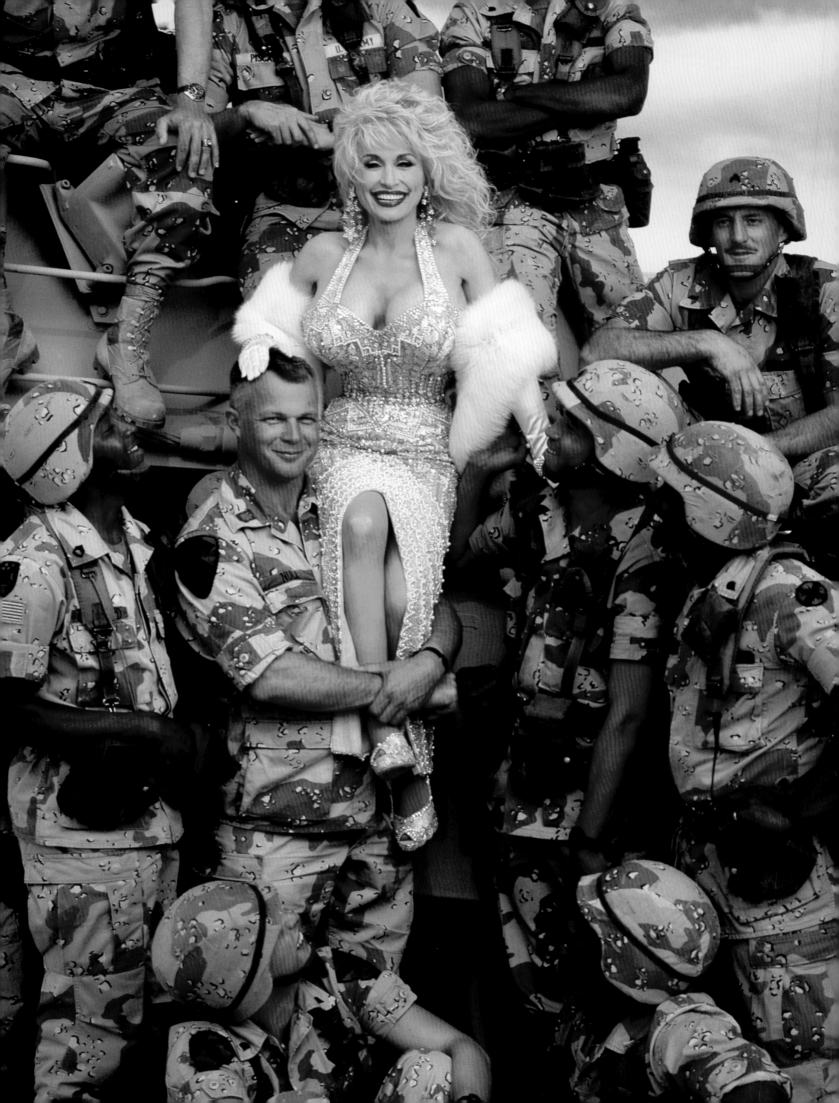

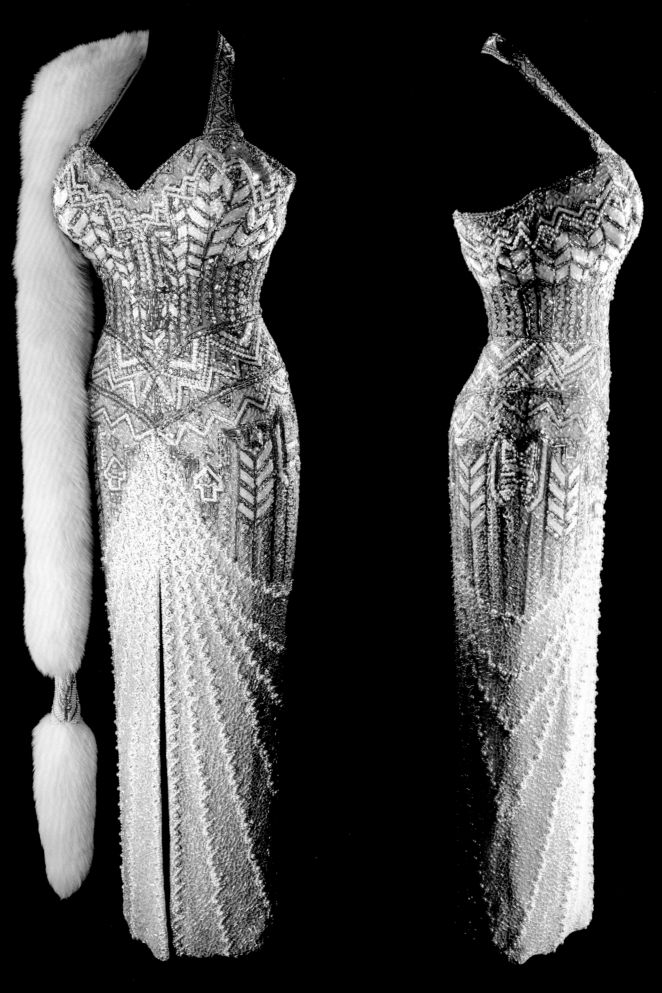

Tony designed a sexy halter dress for me for the cover of *Vanity Fair*, which I also wore at the New York premiere of *Steel Magnolias*. He said this was his favorite "Dolly gown."

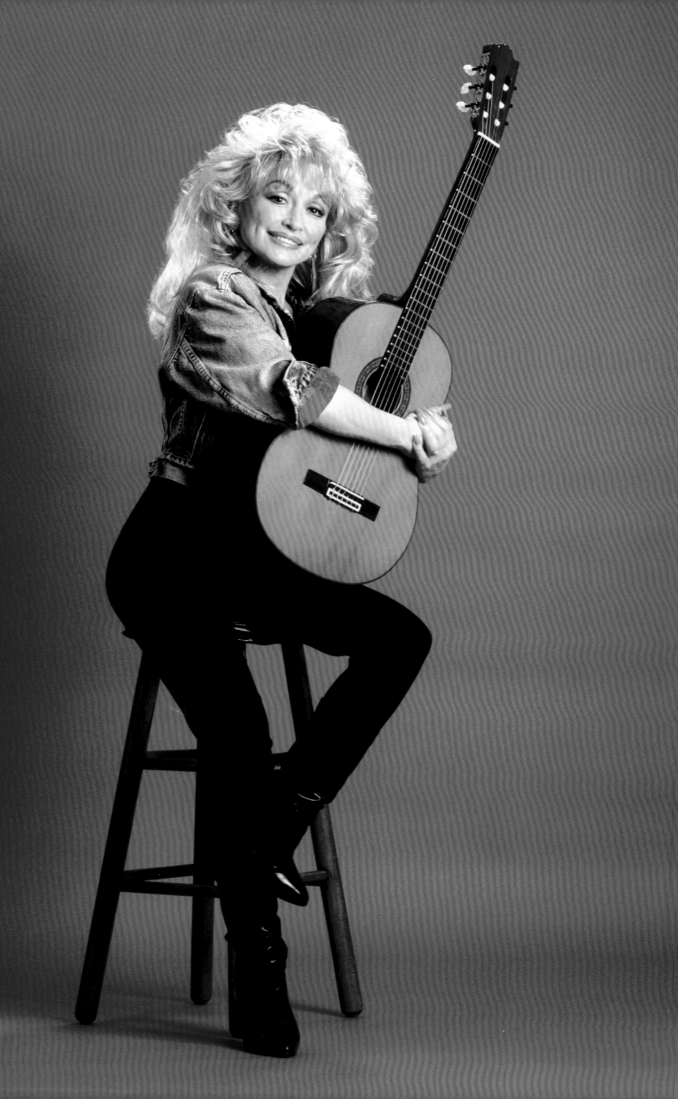

7

The Unsinkable Dolly Parton

"It's not a big job being Dolly. It's just my life."

Dolly

Dolly began the 1990s embracing new styles, working with exciting designers who offered her the opportunity to expand her image. Similarly, her various looks in the decade reflected the diverse roles she played in her life and career—from the stunning beaded gown she donned for the cover of her memoir to the 1950s-inspired red gingham dress on her album *Heartsongs: Live from Home* and beyond. She wore pants that ranged from spandex knickers to worn-out jeans with busted-out knees, and her skirt lengths varied from fringed minis to elegant floor-length gowns. Throughout the decade, Dolly alternated between Hollywood-meets-Nashville glitz and her Smoky Mountains roots. Musically, she found major success with hit country-pop songs like "Romeo" and won kudos singing traditional country music with fellow pioneering artists Loretta Lynn and Tammy Wynette on the 1993 *Honky Tonk Angels* album. That release celebrated the work of Kitty Wells, the first woman (often clad in gingham) to become a country music superstar in 1952. By decade's end, Dolly had released *The Grass Is Blue* (1999), her first full-fledged bluegrass studio album, on indie label Sugar Hill. She would cap the twentieth century continuing to explore new musical and style directions. And many of the fun, fresh looks she adopted in the 1990s would become wardrobe staples onstage and off in the decades to come.

—*Holly George-Warren*

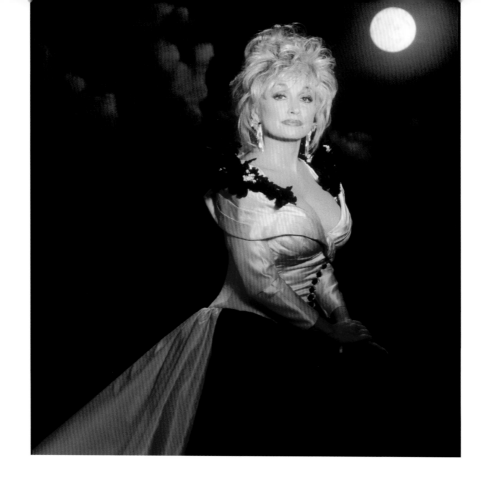

After spending much of the 1980s recording pop albums and making TV shows and films in LA, I began to mix things up in the 1990s. I met some exciting, young designers in California who created wild 'n' wonderful new looks for me. They could go from glamorous and glitzy to vintage rockabilly to "down-home Dolly." Heading to Tennessee, I started making records with kinfolk and playing the kind of mountain music I grew up with. I began spending more time back home and recorded a whole series of rootsy albums that people seemed to like a lot. For those album covers, I worked with such amazing photographers as Randee St. Nicholas and Timothy White.

Randee's cover shot for my album *Slow Dancing with the Moon* holds a special place for me. That day I had a really bad headache because of a back injury. So when she captured me with her camera, I wasn't pretending, I wasn't *on*. I wasn't doing anything but just trying to overcome that pain. I love that outfit, but every time I see it, I think of that headache.

Randee has a bubbly personality, and we had a real good time together. Believe it or not, two things I hate are photo shoots and clothes fittings. They require this energy in me that wears me out. I know I've got my job to do, but I'm glad when it's over and I'm home eating tacos. So that's why it's especially great when somebody makes a photo session fun. You forget that you don't like doing it!

Behind the Seams

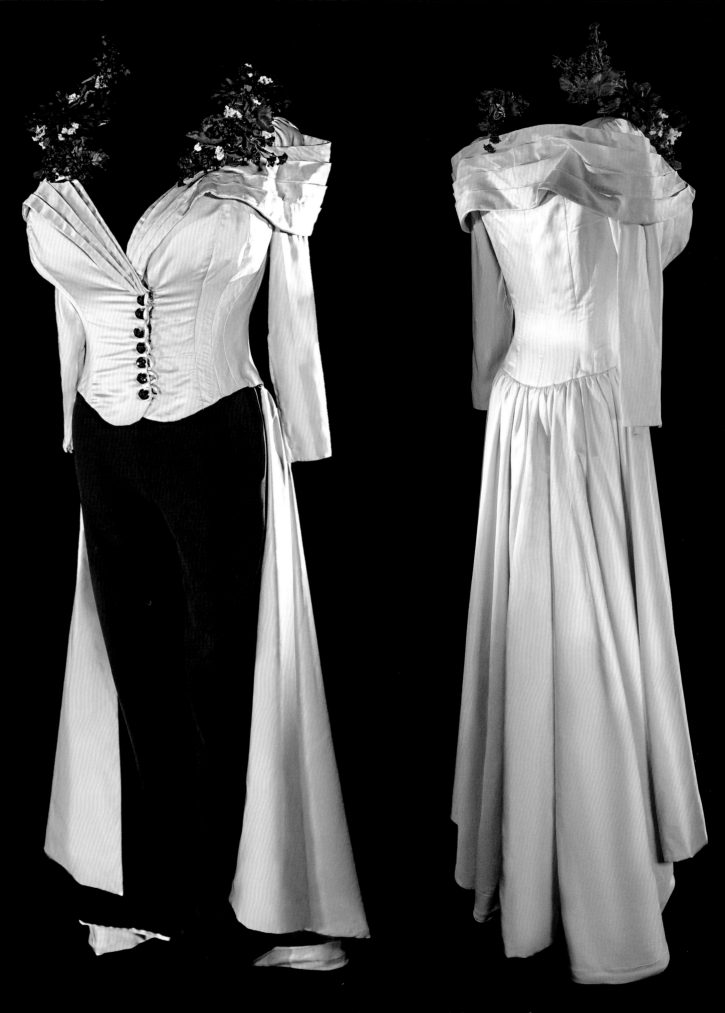

I wore this outfit for the cover of *Slow Dancing with the Moon*. My fans
Patric Parkey and Harrell Gabehart bought it at a charity auction and
generously loaned it to be photographed for this book.

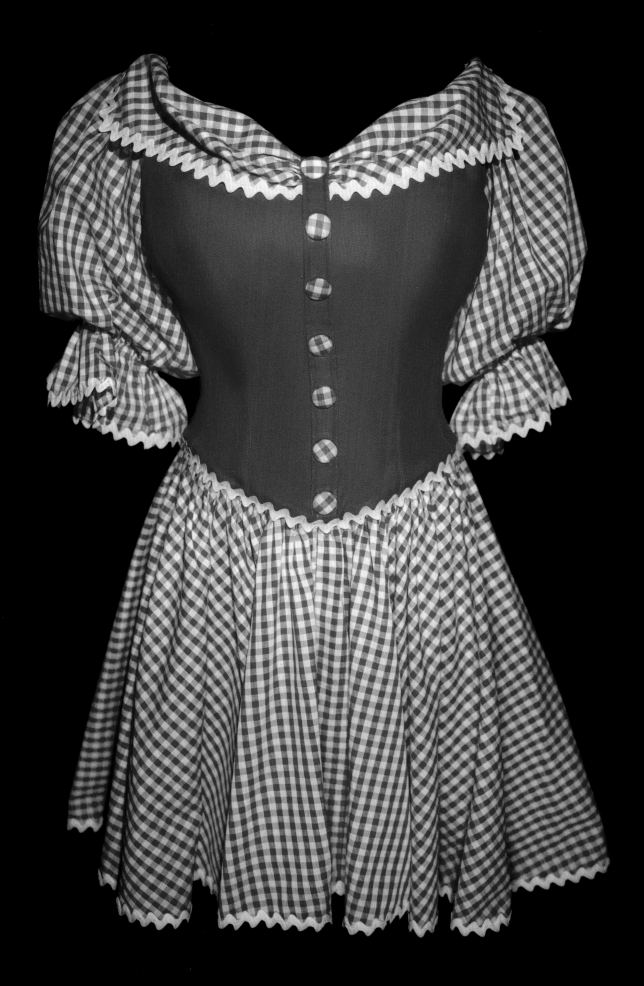

Tony used my childhood favorites, rickrack and gingham, for
the dress I wore for the cover of *Heartsongs: Live from Home*—
one of my all-time favorites. I really did feel I was back home.
Timothy White's beautiful photos capture that joy perfectly.

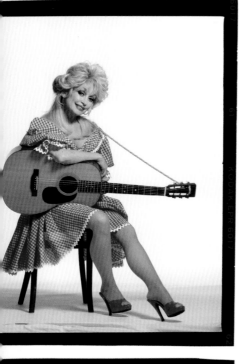
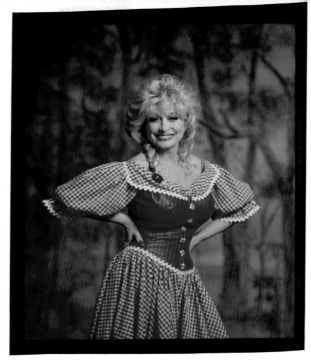
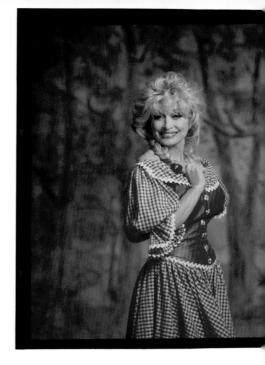
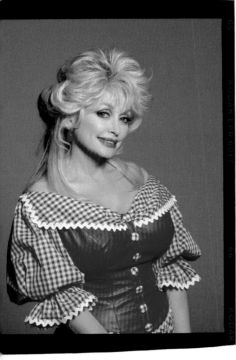
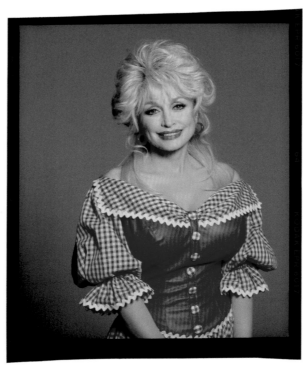
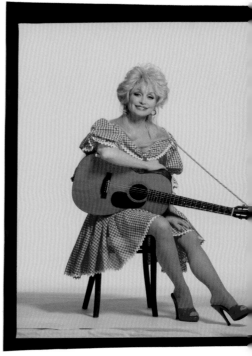
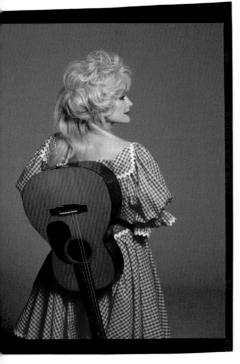
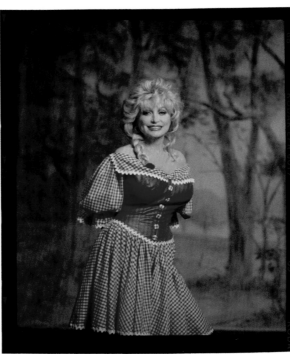
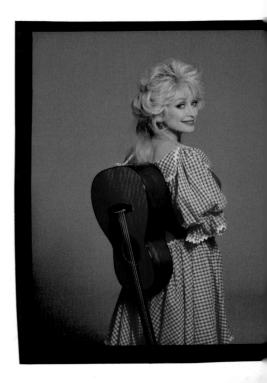

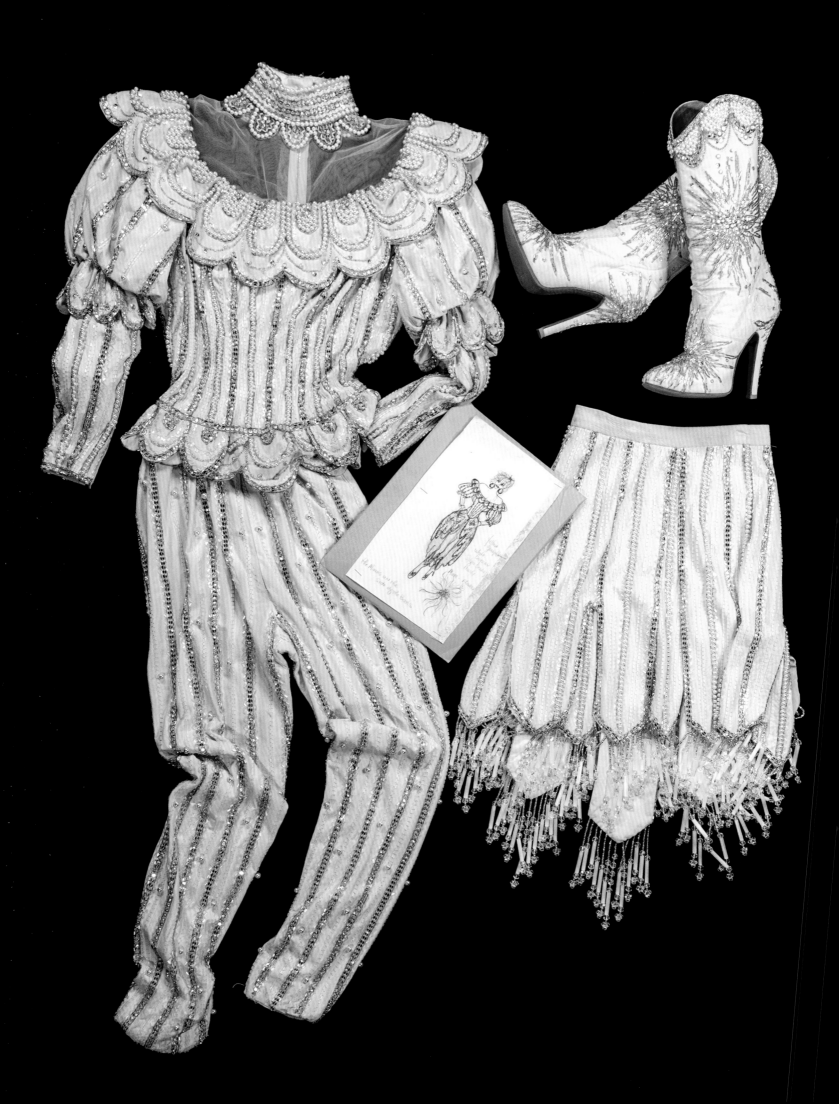

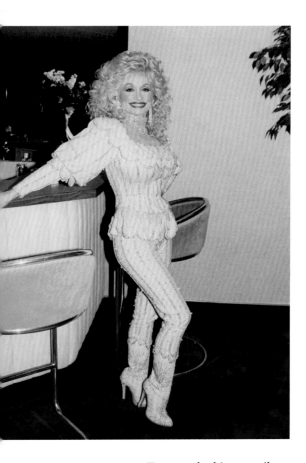

Tony made this versatile
ensemble for me to take on
tour with Kenny Rogers in
1990. I wore one version of
it at the Dove Awards that
year. I'm so glad I held on
to Tony's design sketches;
they remind me of our
wonderful time together.

Back Through the Years
Album Outfits Gallery

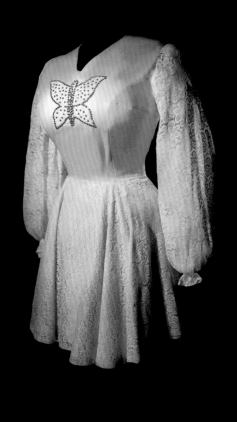

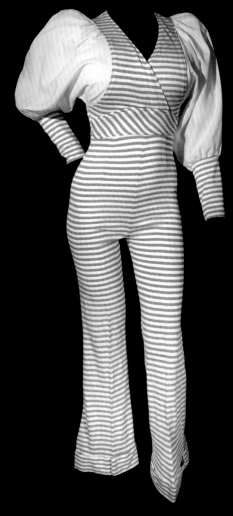

Butterfly Queen

Lucy Adams made one of my
first butterfly dresses.

Puff 'n' Stripes

I bought this Jerrell of Texas
jumpsuit off the rack.

You can really see my evolving look by checking out my record covers over the years. They're almost like a family photo album! Here's just a tiny sampling of the styles I've worn: from 1974, with a duet album with Porter and my big solo smash, to the 1990s, with *Eagle When She Flies* in 1991, and, twenty years later, *Better Day*.

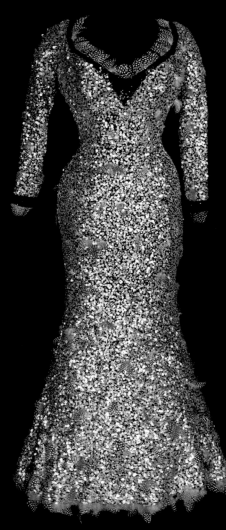

Mountain Girl

Tony designed this top, which looks great with a pair of my favorite painted-on jeans.

Glamour Gal

Steve Summers designed this sequined, feathered gown.

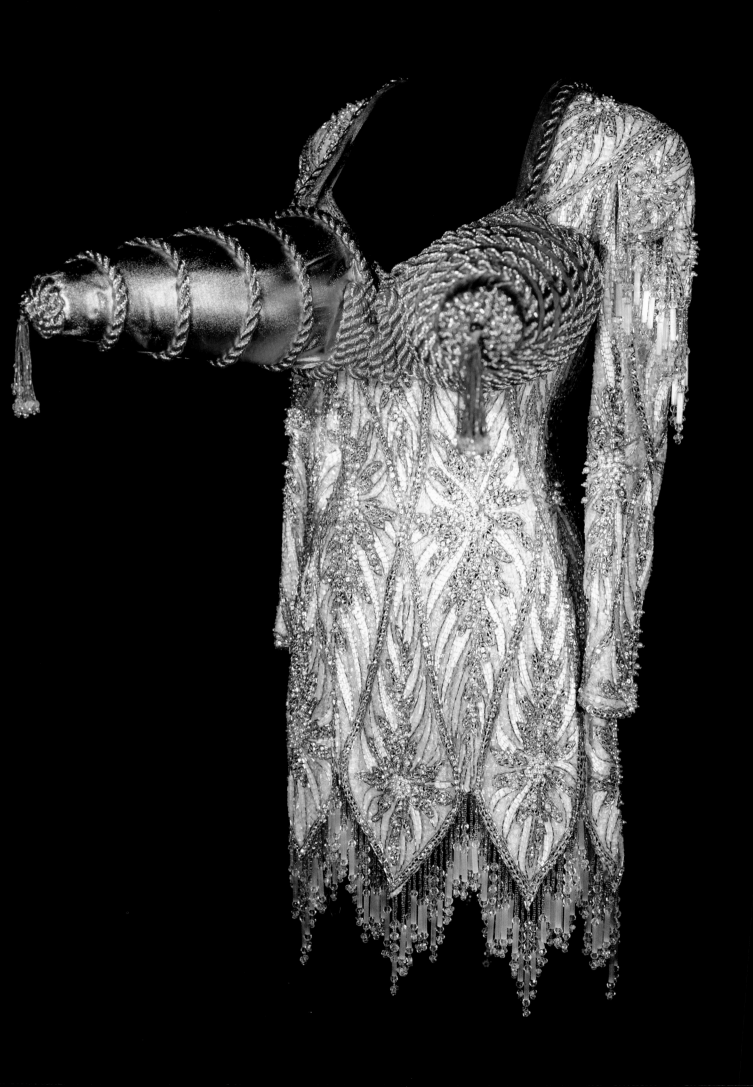

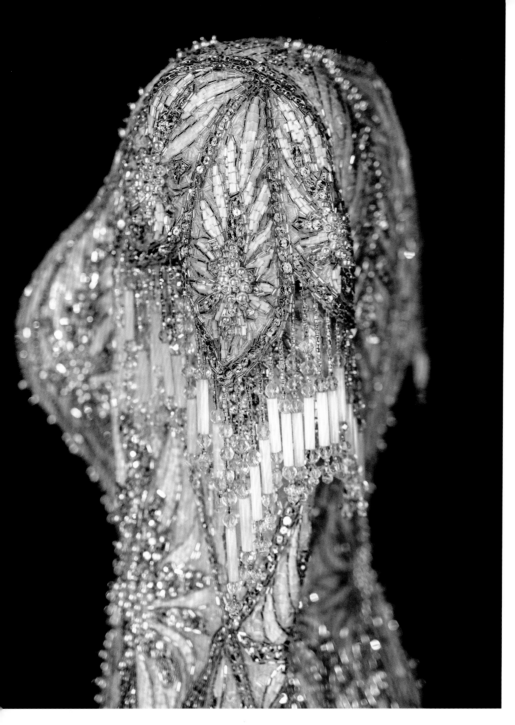

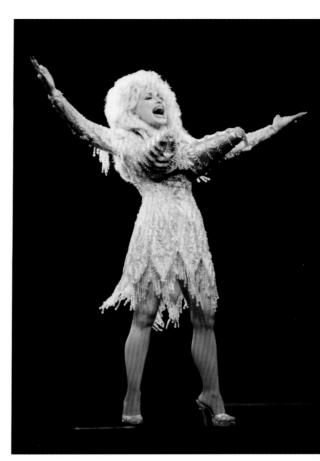

We called this Tony Chase dress (inspired by a Jean-Paul Gaultier creation) "MaDolly," and, of course, I sang a Madonna hit—"Like a Virgin"—while wearing it on tour.

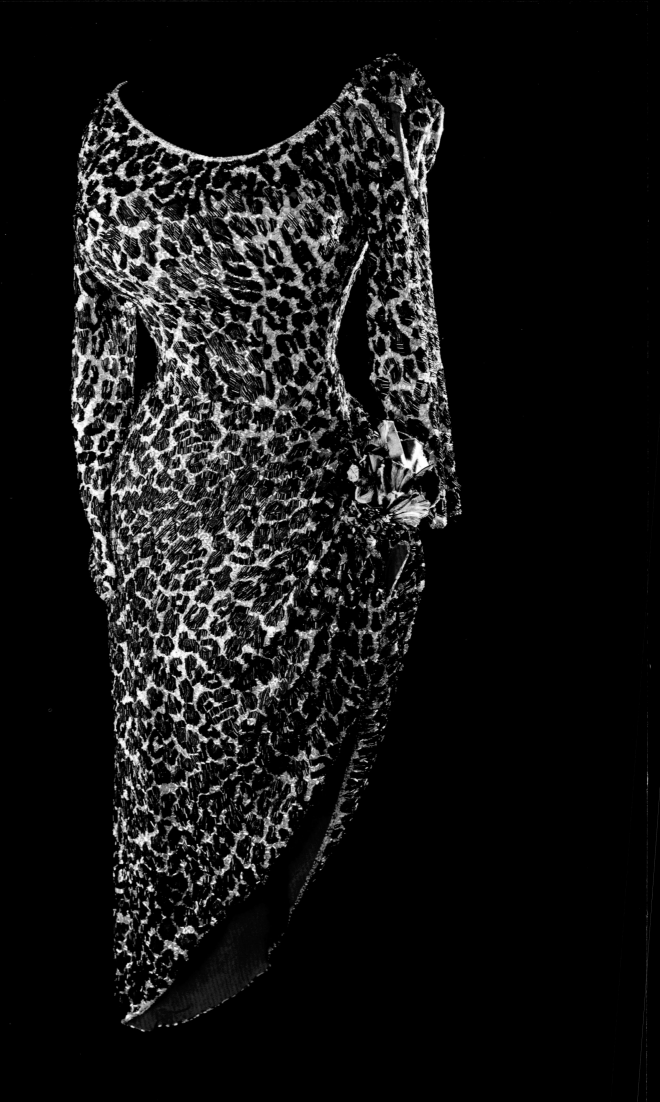

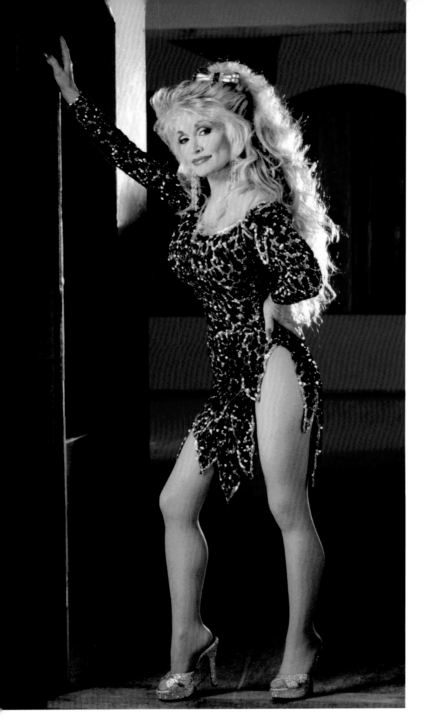

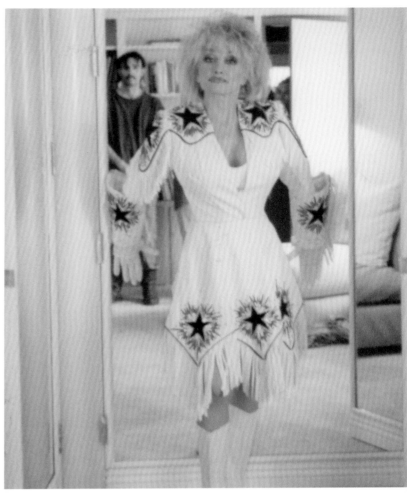

You can see my wonderful Tony looking over my shoulder here. I loved watching his sketches come to life, especially in *Wild Texas Wind*, as he transformed me into Thiola "Big T" Rayfield, the lead singer of a Western swing band.

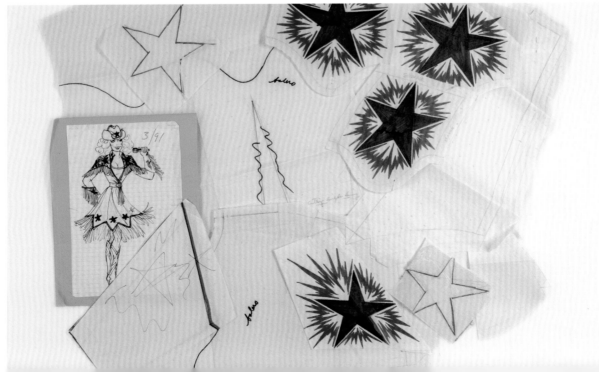

In October 1994, I sadly said goodbye to my dear friend and beloved designer Tony Chase. After battling AIDS for several years, he succumbed to that awful disease. I still worked with Rose Sanchez, who made some of Tony's designs. Rose worked from her home in LA and designed lots of things for me before she moved back to the Philippines.

In the years that followed, I began collaborating with other talented designers, including Debra McGuire. She and Rose were the first women I'd worked with on my clothing designs since my time with Lucy Adams. Debra had been a painter, a jewelry designer, and even designed accessories and costumes for *Friends* before I met her when she was hired as my costume designer for the TV series *Heavens to Betsy*. Although that show never came to pass, it kicked off a great relationship with Debra.

Debra created some exciting new '90s looks for me. I started wearing different kinds of clothes than I'd worn before. She would show me some unique fabrics and say, "Oh, this makes your eyes look good. You should always wear colors that pick up your skin tones and your eyes." She'd convince me that a certain color or style was the right thing to wear. I trusted her and loved working with her. For the ceremony for my induction into the Country Music Hall of Fame in 1999, she made me a beautiful teal outfit. I think that was the first time I'd ever worn teal. It turned out to be a good color for me because my eyes are a true hazel—more green than anything else. Hardly anybody knows that because I wear a lot of makeup. But when I wear the right color to bring out my eye color, people always say, "I didn't know your eyes are green!"

Behind the Seams

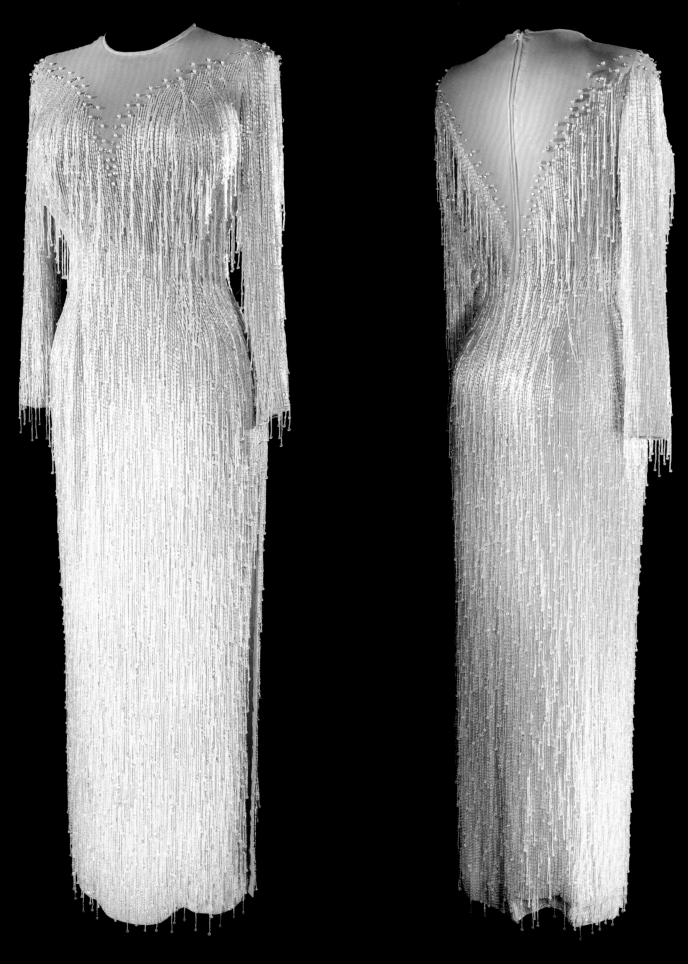

Tony once told me that this dress was inspired by the work of
Hollywood costume designer Jean Louis, who designed the dress
Marilyn Monroe wore while singing "Happy Birthday" to JFK.

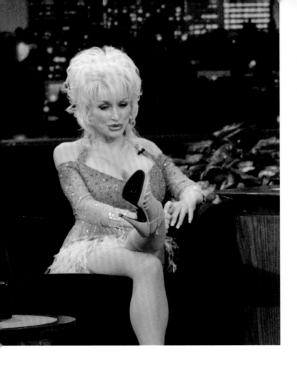

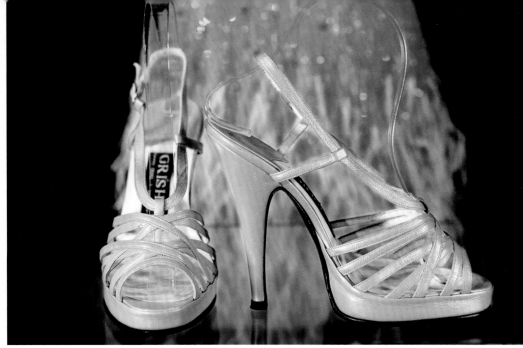

Debra also created a lot of personal outfits for me. She has such great taste and was never afraid to try anything. If I told her, "I want a lot of big bangles, I want to wear this and that," she would do it with good taste. She came up with some wonderful things for me.

In the 1990s, I also worked with a Frenchman for the first time. Originally from Paris, Robért Behar has designed some gorgeous outfits for me, beginning with thirteen costume changes for my November 1996 TV special, *Treasures*, which featured songs from my album of the same name. I've loved working with Robért ever since. He kind of picked up where Tony left off and came up with modern twists on some of those glamorous looks that Bob Mackie and Tony were famous for. He has such an imagination and creative impulse when it comes to fashion.

Also in 1996, I starred opposite Roddy McDowall in another made-for-TV movie, *Unlikely Angel*. It was my first—but not last—time playing an angel. It was a great excuse to wear the beautiful sparkly white dresses I adore! Although I love my bright colors, when all is said and done, white is my absolute favorite when it comes to my clothes. It's a *no color*! In white, I just feel light and airy—white makes you feel clean and pure.

Of course, the opposite of that is wearing black. And I wear that dark, dark shade from time to time, from sleek black gowns and black jumpsuits in all kinds of fabrics to black Chanel-style business suits and leather motorcycle jackets. Oh my gosh, wearing black is basic and it's handy. You can always grab something black to wear at night or even in the daytime. And I don't even particularly like it! But there's something about black. You can just put it on, and it always looks good.

Behind the Seams

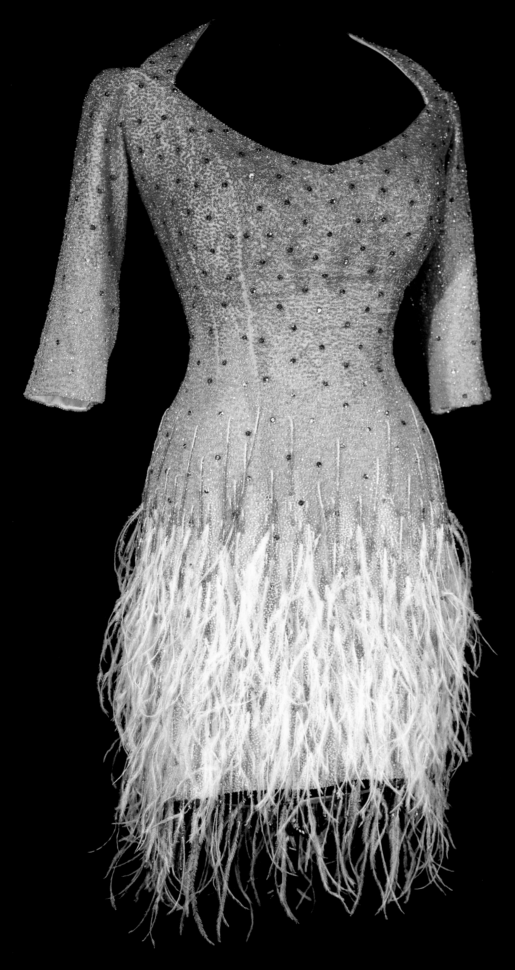

Robért Behar designed this dress using blue and white feathers to symbolize "bluegrass." I wore it on *The Tonight Show* in 1999 to promote my album *The Grass Is Blue*. I do love a theme!

Photographing Dolly

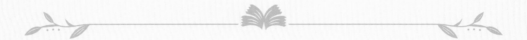

I have lots of many great memories of working with the world's most incredible photographers. I'm so happy that they have some great memories of me too!

Allister Ann: "What I'm most proud of in my career is that my photograph of Dolly is on the Tennessee license plate, with proceeds going to her Imagination Library. To me, Dolly represents Tennessee—plus, she is such a brilliant representation of being a woman and pursuing your dream and the work that you're passionate about."

Aurelia D'Amore: "My uncle Richard D'Amore was the photographer for Dolly's 1985 album *Real Love*. I carry on my uncle's and father's passion for photography, and what stands out to me about his work with Dolly is the soft focus and hand-tinting of the photo: very classic, very romantic. At that time in music, things were so vivid, so to go the other direction with Dolly—who is larger than life—makes the cover stand out."

Jim Herrington: "Dolly's 2001 record, *Little Sparrow*, was kind of dark and gritty and rootsy. The shoot turned out to be exactly what you, as a photographer, want if you're shooting somebody who's legendary: great light and the perfect location. And getting Dolly stripped down accentuates the Dollyness; it directs all the attention to her aura and the face. She looked fantastic."

Stacie Huckeba: "Of course, Dolly's known for telling stories through her songs and books and movies. But people have not recognized that she's also a storyteller through her clothing. There's a very specific reason for each piece she wears, or a very specific symbolism to it. She's masterful in the way she tells stories of her songs—and of her life—through her wardrobe."

Randee St. Nicholas: "I've worked with Dolly and Prince and Whitney and the Bee Gees and Stevie Nicks—artists that I've had long, bonding relationships with. They all have one thing in common: they recognize artistry in others, and they surround themselves with people whom they trust to do what they do. Together, you raise the bar because you have like-minded visions."

Art Streiber: "When I photographed Dolly in 2018 for *People*, I asked her, 'How many times have you been photographed?' She looked at me and said, 'Oh honey, thousands of times.' I had the realization that I was photographing an irreplaceable American icon. There is never going to be another Dolly Parton."

Fran Strine: "I don't get starstruck very often—yet Dolly's presence just filled the entire studio. And her black sequined dress fit her body like a second layer of skin—like she was born in it. It was as if she came out of the womb with it already attached to her."

Timothy White: "Dolly has created her own genre for fashion. And in the process, she's inspired women everywhere to embrace the image of themselves through their own lens. From denim and gingham to sequins and rhinestones, she personifies the purpose of style: to express oneself truthfully."

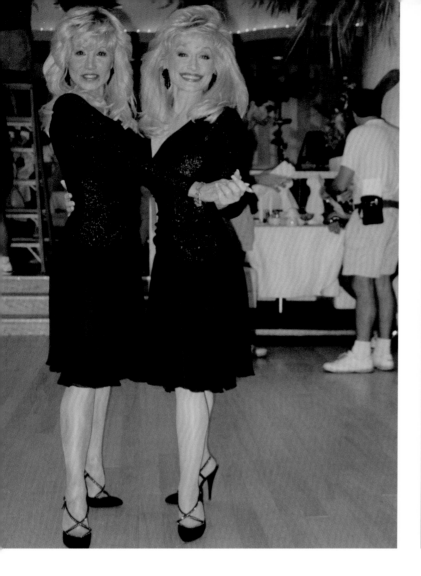
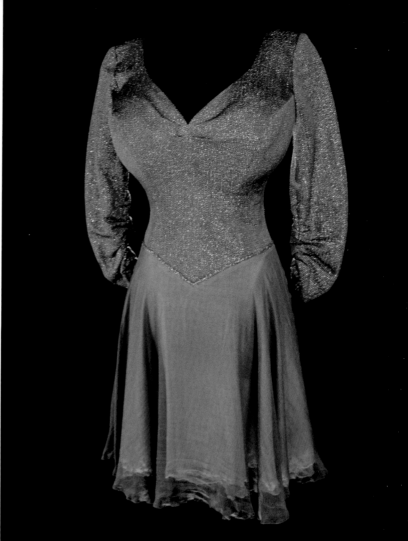

Me and my stand-in cuttin' a rug on the set of *Straight Talk*, 1992.
On the right is my dance-instructor costume, which I wore before
I got "discovered" and became a different kind of radio star.

The 1990s was the decade when I learned that I can wear all kinds of things and still be Dolly—kind of like my character Shirlee in the 1992 movie *Straight Talk*. In a case of mistaken identity, she goes from being a small-town dance instructor to a highfalutin celebrity on Chicago radio, but she never loses her down-home ways.

After looking like a country singer in the 1970s and then a Hollywood star in the 1980s, I went for a little bit of both in the 1990s. Plus, some of those fresh new looks my designers created for me inspired my stage wear in the 2000s, when I'd spend more time onstage than I had in years. And, of course, I'd be taking those rhinestones right along with me into the twenty-first century. I'll never stop wanting to shine!

The Unsinkable Dolly Parton

Costume Designer
Debra McGuire

Debra McGuire began her career as a painter in Northern California, then became a jewelry and accessories designer in New York and, eventually, a costume designer in Paris, where she began creating costumes for movies, television series, and theater productions. Among her best-known works are her costumes for *Friends* and many Judd Apatow films. As Debra recalls:

"I clearly remember my first meeting with Dolly. She was wearing a yellow-and-white gingham dress, and she looked like a porcelain doll. I have goose bumps just thinking about it. It was like nothing I had ever experienced. And that started several glorious years of working with Dolly.

"I decided if I was going to be designing for Dolly, I wanted to make her look like she'd never looked before. Since I was doing *Friends* at the time, I did drawings of Dolly with hair like Jennifer Aniston's. Dolly had never looked like that before. I think just seeing herself in these drawings with that cool hair affected the way I did the designs. They were much more happening in terms of contemporary fashion. To change a look can be challenging.

"One time I'll never forget is when Dolly's office called me three days before her fiftieth birthday and said, "Dolly's birthday is coming up and she wants you to make something." It was a big deal. We did a gold lace dress and worked around the clock to complete it. I had one of my assistants working with me at five o'clock one morning. It was still dark, and suddenly we heard this pitter-patter on the cement outside. We looked at each other and I was like, 'What is that?' And then all of a sudden, there was a knock on the door, I opened it, and there was Dolly. I almost had a heart attack. 'What are you doing here?' I asked. She said she happened to be in my area and saw the light on in my shop. That was the greatest! She just wanted to see my shop.

"I worked with Dolly for a couple of years before passing the baton to her next designer. Afterward, her assistant came to pick up the body form that I had. He had a little red sports car with the top down, and we had to put Dolly's body in it. I just wish I had taken pictures of him driving away, because everybody would recognize 'Dolly' in the back seat. It was hysterical. That image I'll never forget."

Left: I asked Debra to design a special outfit for my induction into the Country Music Hall of Fame in 1999. Its mix of sparkle and fringe reminded me of the country *and* western artists who came before me. *Opposite:* The Debra McGuire dress I wore to honor the '50s-themed Jukebox Junction at Dollywood.

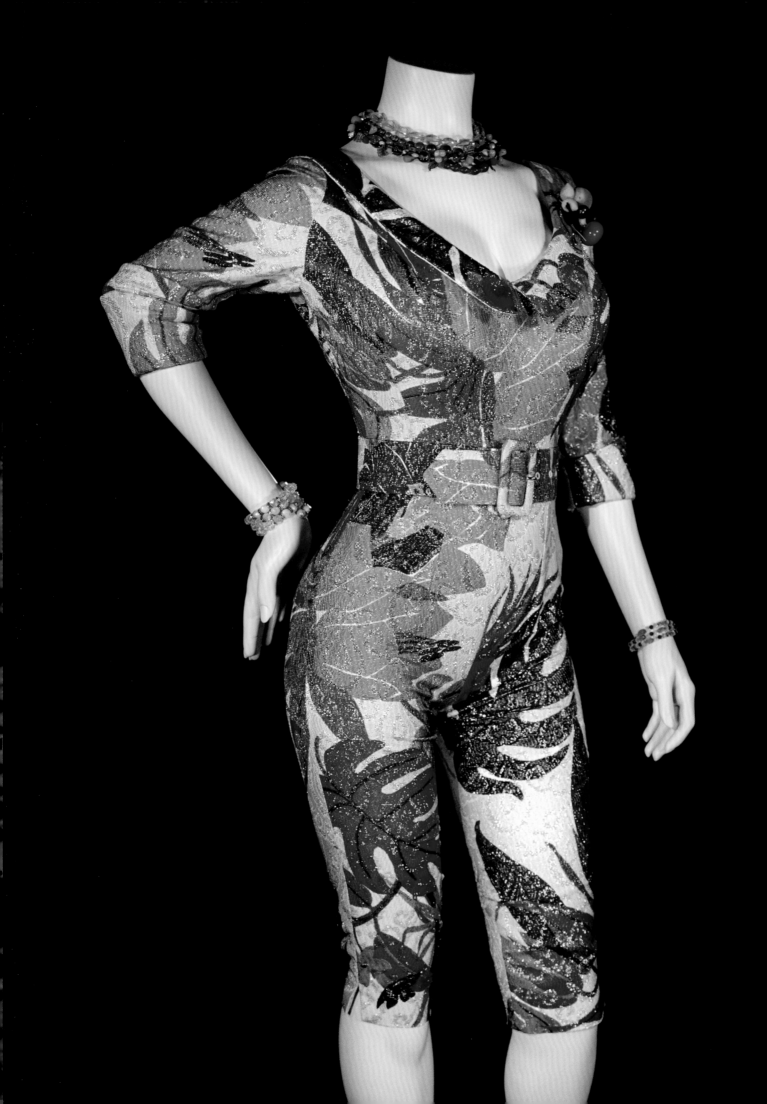

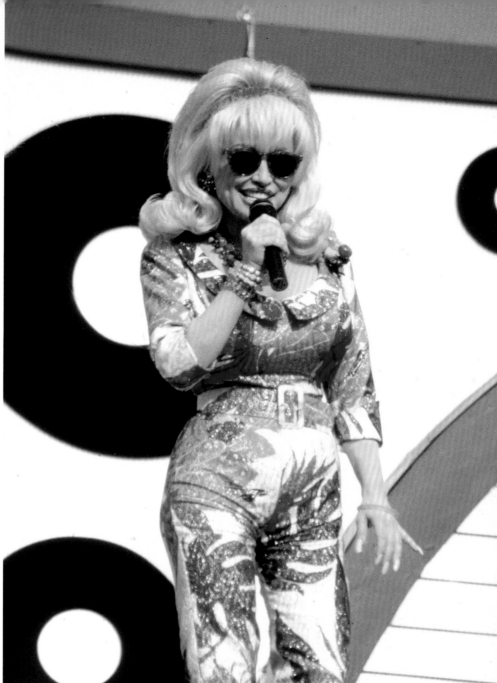

Debra found this unique vintage fabric to make my tropical jumpsuit, which I wore to Jukebox Junction's grand opening. I love the little touch of Carmen Miranda in the fruit jewelry!

Designer
Robért Behar

Robért Behar has been designing custom clothing for Dolly since the mid-1990s. Born and raised in Paris, Robért graduated from the art school Atelier Leconte, then continued his fashion and artistic education at the École des Beaux-Arts before moving to Los Angeles. Robért's clients have also included Janet Jackson, Mariah Carey, and Coldplay. As Robért recalls:

"I grew up in the fashion industry. My first jobs were backstage at fashion shows in Paris. I loved all that. I learned to make patterns and to design fabrics and clothes. I never wanted to design for a line; I just wanted to do couture, clothes that are one of a kind. That was always my dream.

"In 1996, a friend of mine was working with [talent manager] Sandy Gallin, and Sandy was looking for somebody for Dolly because Tony Chase had passed away. Being French, God forgive me, I did not know who Dolly was. I turned down the offer several times, thinking it was a costume-styling job. Then Sandy was calling me incessantly, and we finally spoke. He said, 'It's not about *styling* Dolly, it's about *designing her stage costumes*.' I was like, 'Hold on a second. That I wanna do.'

"My first meeting with Dolly was beyond all right. I had a styling book with all the photo shoots I'd done. She went through it and said, 'Wow, those girls are very pretty, but you know I'm not looking like that.' While I was talking to her, she said, 'That's okay, you can look down—everybody looks at my boobs when they talk to me!' We had a long conversation that day about my ideas for her clothes. Then they called me and said, 'She wants to see all those ideas on paper.' I did sixty sketches and presented them to her. She went, 'I like this, I like that. Will you have time to do all this in three weeks for *Treasures*, my CBS special in November?' And I was like, 'Oh, sure.'

"First, I did an outfit for her appearance on the Jay Leno show to promote *Treasures.* Then we did the CBS special, and suddenly I was there with, like, thirteen costume changes for her—that was a lot! And I had barely met the woman. Oh my God, it was so scary! I'm putting her in the clothes that I made, so they should zip up, no problem. For the opening number, I'm zipping up her leather pants that go with a red leather jacket and white shirt underneath it. I'm tucking in her white shirt, zipping up her leather pants—and the entire zipper literally comes out in my hand. And we're doing a live TV show, so you have the thirty or forty seconds of commercial and that's it. I tell her, 'I'm gonna sew the pants on you,' which I did, and the needle went into my fingers and now I'm bleeding, but I'm like sewing, sewing. Most people would have gone completely berserk, freaking out. But from above, that little angel face looked at me and said, 'Robért, those pants are so tight that if I fart, my wig is gonna blow off.' I'm in pain, and sewing, but now I'm crying *and* laughing! We *did* it, and it was fine. She had diverted the

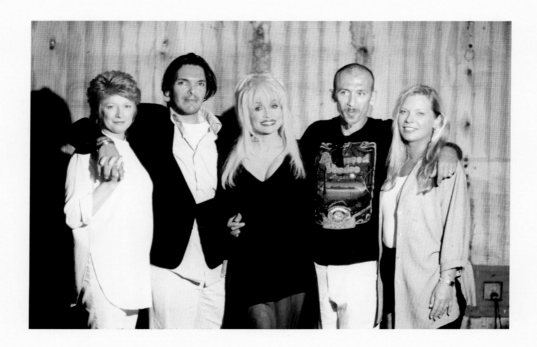

My creative team on my "Peace Train" music video:
Judy Ogle, director Christopher Ciccone (Madonna's
brother), me, Robért Behar, and hairstylist Cheryl Riddle.

situation and made it funny enough that the stress was gone. That's the kind of generosity that you don't find, ever.

"One of my favorite ensembles for the CBS special was a fitted brown suede jacket with gold-and-turquoise buttons and a copper leather lining paired with a tiny gold-and-black satin skirt with a ruffled train to the floor. The clothes for that special were a big departure for Dolly. After that, we went back into a more 'Dollyized' venture.

"When people ask about my inspiration for her designs, the term *Dollyized* is what inspires me the most. It's like, 'How would Dolly wear this?' It's easy for me to Dollyize her clothes because I look at her clothes as sweet and wonderful like she is. They're happy clothes. Dolly loves to wear white and pink, and I love white on her because it's like daylight. Blue, chartreuse, and lavender look great on her—and also yellow, depending on the shade. She's so beautiful. Dolly is color. She brings out the life in a navy blue, but I don't care for her in black—unless, of course, there are rhinestones and she is singing and there is that smile. Her clothes are dramatic, but they're not dark or edgy. It's just all about joy. That's what inspires me the most when I design for her.

"I did things for Dolly that I've never done for anybody else. Like this brown faux-suede jacket and gorgeous dress with white eyelet lacing and hand-painted orchids. (Making that dress is how I met my husband; he was working with orchids then.) She validates your creativity, and she appreciates the work; the appreciation is even better than the paycheck.

"There is no diva in Dolly. In so many years working with her, I've never seen her lose her cool. Once, we did the clothes for a video before we knew the location, which turned out to be Death Valley—in August. She was wearing an aluminum foil dress. I was like, 'Oh my God, she's going to die!' But only consummate professionalism came from her!"

Back Through the Years
Robért Behar Gallery

Robért started designing clothes for me more than twenty-five years ago. I've lost count of just how many Robért outfits I have. His imagination and ability to come up with a look that fits the occasion are really wonderful. We've had quite a few crazy adventures together, that's for sure!

I've worn Robért's designs during some of my most notable occasions, from the Kennedy Center Honors to rockin' out onstage when I was inducted into the Rock & Roll Hall of Fame. So many different looks, so many memories that I'll never forget.

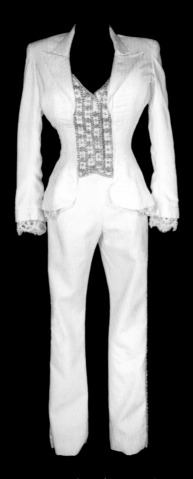

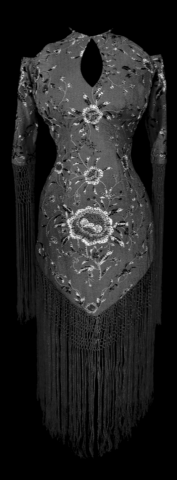

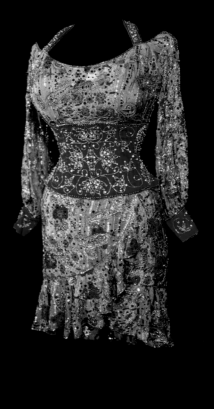

I sang "Travelin' Thru," my Oscar-nominated song, at the Academy Awards wearing this sparkling pantsuit.

I wore this drop-dead gorgeous dress to sing "Creepin' In" with Norah Jones at the Ryman.

One of my favorite Robért Behar dresses from the Vintage Tour, 2005.

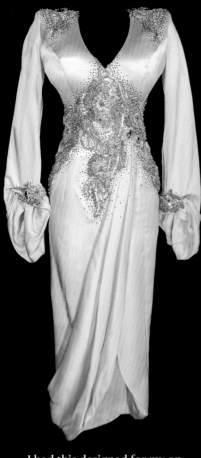

I had this designed for my on-camera introduction to the "These Old Bones" episode of my *Heartstrings* series on Netflix.

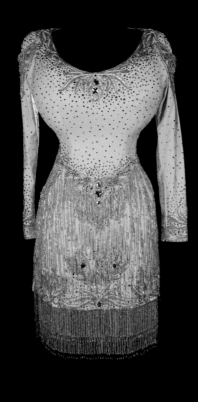

A dress from my 2011 Better Day tour.

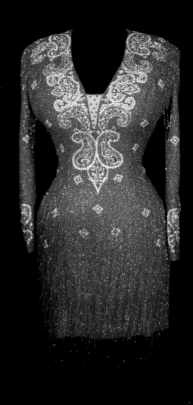

You can see me in this dress in a November 2002 *Vanity Fair* feature; or maybe you saw it onstage during my Halos & Horns tour.

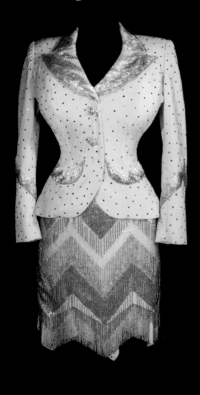

I wore this suit when I was honored at the 2006 Songwriters Hall of Fame ceremony.

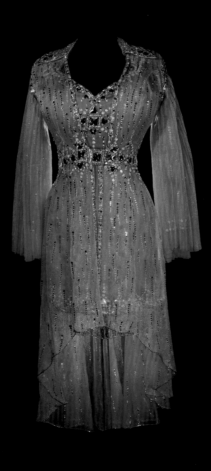

I chose this dress for my *Live from London* filmed concert in 2008.

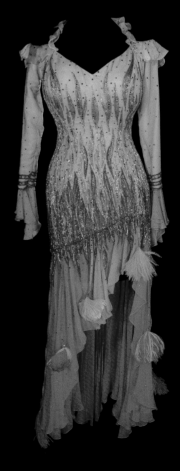

I hosted the CMT Flameworthy Awards wearing this fiery dress in 2004.

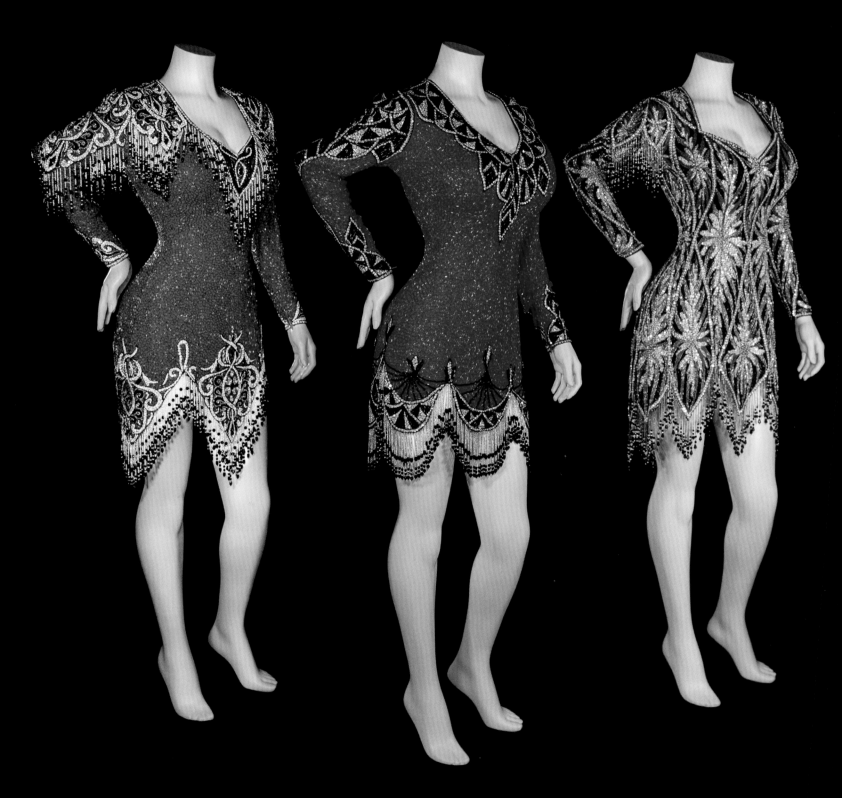

Each of these sisters—designed by Tony Chase—weighs almost ten pounds,
and I alternated among them while performing around the world in the 1990s—
though I probably returned home about an inch shorter than when I left!

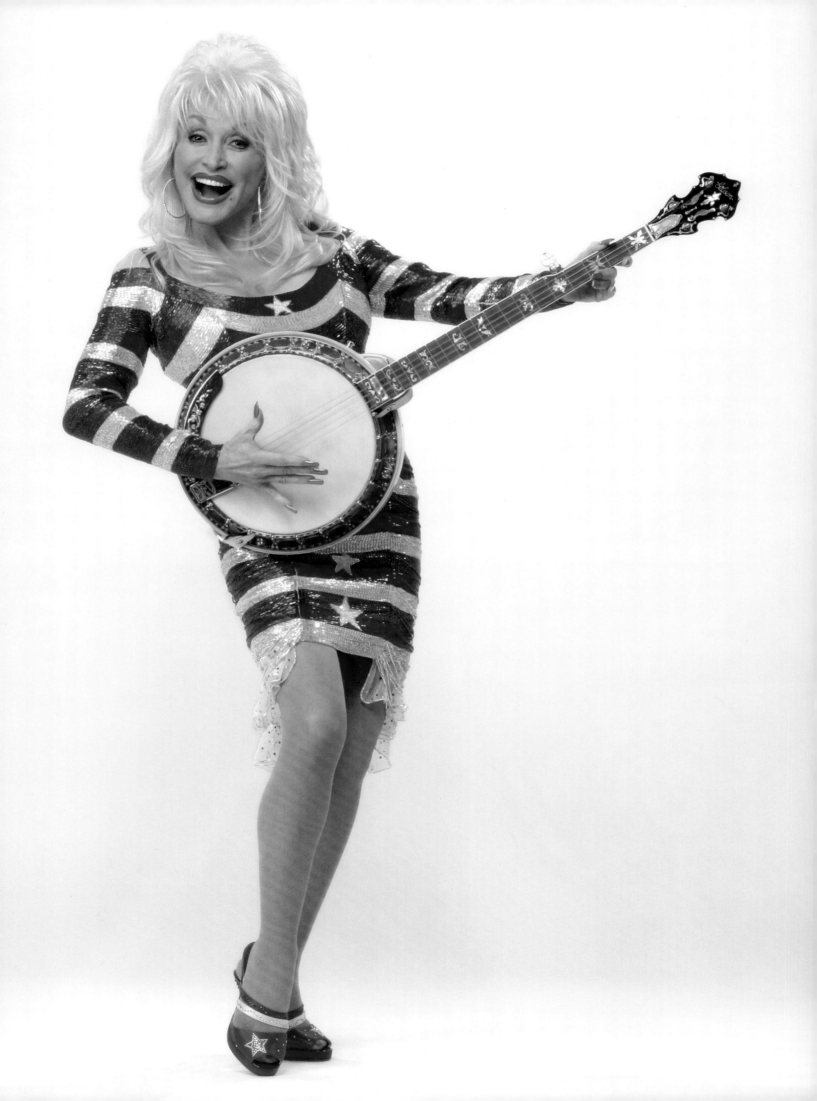

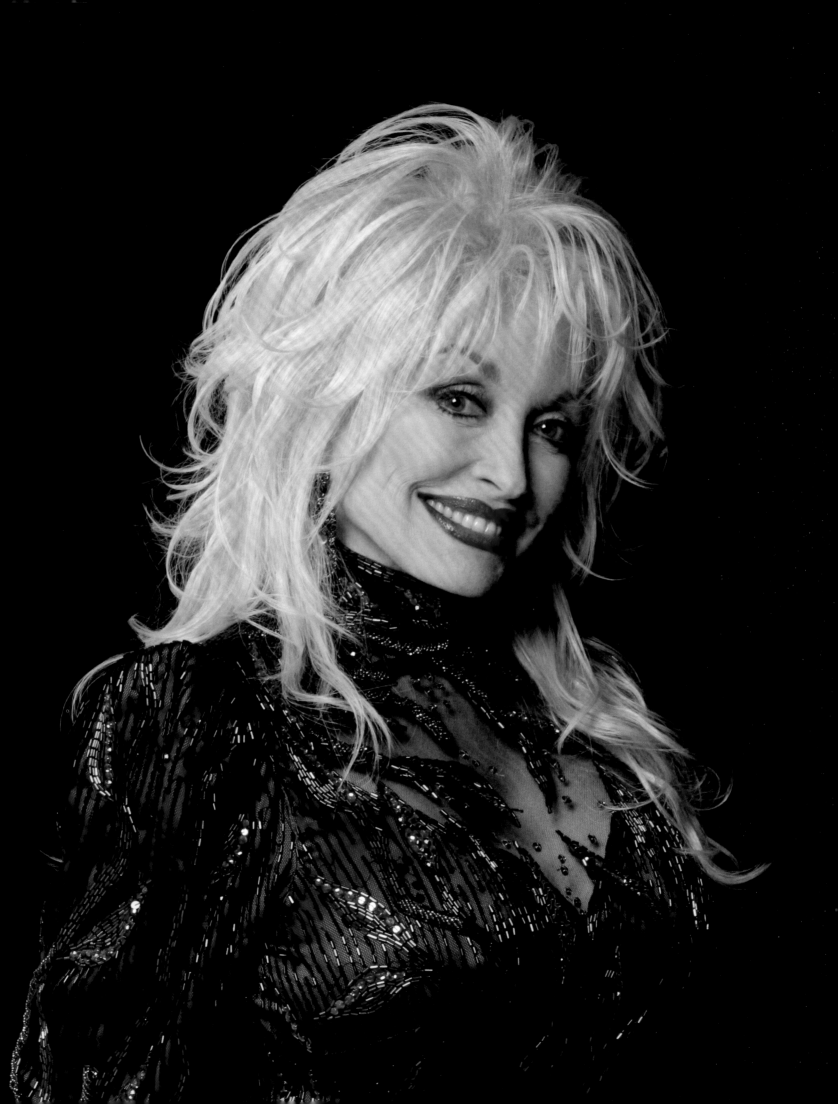

"Find out who you are and do it on purpose, with purpose."

Dolly

Although Y2K fever inspired "futurism" among fashionistas and in American pop culture, Dolly spent the beginning of the new millennium returning to her roots and the bluegrass style she loved as a child, recording several critically acclaimed albums. She began touring the country and abroad again, performing in a plethora of innovative costumes. She also gained a whole new generation of fans through frequent television appearances. In 2006, she began appearing as herself—"Aunt Dolly"—on her goddaughter Miley Cyrus's popular Disney channel TV show, *Hannah Montana*. Around the same time, she did a star turn at the Oscars when her uplifting folksy song "Travelin' Thru" was nominated in the Best Song category for the movie *Transamerica*. Dolly was seemingly everywhere.

As both the elegantly attired Kennedy Center honoree and the gingham-and-denim-clad "Backwoods Barbie," Dolly presented a multitude of eclectic visual approaches throughout the decade. Her dazzling array of looks veered from fringed, feathered, and bejeweled gowns to leg-baring capris and rhinestone-studded denim. Some were the creations of top Los Angeles designers Robért Behar and Stacia Lang. Others came courtesy of her talented Nashville team, led by her newly appointed creative director, Steve Summers, with whom she forged a fruitful artistic relationship and who has guided Dolly's unique visual presentation ever since.

—Holly George-Warren

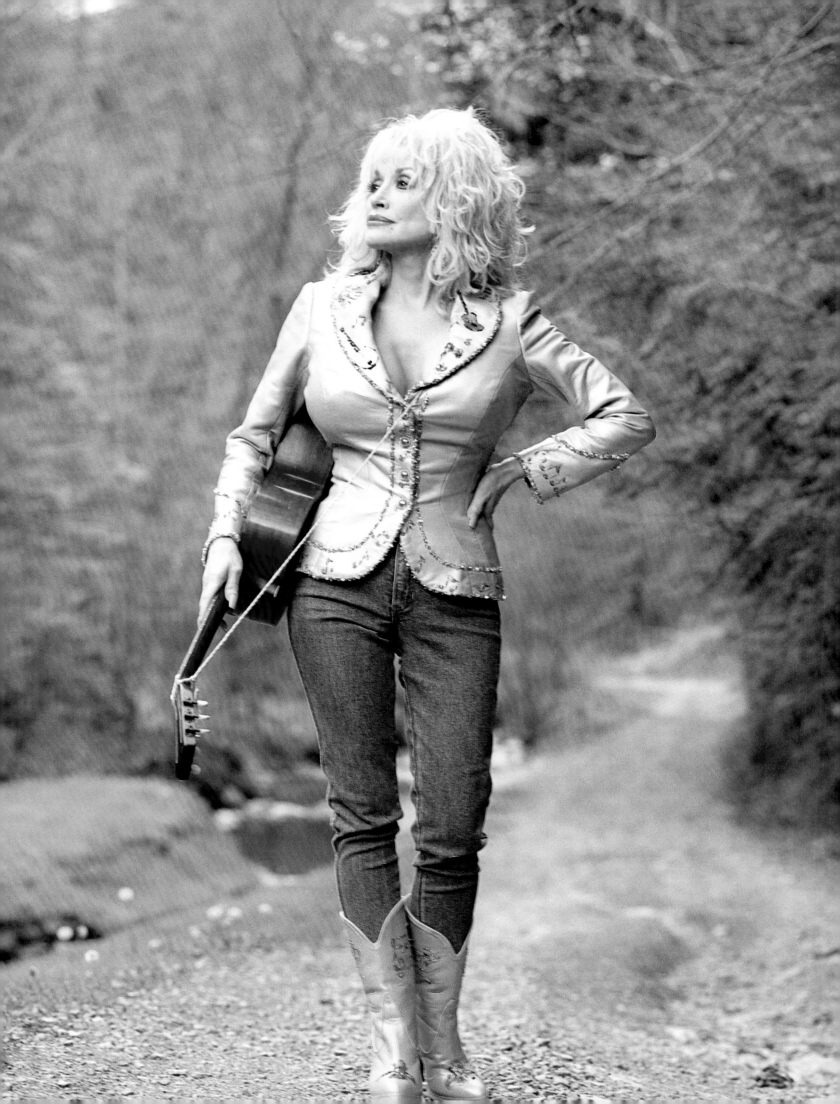

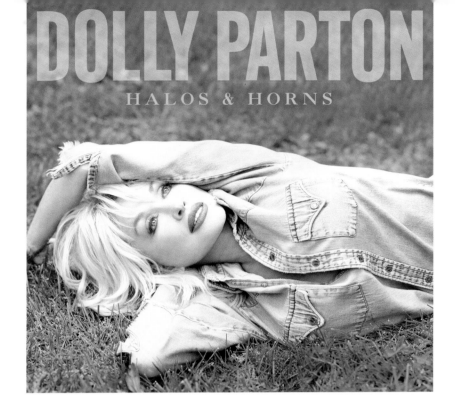

I love these photos of me at my ol' Tennessee mountain
home, which Annie Leibovitz took for *Halos & Horns*.

*W*hile lots of folks started the year 2000 fretting about their computers going crazy, I kicked off the 2000s celebrating a country music tradition that started back in 1925. I cohosted the CBS special *Grand Ole Opry 75th: A Celebration* with Vince Gill. We got to pay tribute to those beloved country artists who came before us. Coincidentally, the music I grew up on also inspired my own recordings in the new millennium. My Smoky Mountain DNA cannot be denied! Playing music from my Appalachian roots means so much to me.

I recorded five albums in this decade. For each of my albums, once I figure out the title, I try to dress accordingly for the cover shoot. I had started experimenting with dressing down in 1998 with *Hungry Again*. A favorite album of mine, it was produced by my cousin Richie Owens. For the cover, I wore real simple clothes: flat shoes and denim overalls. I was sitting in a porch swing, with my hair in a braid, and I thought I looked "hungry again." Three bluegrass albums followed, and I dressed real casual for those cover shoots. For *Little Sparrow* in 2001, Jim Herrington photographed me in a black turtleneck and jeans. And for the cover of *Halos & Horns* in 2002, I pulled out my favorite faded-denim snap-front shirt with frayed sleeves—the one in which I'd been photographed in 1977. Thank goodness I never get rid of anything, even when it's frayed! I love that comfy ol' shirt, and that's one of my favorite looks from the 1970s. All those down-to-earth looks really suited me then, when I felt like I was going back to basics.

Country Girl Glam

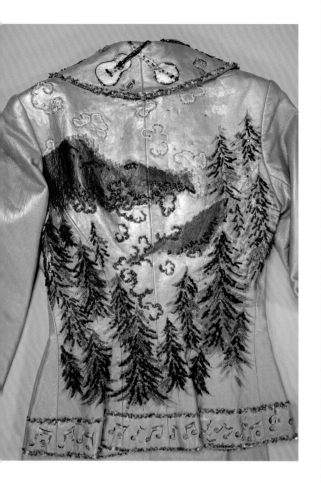

Chicago-based designer Bambi Breakstone painted elements of my life on this spectacular leather jacket in 2002.

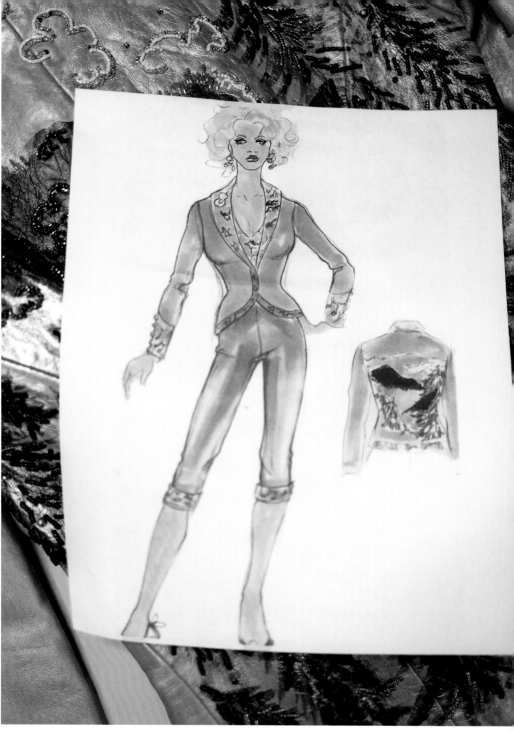

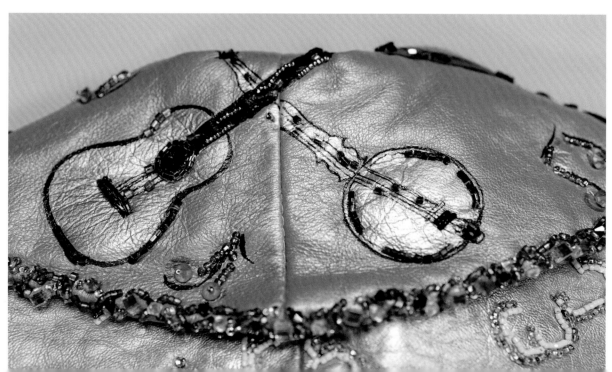

When I compare that comfy feeling of going back to basics with the excitement inspired by the future, I'm always reminded: You need to be your own best friend. You need to know who you are. As I've said before, find out who you are and do it on purpose, *with* purpose. Not everybody's supposed to look like a movie star. You should be comfortable in your own skin, no matter how far it stretches.

I continued to work with the brilliant Robért Behar, whose creativity never ceases to astound me. He designed some spectacular outfits for my special events, my awards ceremonies, and my "theme" album covers, like the 1940s-inspired glittering "stars 'n' stripes" suit with pillbox hat for the *For God and Country* cover in 2003, and some eye-catching country-gal styles for my 2008 *Backwoods Barbie* photo shoot, including an adorable gingham top with denim clamdiggers and matching suspenders. For the LP cover (where I'm perched on hay bales in the back of a pickup!), my outfit looks like a 1960s Barbie doll getup.

And for the first time in ten years, I set off on a national tour. Being back in front of audiences was wonderful and reignited my music career. Touring behind *Little Sparrow* in 2001, I appeared on *Austin City Limits*, and Robért designed the coolest cowgirl outfit this side of Nudie and Manuel: brown leather with embroidered roses, fringe, and rhinestones. For my Halo & Horns Tour the next year, he created a sexy hot-pink chiffon dress. I wanted a "peasant dress" look for my Vintage Tour, behind the *Those Were the Days* release in 2005, and he more than delivered! For my 2007 appearances in London, filmed for a DVD, Robért designed a blue chiffon gown fit for a queen.

Robért also came up with some great stuff for my music videos. In "Shine," which won a Grammy, I wore a blue jean jacket with frayed edges and matching denim miniskirt. For "I'm Gone"—a wild fairy-tale-meets-sci-fi video—he created a gorgeous Cinderella-style dress in chiffon, silk, and tulle. For my 2004 guest appearance at the Ryman Auditorium with Norah Jones, he designed a silk dress with super-long fringe on the hem of the sleeves and the skirt. I could never play guitar while wearing that dress because of all the fringe. Of course, I had to joke around onstage about "fringe benefits."

In addition to Robért, I also discovered some great new talent. Stacia Lang is a remarkable designer whose work for Prince I'd long admired. I figured she could come up with great looks for me—and I was right!

Country Girl Glam

In Love with Leather

I've been wearing leather for decades—pants and jackets and vests and more. You can make it look real sexy: I like wearing a leather jacket with a little bustier—more biker chick than rock star. In the 1980s, I wore leather dresses with shoulder pads, studs, and fringe, and I'm still wearing fringed leather dresses in the twenty-first century! Nothing is greater than leather—you can't hardly beat it. Every time I put on my leathers, I think, *Why ain't I been doing this more?*

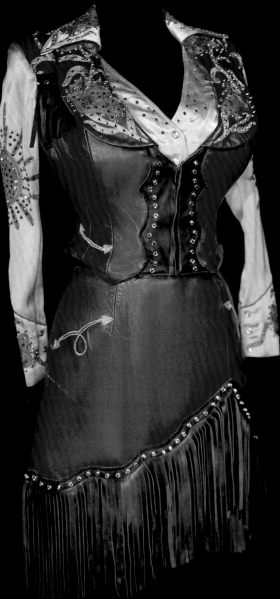

Robért was inspired by an outfit worn by my early influence, Rose Maddox, that he saw in a book called *How the West Was Worn* and made this for me to wear on the *Austin City Limits* TV show.

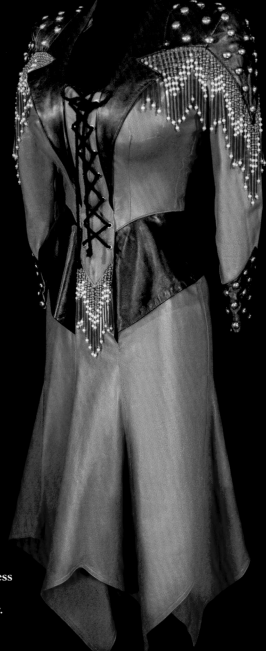

I wore this Tony Chase dress when I sang with Merle Haggard on my TV show.

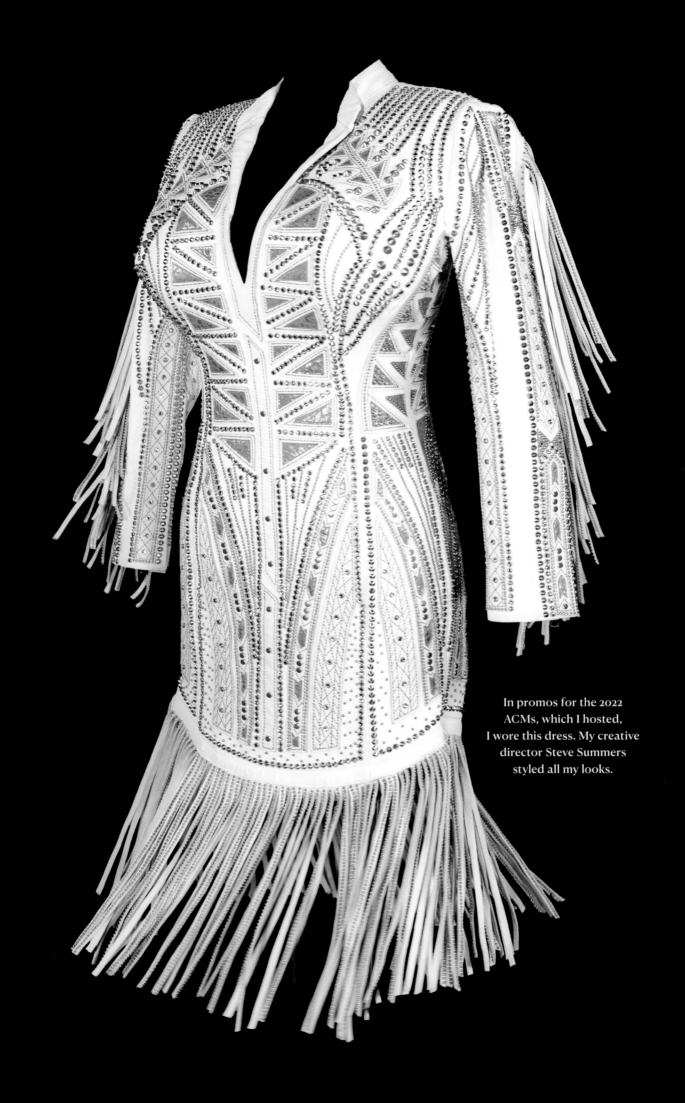

In promos for the 2022 ACMs, which I hosted, I wore this dress. My creative director Steve Summers styled all my looks.

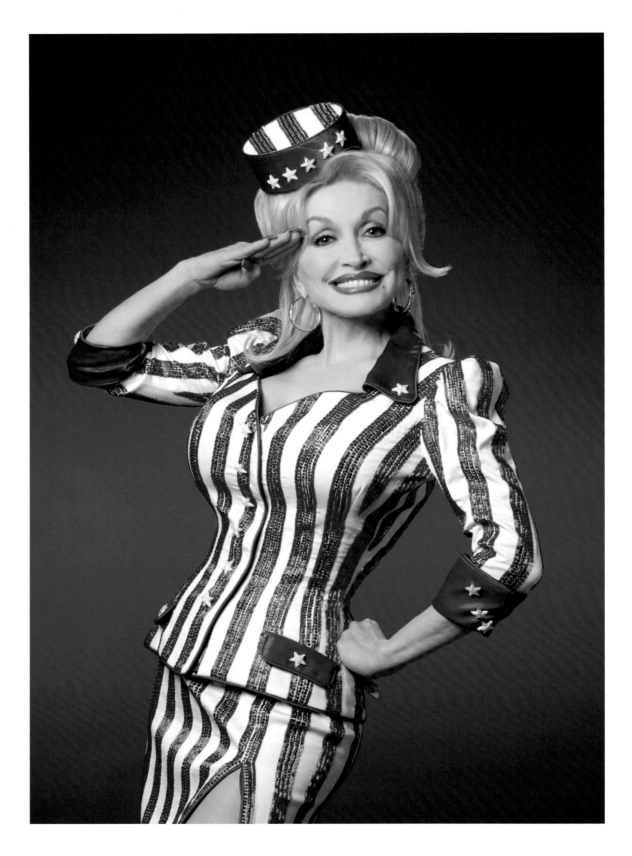

A Frenchman—Robért—designed this patriotic outfit I wore on the cover of *God & Country* and for a Fourth of July celebration at the Capitol building in Washington, DC, in 2003. This image of me was reproduced on the nose of a US Air Force jet. Anything for the boys in uniform!

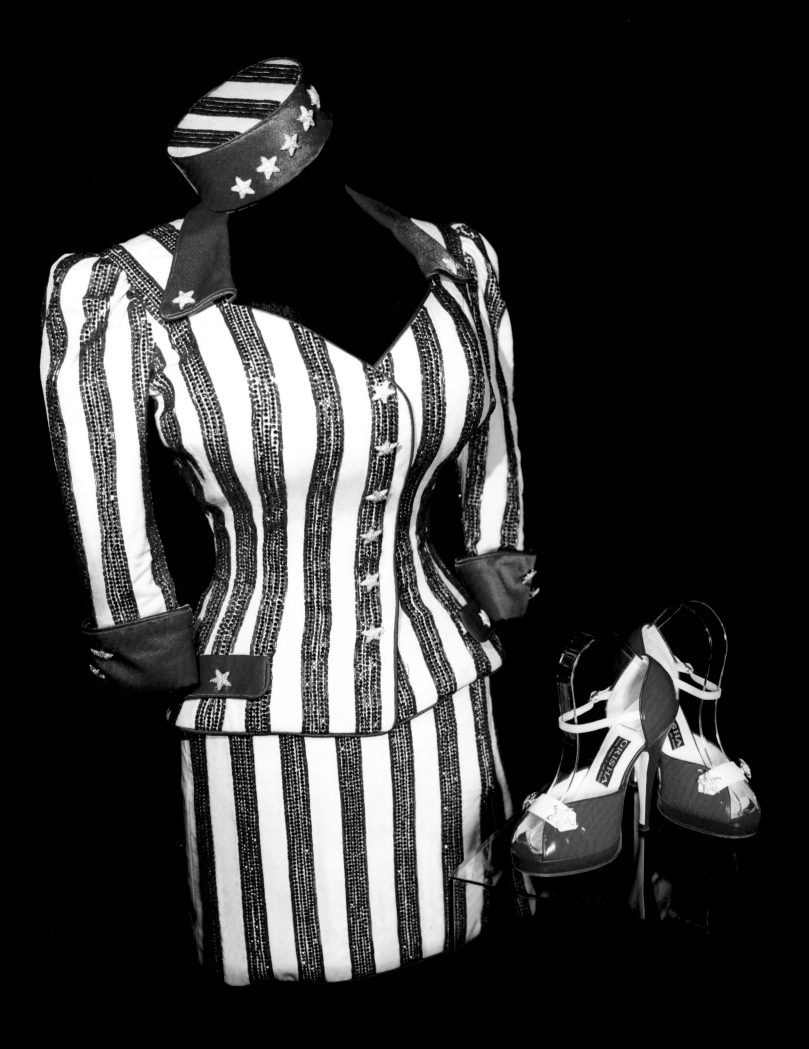

Costume Designer
Stacia Lang

Stacia Lang is a Los Angeles–based costume designer. In 1990, Stacia became the patternmaker and sketch artist at Prince's Paisley Park. Within months, she became his exclusive wardrobe designer. Stacia remembers her path to working with Dolly:

"After graduating from the Fashion Institute of Technology in New York in 1983, I wrote Dolly a letter. She responded, and I still have that letter. She wrote, 'Dear Stacia, Thank you so much for the beautiful designs. I appreciate you sending them to me. However, I'm working with a designer at the present time. Maybe sometime in the future our paths will cross. God bless you. Dolly.'

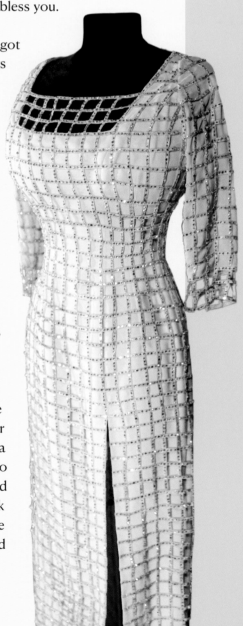

"Many years later, after I was designing for Prince, I got the idea that I really wanted to send her some of the things I'd done. After a few months, Dolly's office called me and said, 'Dolly would love to meet you.' I went to her home, and it was super exciting. She said, 'You did something for Prince, and I feel like you know a little bit about designing for small people.' I said, 'Yes, I do!'

"Of the dresses that I worked on, I especially love the Grand Ole Opry dress with the crisscross lattice-work. For the beading on her clothing, we chose Silvia's in Hollywood; I knew that they were the best at what they did. They came up with samples and showed me techniques they could use. I wanted to add a little different texture for Dolly, giving it the dimension of trapunto (a raised embroidery technique using two layers of fabric). I was excited about the fact that the body of the dress would be solid beadwork.

"I also needed to design the shoes for this look. Prince always had to have the shoes to go with the garment, so I was used to that. When I showed Dolly a sketch, she zeroed in on the clear-vinyl shoes right away. I told her it would be wonderful to show her feet, and the shoes—a collaboration with Dolly's shoemaker, Grecia—helped to elongate her legs. The other similarities between Dolly and Prince are, first of all, neither one could buy off the rack because of their body and stature. Plus, *they* are their name brand. They can do whatever they want, and they have, and that's why their styles stand out."

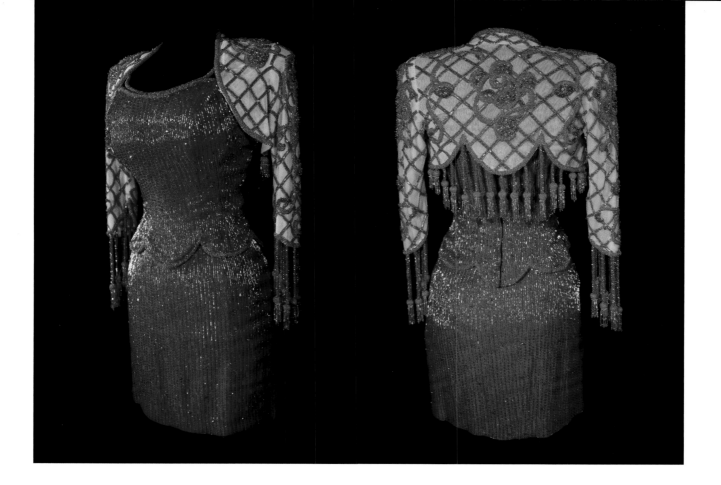

As a little girl, I dreamed of one day being on the Grand
Ole Opry in a red dress. Stacia Lang made my dreams
come true when she designed this beauty to celebrate
the Opry's seventy-fifth anniversary.

For decades now, I've been working closely with the extremely talented Steve
Summers. We first met back in the 1990s when he was a singer and dancer at
Dollywood. It turned out he had a great sense of design and ingenuity regarding
costumes. As a performer himself, he knew what worked better onstage and then
came up with clever solutions to wardrobe problems. I offered to pay his way to
attend the Fashion Institute of Technology.

Afterward, he came back to work at Dollywood, designing my costumes there and
all kinds of other Dollywood costumes and sets. I loved the creativity that Steve
put into my wardrobe. He'd tell me, "You're the best doll I ever had!" He loved
dressing me in those Dollywood outfits. It gave him a chance to really express
himself creatively. He came up with some pretty wild and wonderful things at
Dollywood. And he took that same flair to Nashville when he became my creative
director in 2004.

Country Girl Glam

Creative Director
Steve Summers

Steve Summers began his professional career as a singer and dancer at Dollywood in 1991. After attending the Fashion Institute of Technology in New York, he began designing sets and costumes for Dollywood. In 2004, he became Dolly's creative director, overseeing everything from the creation of hundreds of outfits each year to the looks of her music videos, album covers, and TV, concert, and movie appearances—and anything else with the Dolly Parton brand attached. As Steve recalls:

"When I started at Dollywood, my life experiences were different from most performers there because I wasn't a kid. I was twenty-seven years old, and I already had some experience under my belt—not onstage but in life.

"As a performer, I whined and whined and whined about the costumes and props, like, 'Why is this *real*? You know, it doesn't have to be real.' When they would hand me a shirt to wear with real buttons and I knew I had eight seconds to get out of it, I was like, 'This doesn't make any sense. It should be Velcro with the button sewn on the other side.' They finally got tired of listening to me gripe, and Michael Pageant, the show director at the time, said, 'If you think you can do better, I need a really Vegas-y outfit for the lead dancer to wear in the opening number of the new production, 'Fire on the Mountain.' Why don't you give it a shot and make one?' So I did. The body was made from spandex, and all the trim, the beading, and the feathers were attached with Velcro, so you could just pull them off to clean the garment and then put them all back on. It finally got bigger and bigger to where I was in charge of all the costumes for most of the shows.

"Then, after I'd been complaining about the real wagon wheel I had to carry around the stage and asking why it wasn't made from lightweight Styrofoam, the same thing happened with the sets and scenery. You can learn a lot of things if you're willing to pay attention to how things work—and to ask questions. Dollywood ended up being the best education I ever had.

"My relationship with Dolly began when we worked together at Dollywood many, many times. Then it got to where she would call me and say, 'I'm getting ready to go on tour. Would you come and work on the set for my show?' I would go for a weekend, and then it was like, 'Well, would you design the set and why don't you do all the backup singers' clothes?' Okay. 'Would you do the lighting package too?' Okay. 'Hey, would you come direct my show?' Okay.

"Every time she came to Dollywood, I was always her partner, and I knew enough that she must have thought, *Well, he seems to know just enough about all these different things to maybe be helpful.* I've now been working for Dolly's companies for thirty years.

"Working with Dolly inspires me because it's different every time. I feel like I am a good fit for her because I always believe in whatever she's doing. She's very

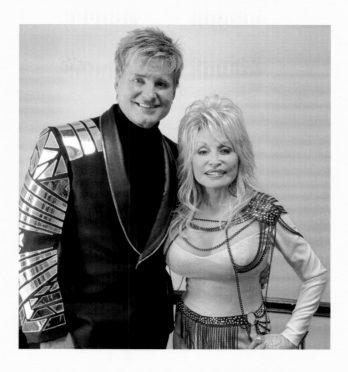

Me and Steve, my creative director and leader of my Dream Team. Sometimes we show up in coordinating outfits, which reminds me of my his-and-hers days with Porter!

much a nurturer when it comes to giving you the information you need to help her get where she wants to go.

"My job is not to decide where Dolly's going; she's driving a locomotive, and I'm just shoveling coal as fast as I can to keep the engine going. I'm not the dreamer-in-chief either; she's the one who figures it out. She is in charge of where she wants to end up with the goal of the look, and then my job is to get us there.

"I get to design for a lot of different people—they all just happen to be Dolly! I get Dolly Parton the singer, Dolly Parton the actress, Dolly Parton the philanthropist, Dolly Parton the theme park owner, Dolly Parton the book lady, Dolly Parton the character actress on TV. I get lots of different Dollies, and every one of them is drastically different. She has always been clear that she isn't as worried about *what* she wears as much as making sure she is always appropriate.

"It would blow people's minds if they understood the sheer volume of what we are doing on a monthly basis, on a yearly basis. We've got at least one outfit in production every day. It's about three hundred outfits a year. If we go to an event in New York and we're gonna do press, we may only be there for twelve hours, but she might wear twelve different outfits. And when she goes to Dollywood for five days, that might be fifty outfits—if she goes there five times in a year, that's two hundred and fifty.

"Dolly has trained me well. I learned the hard way, a lot of times, by failing. I did this one dress that I thought was the greatest thing on the planet. It was chartreuse leather and sea-green beads. I loved this outfit, but the leather was way too thick, and it never fit right. Dolly finally pulled me aside and said, 'Steve, you're not gonna win 'em all. But the thing is, we have to keep trying.'

"One thing I love about Dolly is she always says *we*. And we do have an amazing team that works so well together to bring to life so many different ideas for Dolly's outfits."

Back Through the Years
Steve Summers Gallery

I think I'd call Steve my style soulmate. We've worked so closely together over the decades that he can convey my thoughts and ideas into spectacular clothing that has accompanied me all over the world. He's so inventive. He likes to say that working at Dollywood was where he got the education he needed to become my creative director. He knows my wardrobe inside and out, from the 1960s on, and he loves to surprise me with little design elements from the past in my current outfits. I just love being Steve's human Barbie doll and letting him dress me!

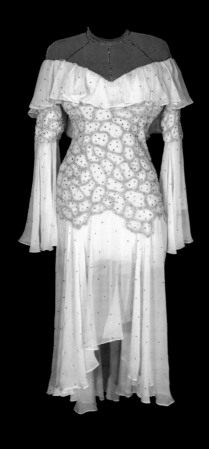

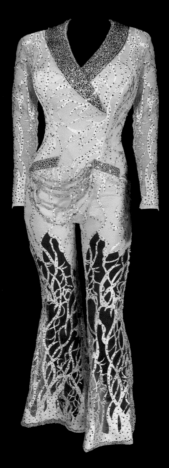

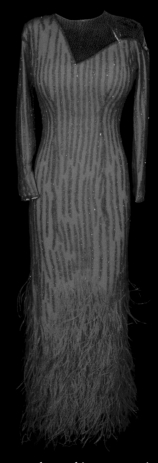

I chose this design to host the CMA Awards in 2019.

This is what I wore at my Pigeon Forge concert during the Pure & Simple Tour.

Steve made me this asymmetrical Christmas dress in 2020.

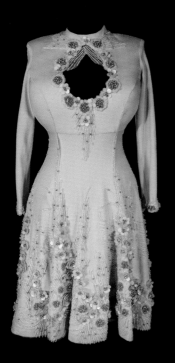

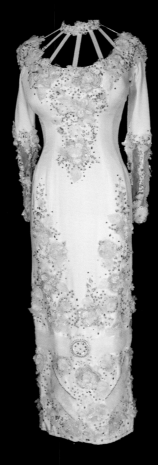

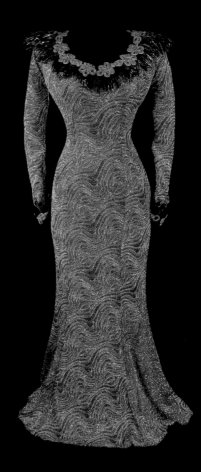

I wore this Steve Summers dress in the music video for "Does He Love You," a duet with my longtime friend Reba McEntire.

Steve says this is his favorite of the many dresses he's designed for me. I wore it in my "Home" music video in 2014.

Believe it or not, I wore this gown while milking a cow in a photo session for my *Better Day* tour program book!

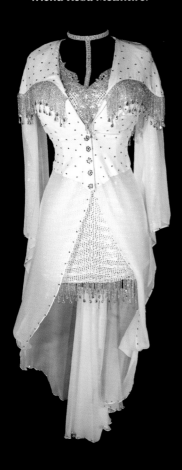

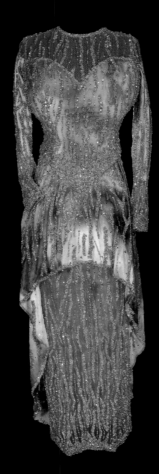

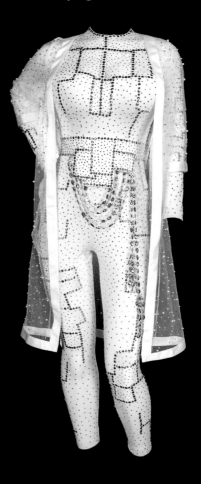

I wore this in my 2020 "Holly Dolly" Christmas special.

Just before my last performance with Kenny Rogers in 2017, I chose this dress for our appearance on the *Today* show.

I performed "Girl in the Movies" wearing this catsuit on *The Tonight Show with Jimmy Fallon*.

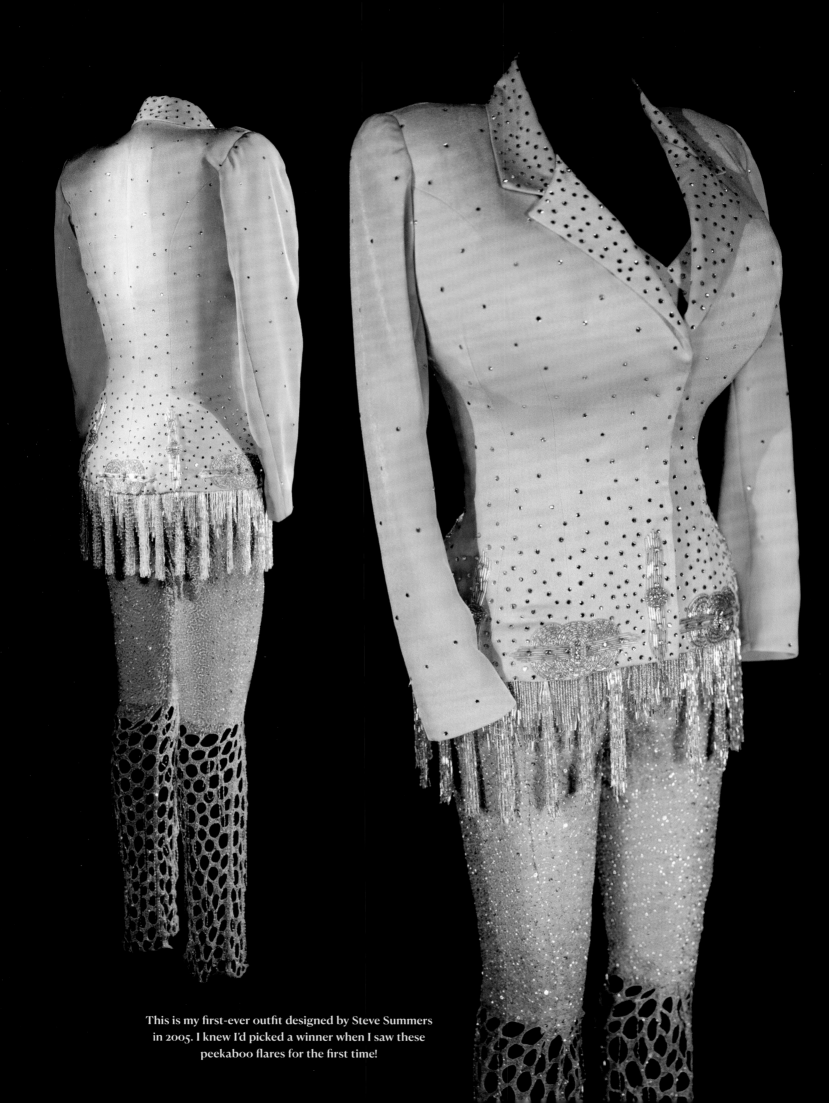

This is my first-ever outfit designed by Steve Summers in 2005. I knew I'd picked a winner when I saw these peekaboo flares for the first time!

Another crucial member of my team is the amazing Iisha Lemming. She can do—and is willing to try—just about anything. And the details! I especially loved the intricate hoopskirt that she made for me with images of the whole Smoky Mountain range on it. She and Steve work so well together. They are like the Nashville version of Tony Chase and Silvia back in the 1980s. We're so lucky to have Iisha. She's done some of my prettiest things.

Because people see me in so many different outfits onstage and on TV, I've had people ask me, "Do you wear clothes just one time?" *No!* Sometimes I have them remade or reshaped. If it's a long gown and I like the way it fits, I'll have it cut off and made into a short one, more like a cocktail dress, for example. Or I'll have a blouse that's thirty years old and get a new pair of pants and a new belt to freshen up that outfit. If I have something I like, I just won't let it go. I don't believe in wasting things. I donate a lot of my clothes to charities, but otherwise I like to keep them and rework them and use them as much as I can.

Coming up with ideas for new stage clothes usually starts with a discussion between Steve and me. I'll remind him, for example, "I can't wear fringe on my sleeves because it's going to get caught in my banjo or in my Autoharp." Or "Those details on the clothes are going to mess up my dulcimer." I like looking elegant onstage, and I love it when you can see the silhouette of my legs when I wear sheer bell-bottoms—that's pretty, but it's workable. Since I sit on a stool for my acoustic set of Tennessee mountain songs, I can't wear a short dress and "show the box office." So Steve created little pantaloons that match my outfit, which has the look of a dress. That way I can sit, I can play instruments, and then I can get up from sitting on the stool with no problem. This is another reason I love my jumpsuits.

People don't realize how much performers have to think about. As much as I love cinching my waist in, I've got to have my diaphragm free enough so that I can actually sing. I want to look as good as I can, but I still need to breathe.

"People always ask me, 'What do you want people to say about you a hundred years from now?' I want them to say, 'Dang, don't she look good for her age?'"

—Dolly, 2009

Behind the Seams

242

Hairstylist
Cheryl Riddle

Nashville-based hairstylist Cheryl Riddle has been styling Dolly's wigs for the past thirty-nine years. As she recalls about her long relationship with Dolly:

"Dolly is such a beautiful lady, and I love creating different looks for her. One of my favorite wigs was for a show in London, and Dolly named that one Cupcakes. She names them all. That one looked like little cupcakes coming down the back of her hair. It took every bit of six hours to do. She named another one Twist and Spout. It kind of spouts out all over. Another one we call Stessany is a French-roll type thing. She named it after somebody she once knew back in school who used to wear her hair similar to that. Then we have the one we use the most, which is called Simple Classic. It's one she can wear with a lot of different outfits.

"My biggest challenge is to keep Dolly from getting bored. After almost forty years, I'm still trying to keep myself educated, seeing what's new and what's out there. But if you look at the runways right now, the girls are doing the straight part down the middle, and I'm like, 'No, no, no.' I wanna go back to the 1980s when they actually did stuff with their hair! There was so much creativity then!

"More than anything, I love seeing Dolly walk out with the full confidence of knowing that she looks beautiful. It's all about putting a smile on her face, and her walking out with that chin up—literally ready to conquer the world."

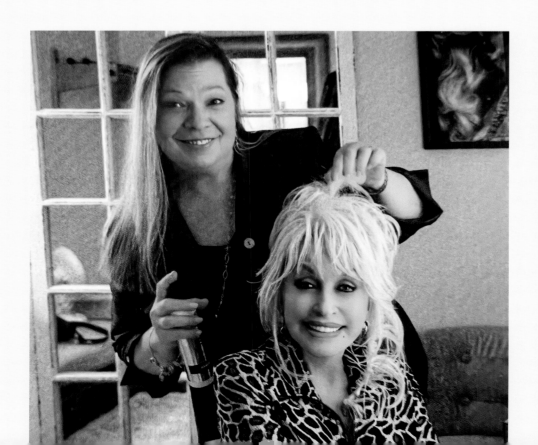

Master Draper
Iisha Lemming

After attaining her master's degree at the University of North Carolina, Iisha Lemming worked with theatrical costumes in New York and New Jersey. In 2007, she began working with Steve Summers. She has been working as the full-time pattern-maker and tailor for Dolly ever since. Iisha describes her creative process like this:

"The way Steve and I collaborate is that he's the architect and I'm the engineer. He draws the picture, and he or Dolly picks the fabric based on what color she wants or what the event is. Then I sculpt it to where it fits her as well as it can and looks as good as it can. I'm the technical part of it. My master's is in costume production—some people call it costume technology. Not everybody can be a designer—I don't have that brain. But I can make a designer's sketch—or Dolly's ideas—come to life.

"It's very exciting to see my art onstage because at that point it becomes part of Dolly's art too. For a long time, I've felt like this job has been part of my purpose on the planet—to support the good that Dolly puts out in the world."

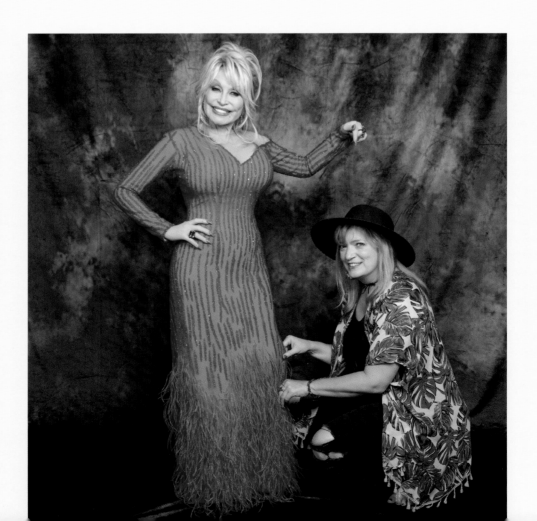

My design staff really worked hard on my 2017 Emmy Awards outfit. Iisha did the tambour beading with assistance from Hillary Adcock, and Rebecca Seaver and Bridget Corsa did the rhinestoning.

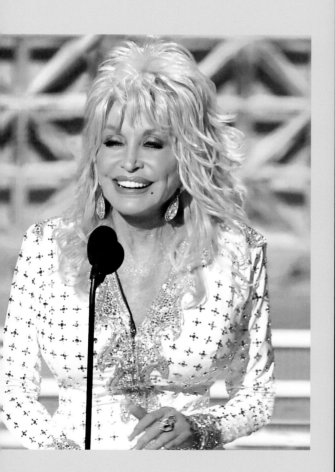

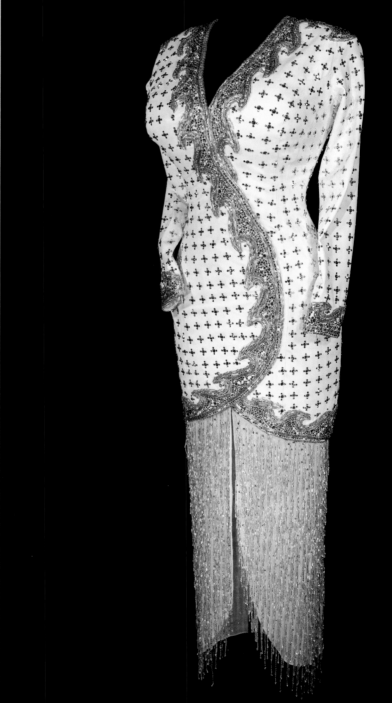

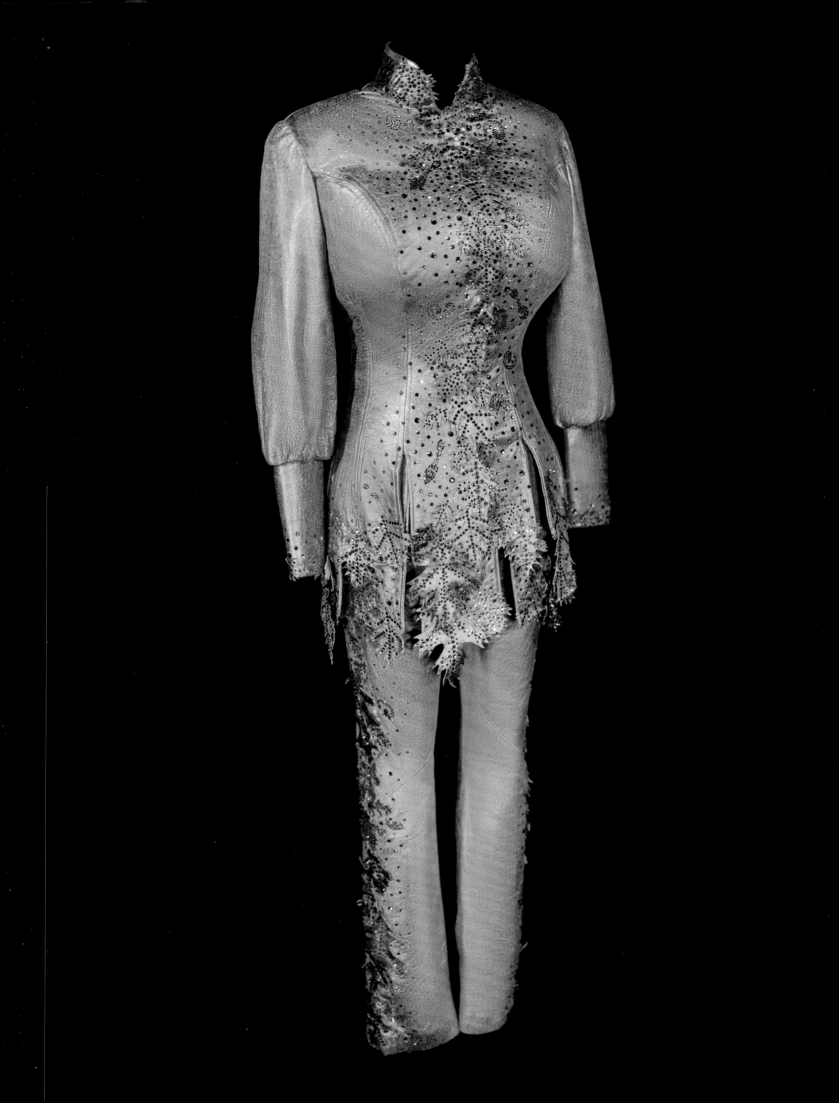

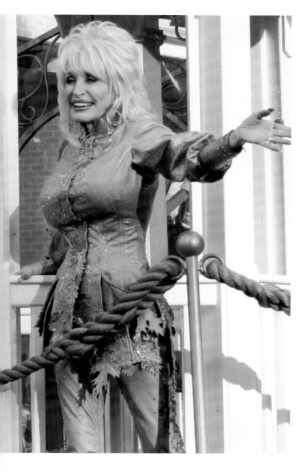

Steve cooked up this incredible Macy's Thanksgiving Day Parade outfit for me in 2007. Iisha cut all those intricate leaves by hand.

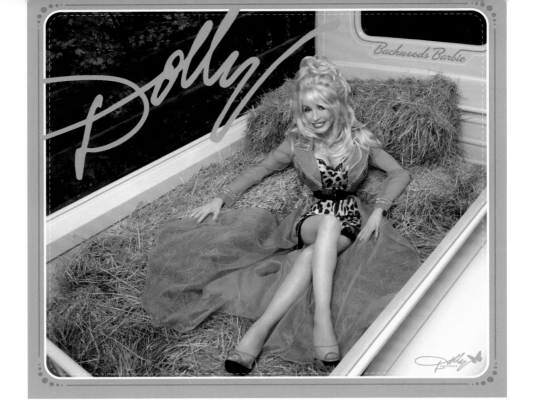

For my album cover shoot, Cheryl Riddle stacked
three wigs to make one fabulous do. And Robért
envisioned me as a 2008 Barbie doll.

And then there are the award shows! In the 2000s, I was fortunate to get nom-
inated for so many: Emmys, ACMs, Grammys, CMAs, CMTs, Tonys, and even
Oscars. Getting ready for an awards show or some other big event is always
scary. You spend weeks preparing for it. You need to figure out what you're going
to wear, and you go through all kinds of things to get ready. Then, no matter
how prepared you are, on the very night, you can pop a zipper—so it's always
nerve-racking.

During the 2000s, I was also inducted into the Songwriters Hall of Fame and
celebrated at the Kennedy Center Honors. Robért designed two exquisite gowns
for the Kennedy Center ceremony: a 1920s-looking black chiffon with deco-style
embellishment for the pre-party and a beaded white dress for the televised event.
My hair—thanks to Cheryl Riddle—looked especially good. Some wonderful art-
ists sang my songs and made a big deal over me. That was a very special night
for me, and I wanted to look and feel special—and I did! A perfect way to start
the new century!

Behind the Seams

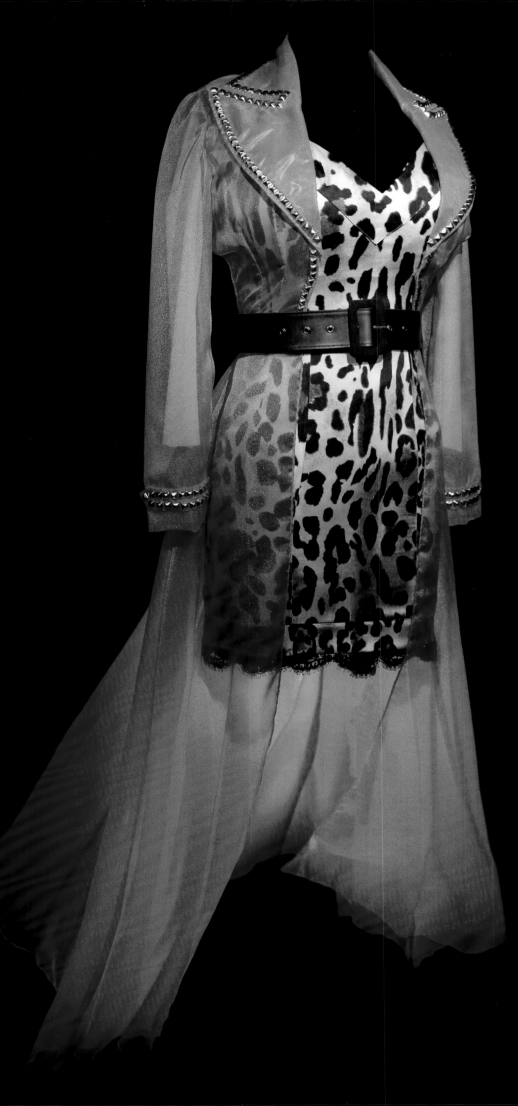

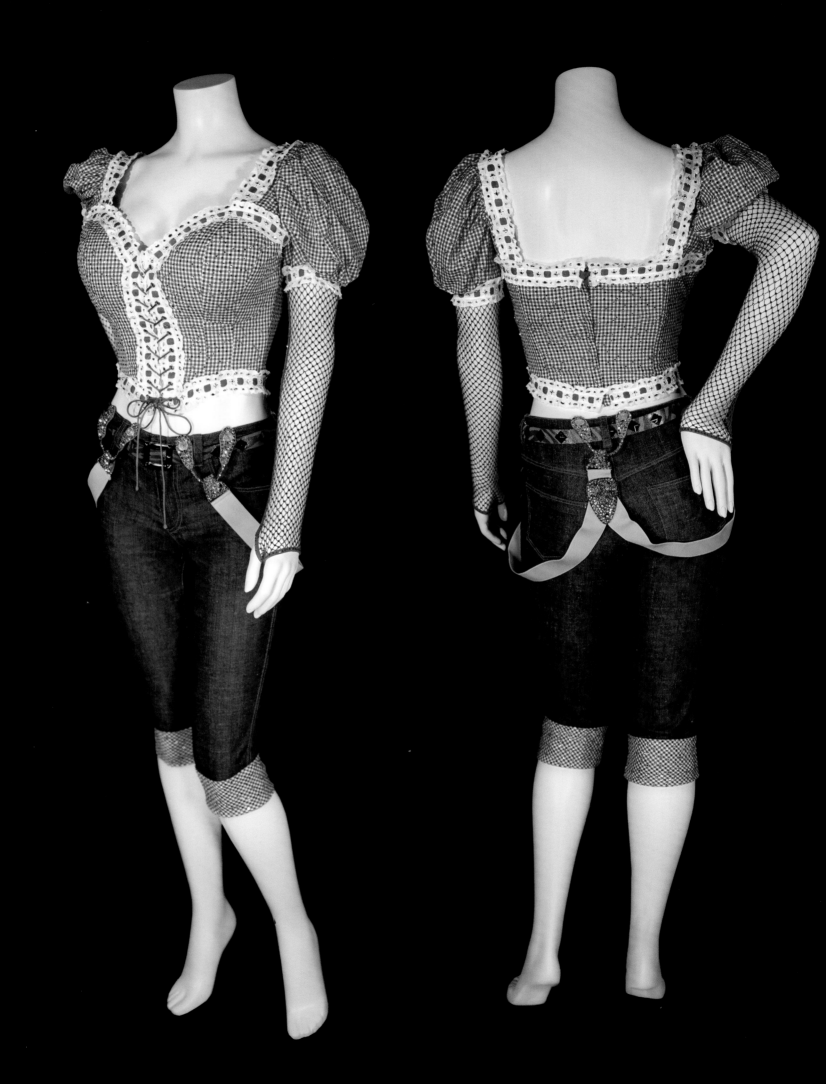

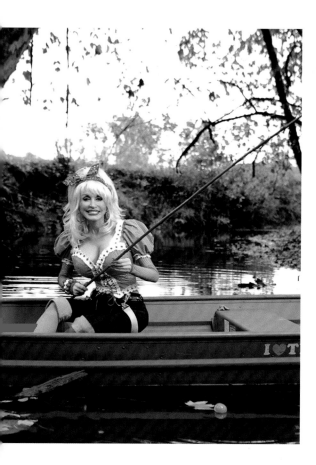

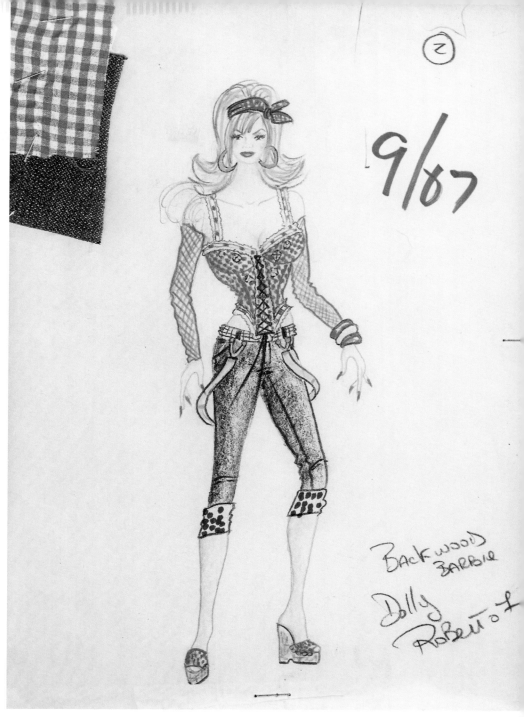

I got to wear fishnets and gingham in this cute little outfit Robért designed for my *Backwoods Barbie* album photo shoot.

BACKWOOD BARBIE
Dolly
ROBEIIT07

And the Winner Is . . .

I love awards shows, and I have gotten to wear a lot of beautiful dresses over the years, but the tricky thing is that it's almost impossible to be comfortable in that outfit where you look your best! For example, if you want that hourglass look, you've got to cinch your waist and wear a tight dress. But if you have to sit for two or three hours in the front row at an awards show, it can be trying. And when you're up for an award, like an Oscar, jewelers want to loan you real diamond necklaces and things like that. But honestly, I'm more comfortable wearing rhinestones, especially if it's somebody else's diamonds. I can't wait to get those off of me because I'm worried I'm going to lose them. They all look the same to me! Robért designed the gown I wore on the red carpet at the 2006 Academy Awards. It was made from a special woven silk chiffon with a matching silk lace petticoat. He later told me it was "a work of love" that took a team of thirty people some 465 hours to make! It was hand-beaded inside and out, so when I walked and it flared out, you could see even more beads. Wearing it, I really felt like Cinderella at the ball.

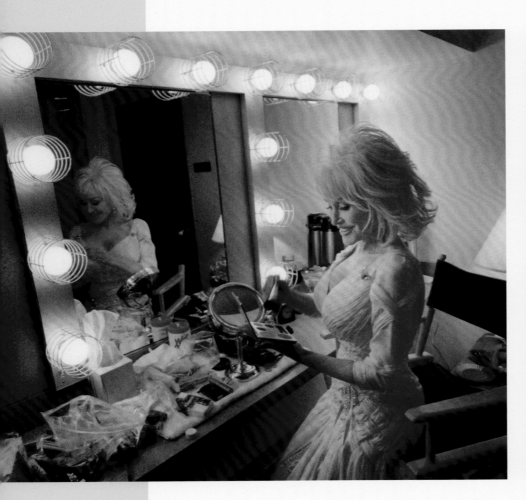

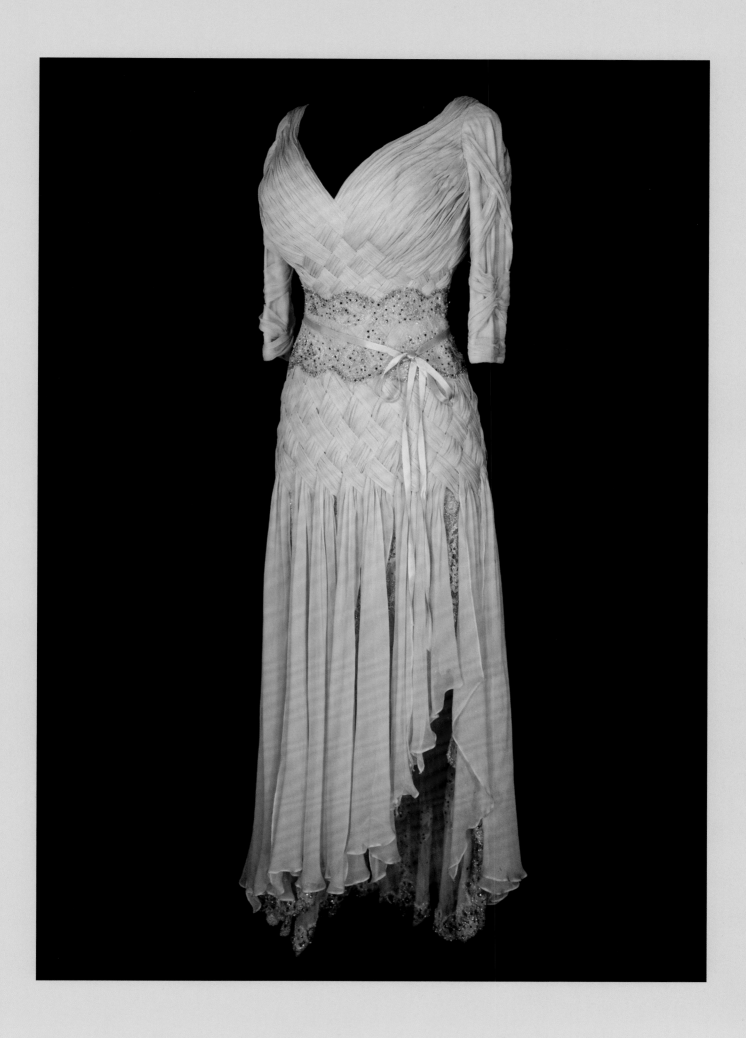

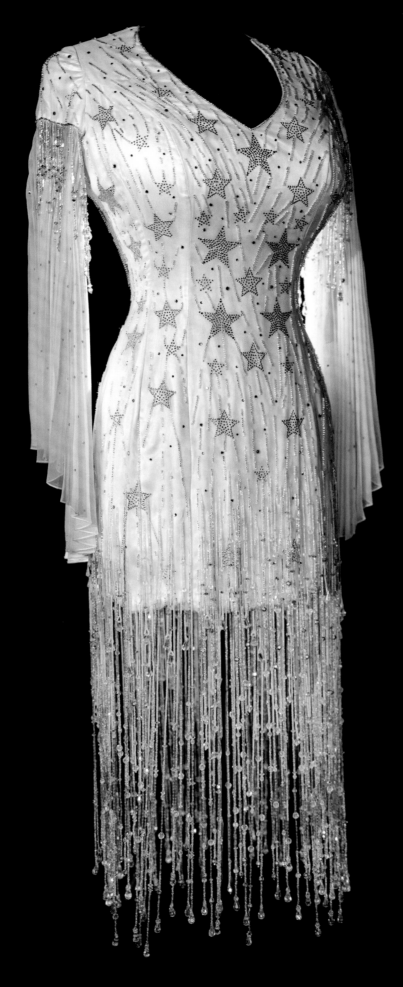

A little glam, a little rock and roll. I wore this Robért design in 2003
on the red carpet for the "Women Rock! Songs from the Movies"
TV special, where I appeared with Debbie Reynolds and Bonnie Raitt.

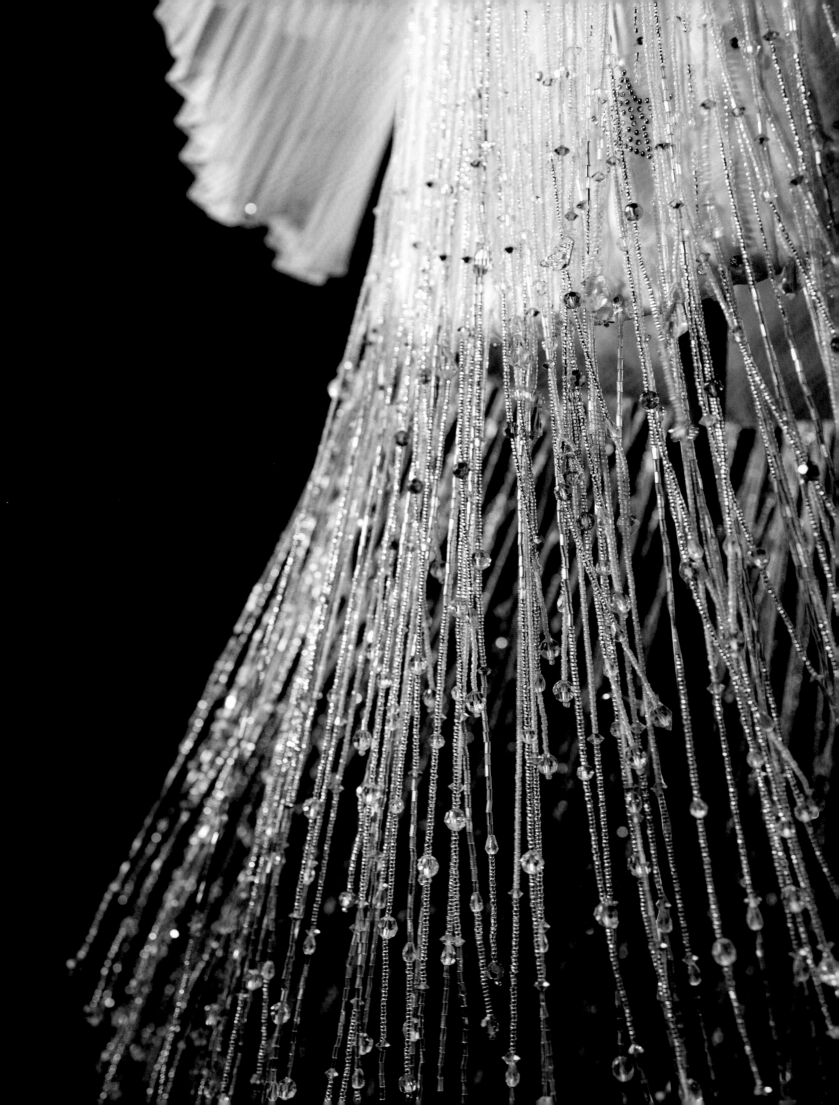

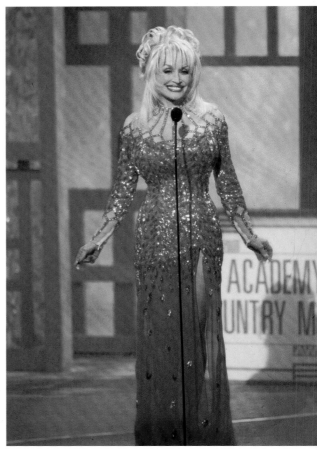

Another glamorous Robért design, this one for the 2000 ACM Awards, where I became the first woman to ever host the show solo.

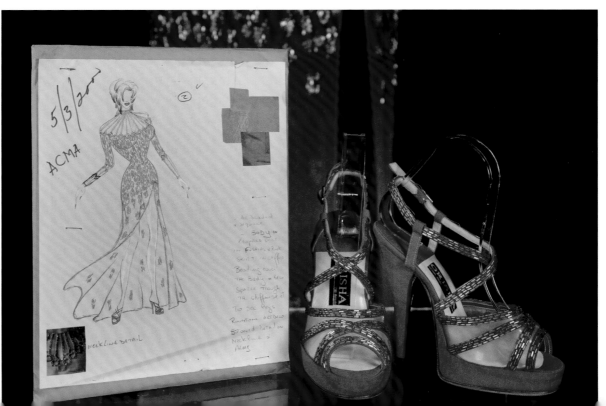

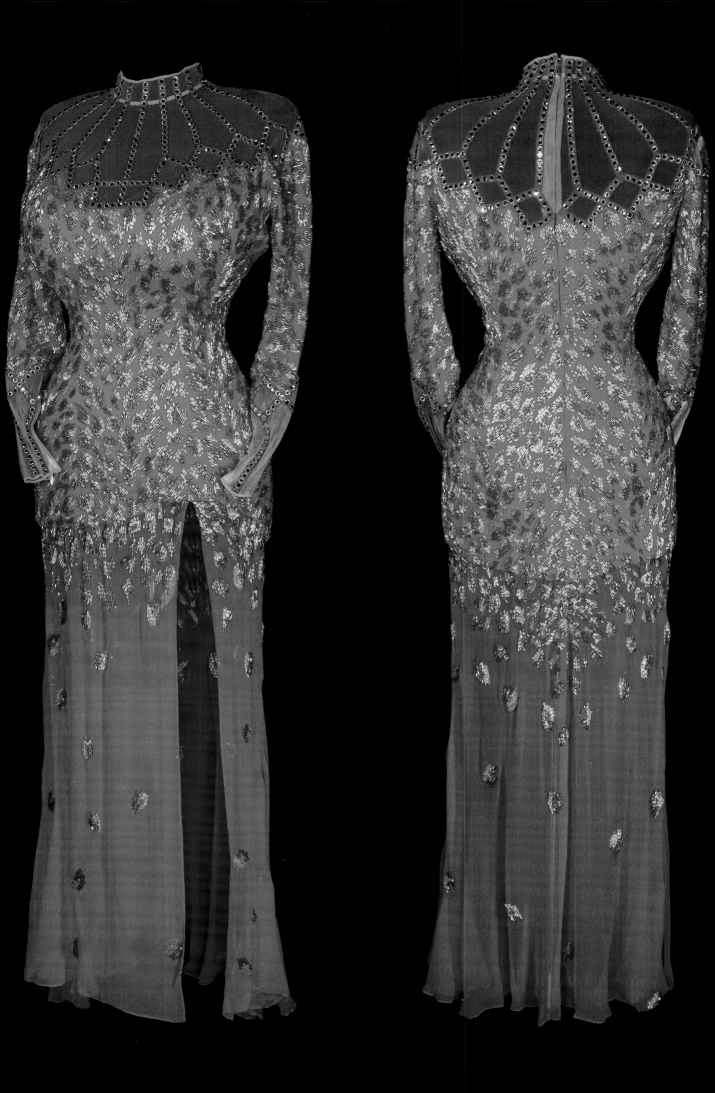

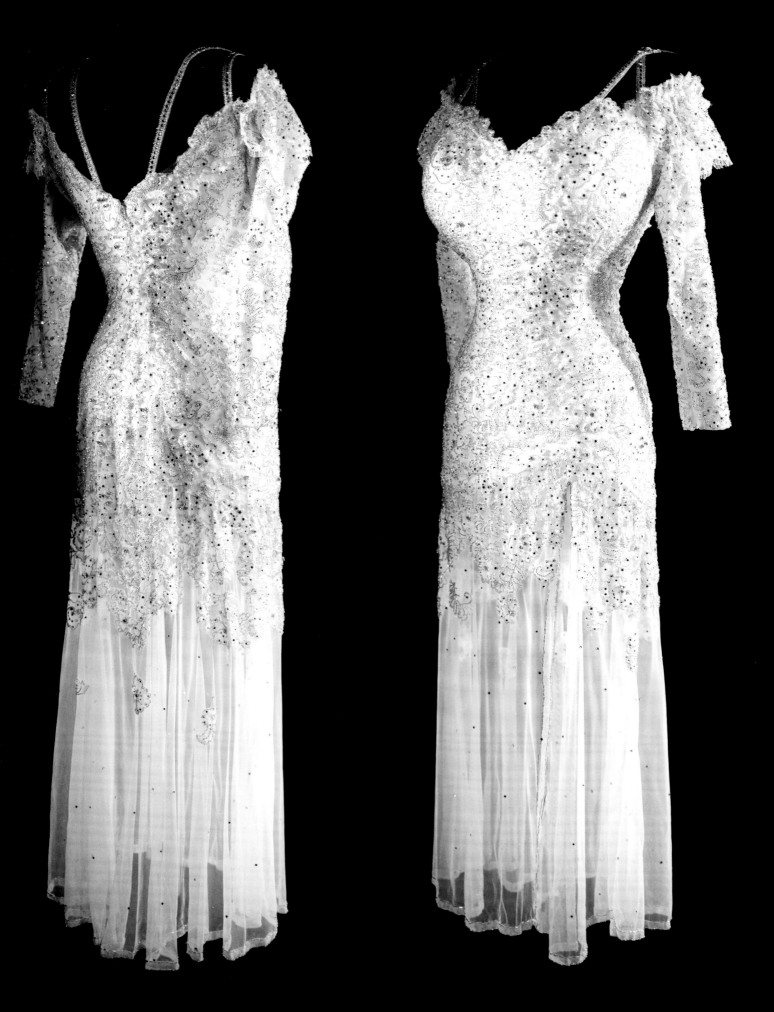

I love how the chiffon shows off my legs and the rhinestone straps are both functional and beautiful. As I always say, never leave a rhinestone unturned.

Silvia Tchakmakjian

A native of Armenia, Silvia Tchakmakjian learned to sew from her mother, a talented seamstress herself, and started her own custom costume company in 1981. Her shop, Silvia's Costumes, creates the beadwork, rhinestoning, and embroidery on some of Dolly's most iconic clothing, including the Tony Chase–designed gown from 1986 featured on the cover of *Behind the Seams*. As Silvia recalls:

"I met Dolly through Tony Chase in 1987, and she's one of my favorite celebrities to work with. From day one, she's been so kind. She will walk into our workroom and feel at home. She will dance with my ladies, and we'll have coffee together. We adore her and love bringing our talent to her costumes, which might take hundreds of hours because of the handwork. That isn't something you can rush; you have to do it right.

"When you do all that work and then you see her on TV or live, it's a great feeling. Sixteen years ago, my daughter, Betty, and I were at her concert in Palm Springs, and Dolly said, 'Ladies and gentlemen, do you like the costumes I'm wearing tonight?' They all applauded. And then she said, 'The person who made them—Silvia—is here with her daughter, who's pregnant, and I'm going to dedicate the next song to them.' When Betty and I talk about that show to this day, we both cry. I'm never going to forget it."

If you ever wonder why my costumes sparkle, a big reason is my dear friend Silvia *(bottom right)* and her wonderful team at Silvia's Costumes.

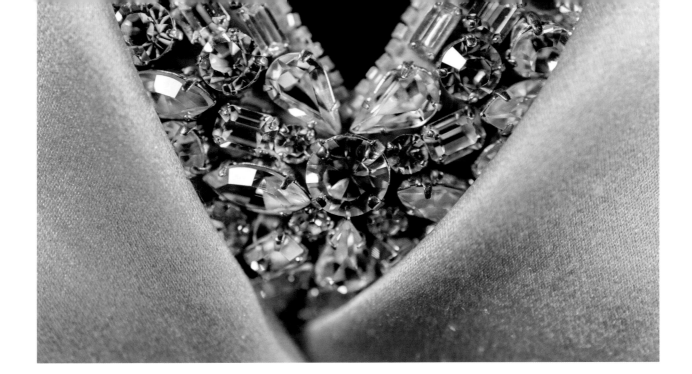

In 2009, I was nominated for a Tony for the musical *9 to 5*, and at the New York ceremony I wore this Robért gown with a tuxedo-style top juxtaposed with a sheer skirt. Masculine meets feminine!

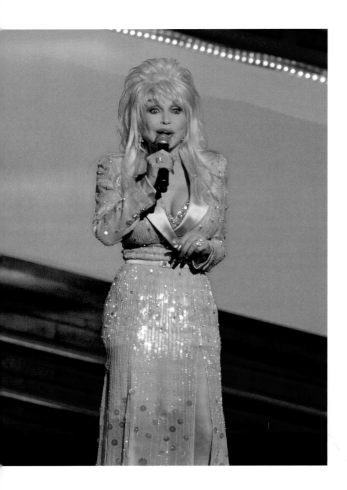

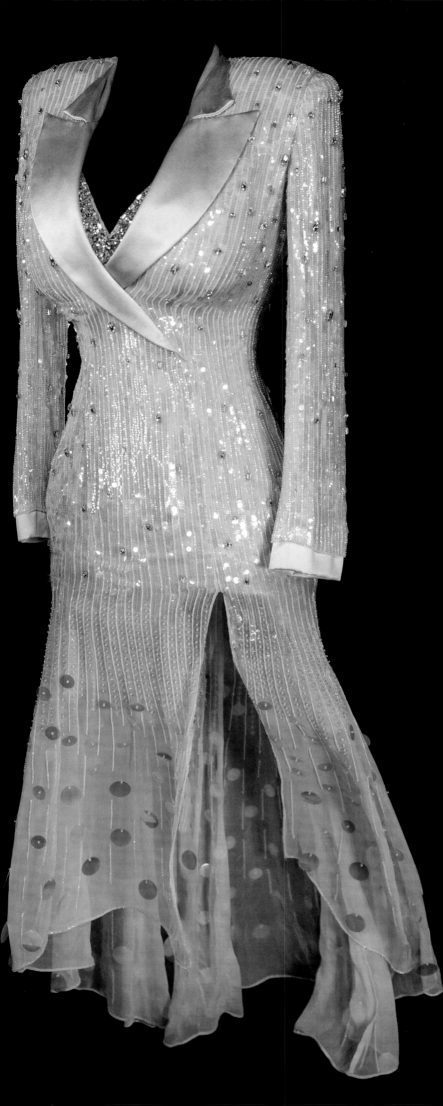

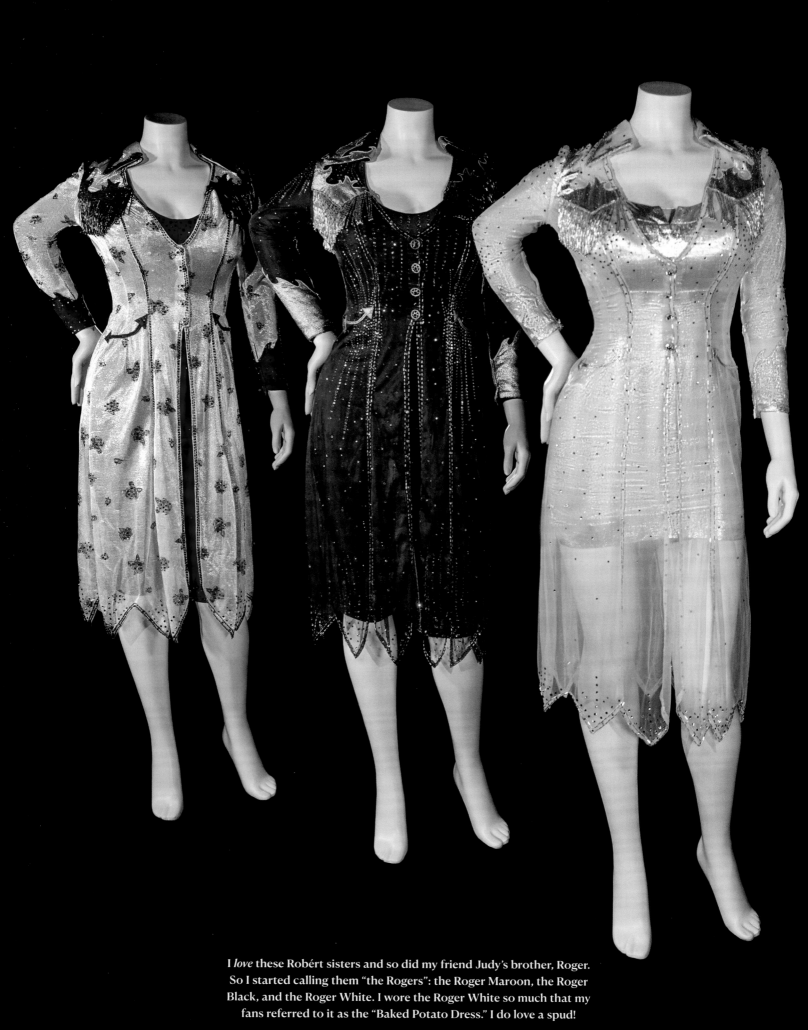

I *love* these Robért sisters and so did my friend Judy's brother, Roger. So I started calling them "the Rogers": the Roger Maroon, the Roger Black, and the Roger White. I wore the Roger White so much that my fans referred to it as the "Baked Potato Dress." I do love a spud!

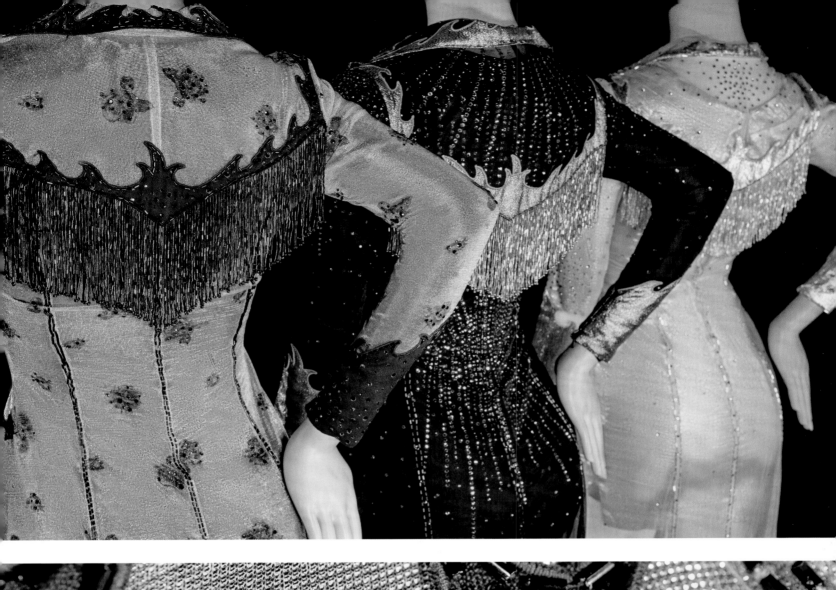

My team kept the styles coming all weekend long at the Kennedy Center Honors in 2006, culminating in this spectacular gown with beads, pearls, and rhinestones by Robért. I felt so special in it at the ceremony, where it went perfectly with my award of many colors.

DOLLY PARTON

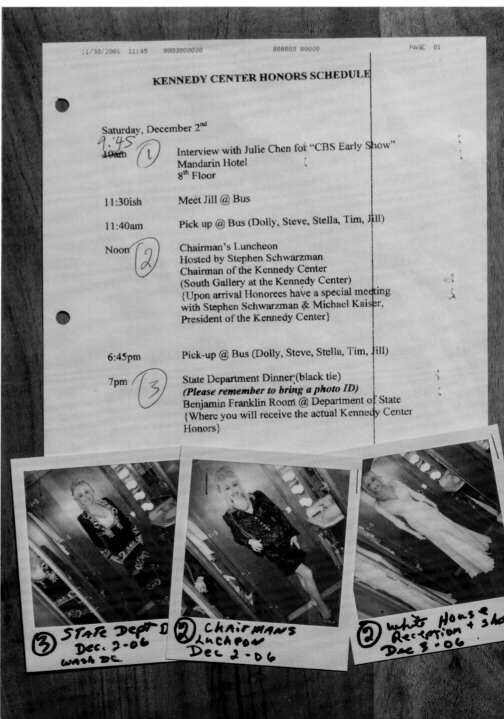

11/30/2006 11:45 0000000030 000000 00020 PAGE 01

KENNEDY CENTER HONORS SCHEDULE

Saturday, December 2nd

9:45
10am (1) Interview with Julie Chen for "CBS Early Show"
 Mandarin Hotel
 8th Floor

11:30ish Meet Jill @ Bus

11:40am Pick up @ Bus (Dolly, Steve, Stella, Tim, Jill)

Noon (2) Chairman's Luncheon
 Hosted by Stephen Schwarzman
 Chairman of the Kennedy Center
 (South Gallery at the Kennedy Center)
 {Upon arrival Honorees have a special meeting
 with Stephen Schwarzman & Michael Kaiser,
 President of the Kennedy Center}

6:45pm Pick-up @ Bus (Dolly, Steve, Stella, Tim, Jill)

7pm (3) State Department Dinner (black tie)
 (Please remember to bring a photo ID)
 Benjamin Franklin Room @ Department of State
 {Where you will receive the actual Kennedy Center
 Honors}

(3) State Dept Dinner
Dec. 2-06
Wash DC

(2) Chairmans
Luncheon
Dec 2-06

(2) White House
Reception + Sho
Dec 3-06

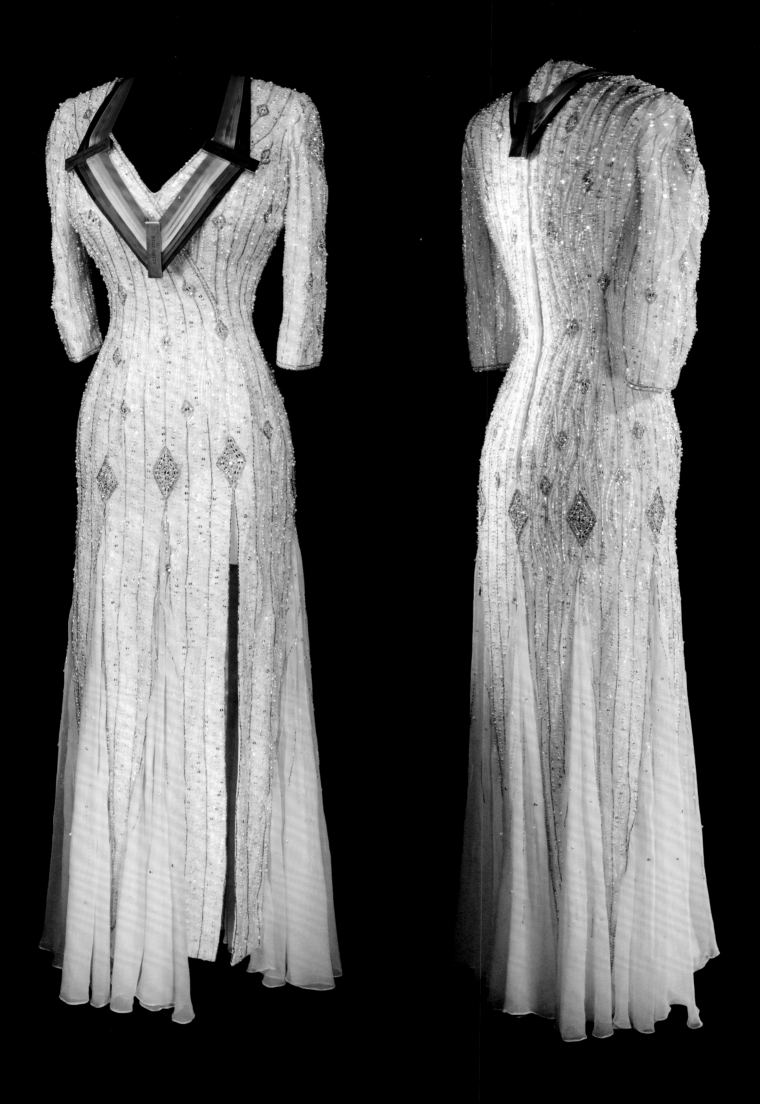

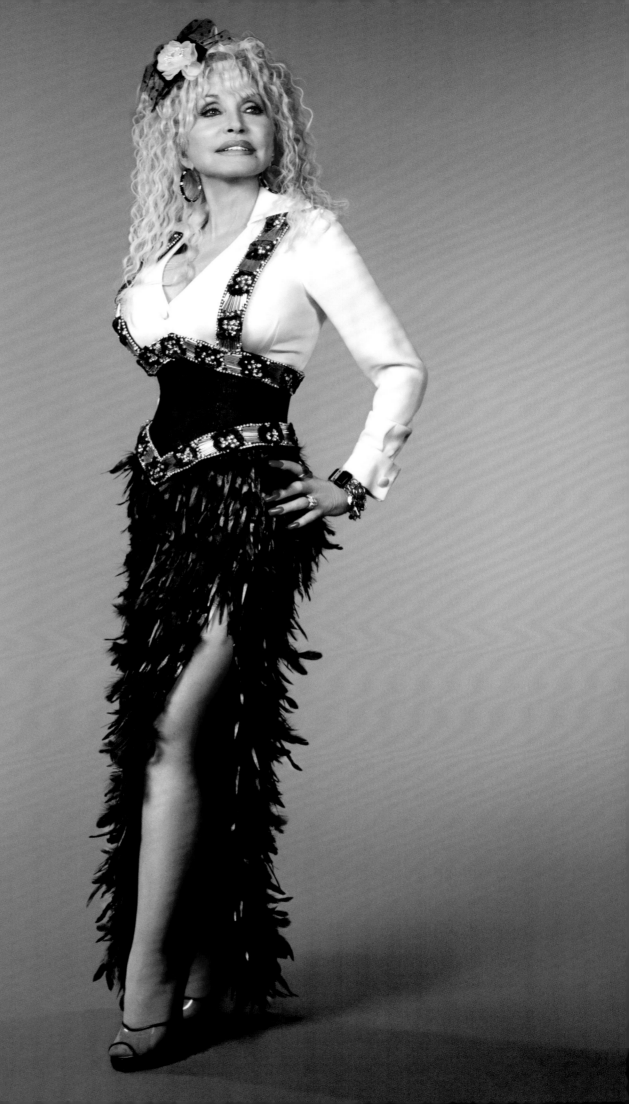

9

Head Over
High Heels

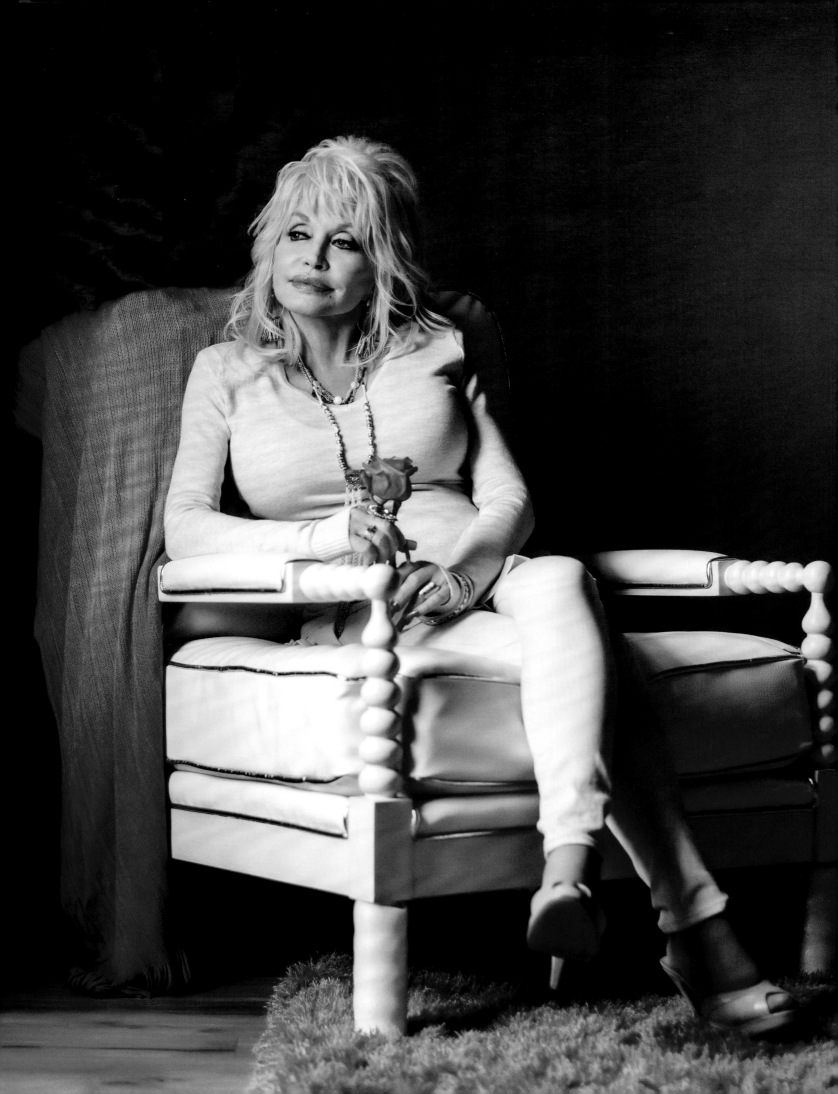

"That's one of the reasons my boobs are so big: it's just all heart pushin' out my chest!"

Dolly

Dolly's influence in the 2010s expanded to nearly every area of popular culture. By decade's end, magazines ranging from *BUST* to *Elle* were calling Dolly a fashion icon, interviewing her about her music, her philanthropy, and the influence of her personal style in the New York fashion world and on international runways.

Throughout the decade, she continued to write, sing, act, record, tour, and work on various business and charitable endeavors. Her generosity is legendary, with her donation of millions of dollars and her time to advance childhood literacy, provide disaster relief, finance college scholarships, endow children's hospitals, and preserve the environment, among many other causes.

She also garnered accolades as an entertainer. In 2016, Dolly won the CMA's Lifetime Achievement Award. During the 2019 Grammy week, she was saluted as the MusiCares Person of the Year and was the subject of a major exhibition at the Grammy Museum. That same year, her series *Dolly Parton's Heartstrings* debuted on Netflix, with each episode a dramatized story inspired by one of her songs, including "Jolene" and "If I Had Wings."

In the 2010s, Dolly certainly did have wings.

—Holly George-Warren

I got from my daddy the skill to be a good businesswoman. Daddy couldn't read or write, but he was so smart. He knew how to barter. He knew how to bargain. He knew how to do all the things that it takes. You didn't trick him on a dollar; he could count money in his head. I got my business sense from Daddy, my creative side from Mama, but I just knew that I wanted to do anything and everything I could. I've got a lot of energy, and I like to spend that on creative things rather than turning that energy in on myself. I think you need to do that. As time went by, I just saw that once I accomplished "this," "that" would start—it would kind of spring into a new dream.

I love being busy. I know what I can do and what I want to do, but I try to be smart about the things I choose to do. I also surround myself with really good people. I ask God every day to bring all the right things and all the right folks into my life and to help me recognize them when they show up. That's how I built my whole life, whether it's Dollywood, the Imagination Library, my production companies, my publishing companies, line of wigs, perfume, or anything else. I just take advantage of everything and see where I can make a difference. I know that my fans share my love of music and my love of fashion, and I'm so grateful that I've been able to take that love—and the success that it's afforded me—and make a difference.

In 2016, the state of Tennessee put my picture on a special license plate that drivers can buy, and I loved it because the proceeds went to the Imagination Library. (When you're known for your image, you sometimes see yourself in some strange places!) My niece Rebecca Seaver says when she sees that license plate on random cars, she feels like I'm watching her! The photo came from a session I did with the very talented photographer Allister Ann. It originally appeared on the cover of my 2014 album, *Blue Smoke*, and I'm wearing my ol' faded denim shirt again!

The *Blue Smoke* record means a lot to me. It has all the colors of my life and my personality on it, from gospel to mountain music to bluegrass to the country flavor and the pop stuff. It has duets, too, so it kind of marks all the things I've done through the years.

One of my favorite duets on the record, "You Can't Make Old Friends," is with *my* old friend Kenny Rogers. Steve Summers designed a gorgeous gown for me to wear in the video we did together for the song. Also on *Blue Smoke* is "From Here to the Moon and Back," where I got to sing with another special fella and longtime duet partner, Willie Nelson. In my 2012 movie, *Joyful Noise*, when I played the feisty G.G. Sparrow, I sang that same song with Willie's close friend Kris Kristofferson, who played my character's late husband. That movie was a fun experience. I liked

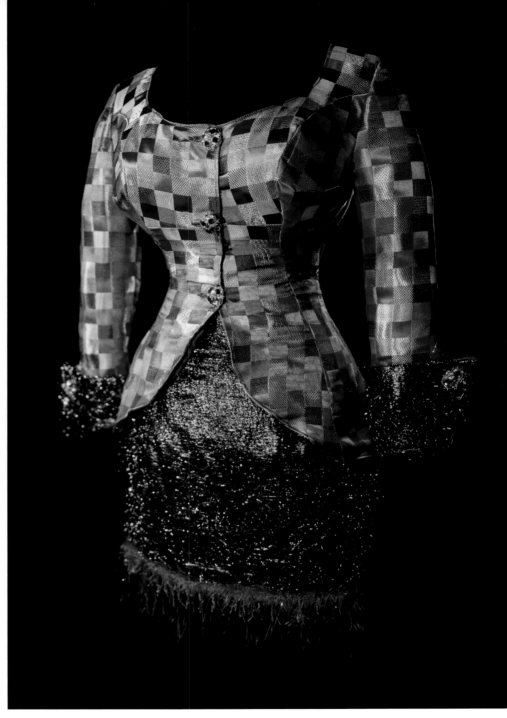

My parents were with me on the day Phil Bredesen, governor of Tennessee, announced that my Imagination Library program would be expanded statewide. I'd created the program with Daddy in mind, and my Steve Summers outfit at the 2004 press conference reminded me of the patchwork Coat of Many Colors Mama made for me.

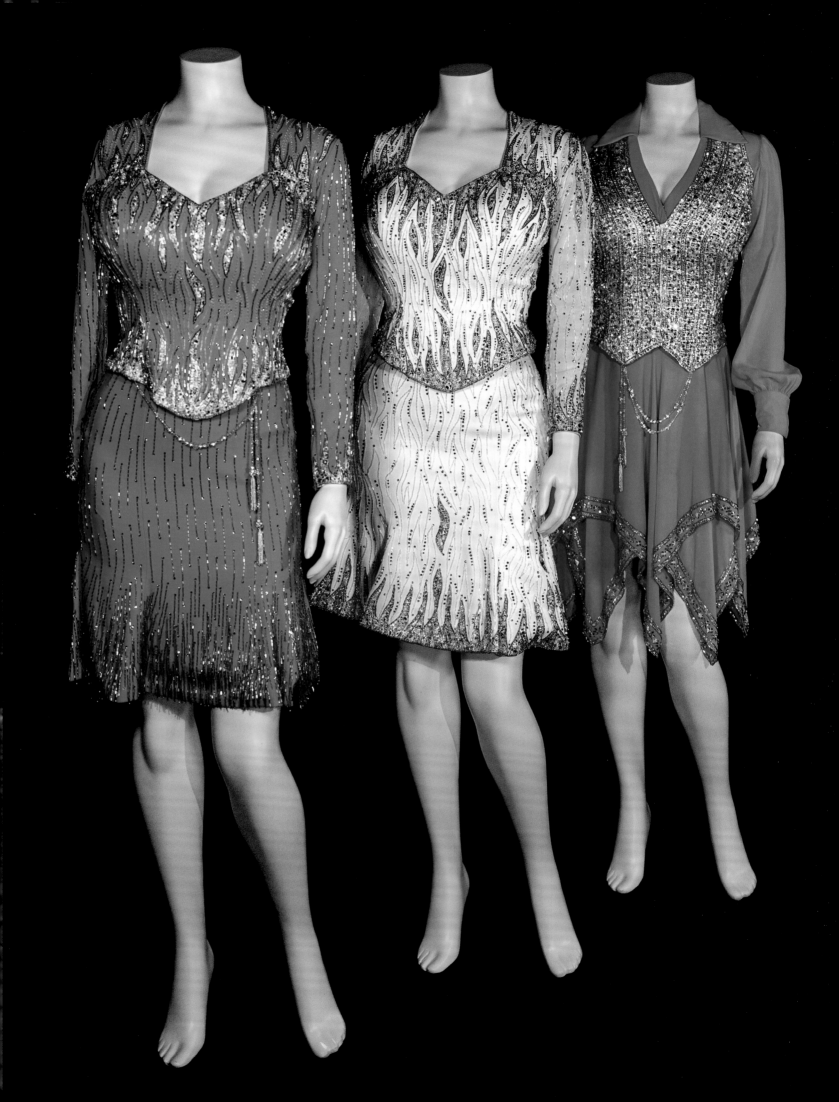

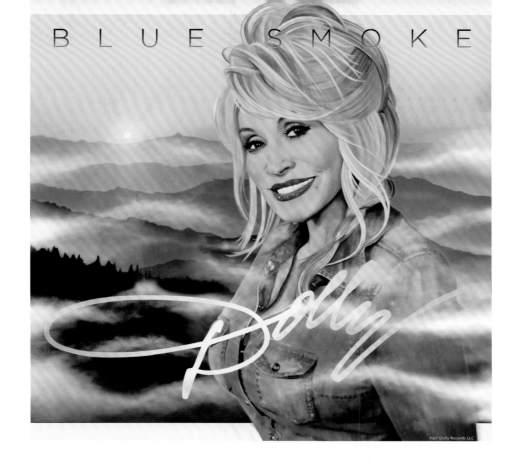

My 2014 Blue Smoke World Tour sisters *(opposite)*, designed by Steve Summers, made me think of the mist that covered the Great Smoky Mountains of my youth. We called it "blue smoke."

working with Queen Latifah, who played Vi Rose Hill. We're competing choir ladies who, in the end, resolve our differences and come together for the greater good. G.G. has had her fair share of cosmetic surgery, and at one point, she says, "Who cares if I've had a few nips and tucks? God didn't make plastic surgeons so they could starve!" When I tell Vi Rose Hill, "I am who I am," she snaps back, "Well, maybe you were—five procedures ago!" I got Steve to alter G.G.'s choir-robe costume, cinching it at the waist to fit me nice and snug, the way I like all my clothes. As G.G. says, "I want to look good for God."

From the beginning of my career, I've asked family members to play important roles, and that has continued to this day. I'm so fortunate that Rebecca Seaver, my godchild and niece, has worked with me for the past dozen years. Her mother, my sister Cassie, has always had style and class. Of the twelve of us kids, Cassie had that the most. Rebecca is more like me. She went a little more bizarre with her style because it fits her personality. She grew up onstage with me, and she's been a performer herself. And even as a little girl, she started wearing my shoes and trying on my clothes. She's lived and breathed my wardrobe her whole life. I know she loves it, I know she understands it, and I know she feels it.

Head Over High Heels

273

Pretty as an Angel

First of all, I'm no angel! I just play one on TV and in movies! I don't know why they give me those roles, but they're all fun. Of course, I love wearing white. Dressing up as an angel actually makes me feel spiritual—makes me feel like I have a responsibility. I've been a very spiritual person all my life. I believe there's something greater than me out there, and I'm continually looking to that light. I try to draw it to myself. And then it becomes like an energy inside of me that I can give back.

When you're acting, you think of all kinds of things. But when I'm dressed like an angel, I try to picture myself as if I were a real angel—as if I could really throw out some good vibes to everybody at the studio or I could make everybody feel better. Or if somebody's looking at you and you think, *Well, I'm not perfect. Nobody is. But, at least today, I'm dressed like someone who is.* So it makes you feel good inside.

Of course, there are many angels in many guises. You don't have to wear wings, you don't have to wear a white dress, and you don't have to play a part. There are angels all around us. No doubt about it.

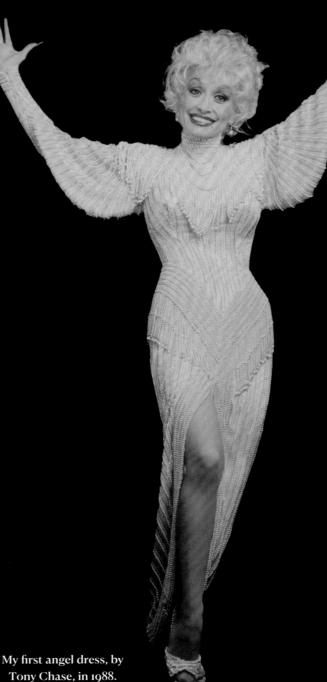

My first angel dress, by
Tony Chase, in 1988.

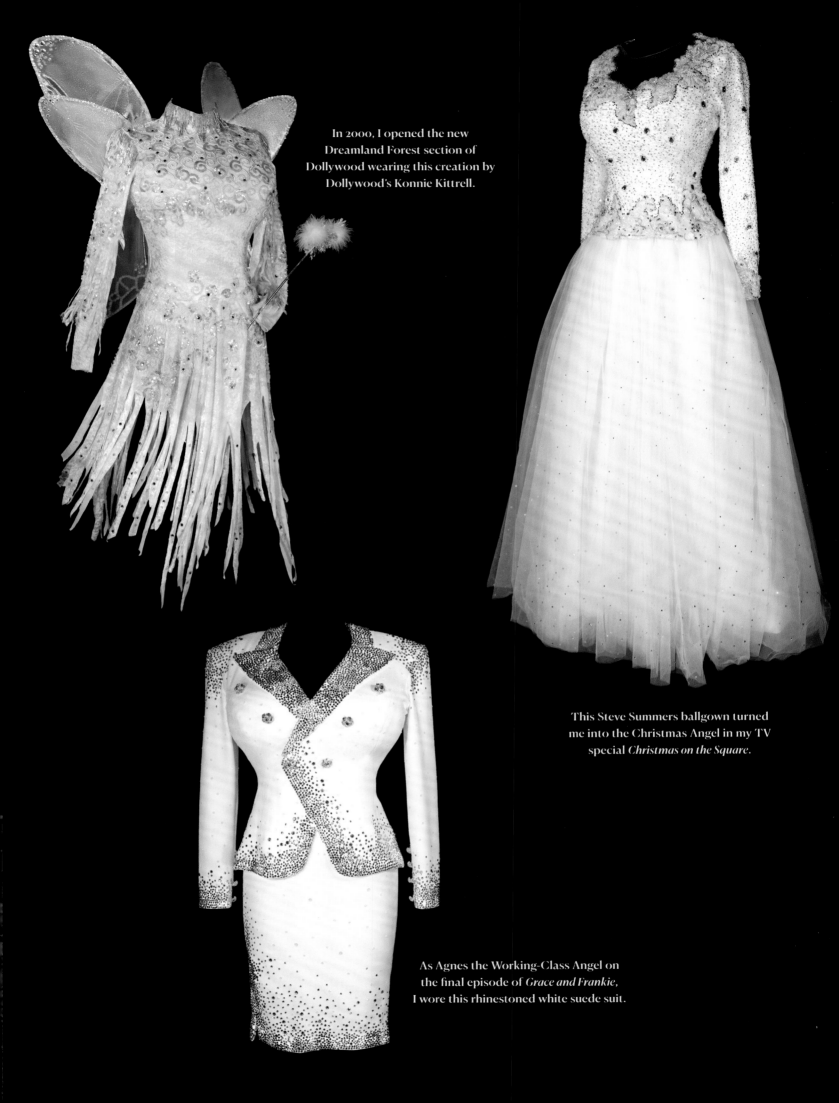

In 2000, I opened the new Dreamland Forest section of Dollywood wearing this creation by Dollywood's Konnie Kittrell.

This Steve Summers ballgown turned me into the Christmas Angel in my TV special *Christmas on the Square*.

As Agnes the Working-Class Angel on the final episode of *Grace and Frankie*, I wore this rhinestoned white suede suit.

Inside the Archive
with Rebecca Seaver

Rebecca Seaver is the creative production manager of Dolly Parton Productions and the lead archivist of the Dolly Parton Collection. She began her career as a performer at Dollywood and as a performer and choreographer in Music City Burlesque in Nashville. As Rebecca recalls:

"From the time I was tee-tiny, I was always around—on set, on tour, at shows—and I just thought Dolly (or 'Aunt Granny') was everything—because she is. One of my first memories is of being on an airplane to Hawaii with Dolly, and she was wearing a denim jacket covered in rhinestones. Every time the sun hit her from the airplane window, it reflected those glittery sparkles all over the plane. I thought that was the most magical thing I had ever seen. I was about three years old.

"To a little kid, Dolly is very childlike herself. She would play dress-up with us and get into costume. One time, she had clown costumes made for all of us, and there's a photo of her in a clown wig and full clown makeup. She goes 100 percent for things. Another time, I remember her going out trick-or-treating with us. She wore a sweatshirt with a pumpkin on it paired with black leggings, and she had on this big pumpkin head made out of foam. But if you looked at her body, you knew who it was. And even though her head was covered, you could see a little blond hair coming out of the back. Dolly loves to play characters, even when they're just completely bananas. That's because she's such a character herself.

"I've been working for Dolly since I was a teenager, and I've always worked in some capacity with her costumes, though my role has evolved over time. I've been an assistant. I've been her manager's secretary. I've rhinestoned clothes, and I've sewed clothes. Now I'm swimming in this costume archive pool, overseeing the photography of her clothing and accessories.

"I love that Dolly is coming into this whole other era of her life. She's a little rainbow of light who embodies the many facets of a woman: softness, beauty, strength. I think of *Behind the Seams* as Dolly's "Book of Many Colors." Working with her on this project has been incredibly fulfilling. I want to make sure that her archive is represented the way Dolly would want it represented. My aunt Rachel has been a big help—she's also been there since the beginning of her career. And since I got to train under Judy Ogle, the founder of the archive, before she retired, I learned her method and her process. Judy saved everything and organized it all. Her process was so methodical. I learned why she was so protective of the archive, which is very central to my own thinking.

"In addition to Dolly's archive, we have family artifacts that go back to the pre–Civil War era. Our family has been making music for so many generations! I feel very lucky to be part of this family and to preserve artifacts that go back hundreds of years."

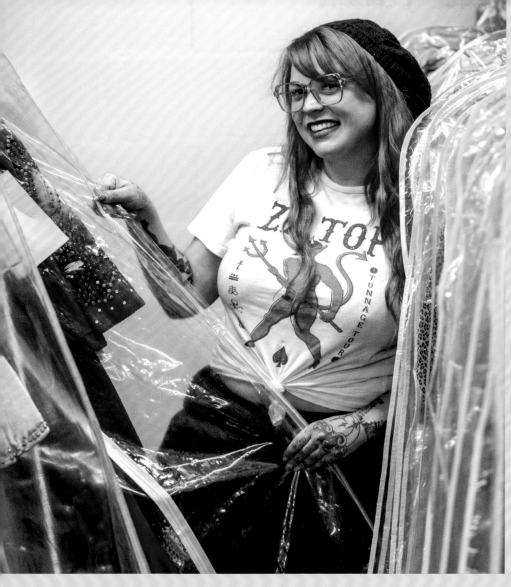

Left: Rebecca keeps track of everything Dolly—from my costumes to my road cases and guitar straps. She's the wind beneath my butterfly wings. *Below:* With Rebecca and Iisha, celebrating a special creation.

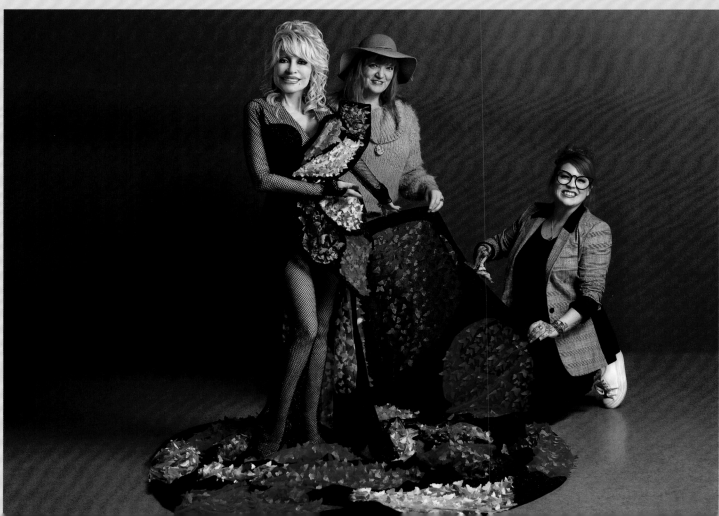

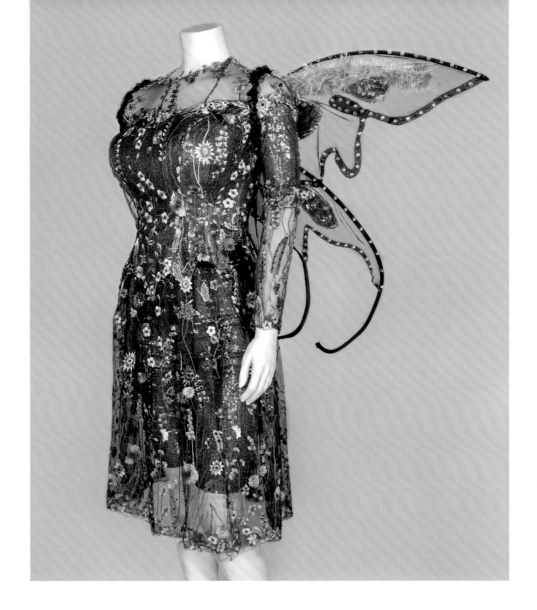

I wanted to be a mountain butterfly in 2017 for the Dollywood Homecoming Parade. It was just after those awful wildfires in the Smokies destroyed people's homes and our beautiful forests.

With all my heart, I'm so proud of Rebecca. She's done a wonderful job overseeing my clothing archive and curating this book. It's a big responsibility. She's doing it for the love of family. She wants the whole family to be proud of this project. She's representing our family as well as me. I'm the one who got to be a star first, but I'm not the only talented one in the family!

I'm sometimes asked what it takes to be *pretty*. For me, feeling pretty is feeling like I accomplished what I wanted to do that day. That's a different thing from fashion or how you wear your makeup or your eyelashes. If you know who you are and keep that in mind at all times, then you won't sacrifice your principles, your

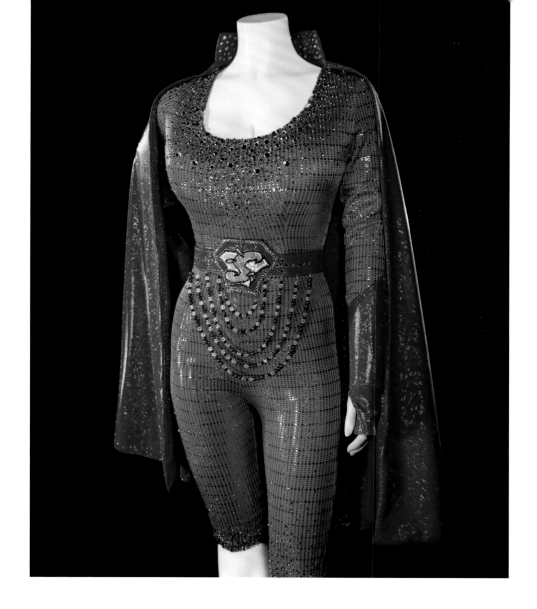

You've heard of the Flash—well, I'm the Splash Woman! Here's
the outfit to prove it, which I wore at the opening of Splash
Country's River Rush in 2013.

values, your true self. You can look in the mirror and feel good about yourself—
even feel pretty—inside and out.

When I started out pursuing my career, I realized early on that it's important
to do good things and hopefully leave something good behind. I'm happy that
I'm still very much involved in the business and in my passion projects, like the
Imagination Library, and that I can see those kinds of things continue to bear
fruit into the future. It makes me humble to think I've touched the lives of people,
especially the young and those trying to come up in the business. I want to show
them that dreams can come true.

Head Over High Heels

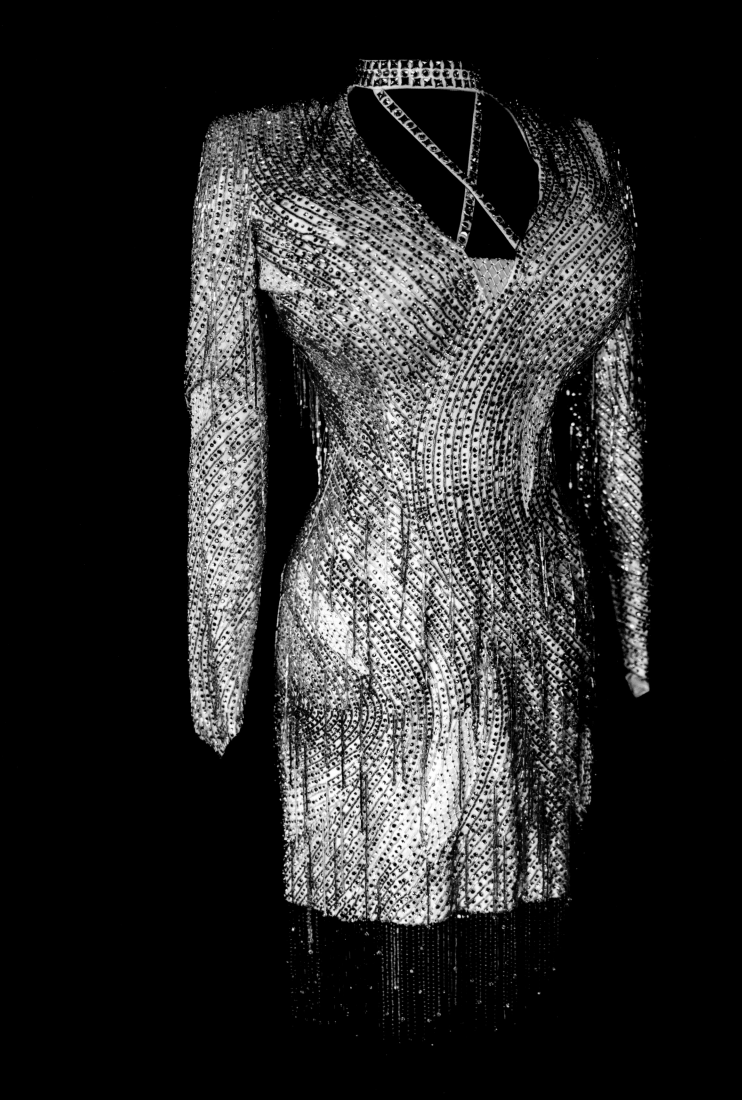

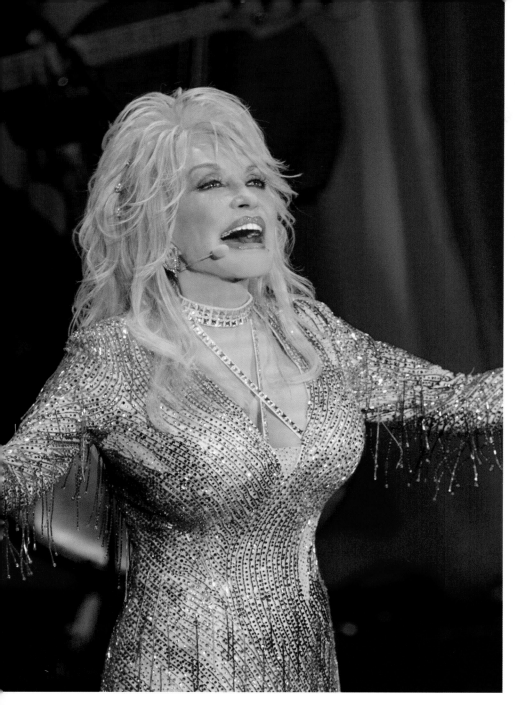

The folks at Silvia's did the rhinestoning on this outfit, which Robért designed in 2015. Rebecca, an ace rhinestoner herself, estimates that there are nearly ten thousand stones on this dress.

Back Through the Years
Dollywood Costumes

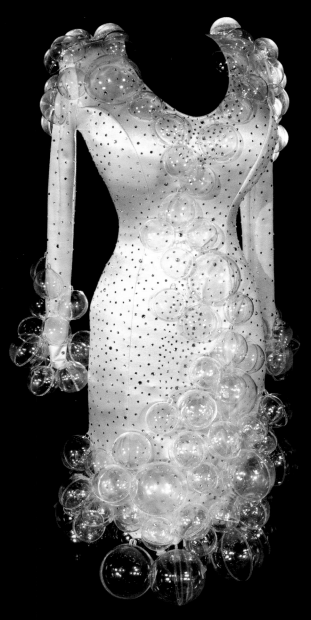

I was "bubblin' over" at KidFest at Dollywood in 2011 in this dress by Steve.

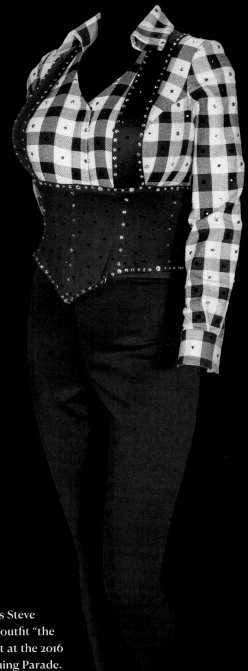

My staff calls this Steve Summers–designed outfit "the Lumberdolly." I wore it at the 2016 Dollywood Homecoming Parade.

Having your own theme park lets you wear all kinds of wild costumes—that is, if your park happens to be Dollywood! I never get tired of playing dress-up, and Dollywood gives me the opportunity to do just that. Traditions like our annual homecoming parade, events like Kidfest, and various themed sections of the park allow me to transform into lots of different characters. It's more fun than a barrel of . . . *whatever*!

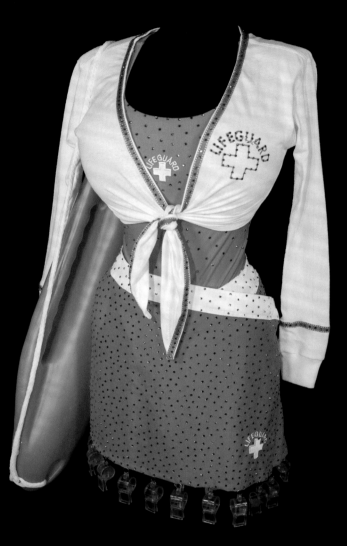

I think I'm the first to wear "whistle fringe"!
I wore this inventive look at the 2013
Dollywood Homecoming Parade.

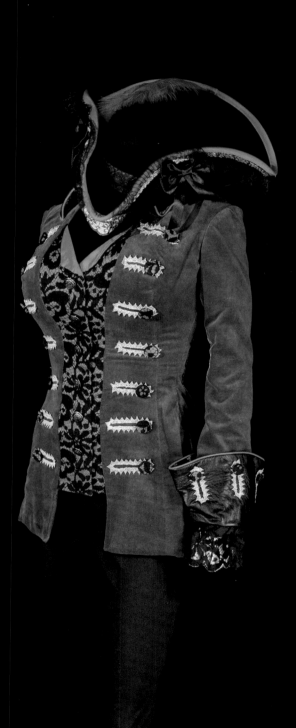

Ahoy, matey! I wore this swashbuckling
getup at the opening of my themed
dinner theater, Pirate Voyage, in 2011.

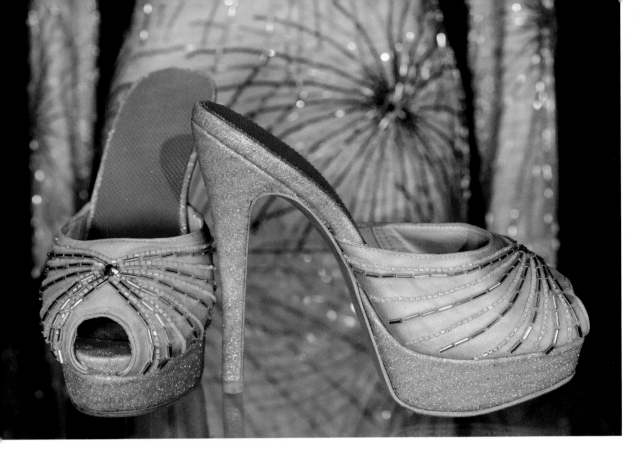

I wore this Robért fireworks dress in a New Year's Eve scene in the "Two Doors Down" episode of *Heartstrings* in 2019.

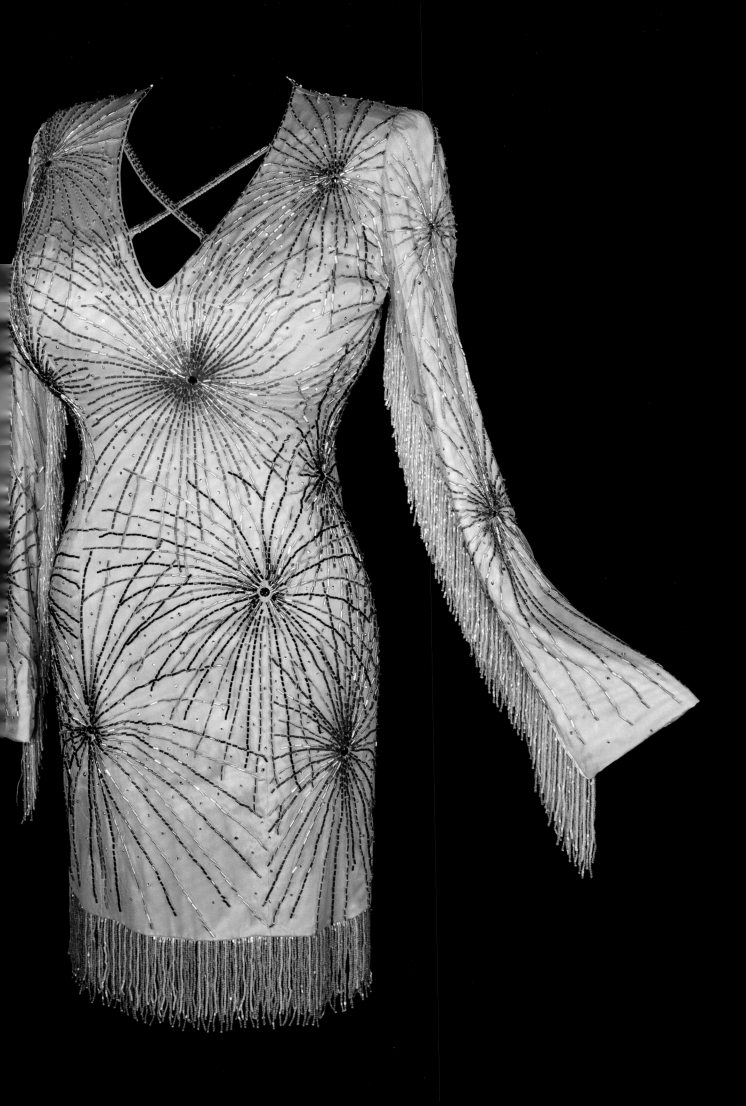

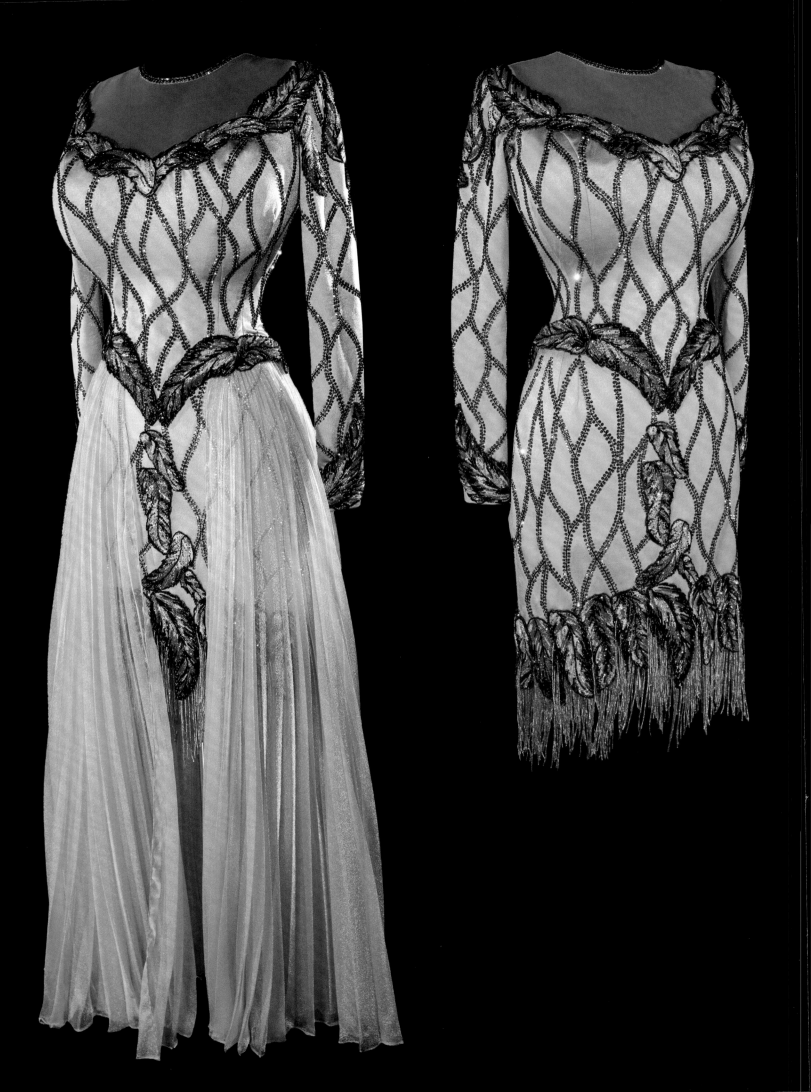

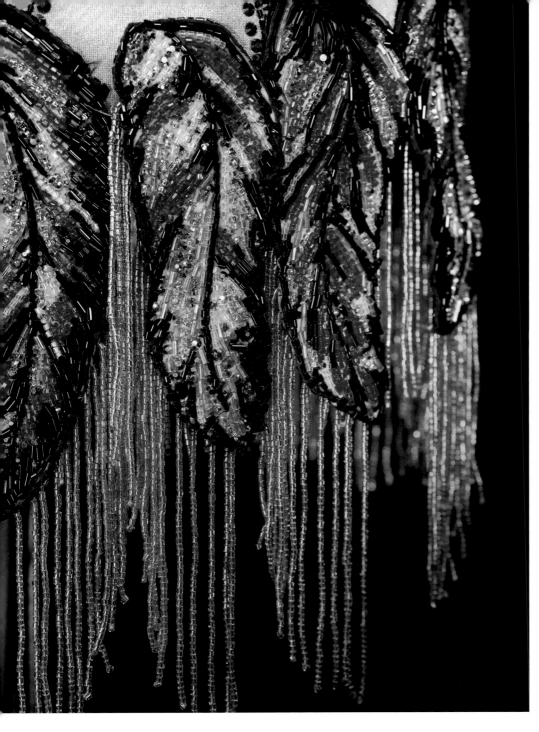

I've always loved feathers ever since wearing them in my hair as a child, and the beaded ones Steve designed for this dress are so fun. I like adding a little chiffon "put on" to my costume when returning onstage for the encore, as I would at the end of my Red Rocks concert in 2016.

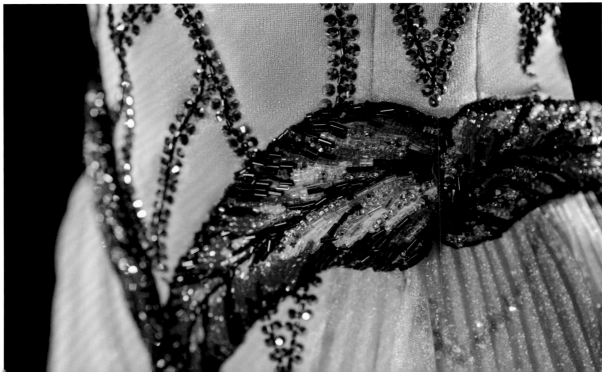

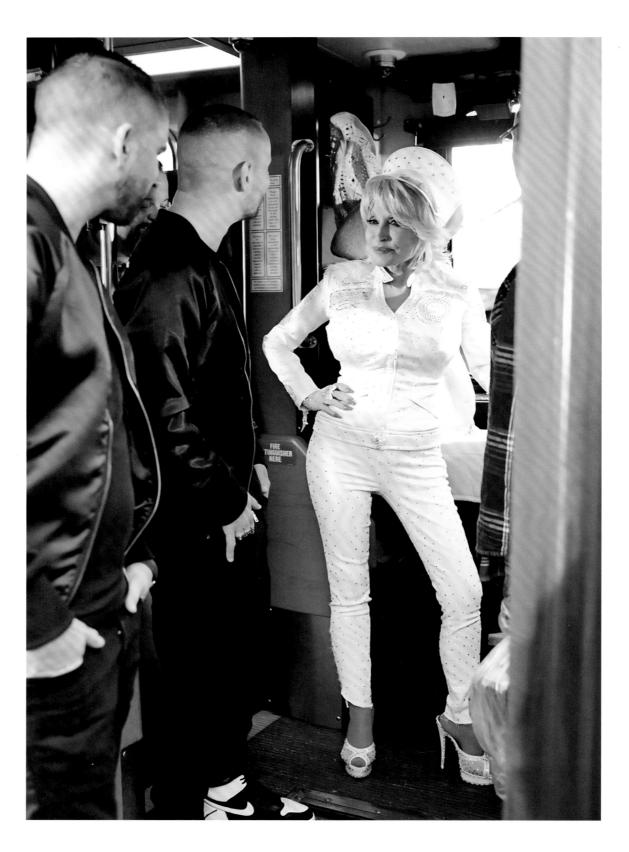

I repurposed this angelic race-car costume designed for a
scene in *Christmas on the Square* to play a tour-bus driver in
the "Faith" music video with Galantis. All the angel-themed
custom patches were made by Denyse Hammen.

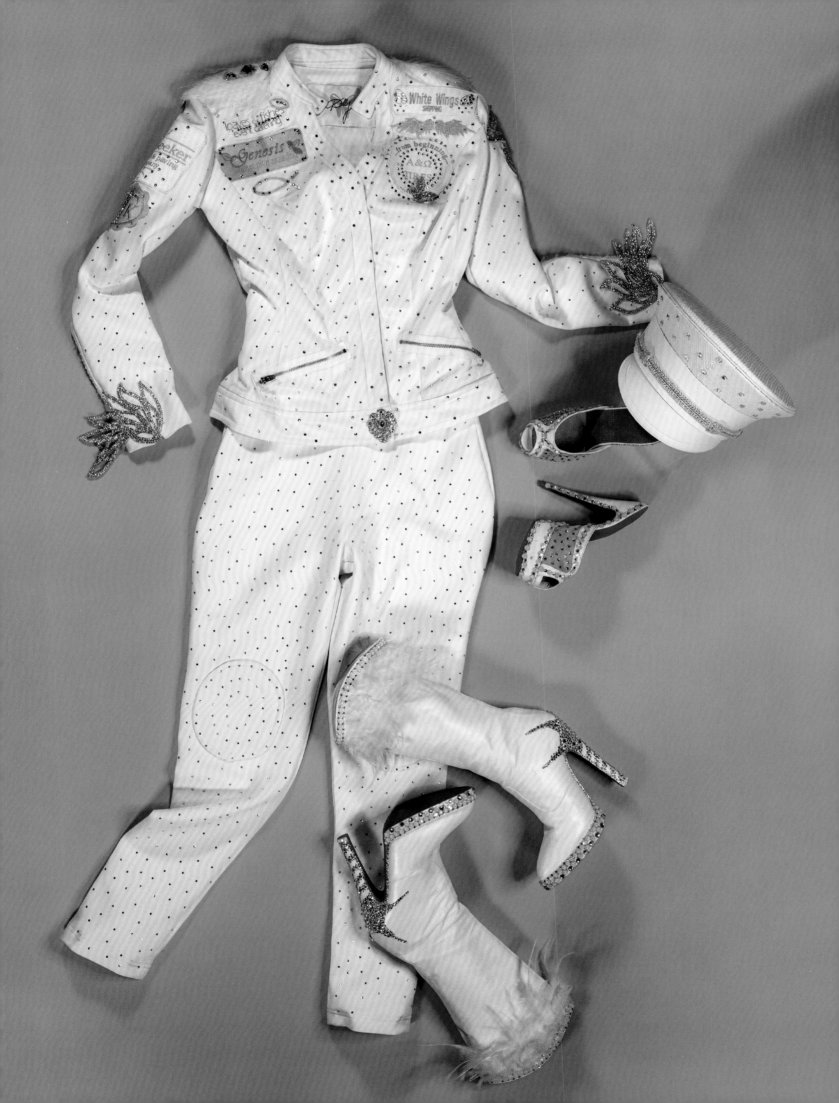

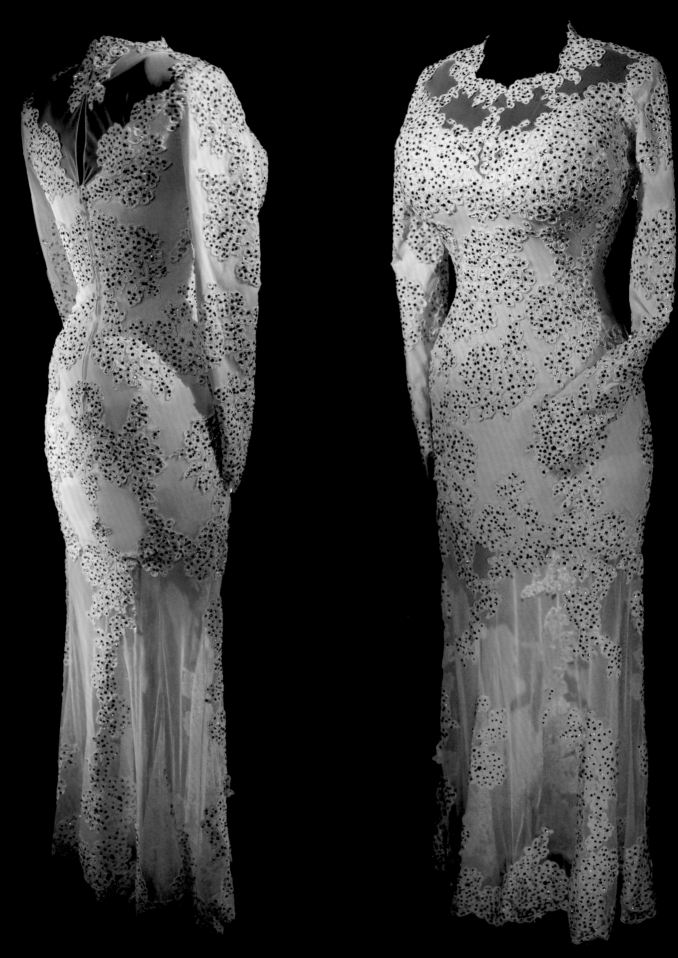

While wearing this dress, designed by Robért, I was presented with
the Willie Nelson Lifetime Achievement Award at the CMAs in 2016.

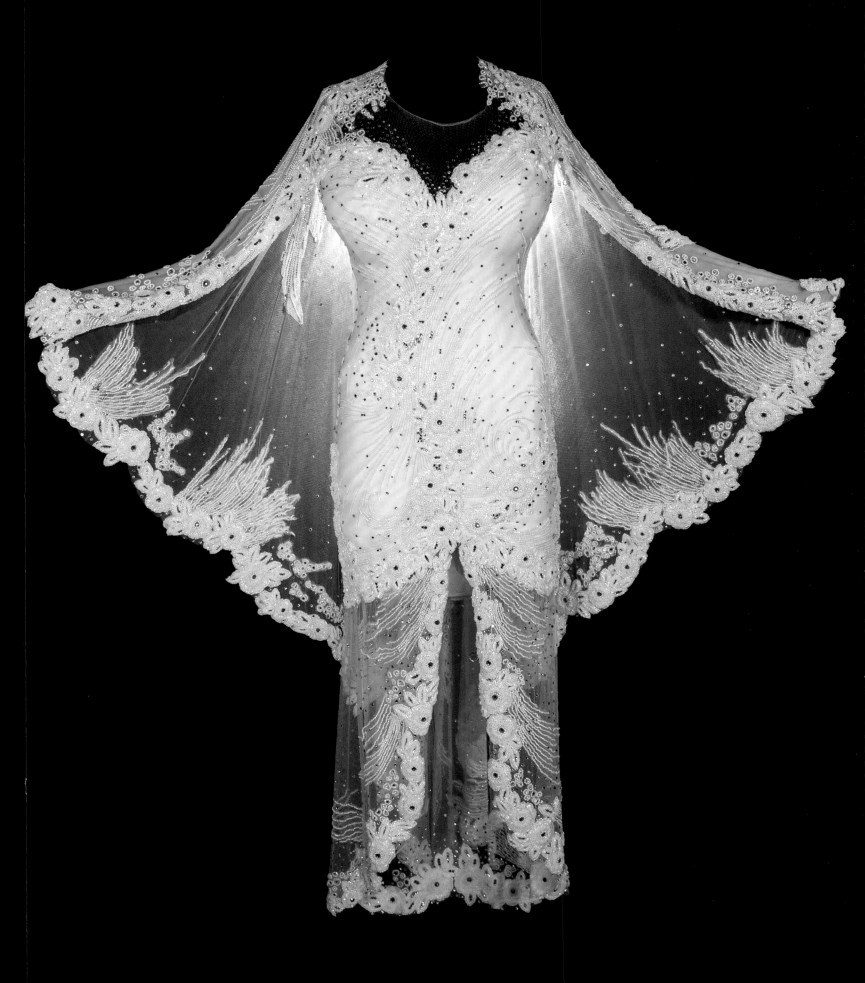

The Recording Academy named me MusiCares Person of the
Year in 2019, and I wore this dress designed by Steve and created
by the design staff for my performance during the Grammys.

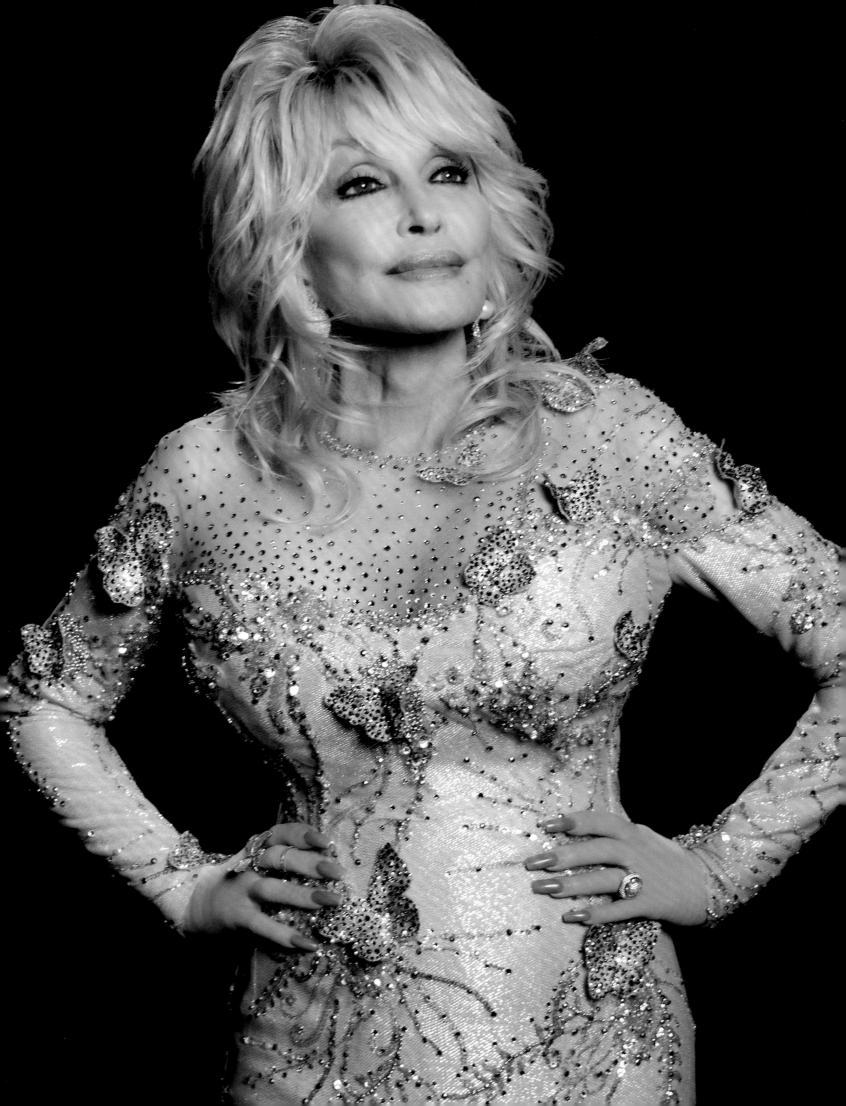

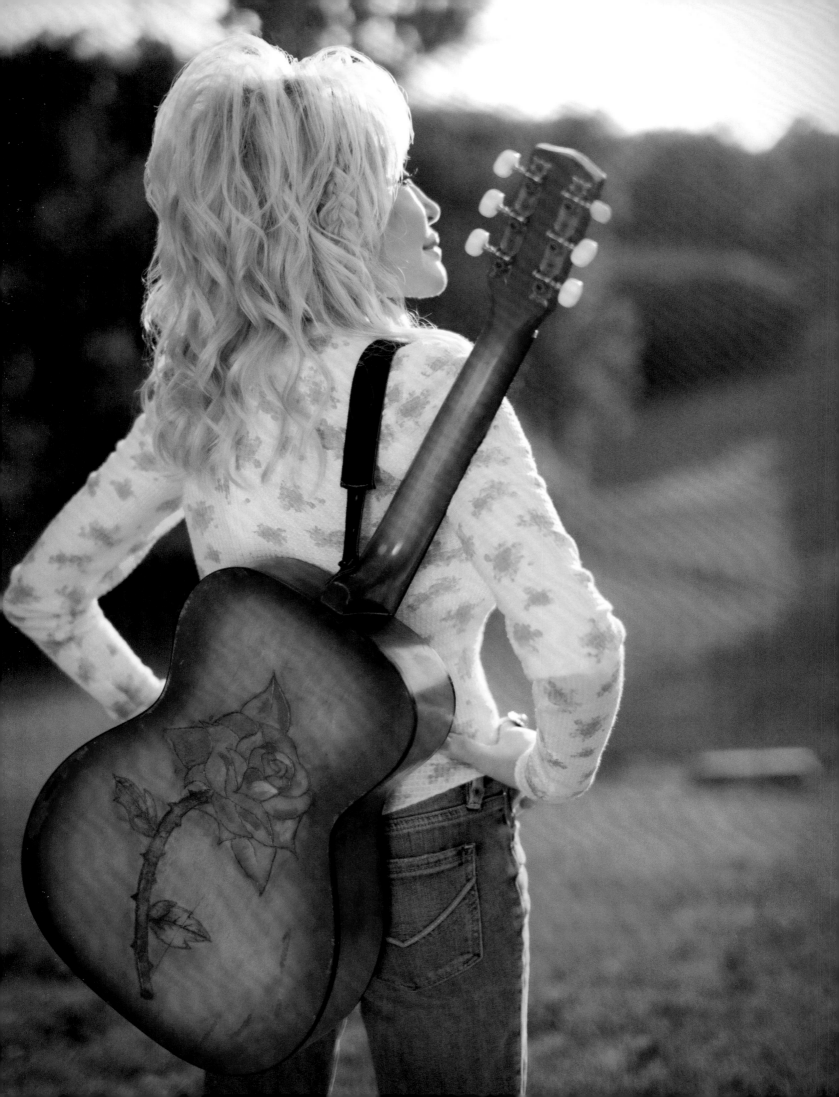

"I wake up with new dreams every day."

Dolly

Like everyone else, Dolly's life was upended by the COVID-19 pandemic in 2020. But when she received her first COVID vaccination, she did so in Dolly style, donning a peekaboo-sleeved blouse, an image that went viral.

In 2021, she wowed as host of the Academy of Country Music Awards, wearing an array of spectacular outfits designed by Steve Summers. She also expanded her horizons as an artist, co-writing a novel, *Run, Rose, Run*, with James Patterson and releasing a studio album—her forty-eighth—that featured twelve songs inspired by the book.

In November 2022, Dolly was inducted into the Rock & Roll Hall of Fame. Onstage in a studded leather jumpsuit, Dolly sang a new rock song—a preview of her forthcoming rock album, the first in her sixty-year career. She ended the year by celebrating her favorite holiday with *Dolly Parton's Mountain Magic Christmas* on NBC.

And to mark the occasion of *Behind the Seams* in 2023, Dolly, Rebecca Seaver, and Steve Summers and his design team dreamed up a breathtaking butterfly-themed outfit that beautifully summarizes Dolly's six decades of style. As for Dolly, she continues to look to the future, drawing inspiration from new collaborators, new styles, and new ways to, as her aunt Dorothy Jo said all those years ago, "look pretty."

—*Holly George-Warren*

*W*hen I look at the photos of my clothing archive, my first thought is, *Good Lord! How much time did I spend wearing all those clothes!* Then I think about just how blessed I've been, how lucky I am that I've been able to see all my dreams come true. As I've said, a piece of clothing will take me right back to a specific time. I recall where I was, what I was wearing, what I was thinking, and what age I was. Some people say, "You can't go home again," but the photographs in this book take me back—onstage, in the studio, on the road, with musicians and friends. So if you're me, you *can* go home again! My archive assures that. I love seeing it. I love letting people see what I've worn over the past sixty years.

I have been blessed with great people who've helped make my dreams a reality. As you grow as an artist, a good designer meets you at each stage of your career and helps you change your wardrobe organically. I'm so fortunate that I met people who saw me as I was in those time periods: from Ruth Kemp and Lucy Adams in the early days to Bob Mackie and Tony Chase in my glitzy years to Rose Sanchez and Debra McGuire in the '90s to Stacia Lang in the early 2000s to Robért, Steve, and Iisha, who are still going strong today.

Since I was a teenager, I'd hoped to be successful and be a star. I used to wonder, if I did become successful, how would I feel when I looked back on my life? Would I be able to look back with pride? I am, and I *do*—and I'm grateful for that. At the same time, I'm always looking forward to doing things that I've never done before. And that goes for fashion too. I'm so glad to get to dress up and do all of these fun things, with so many interesting people, and hope to keep on adding to my archive for many years to come!

Behind the Seams

My team calls their workplace "the Secret Rhinestone Headquarters." But I call it "Sew Pretty," because they better sew pretty!

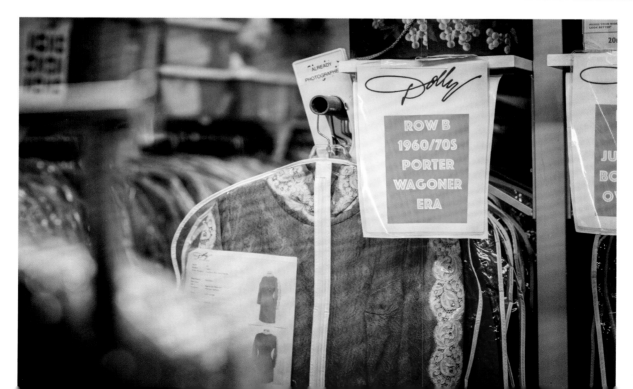

Design Team

Riley Reed Hanratty
& Vance Nichols

Riley Reed Hanratty is a Western-wear designer and the Collection Conservator of the Dolly Parton Archive. As Riley remembers:

"I joined Dolly Parton Productions in 2018 to do some sewing to help out Iisha Lemming. My first big project was Dolly's 2019 Grammys outfit—a white dress with little red rhinestones all over it. We had a week and a half to get it ready, and it was all completely rhinestoned and beaded. There were ten of us working long hours to try to get it done. In decades past, Dolly's garments were embellished with rhinestones in Tiffany settings with metal prongs. Today, we use heat-set rhinestones that are more lightweight and don't snag. Then just a couple weeks later, I got to watch it on TV, and that was the first moment of seeing something I worked on for her on TV. That will always be really special!"

Vance Nichols is a Nashville-based lifestyle design consultant. As Vance shares:

"I started with Dolly's design team around 2018. I'm lucky that growing up as this little Appalachian kid, I had two amazing grannies who taught me how to sew and do lots of fun creative things. Over the years, I've helped Dolly's team with set decoration, rhinestoning, and hand-sewing. I especially loved working on the outfits for her fiftieth anniversary on the Grand Ole Opry concert. I also decorated her guitar, dulcimer, and guitar strap, though she ended up not using the strap because it wouldn't fit over her hair!

"Working in Dolly's archives, I realize that her style has changed over the decades. Early on, with Lucy Adams, it was 'country couture.' Then with Tony Chase, she was 'über glam.' With Robért, she was kind of a 'softer glam.' Now with Steve, she's very stylish. He really knows how to dress her in a current, top-notch look."

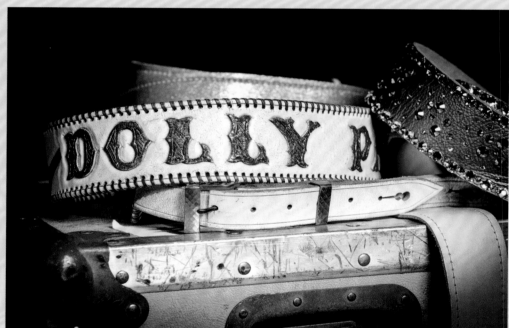

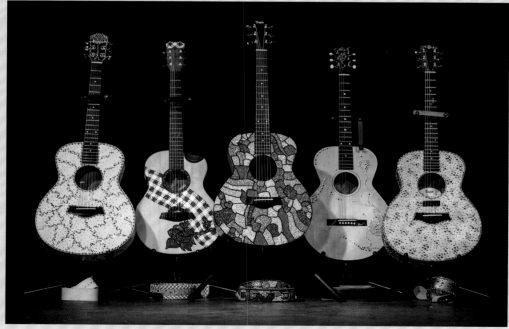

My Inspirations
RuPaul

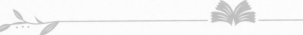

I just love RuPaul's look. He's definitely one of my style icons! And I have to say, I think it's a mutual admiration society. I've loved the attention I've gotten from the participants on *RuPaul's Drag Race* and getting to appear on the show myself. RuPaul and I got to have a conversation about something we have in common—wigs!—for *Marie Claire* magazine. It was fun comparing notes:

RuPaul: People always ask me how many wigs I have, and I name each of them different names . . . I have wigs that I still wear that are about twenty-three years old. Do you have wigs that are that old?

Dolly: I do, but most of them are museum-type pieces. I don't think I have any that are that old that I wear, but I know what you mean. See, you're a drag queen. Those are like costumes to you. This is my living self. I am a living drag queen. You just dress up now and then, but for me, I like the wigs and I wear them almost every day. . . . I actually keep my own hair the same color and I just pull it up in little scrunchies around the house. But [at home] I still like to put on makeup and have my hair fluffed.

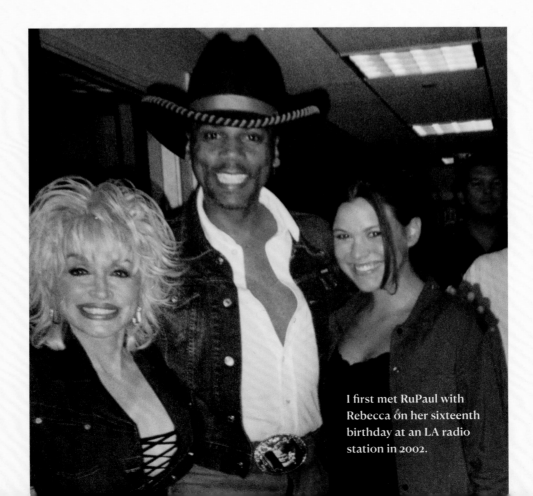

I first met RuPaul with Rebecca on her sixteenth birthday at an LA radio station in 2002.

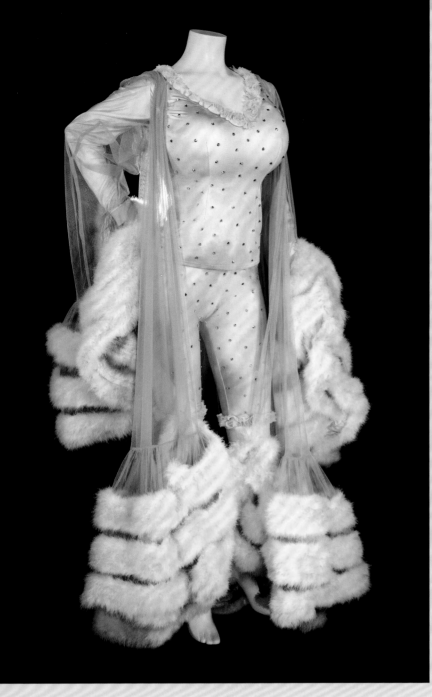

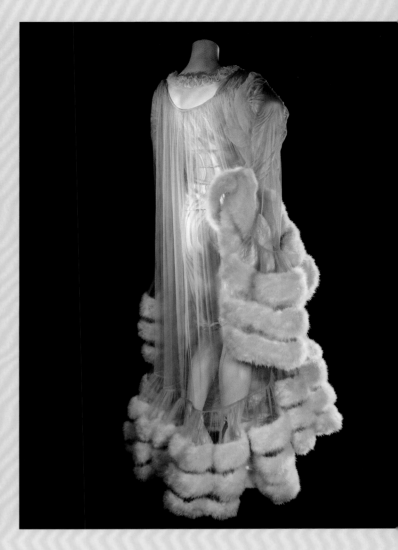

Since Rebecca is also a burlesque and drag performer now, I thought it was only fitting to borrow her luxurious Catherine D'lish robe to appear on *RuPaul's Drag Race*. The little pajama set is from Target's kids' section and was gussied up with rhinestones by my gals.

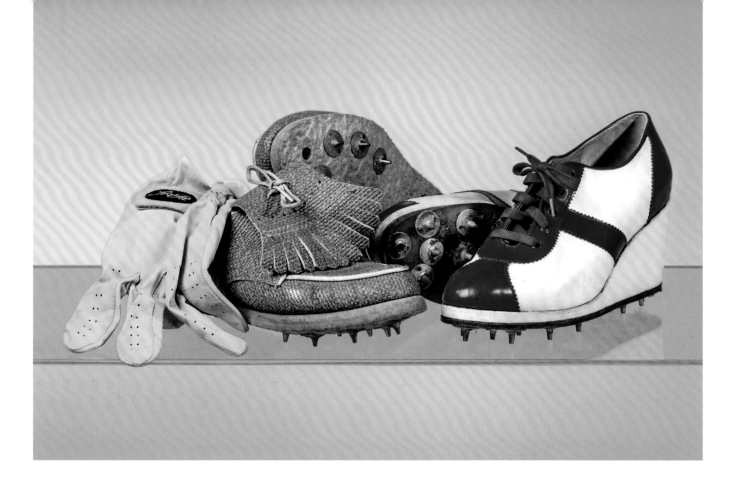

I wore these golf shoes in the 1970s—who says you can't wear heels
on the green! Speaking of heels, I've worn the most glamorous
five-inch spikes you can find, and I've clowned around on shoes
with wheels. I never get tired of my heels!

*"The holidays make me very creative. I try to remember and draw
from the spirit of Christmas. Even if you don't believe in Jesus, the
spirit is really about giving and tolerance, understanding, and
acceptance."*

—Dolly, 2022

Speaking of things I look forward to, I like all holidays, but I just love Christmas.
I love the decorating, the cooking, the colors, the shopping, the music. What's not
to love about Christmas? I have my Christmas decorations up at Thanksgiving,
turn on the lights the day after Thanksgiving, and keep the decorations up till
after my birthday, January 19—though some people say that's too much. Going
all the way back to the 1960s, I've loved dressing in "Santa Claus drag." For
some people, in fact, I've become synonymous with Christmas—which makes
me very happy.

Behind the Seams

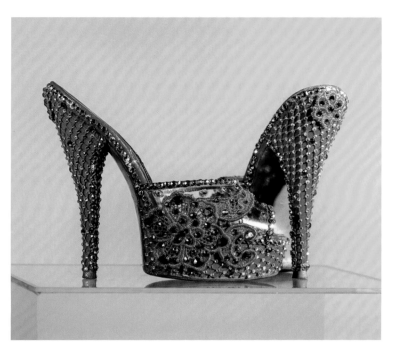
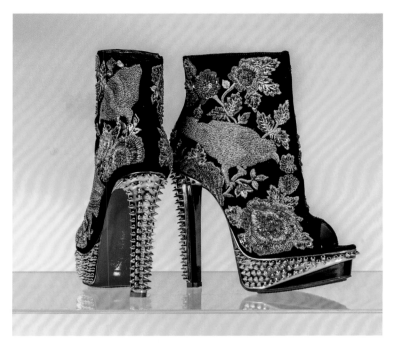
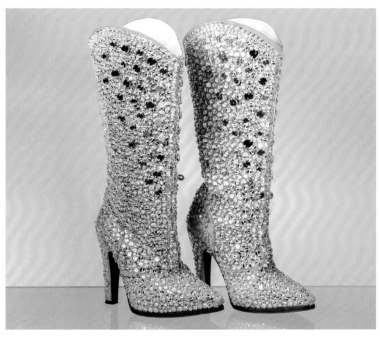

Back home, we didn't have that much growing up, but we always had Christmas and we always fantasized that Santa Claus was coming, though he never did. Daddy would say the reason Santa didn't come to our place was because we lived so far back in the woods and didn't have electric lights. So we didn't blame Santa too much. We just knew he had looked for us but probably couldn't find us. But I always believed in that magic. And I still do.

I love making cookies and sharing presents with the kids and my family. As long as I can remember, I've dressed up in some sort of Santa suit and become "Granny Claus." I have so many different outfits. In the archive, there are even some Santa costumes dating back to the Lucy Adams days. Every year on Cookie Night, I have all the nieces and nephews—and now the great-nieces and great-nephews—spend the night with me. I have an elevator and the bottom of it is painted with flames; I dress up in my Santa suit with the hat and boots, put toys in a big ol' sack, and from upstairs I come down the "fireplace" elevator. When I open the door with their toys, I'm hollering, "Ho, ho, ho, here comes Granny Claus—or GG Claus!" It's such fun!

I'm always in costume at Christmas. If I'm not in a Santa suit, I wear reds and greens. I wear sweaters with Christmas lights on them where I can push a button and I light up. My hairdresser, Cheryl Riddle, even puts Christmas lights in my hair for Cookie Night. At Dollywood, we do special Christmas events, so I get to dress up in Christmas outfits for those too.

I have so many Christmas memories, but one of my favorites is from 1982. My sister Rachel was living in LA starring as Doralee in the *9 to 5* TV series, so she couldn't come home for Christmas. Both she and I felt really bad because she couldn't come home—we'd always been together at Christmas. So after we did our Cookie Night, I flew to LA in my Santa suit. It was Christmas Day, and the plane was pretty empty. I got on the microphone with the flight attendants, and we started singing Christmas songs. Everybody was having a great time. When Rachel picked me up at the airport, I came out in my Santa suit and she just started crying. It was so sweet. There was no way I was going to let her have Christmas without me.

Christmas is so important to me that I used to do a Christmas movie or a Christmas special every year. For years and years and years, I was known as "Little Christmas." People would ask, "What are you doing this year? Are you doing a special; are you doing a movie?" Early on, I was a guest on one of Bob Hope's Christmas specials, and I dressed as a reindeer. Later I'd dress as a reindeer on David Letterman's show and on my own *Christmas at Home* special in 1990.

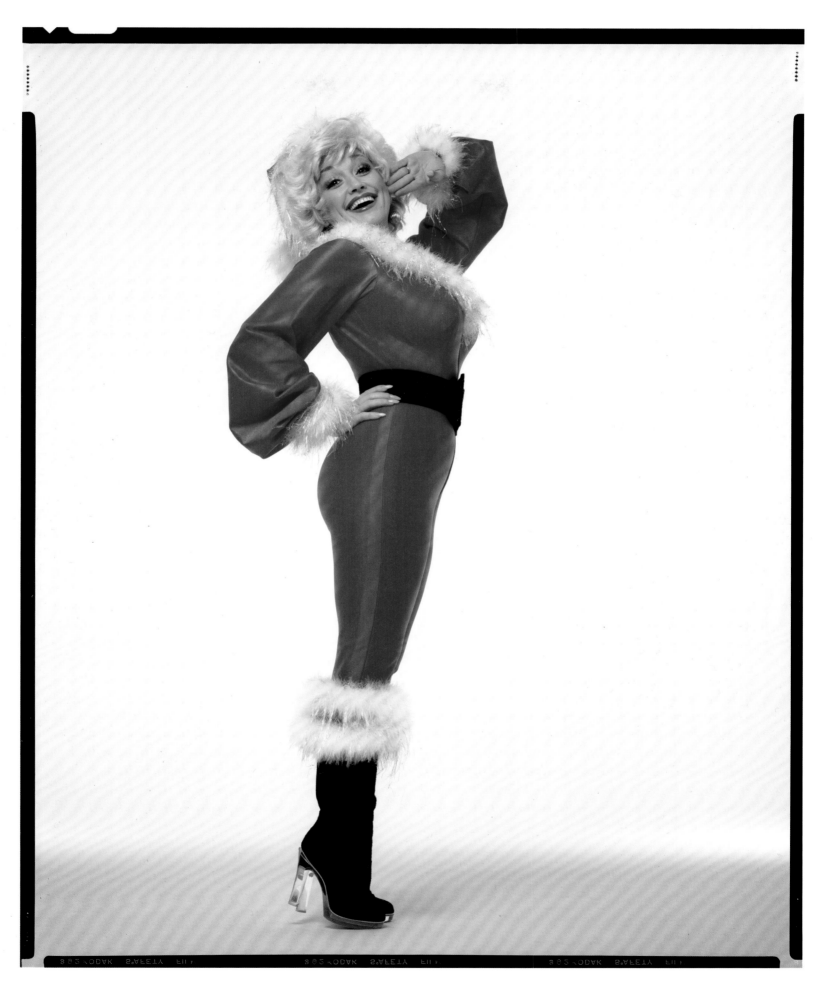

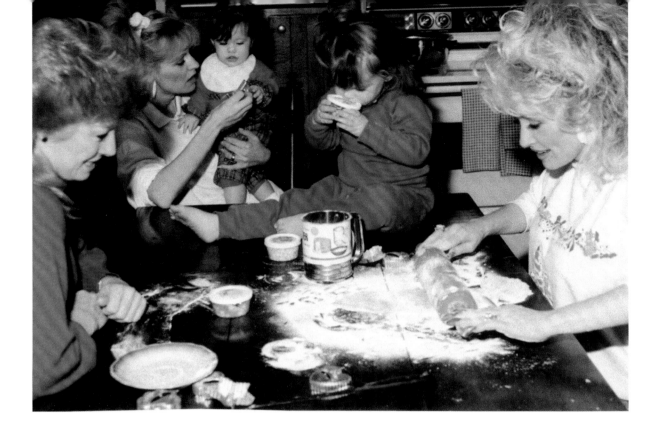

Some fun Cookie Night memories *(clockwise from top):* a 1990 night with *(from left)* Judy, Cassie (holding Hannah), Rebecca, and the Cookie Lady; my great-nephew Asher is my little elf who helps me get my Christmas presents ready for the family; me and little Hannah.

In 1984, I did a TV special with Kenny Rogers—*Kenny & Dolly: A Christmas to Remember*—one of my favorite Christmas things I ever did. We had just released the album *Once Upon a Christmas*. That's still one of the biggest Christmas albums ever released—it's sold double-platinum. We loved doing that together. We played Mr. and Mrs. Claus on the TV special.

Smoky Mountain Christmas, in 1986, was also fun to do. I had the story idea for it and wrote all the songs; it was directed by Henry Winkler. People love it because it has a bunch of orphans hiding out in a mountain cabin with my character, Lorna Davis, who's "escaped" Hollywood. Lee Majors, a big star at the time, was my costar. In one scene, I wore a cute little "Santa's elf" costume—when I see myself in that now, I see my big hair more than anything else. My hair was like a mountain of snow.

Tony Chase made me a gorgeous white outfit to wear on the cover of my 1990 album *Home for Christmas*. I'm sitting in a white sleigh—kind of like the one I was in on the Bob Hope TV special a long time ago. For the back cover, I'm wearing a gorgeous red velvet cloak. Another thing I love about that album is that I recorded it in Tennessee with my Mighty Fine Band, some of whom perform with me to this day. And it includes some guests, like my nieces and nephews, on background vocals.

During 2020, with the pandemic raging, I worked on two Christmas projects that I hoped would cheer people up. I made a new Christmas album called *Holly Dolly Christmas*, its title based on the old Burl Ives hit "Have a Holly Jolly Christmas." I really like all the songs on there. A couple that I'm most drawn to are "Circle of Love" and a special one called "Mary, Did You Know?" The album includes a bunch of wonderful duets with guests like Jimmy Fallon, Willie Nelson, Michael Bublé, and Miley Cyrus, my little goddaughter. She and I did a song I wrote called "Christmas Is." And I made the TV musical *A Christmas on the Square* for Netflix, for which I wrote fourteen new songs. It was choreographed and directed by Debbie Allen, with a lot of dancing, and the theme was people coming together to save their community. I thought that would be uplifting, since that year most of us could not go out and be with our loved ones due to the pandemic. I wanted people to feel that sense of community.

Most recently, in 2022, I did another TV musical, this one filmed at Dollywood, *Dolly Parton's Mountain Magic Christmas*. Every year, Dollywood has such spectacular Christmas decorations and a special "Christmas in the Smokies" program. I wanted to show that off. We also included Dollywood performers—a bunch of good-looking people! That was a lot of fun to make, and we had a great cast: Jimmy Fallon, Ana Gasteyer, Tom Everett Scott, and my friends and kinfolk,

Better Get to Livin'

Dolly Parton

Home For Christmas

I bring out this sleigh every year as part of
my Christmas decorations at home.

including Steve Summers, Miley Cyrus, my sisters Rachel and Cassie, my niece Rebecca, and other nieces and nephews. It goes "behind the scenes" of a TV special to reveal the ins and outs of putting on a big Christmas show and how it's hard to get your ideas across when the producers have something more commercial in mind. My goal was to share the mountain magic that naturally exists around Dollywood at Christmas. I end up "going rogue," after I cross paths with my own Three (singing) Wise Men, played by Willie Nelson, Billy Ray Cyrus, and Zach Williams. The idea is that Christmas means something to us because of the people we share it with, and how my faith ties together Christmases past, present, and future.

"I like to dress up for Christmas, and that's where Steve Summers comes in. Like I say, he's the best playmate I've ever had. The best elf I've ever had! When I needed to do some December [2022] spots for my new Smoky Mountain perfume on HSN, he said, 'Well, you got to dress like Christmas. So let's make you an up-to-date Santa suit.' He made me a new one with little straps, which I love. So I wore it for Cookie Night, because I liked it so well."

—Dolly, 2022

Behind the Seams

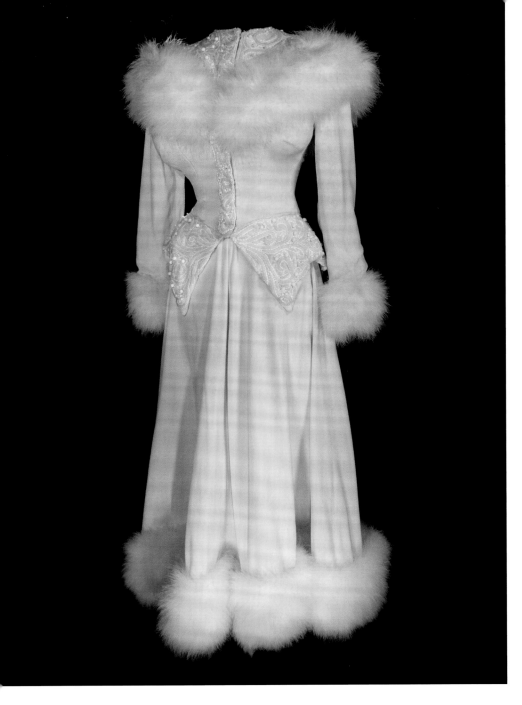

I love this classic white velvet Christmas skirt and jacket, designed by Tony Chase for the *Home for Christmas* album. Over the years, I've worn it at Dollywood for our big Christmas Tree lighting ceremony.

A Holly Dolly Christmas

Though Christmas only comes once a year, I like to keep the spirit of my favorite holiday all year long. I've worn everything from a Mrs. Claus outfit on a record cover and TV special with Kenny Rogers to a glamorous Santa jumpsuit on the cover of *Rolling Stone*.

Over the years, all my designers have come up with their own unique take on Christmas clothes—and, in fact, they fill up a whole wing in my archive. Each outfit brings back a fun memory, usually of my family—so I love to go in and look at them from time to time. It's kind of like a photo album covered in rhinestones!

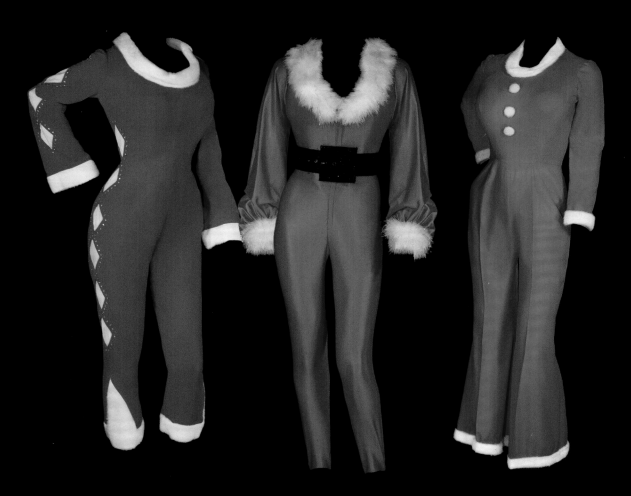

While nothing can top spending time with my *real* sisters at Christmas, these sisters by Ann Roth *(middle)* and Lucy Adams *(left and right)* come a close second.

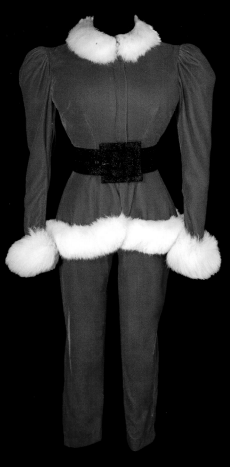

From *A Downhome Country Christmas*
TV show, 1987.

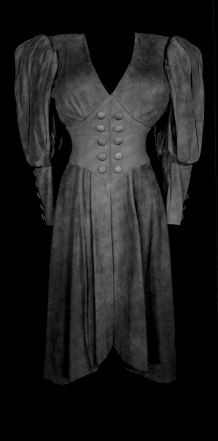

From my *Home for Christmas*
television special, 1990.

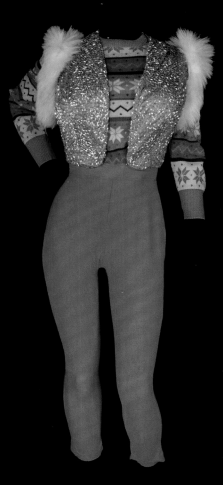

From the "Downhome
Country Christmas" episode of
my TV show, 1987.

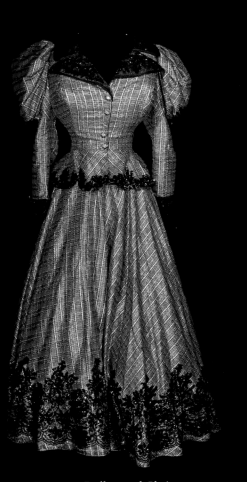

From my Dollywood Christmas
concert, 2000.

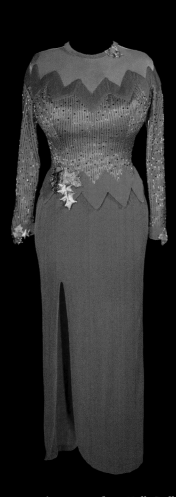

From the cover of my *Holly Dolly
Christmas* album, 2020.

My Mrs. Claus outfit from Kenny's and
my *Once Upon a Christmas* album cover
(notice my little granny eyeglasses!).

I love tradition, but as you've seen, I also enjoy jumping in and trying new things, and that includes my music. Over the years I've done country and all that, but getting to do more of the rock-and-roll thing these days is so fun. It's like dress-up!

I can always depend on Steve and Robért to do great things for my special events, and they rose to the occasion when it came to my Rock & Roll Hall of Fame induction on November 5, 2022. I wanted both Robért and Steve to design my outfits. Since Steve is my creative director, I asked him, "What do you think about Robért doing two or three things for this and you do two or three things? So I'll have my choice, because this is a big, big night for me."

Steve designed a really special outfit inspired by a Tina Turner dress with lots of sparkle and fringe. I loved that one! And he also did a great black dress covered in little chains for the red carpet. Steve had told Robért that I wanted something Elvis-y to wear when performing my new song "Rockin'," because it starts out with lyrics about how I grew up loving Elvis. It just seemed like the King was the right touch. I told Robért I wanted the collar to have that Elvis look. I love that big stand-up collar! Then he incorporated other rock-and-roll elements—the leather, the studs—into the perfect outfit.

I was honored to have P!nk and Brandi Carlile at the Rock & Roll Hall of Fame induction ceremony. P!nk's induction speech was fantastic; I was so touched and moved by it. She's a fantastic gal. She looked great in her bright green suit. I love P!nk in green. I love P!nk in blue. I love P!nk!

I'm so happy that she and Brandi Carlile are singing on my cover of the Rolling Stones' "(I Can't Get No) Satisfaction" on my new album, *Rock Star*. I really wanted to pull out all the stops on this record. And boy, did I ever get some rock stars to join me! I even got a Beatle—Paul McCartney! Elton John, Joan Jett, Stevie Nicks, Ann Wilson, and John Fogerty are just some of the rockers who contributed vocals to the record.

You know, rock is not just a sound, it's an attitude. Doing things your way, being a rebel. And that's why I think I've always had some rock and roll in my soul.

Behind the Seams

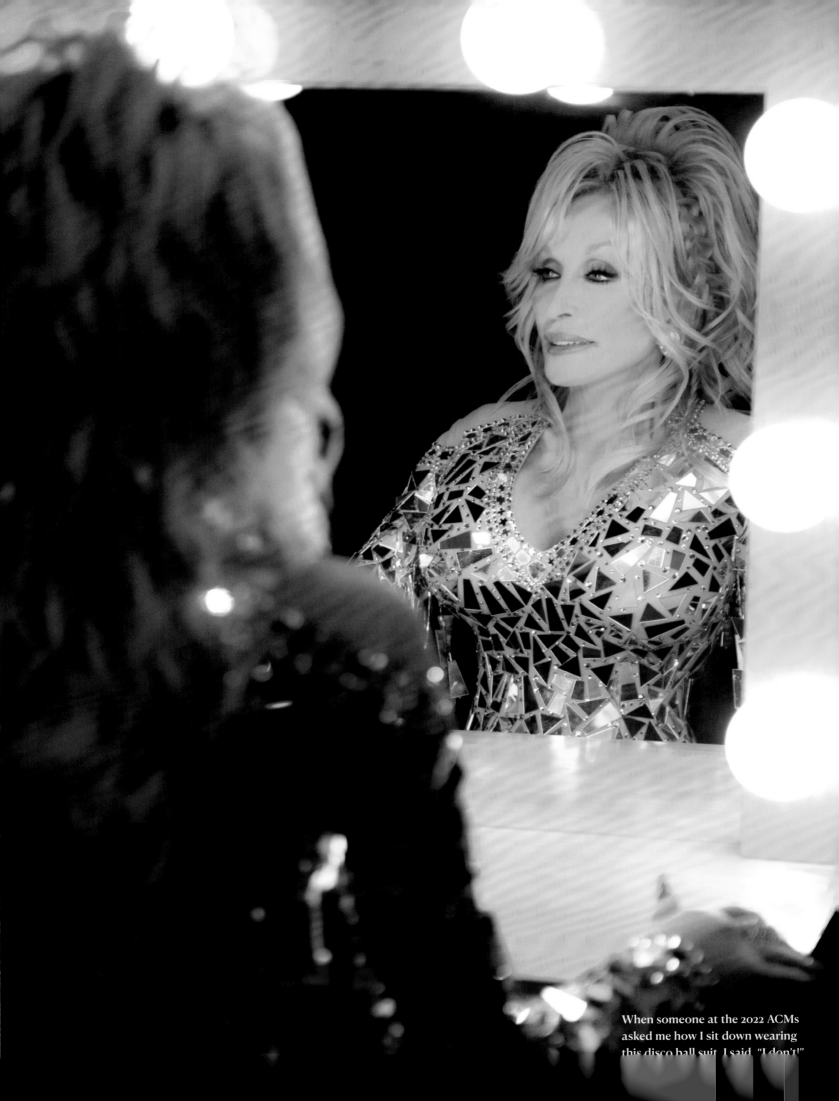

When someone at the 2022 ACMs
asked me how I sit down wearing
this disco ball suit, I said, "I don't!"

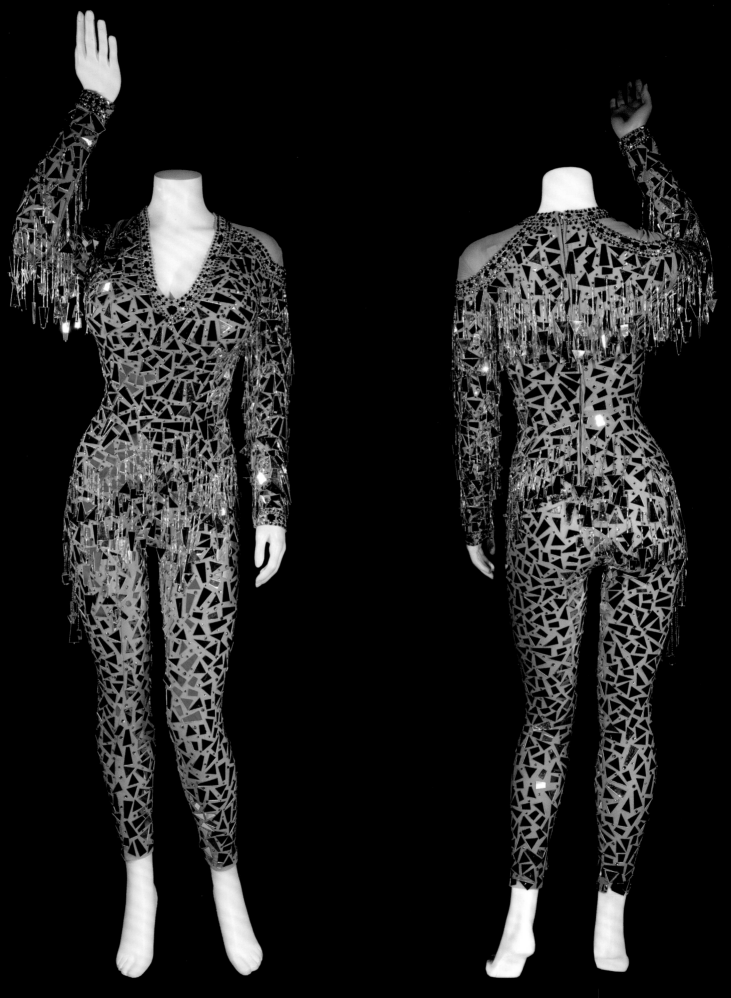

Steve Summers told me that this outfit was one of the favorites that
he's ever designed for me. I just loved the way the lights hit it—
I felt like I had the power to make anyone get up and dance!

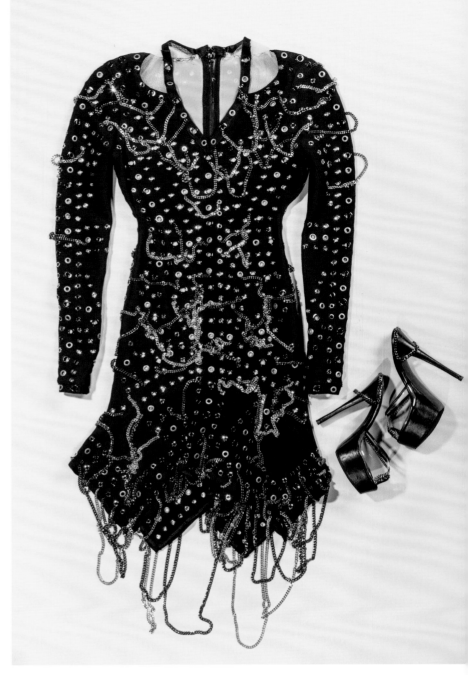

More of Steve's creativity at play: Steve's dress *(right)* for the red carpet of my Rock & Roll Hall of Fame induction in LA; I had to wear an outfit with an Elvis collar *(below)* to rock out onstage.

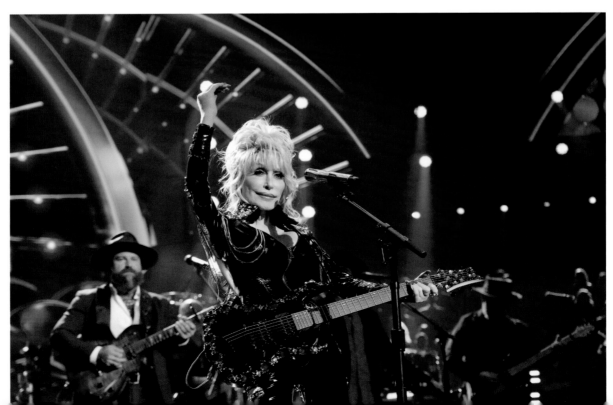

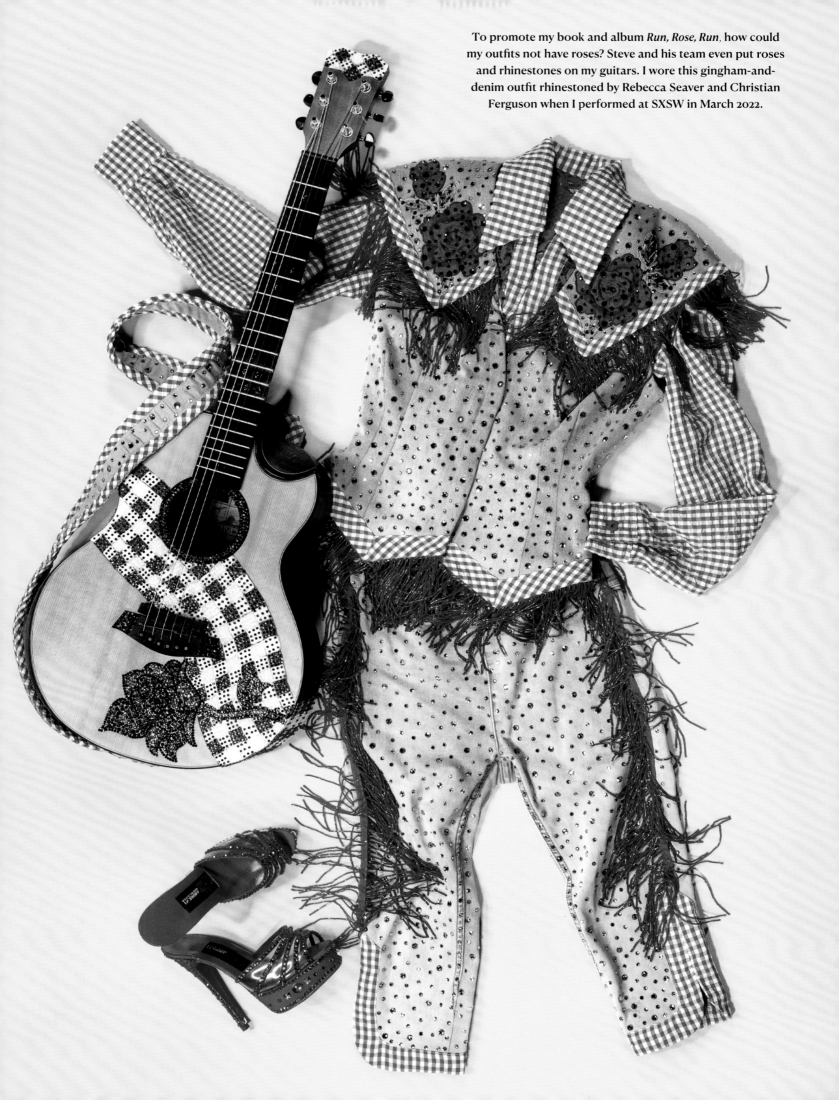

To promote my book and album *Run, Rose, Run*, how could my outfits not have roses? Steve and his team even put roses and rhinestones on my guitars. I wore this gingham-and-denim outfit rhinestoned by Rebecca Seaver and Christian Ferguson when I performed at SXSW in March 2022.

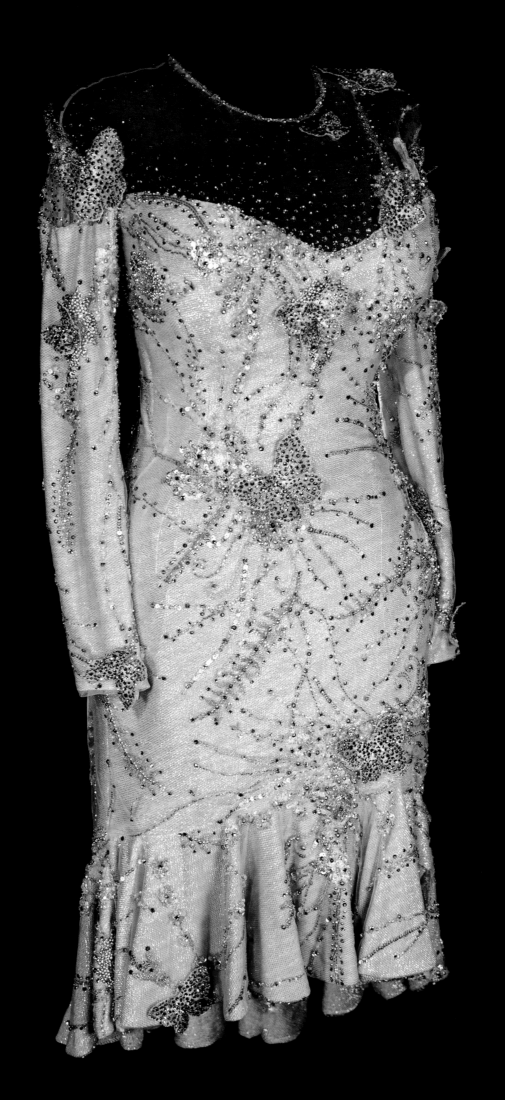

I wore this beauty for the Scent from Above perfume launch, as well as on my record *Sent from Above*. It was designed by Steve, embellished by Barrie Kaufman, and covered with some special butterflies.

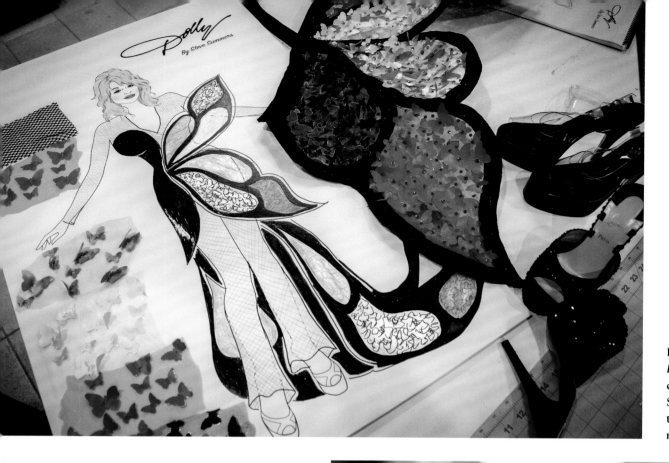

I loved watching my new *Behind the Seams* dress come to life, starting with Steve's sketch. Of course there had to be lots of rhinestones!

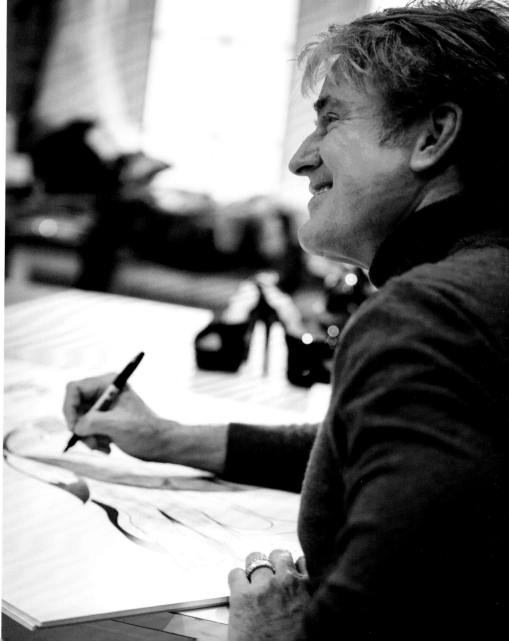

I'm not sure if anyone has ever gotten a dress custom-designed for a book before, but if anyone's gonna do it, it's me! Such great creativity went into the design of the special dress made for *Behind the Seams*. It all started with Rebecca, who had the idea to make a dress with a big tail and drape like a butterfly. She and Steve also talked about including an element from my Coat of Many Colors into the dress because, in a sense, that's what this book is: my book of many colors! And the dress got a train of many colors! The train just goes on and on and on—kind of like my life.

The outfit is absolutely beautiful. I love the way the top looks with the butter-flies, and the sleeves are made out of fishnet, like the stockings I first adored as a girl (and still do). The dress has elements from my whole life. Wearing it feels magical—just like those fantasies I had as a kid dreaming about the big fine dress that I'd wear one day. The dress reminds me of my mountain home and chasing butterflies in those fields. I imagine that Rebecca and Steve were trying to create a look that made me into a very glamorous butterfly.

Just like wearing my butterfly dress brings back so many memories of my life, I think certain colors and even clothing styles can reflect what you're feeling inside. People see that I'm kind of flamboyant and love to laugh, and I think that my personality is basically that. Of course, like anybody, you have your hard times, and you're never all that some people may think you are. But I was born with a happy heart. I've always tried to let that shine even during my dark times. I'm one of those people who, even if things are not right, goes about trying to make it as right as I can rather than just lying around on my ass and wallowing in it all day. I think, "Well, I can either do *this* or I can do *that*." I choose to get up and try to make it better if I can.

I also try to accentuate the positive when it comes to dressing up and wear-ing makeup as I get older. I try to make the most of what I've got to work with. Same thing with clothes. In recent years, gloves have become an important fashion accessory for me. I've actually always loved gloves. Decades ago, I even bought some sexy little gloves from the Hustler shop with rhinestones on them. Nowadays, I don't really like the look of my hands, but like anything else, I'm going to make the best out of them. So Steve and Robért started making me little gloves out of the same fabric as my outfits. I've got short gloves and long ones to wear with shorter sleeves. I've also got some completely sheer gloves with rhinestones on them that look like I've got rhinestones on top of my hands. They've become part of the flair of my outfits.

Better Get to Livin'

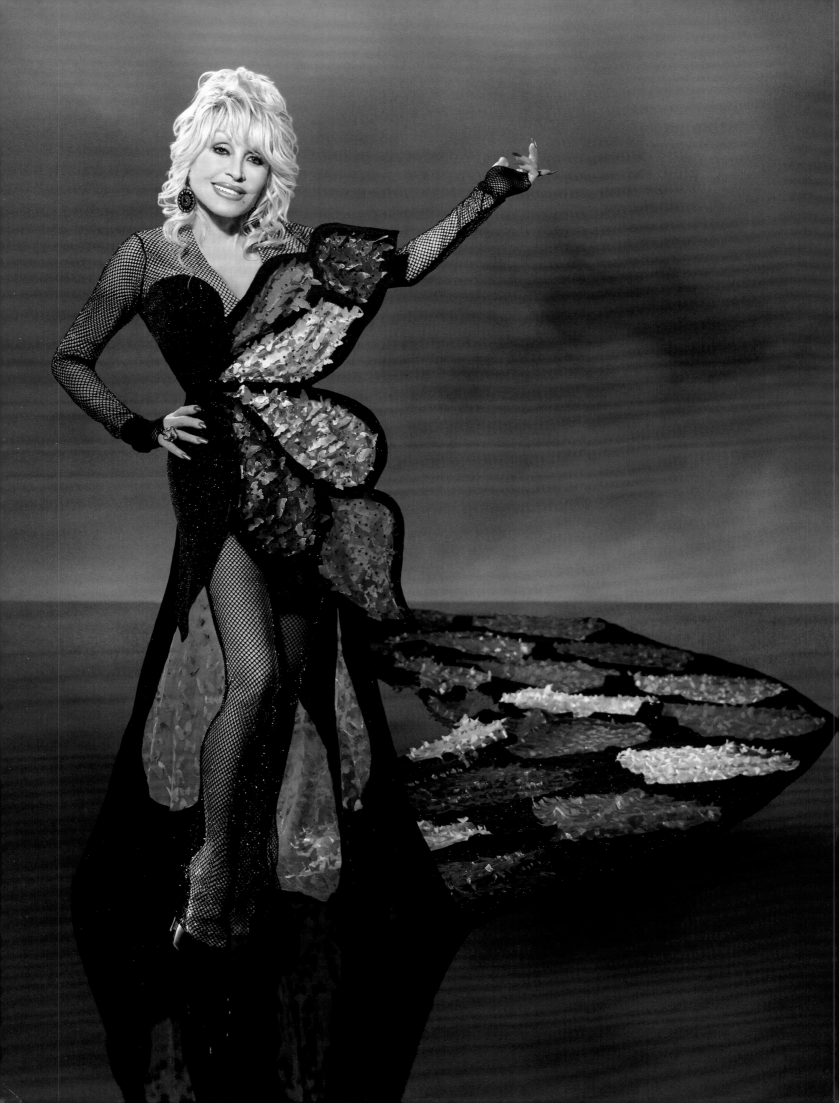

Speaking of rhinestones, I swear I don't sleep in them. But I probably could and be comfortable! At home, I've got my little comfy clothes that don't bind me or pinch me if I'm working or relaxing. I do wear some kind of heels, though—I call them my baby shoes. I have to wear them so I can reach up into my cabinets. And I like to look pretty at home. I never know who's going to show up at my door!

"I'll be this way when I'm eighty, like Mae West. I may be on crutches, in a wheelchair, or propped up on some old slant board, but I'll have on my high heels, my nails and makeup on, my hair'll be all poufed up, and my boobs will still be hangin' out."

—Dolly, 1995

When I started out as a songwriter and entertainer, only a few women had become stars in the country-music field. Thankfully, things have really changed for women artists. I'm so happy that now there is an abundance of women singers building successful careers and a legacy of their own. I'm always honored and flattered when they say they've learned something from me or that I've influenced them, whether because of my business or the way I dress or the way I write or the way I sing. I'm proud to be there for all the young gals trying to make it. I always say, "I don't give advice, but I got a lot of information to share." So if you want to ask me for some information, just come to me.

When thinking about my stage clothes, I look at them in the same way I consider my other creative projects. I try to be a better me. I don't try to compete with anybody else. I got to be me. When people who are afraid to be themselves ask me what to do, I tell them, "Don't be a coward. Don't be influenced by other people. You know who you are. If you don't, you need to find out pretty soon. You can't live your life trying to please other people. Go for it!"

Of course, I try to improve every day. If there's a better outfit, I want to wear it. If there's a better song, I want to write it. If there's a better record, I want to record it. If there's a better movie, I want to make it. I will continue to be as good as I can be. And I intend to keep coming up with new ideas all the time. In this book, you see how my ideas have come to life over the past six decades. I hope you've enjoyed perusing my whole life in clothes, in rhinestones—and *behind the seams.*

But watch out, there's lots more to come!

Better Get to Livin'

Acknowledgments

From Dolly Parton: I owe a lot of thanks to a lot of people that have helped bring this book to life. It's a life that I have lived, but it takes a world of people to polish and shine a star, so to speak. Not only for the costumes and hairstyles but gathering all the stories, facts, artifacts, photographs, and a million little things that truly happen "behind the seams."

My personal thanks to Rebecca Seaver (curator), my niece, who has worked so hard and has done such a great job to make this book all that it is.

My sister, Rachel Parton George, and Devon Larson (photo archives) for spending endless months, weeks, days, and nights gathering all the photos for this book. I'm sure they never want to see my face again!

Steve Summers (creative director), who is always there for all of us, helping with all things creative.

Holly George-Warren (writer/editor), we couldn't have done it without her at all. She's always looking out for all of us and for that I am so grateful.

From Holly George-Warren: It's been a joy to collaborate on *Behind the Seams* with the amazing Dolly Parton and her Dream Team. Thanks so much to Dolly, Rebecca Seaver, John Zarling, Stacie Huckeba, Christian Ferguson, and Riley Reed Hanratty. I've really enjoyed working with the Ten Speed crew: our estimable editor, Matt Inman, and wonderful design team, Emma Campion and Annie Marino. Also very helpful: Fariza Hawke, Sharon Silva, Janice Race, Ivy McFadden, and Taylor Teague. Thanks so much to my agent, Laura Nolan, and Aevitas Creative's Catharine Strong, as well as Jeff Kleinman and Steve Troha. I'm also appreciative of all those who shared their insights on working with Dolly over the years: Allister Ann, Auriela D'Amore, Robért Behar, Riley Reed Hanratty, Jim Herrington, Stacie Huckeba, Bobbe Joy, Stacia Lang, Iisha Lemming, Debra McGuire, Vance Nichols, Jason Pirro, Cheryl Riddle, Ann Roth, Randee St. Nicholas, Rebecca Seaver, Art Streiber, Fran Strine, Steve Summers, Silvia Tchakmakjian, and Timothy White. In addition, my thanks to Robert K. Oermann, Mary Bufwack, and Alanna Nash, whose help and advice were indispensable. Alanna's 1978 book, *Dolly*; Dolly's 1994 memoir; and her 2020 book, *Songteller*, were tremendously helpful, as was *Dolly on Dolly: Interviews and Encounters*, edited by Randy L. Schmidt (Chicago Review Press, 2017). Thanks also for the enthusiasm and support from Allan Hirsch, Katy K, David Kraai, Brenda Colladay, Jack Warren, and Beatrix Herriott-O'Gorman. As always, my husband, Robert Burke Warren, was my sounding board and my rock.

From Rebecca Seaver: This book has been a dream come true and a joy to create. There are so many wonderful people that brought this book to life, and I am so grateful to every single one of them.

I want to acknowledge the incredible woman who inspired it all: Dolly Parton, my Aunt Granny. Thank you for bringing me along as a child and including me in your journey as I have become an adult. My first memories of you are sparkling, and they will continue to shine because of the light you carry. It's an incredible honor to preserve and celebrate your many accomplishments and our family's memories. I cherish our bond and love you endlessly.

An enormous thank-you to Judy Ogle for showing me the way. Thank you to the Dolly Team, Holly George-Warren, my mom Cassie, my aunt Rachel George, Riley Reed Hanratty, Christian Ferguson, Steve Summers, Danny Nozell, John Zarling, Jeremiah Scott, and everyone at Ten Speed Press, especially Matt Inman, Emma Campion, and Annie Marino. The biggest thank-you and love to my son, Leroy Brown: you are my heart and my everything.

Photography Credits

Front cover: Photograph by
 Dennis Carney

Page i: Photograph by Herb Ritts/
 Trunk Archive
Page ii: Photograph by Stacie Huckeba
Page iv: Photograph by Herb Ritts/
 Trunk Archive
Page v: Photograph by Madison Thorn
Page vi: Photograph by Herb Ritts/
 Trunk Archive

Introduction
Page viii: Courtesy of Dolly Parton Archive
Page 3: Photograph by Gillian Laub

Chapter 1
Page 4: Courtesy of Dolly Parton Archive
Page 6: Courtesy of Dolly Parton Archive
Page 8: Photograph by Sebastian Smith
Page 9: Courtesy of Dolly Parton Archive
Page 11: Photograph by Jeremiah Scott
Page 12: Courtesy of Dolly Parton Archive
Page 14–15: Photograph by Jeremiah
 Scott
Page 17: Photograph by Jeremiah Scott
Page 18: Quantrell Colbert/NBCU Photo
 Bank/NBCUniversal via Getty Images
Page 19: (upper left and right)
 Photograph by Stacie Huckeba;
 (bottom left) Courtesy of Sony Music
 Entertainment
Page 20–21: Courtesy of Dolly Parton
 Archive
Page 22: Photographs by Stacie Huckeba
Page 24: (left) Photograph by Stacie
 Huckeba; (right) Donaldson Collection/
 Moviepix via Getty Images
Page 25: Courtesy of Dolly Parton Archive
Page 27: Courtesy of Dolly Parton Archive
Page 28–29: Photograph by Sebastian
 Smith

Chapter 2
Page 30: Courtesy of Dolly Parton Archive
Page 32: Nashville Public Library, Special
 Collections, The Banner Archives.
 Photograph by Bill Goodman
Page 35: Courtesy of Dolly Parton Archive
Page 36: Photograph by Stacie Huckeba

Page 38: (top left) Courtesy of Dolly
 Parton Archive; (top right) Photograph
 by Stacie Huckeba; (bottom)
 Photograph by Madison Thorn
Page 40: (top) Photograph by Madison
 Thorn; (bottom left) Courtesy of
 Dolly Parton Archive; (bottom right)
 Photograph by Stacie Huckeba
Page 41: (top left and bottom) Photograph
 by Stacie Huckeba; (top right) Courtesy
 of Opry Archives. Photograph by Les
 Leverett
Page 42–43: Courtesy of Dolly Parton
 Archive. Photographs by Stacie
 Huckeba
Page 45: (left) Courtesy of Dolly Parton
 Archive; (right) Photograph by
 Stacie Huckeba
Page 46: Photograph by Madison Thorn
Page 47: Photograph by Stacie Huckeba
Page 49: Photograph by Frank Empson/
 USA Today Network
Page 50: (top and bottom) Courtesy of
 Dolly Parton Archive
Page 51: Photograph by Stacie Huckeba
Page 52–53: Courtesy of Dolly Parton
 Archive
Page 54: (top) Courtesy of Sony Music
 Entertainment; (bottom left and right)
 Courtesy of Dolly Parton Archive
Page 55: Photograph by Stacie Huckeba
Page 57: (left) Courtesy of Sony Music
 Entertainment; (right) Photograph by
 Stacie Huckeba
Page 58: Courtesy of Sony Music
 Entertainment
Page 59: Photograph by Stacie Huckeba
Page 60: Photograph by Bill Preston/USA
 Today Network
Page 61: (left) Photograph by Stacie
 Huckeba; (right) Courtesy of Dolly
 Parton Archive
Page 62: Photograph by Madison Thorn
Page 63: Photograph by Stacie Huckeba

Chapter 3
Page 64: Courtesy of Country Music Hall
 of Fame and Museum. Photograph by
 Howard Kamsler
Page 66: Courtesy of Dolly Parton Archive
Page 68: Photograph by Stacie Huckeba
Page 69: Doug Smith Collection

Page 71: Photograph by Stacie Huckeba
Page 72–75: Photograph by Jeremiah Scott
Page 77: (top) Photograph by Madison
 Thorn; (bottom left) Photograph
 by Stacie Huckeba; (bottom right)
 Courtesy of The Hope Powell
 Collection by Singleton/Curb
Page 78: Photo by Raeanne Rubenstein.
 Courtesy of Country Music Hall of
 Fame and Museum
Page 79: Photograph by Stacie Huckeba
Page 80: (top) Photograph by Madison
 Thorn; (bottom left) Photograph
 by Stacie Huckeba; (bottom right)
 Courtesy of The Doug Smith Collection
Page 81: Photograph by Stacie Huckeba

Chapter 4
Page 82: Photograph by Annie Leibovitz/
 Trunk Archive
Page 84: Courtesy of Dolly Parton Archive
Page 86: Photograph by Stacie Huckeba
Page 87: Courtesy of Dolly Parton Archive
Page 89: (left) Courtesy of Dolly Parton
 Archive; (right) Photograph by
 Stacie Huckeba
Page 90–91: Photograph by Stacie
 Huckeba
Page 92: Photograph by Madison Thorn;
 Sketch by Bob Mackie
Page 94: MediaPunch Inc/Alamy
 Stock Photo
Page 95: (top left) Photograph by Stacie
 Huckeba; (top right and bottom)
 Photographs by Madison Thorn
Page 96: Courtesy of The Doug Smith
 Collection
Page 97: (left) Photograph by Stacie
 Huckeba; (right): Photograph by
 Timothy White
Page 99: Photograph by Stacie Huckeba
Page 100: The Estate of David Gahr/
 Premium Archive via Getty Images
Page 101: Photograph by Stacie Huckeba
Page 102: (top and bottom left)
 Photograph by Madison Thorn;
 (bottom right) Photograph by Stacie
 Huckeba
Page 103: Harry Langdon/Archive
 Photographs via Getty Images
Page 105: Courtesy of Dolly Parton Archive
Page 106: Wire Image

Page 107–108: Photograph by
 Stacie Huckeba
Page 109: Photograph by Ed Caraeff.
 Courtesy of Iconic Images
Page 110: (top) Photograph by Madison
 Thorn; (bottom left and right) Courtesy
 of Dolly Parton Archive
Page 111–112: Photograph by
 Stacie Huckeba
Page 113: Photographs by Madison Thorn

Chapter 5
Page 114: Photograph by Ron Slenzak
Page 116: Photograph by Herb Ritts/
 Trunk Archive
Page 119: Courtesy of Dolly Parton Archive
Page 120: (top) Photograph by Madison
 Thorn; (bottom left) Photograph
 by Stacie Huckeba; (bottom right)
 Steve Schapiro/Sygma. Courtesy
 of Fox Films
Page 121–122: Photographs by Stacie
 Huckeba
Page 123: (bottom left) Photograph by
 Stacie Huckeba; (top and bottom right)
 Photographs by Madison Thorn
Page 125: (top left) Photograph by Stacie
 Huckeba; (bottom) Photograph by
 Madison Thorn; (top right) Ron Galella/
 Ron Galella Collection via Getty Images
Page 126: Photograph by Stacie Huckeba
Page 127: Photograph by Madison Thorn
Page 129: Photograph by Stacie Huckeba
Page 130: Photograph by Madison Thorn
Page 131: Photograph by Stacie Huckeba
Page 132–133: Photographs by
 Jeremiah Scott
Page 134: (top) Courtesy of Dolly Parton
 Archive; (bottom) Photograph by
 Stacie Huckeba
Page 135: Photograph by Stacie Huckeba
Page 136: Pete Still/Redferns via Getty
 Images
Page 137: (top left) Photograph by Stacie
 Huckeba; (top right and bottom)
 Photograph by Madison Thorn
Page 138: Photograph by Stacie Huckeba
Page 139–140: Photograph by Madison
 Thorn
Page 141–142: Photograph by Stacie
 Huckeba
Page 143: Photograph by Madison Thorn
Page 144: (bottom right) Photograph by
 Doug Smith; (top and bottom left)
 Photographs by Madison Thorn
Page 145: Photograph by Stacie Huckeba
Page 146–147: Photograph by
 Jeremiah Scott

Page 148: Photograph by Stacie Huckeba
Page 149: Photograph by Richard D'Amore
Page 150–151: (Polaroids) Courtesy of Dolly
 Parton Archive
Page 151: (bottom) Photograph by
 Jeremiah Scott
Page 152: Photograph by Stacie Huckeba
Page 153: (top) Photograph by Stacie
 Huckeba; (bottom left) Photograph
 by Madison Thorn; (bottom right)
 Courtesy of Dolly Parton Archive

Chapter 6
Page 154: Photograph by Robert Blakeman
Page 156: ABC Photo Archives/Disney
 General Entertainment Content via
 Getty Images
Page 158: Courtesy of Dolly Parton Archive
Page 159: (top left) Courtesy of Dolly
 Parton Archive; (top center) ABC
 Photo Archives/Disney General
 Entertainment via Getty Images; (top
 right) Courtesy of Dolly Parton Archive;
 (middle left) ABC Photo Archives/Getty
 Images; (middle center) Courtesy of
 Dolly Parton Archive; (middle right) Julie
 Fineman/ABC Photo Archives/Disney
 General Entertainment via Getty Images;
 (bottom) ABC Contributor/Disney
 General Entertainment Content via
 Getty Images
Page 161: (top and bottom left)
 Photograph by Stacie Huckeba;
 (bottom right) Photograph by
 Madison Thorn
Page 163: (top left) Photograph by Dennis
 Carney; (top right) Courtesy of Dolly
 Parton Archive; (bottom) Photograph
 by Doug Smith
Page 164–166: Photographs by
 Stacie Huckeba
Page 167: Photographs by Madison Thorn
Page 169: Photograph by Stacie Huckeba
Page 170: Jerry Fitzgerald/ABC Photo
 Archives/Disney General Entertainment
 via Getty Images
Page 171-174: Photographs by
 Stacie Huckeba
Page 175: (top) Photograph by Stacie
 Huckeba; (bottom left) Photograph
 by Madison Thorn; (bottom right)
 Photograph by Lee Calvert
Page 176: (left) Photograph by Robert
 Blakeman; (right) Photograph by
 Stacie Huckeba
Page 178: (top) Photographs by Stacie
 Huckeba; (bottom) Photograph by
 Madison Thorn

Page 179: (left) Courtesy of Dolly Parton
 Archive; (right) Photograph by Stacie
 Huckeba
Page 180: Photograph by Stacie Huckeba
Page 181: (top) Photograph by Madison
 Thorn; (bottom) Courtesy of Dolly
 Parton Archive
Page 182: AP/Photograph by Mark
 Humphrey
Page 183: Photographs by Madison Thorn
Page 184: Courtesy of Sony Music
 Entertainment. Photograph by
 Bob Sebree
Page 185: Photograph by Stacie Huckeba
Page 186: Courtesy of The Dollywood
 Company
Page 187: Courtesy of Dolly Parton Archive
Page 188: Photograph by Annie Leibovitz/
 Trunk Archive
Page 189: Photograph by Stacie Huckeba

Chapter 7
Page 190: Courtesy of The Dollywood
 Company
Page 192: Photograph by Dennis Carney
Page 194: Photograph by Randee
 St. Nicholas
Page 195–196: Photographs by
 Stacie Huckeba
Page 197: Photographs by Timothy
 White
Page 198: Photograph by Stacie Huckeba
Page 199: (top left) Courtesy of Dolly
 Parton Archive; (top right and bottom)
 Photograph by Madison Thorn
Page 200: (top) Photographs by Stacie
 Huckeba; (bottom) Courtesy of Sony
 Music Entertainment
Page 201: (top) Photographs by Stacie
 Huckeba; (bottom left) Courtesy of
 Sony Music Entertainment; (bottom
 right) Photograph by Fran Strine
Page 202: Photograph by Stacie Huckeba
Page 203: (top right) Photograph by
 Larry Ferguson; (top left and bottom)
 Photograph by Madison Thorn
Page 204: Photograph by Stacie Huckeba
Page 205: (top left) AJ Pics/Alamy Stock
 Photo; (top right) Courtesy of Dolly
 Parton Archive; (bottom) Photograph
 by Jeremiah Scott
Page 206: Photograph by Patrick
 Demarchelier/Trunk Archive
Page 207: Photograph by Stacie Huckeba
Page 208: (left) NBC/NBCUniversal via
 Getty Images; (right) Photograph by
 Stacie Huckeba
Page 209: Photograph by Stacie Huckeba

Behind the Seams

Page 211: (left) Courtesy of Dolly Parton Archive; (right) Photograph by Stacie Huckeba

Page 212: Photograph by Stacie Huckeba

Page 213: (top left) Photograph by Stacie Huckeba; (top right and bottom) Photographs by Madison Thorn

Page 214: Photograph by Stacie Huckeba

Page 215: (top left and bottom) Photographs by Stacie Huckeba; (top right) Photograph by Doug Smith

Page 217: Courtesy of Dolly Parton Archive

Page 218–220: Photographs by Stacie Huckeba

Page 221: Photographs by Madison Thorn

Chapter 8

Page 222: Photograph by Dennis Carney

Page 224: Photograph by Dennis Carney

Page 226: Photograph by Annie Leibovitz/ Trunk Archive

Page 227: Courtesy of Dolly Records

Page 228: Sketch by Robért Behar. Courtesy of Dolly Parton Archive; Photographs by Madison Thorn

Page 230–231: Photographs by Stacie Huckeba

Page 232: Photograph by Dennis Carney

Page 233–235: Photographs by Stacie Huckeba

Page 237: Courtesy of Steve Summers

Page 238–239: Photograph by Stacie Huckeba

Page 240: Photograph by Madison Thorn

Page 241: Photograph by Stacie Huckeba

Page 243: Courtesy of Dolly Parton Archive

Page 244: Photograph by Stacie Huckeba

Page 245: (top) Photograph by Madison Thorn; (bottom left) Photography by Kevin Winter via Getty Images; (bottom right) Photograph by Stacie Huckeba

Page 246: Photograph by Stacie Huckeba

Page 247: (top right and bottom) Photograph by Madison Thorn; (top left) Curtis Means/NBS NewsWire/ NBCUniversal via Getty Images

Page 248: Courtesy of Dolly Records

Page 249–250: Photographs by Stacie Huckeba

Page 251: (top left) Photograph by Kii Arens; (top right) Sketch by Robért Behar; (bottom) Photograph by Madison Thorn

Page 252: (left) Courtesy of Dolly Parton Archive; (right) Photograph by Madison Thorn

Page 253–254: Photograph by Stacie Huckeba

Page 255: Photograph by Madison Thorn

Page 256: (top left) Photograph by Madison Thorn; (top right) Courtesy of Academy of Country Music; Sketch by Robért Behar and shot by Stacie Huckeba

Page 257–258: Photograph by Stacie Huckeba

Page 259: Courtesy of Dolly Parton Archive

Page 260: (bottom left) Dimitrios Kambouris/WireImage via Getty Images; (top and bottom right) Photograph by Madison Thorn

Page 261–262: Photograph by Stacie Huckeba

Page 263: Photographs by Madison Thorn

Page 264: (top and bottom left) Photograph by Madison Thorn; (bottom right) Courtesy of Dolly Parton Archive

Page 265: Photographs by Stacie Huckeba

Chapter 9

Page 266: Courtesy of CTK. Photograph by Allister Ann

Page 268: Courtesy of The Dollywood Company. Photograph by Steven Bridges

Page 271: (top left) Photograph by Madison Thorn; (top right) Photograph by Stacie Huckeba; (bottom) Photograph by Larry Ferguson

Page 272: Photograph by Stacie Huckeba

Page 273: Courtesy of Dolly Records

Page 274: Photograph by Bob D'Amico. Courtesy of ABC Photo Archives

Page 275: Photographs by Stacie Huckeba

Page 277: (top) Photographs by Jeremiah Scott; (bottom) Photograph by Jim Herrington

Page 278–280: Photographs by Stacie Huckeba

Page 281: (top left) Photograph by J. B. Rowland. Courtesy of CTK Enterprises; (top right and bottom) Photographs by Madison Thorn

Page 282–283: Photographs by Stacie Huckeba

Page 284: (top) Photograph by Stacie Huckeba; (bottom left and right) Photograph by Madison Thorn

Page 285–286: Photograph by Stacie Huckeba

Page 287: (top right) Photograph by J. B. Rowland. Courtesy of CTK Enterprises; (top left and bottom) Photograph by Madison Thorn

Page 288: Photograph by J. B. Rowland. Courtesy of CTK Enterprises

Page 289–291: Photograph by Stacie Huckeba

Chapter 10

Page 292: Photograph by J. B. Rowland. Courtesy of CTK Enterprises.

Page 294: Photograph by Stacie Huckeba

Page 296–297: Photographs by Jeremiah Scott

Page 298: Photograph by Stacie Huckeba

Page 299: Photographs by Jeremiah Scott

Page 300: Courtesy of Dolly Parton Archive

Page 301: Photographs by Stacie Huckeba

Page 302-303: Photographs by Jeremiah Scott

Page 305: Photograph by Richard Avedon. Courtesy of The Richard Avedon Foundation

Page 306: (all photographs) Courtesy of Dolly Parton Archive

Page 308: Courtesy of Sony Music Entertainment

Page 309: (top left) Photograph by Stacie Huckeba; (top right and bottom) Photograph by Madison Thorn

Page 310–311: Photograph by Stacie Huckeba

Page 313: Photograph by J. B. Rowland. Courtesy of CTK Enterprises

Page 314: Photograph by Stacie Huckeba

Page 315: Photograph by Madison Thorn

Page 316: (top left and right) Photograph by Jeremiah Scott; (bottom) Kevin Mazur/Getty Images Entertainment via Getty Images

Page 317–318: Photographs by Stacie Huckeba

Page 319: (top and bottom right) Photograph by Madison Thorn; (bottom left) Photograph by Stacie Huckeba

Page 320: Photographs by Jeremiah Scott

Page 322: Photograph by Jim Herrington

Photography Credits

Text copyright © 2023 by Dolly Parton

All rights reserved.
Published in the United States by Ten Speed Press, an imprint of the Crown Publishing Group, a division of Penguin Random House LLC, New York.
TenSpeed.com

Ten Speed Press and the Ten Speed Press colophon are registered trademarks of Penguin Random House LLC.

Typefaces: Commercial Type's Canela, DJR's Crayonette, and Ilham Herry's Caniste and EFCO Songster

Library of Congress Control Number: 2023934160

Hardcover ISBN: 978-1-9848-6212-9
eBook ISBN: 978-1-9848-6213-6

Printed in China

Acquiring editor: Matt Inman | Production editors: Doug Ogan and Terry Deal
Assistant Editor: Fariza Hawke
Designer: Annie Marino | Art director: Emma Campion
Production designers: Mari Gill and Faith Hague
Production and prepress color manager: Jane Chinn
Prepress color assistant: Claudia Sanchez
Director of photography: Stacie Huckeba | Assistant director of photography: Madison Thorn | Additional Photography by: Dennis Carney, Jim Herrington, Sebastian Smith, and Jeremiah Scott | Photo retouching: Tammy White and Jeremy Blum
Illustrator: Bailey Sullivan
Copyeditor: Sharon Silva | Proofreaders: Janice Race, Ivy McFadden, and Taylor Teague
Publicists: Kate Tyler and Jana Branson | Marketers: Allison Renzulli and Brianne Sperber

10 9 8 7 6 5 4 3 2 1

First Edition